THE PHOTOGRAPHIC IMAGE IN DIGITAL CULTURE

This new edition of *The Photographic Image in Digital Culture* explores the condition of photography after some 20 years of remediation and transformation by digital technology. Through ten specially commissioned essays, by some of the leading scholars in the field of contemporary photography studies, a range of key topics are discussed including:

- the meaning of software in the production of photographs
- the nature of networked photographs
- the screen as the site of photographic display
- the simulation of photography in the videogame
- photography, ubiquitous computing and technologies of ambient intelligence
- developments in vernacular photography and social media
- the photograph and the digital archive
- the curation and exhibition of the networked photograph
- the dominance of the image bank in commercial and advertising photography
- the complexities of citizen photojournalism.

A recurring theme addressed throughout is the nature of 'photography after photography' and the paradoxical nature of the medium in the twenty-first century; a time when the traditional technology of photography has become defunct while there is more 'photography' than ever.

This is an ideal book for students studying photography and digital media.

Martin Lister is Professor Emeritus in Visual Culture at the University of the West of England, Bristol. His recent publications include the co-authored second edition of *New Media: A Critical Introduction* (Routledge, 2009), 'The times of photography' in *Time, Media and Modernity* (Palgrave, 2012) and 'Overlooking, rarely looking, and not looking' in *Digital Snaps: The New Face of Photography* (I.B. Tauris, 2013). He is an editor of the journal *Photographies* published by Routledge.

Comedia

Series Editor: David Morley

Comedia titles available from Routledge:

ADVERTISING INTERNATIONAL
The Privatisation of Public Space
Armand Mattelart translated by Michael Chanan

BLACK BRITISH CULTURE AND SOCIETY
A Text Reader
Edited by Kwesi Owusu

THE CONSUMERIST MANIFESTO
Advertising in Postmodern Times
Martin Davidson

CULTURAL SNIPING
The Art of Transgression
Jo Spence

CULTURE AFTER HUMANISM
History, Culture, Subjectivity
Iain Chambers

CULTURE IN THE COMMUNICATION AGE
Edited by James Lull

CULTURES OF CONSUMPTION
Masculinities and Social Space in Late Twentieth-Century Britain
Frank Mort

CUT 'N' MIX
Culture, Identity and Caribbean Music
Dick Hebdige

THE DYNASTY YEARS
Hollywood Television and Critical Media Studies
Jostein Gripsrud

FAMILY TELEVISION
Cultural Power and Domestic Leisure
David Morley

A GAME OF TWO HALVES
Football, Television and Globalisation
Cornel Sandvoss

HIDING IN THE LIGHT
On Images and Things
Dick Hebdige

HOME TERRITORIES
Media, Mobility and Identity
David Morley

IMPOSSIBLE BODIES
Femininity and Masculinity at the Movies
Chris Holmlund

THE KNOWN WORLD OF BROADCAST NEWS
Stanley Baran and Roger Wallis

MEDIA/THEORY
Thinking About Media and Communications
Shaun Moores

THE PHOTOGRAPHIC IMAGE IN DIGITAL CULTURE

Second edition

Edited by Martin Lister

Routledge
Taylor & Francis Group

LONDON AND NEW YORK

Second edition published 2013
by Routledge
2 Park Square, Milton Park, Abingdon, Oxon OX14 4RN

Simultaneously published in the USA and Canada
by Routledge
711 Third Avenue, New York, NY 10017

Routledge is an imprint of the Taylor & Francis Group, an informa business

© 1995, 2013 Martin Lister for selection and editorial matter; individual
contributions the contributors

First edition-published by Routledge 1995

British Library Cataloguing in Publication Data
A catalogue record for this book is available from the British Library

Library of Congress Cataloging in Publication Data
The photographic image in digital culture / edited by Martin Lister. -- Second
edition.
pages cm
Includes bibliographical references and index.
1. Photography--Social aspects. 2. Images, Photographic. 3. Photography--
Philosophy. 4. Mass media and the arts. 5. Popular culture--History--20th
century. I. Lister, Martin, 1947– editor of compilation.
TR183.P48 2013
770--dc23
2013008149

ISBN: 978-0-415-53527-4 (hbk)
ISBN: 978-0-415-53529-8 (pbk)
ISBN: 978-0-203-79756-3 (ebk)

Typeset in Bembo
by Taylor & Francis Books

MIX
Paper from
responsible sources
FSC® C013604

Printed and bound by CPI Group (UK) Ltd, Croydon, CR0 4YY

CONTENTS

·

LIST OF ILLUSTRATIONS

LIST OF CONTRIBUTORS

Martin Lister is Professor Emeritus in Visual Culture at the University of the West of England, UK. His recent publications include the second edition of *New Media: A Critical Introduction* (Routledge, 2009), 'The times of photography' in *Time, Media and Modernity* (Palgrave, 2012) and 'Overlooking, rarely looking, and not looking' in *Digital Snaps: The New Face of Photography* (I.B. Tauris, 2013). He is an editor of the journal *Photographies* published by Routledge.

Stuart Allan is Professor of Journalism in the Media School, Bournemouth University, UK, where he is also the Director of the Centre for Journalism and Communication Research. He has authored several books, the most recent of which is *Citizen Witnessing: Revisioning Journalism in Times of Crisis* (Polity, 2013). Currently, he is conducting a research study examining the uses of digital imagery in news reporting, while also writing a history of war photography for Routledge.

David Bate is Professor of Photography at the University of Westminster based in London, UK. As a photographer, writer and teacher, his work is situated at the intersection of practice and theory and refuses the divide that makes it so binary for some critics. His photographic work has been exhibited widely in the UK, Europe and North America. An author of many artworks and writings on photography and culture, his many publications include the books *Zone* (London, Artwords Press, 2012), *Photography: Key Concepts* (Berg, 2009) and *Photography and Surrealism* (I.B. Tauris, 2004).

Andrew Dewdney is a research professor at the Centre for Media and Cultural Research at London South Bank University, UK, and was most recently the Principal Investigator and Director of the AHRC Tate Encounters project at Tate Britain (2006–10). Trained as a fine artist, he has previously been Head of the

School of Film and Photography at Newport College of Art, and Director of Exhibition and Photography at the Watershed Media Centre in Bristol. His teaching focuses upon new media and visual culture and he is co-author of *The New Media Handbook* (Routledge, 2006), which he is currently updating for a second edition.

Paul Frosh is Associate Professor in the Department of Communication and Journalism, and Distinguished Scholar at the Rothberg International School of the Hebrew University of Jerusalem. His research interests include visual culture and media aesthetics; the cultural industries and consumer culture; media, terrorism and national sentiment; the media and ethical concern. His books include *The Image Factory: Consumer Culture, Photography and the Visual Content Industry* (2003), *Meeting the Enemy in the Living Room: Terrorism and Communication in the Contemporary Era* (2006, in Hebrew, edited with Tamar Liebes), *Media Witnessing: Testimony in the Age of Mass Communication* (2009, second edition 2011, edited with Amit Pinchevski), and *Democracy and Communication: Mutual Perspectives* (2009, in Hebrew, edited with Anat First).

Seth Giddings teaches theory and practice of digital media in the Department of Creative Industries at the University of the West of England, UK. A researcher with the Digital Cultures Research Centre (dcrc.org.uk), he is co-author of Lister et al. *New Media: a Critical Introduction* (second edition, 2009) and co-editor of *The New Media and Technocultures Reader* (2011), both Routledge.

Sarah Kember is a writer and academic. Her work incorporates new media, photography and feminist cultural approaches to science and technology. She is Professor of New Technologies of Communication at Goldsmiths, University of London, UK. Publications include a novel and a short story, respectively *The Optical Effects of Lightning* (Wild Wolf Publishing, 2011) and 'The Mysterious Case of Mr Charles D. Levy' (Ether Books, 2010). Experimental work includes an edited open access electronic book entitled *Astrobiology and the Search for Life on Mars* (Open Humanities Press, 2011) and 'Media, Mars and Metamorphosis' (*Culture Machine*, Vol. 11). Her latest monograph (with Joanna Zylinska) is *Life After New Media: Mediation as a Vital Process* (MIT Press, 2012).

Susan Murray is Associate Professor of Media, Culture and Communication at New York University, USA. She is the author of *Hitch Your Antenna to the Stars: Early Television and Broadcast Stardom* (2005) and a co-editor, with Laurie Ouellette, of two editions of *Reality TV: Remaking Television Culture* (2004; 2009). She is currently working on a history of colour television, which is under contract with Duke University Press.

Daniel Palmer is a writer and Senior Lecturer in the Art History and Theory Program at MADA (Monash Art, Design and Architecture). He has a long-standing

involvement with the Centre for Contemporary Photography in Melbourne, as a former curator and current board member. His publications include the books *Twelve Australian Photo Artists* (2009), co-authored with Blair French, and the edited volume *Photogenic: Essays/Photography/CCP 2000–2004* (2005). His scholarly writings on photography have also appeared in journals such as *Photographies, Philosophy of Photography* and *Angelaki*.

Daniel Rubinstein is a critical theorist, writer and photographic artist who is a senior lecturer in the Department of Arts and Media, London South Bank University, UK. His research covers the trans-disciplinary fields of photography, Media Art, contemporary philosophy and communication technology. Underpinned by multifaceted engagement with photography, his work examines the digital image within the context of networked and mediated urban environments. He is the editor of the international journal *Philosophy of Photography* published by Intellect.

Katrina Sluis is a New Zealand-born writer, curator, educator and artist. She is presently Curator (Digital Programme) at The Photographers' Gallery, London and Senior Lecturer at London South Bank University, UK. Her present research concerns questions of materiality, archiving and transmission in relation to the networked photograph both inside and outside the museum. Her writing has been featured in *Photographies, Philosophy of Photography* and recent exhibitions curated include *Born in 1987: The Animated GIF* and *For the LOL of Cats: Felines, Photography and the Web*.

Nina Lager Vestberg is Associate Professor of Visual Culture at the Norwegian University of Science and Technology (NTNU), Trondheim. Before obtaining a PhD in the history of art she trained as a photographer and worked for several years as a picture researcher in the UK press. Previous publications include articles and chapters on French photography and cultural memory, the digitisation of photographic archives and issues of copyright. Her current research focuses on the ethical and environmental challenges of digital media culture.

1

INTRODUCTION

Martin Lister

The first edition of this book was published in 1995 as rapid and startling technological developments took place and the emergent implications of computation and digitisation for photography began to be glimpsed. Since that date the changes in photographic production, distribution and consumption to which the book first pointed have been enormous. For some contributors to this edition the changes are ontological, they strike at the very heart of what the photographic image is or is becoming (see Rubinstein and Sluis, this volume) while for others change, even if marked, is seen to take place within existing structures and continuities (see, for instance, Frosh and Murray, this volume). Over the same period, what constitutes digital culture has also changed. Commensurately, research and debate about the cultural meaning of digital photography, its significance for the historical practice of photography, the emergence of a 'post-photographic era' and subsequently a time of networked and computed photography, have been considerably elaborated. Further, dramatic changes have taken place that were unforeseen in the mid-nineties and hence found no mention in that first edition; not least the development from 2002 of the Web 2.0 with its user-generated and editable content, the spectacular growth from the mid 2000s of social network sites, the massive accumulation of personal, corporate and historical bodies of photographs in online databases and archives, and the mass availability and use, within the period, of an important hybrid communication device: the camera-phone. We have also witnessed new forms of photojournalism and shifts in the practices of snapshot and personal photography. In the same time frame, the distinction between the still and the moving image has become hard to secure, the chemical photograph has become an historical artefact and its traditional means of production have become all but unavailable. In the 17 years between the first and second edition of this book, there has been an explosion of new kinds of photographic practices, technologies and

institutions that, alongside apparent continuities, have raised a range of new questions.

The first edition of this book was one of the first to use the term 'digital culture' in its title, and this too has changed since 1995. The first edition opened with an image of personal computers humming and blinking on desks in formal institutions. They are, of course, still to be found, but computers have also moved off desks and out of their beige boxes to be integrated into a range of embedded smart devices and closer to the fabric of everyday life, to be mobile, pervasive and ubiquitous. Rather than dramatic novelties, so called 'new' or 'digital' media technologies are now the stuff of habit, routine, everyday life and work. We have seen a shift in the terms we use to describe contemporary media with 'digital' and 'new' giving way to 'networked', 'mobile', 'social', 'locative' and 'pervasive' (see Kember, this volume). The politics of new communications technologies have shifted as the incorporation, institutionalisation, regulation and surveillance of global information systems presents a less utopian picture than some saw, perhaps naively, 17 years ago. There are fierce and relentless attempts to police and legislate over access and control of the information passing through and stored on the internet and the web. Forms of social media that once seemed best described in terms of their folksy grass roots and bottom-up organisation are now also recognised as ways of 'monetising' the labour of amateurs and selling it back to them. The vast server farms that feed the internet have become a major consumer of fossil fuels and the earth is scoured in a race to monopolise the rare metals essential in the fabrication of microelectronics. The once proclaimed light touch of digital technologies on the environment – the sustainability of the virtual (the paperless office!) in contrast to energy devouring and polluting real world industries – is appearing to be hubristic (Taffel 2012). The 'loss of the real' takes on a new meaning. This time, more than a semiotic equation is at stake; it is the real in the most material and physical sense that could be lost.

The first edition

If these are some of the main changes that have taken place with respect to the photographic image *and* with respect to digital culture in the period between the first and second editions of this book, it may be worth briefly revisiting the introduction to the first edition in order to gauge the difference between the questions that faced us then and those that face us now.

Looking back at the introductory essay in the first edition it is clear how much it was concerned with teasing out the continuities in the practice and culture of photography that ran across technological change and tempered the often hyperbolic terms in which it was conceived. It is also clear that it sought clarity and grounded argument amid wild and bewildering speculation. Noting the 'startling' and 'dramatic' technological changes in 'the means of image production' that had taken place from the end of the 1980s, it saw widespread critical chaos. This essay saw the sheer scale of the intellectual entities that clamoured for attention; a

'postphotographic age' was only one among hyperreality, virtuality, cyberspace, nano-technology, artificial intelligence and genetic engineering, and it warned that we faced a situation in which 'focused thought' could become impossible. The book intended to be 'a contribution to gaining such a focus'. It promised to eschew generalisation and abstraction to look instead at the concrete 'social sites of photographic production and consumption' (1995: 2) which, it suggested, were precisely the sites in which the new technologies of the image were being put to work. A key task that it set itself was to insist that the new discourses of the digital image should engage with the body of historical and theoretical knowledge about photography that we already possessed and to which they seemed blind (1995: 5). Rather than a caricature of photography set in a crude opposition to 'millenarian futurology', it called for a taking into account of 'a body of critical thought about nineteenth and twentieth-century technological forms of visual representation' (1995: 5). On this basis the introduction took issue with monolithic and essentialist conceptions of photography; it advocated instead, following Tagg (1988), the concept of 'photographies', which decentres the technology employed in the medium and foregrounds its plural social uses. It warned of an equivalent essentialism being applied to digital technology, and was highly critical of the view that digital photography simply broke the photograph's indexical connection to its referent and that a digital photograph was not (or could not be) indexical. This introductory essay reminded us that photographic representation was part of a wider Cartesian scopic regime that, far from being disrupted, was being engineered into the new image technologies, including digital cameras. It insisted on the hybrid nature of photography prior to its digital form by recalling its past relationships with other technologies: print, graphic, electronic, televisual and telegraphic. It saw the convergence between photography and digital media as an acceleration of this longer history, and insisted that analogue photographs were intertextual and polysemous and that these were not newly defining or distinguishing qualities of digital images.

I think that these points still stand. Indeed, they might be due for a little reinforcing. In short, where photography is concerned, analogue or digital, we should remember to keep its plurality or multiplicity of forms and uses in view; we should keep its indexicality within strict critical limits; we should be aware of the enormous weight of the representational conventions that it embodies while insisting on its (historical as well as current) hybridity and promiscuity with other technologies and practices.

The second edition: from image to network

Much has changed since these positions were formulated. When these arguments were made certain developments were yet to take place. As Daniel Palmer observes (this volume), in 1995 the World Wide Web was in its infancy with the first images having been uploaded in 1992, and its traffic in images was slow and cumbersome. What has become the 'networked' image was not an object of

attention at that time. Interest was exercised at the level of the discrete image itself, and its newly acquired 'interactivity' in 'stand alone' forms of media storage, such as the CD Rom, and 'rich media' software such as Photoshop and Macromedia Director. Now, in 2013, attention has shifted from the digitally encoded image to the dispersed life of images online and to what is increasingly referred to (in the somewhat ominous and singular noun) as 'the network'; such that we now routinely affix 'networked' to 'digital image'.[1] The 'network image' has demanded new kinds of attention and it is this that most strongly marks out this second edition from the first, especially the perception of a new transience of the photographic image as it is assimilated to a global flow of data and information.

It is also true that the intellectual project of the first edition, with its confident tone of 'clearing the ground' and reinstating 'focus' by engaging 'the body of historical and theoretical knowledge about photography', has become less straightforward. The idea that the intellectual challenge was to use the history and theory of photography and media and cultural theory to qualify and inject some rigour into the wild discourses of the digital revolution no longer holds in quite the same way. Both digital photography and the World Wide Web were emergent in 1995. In this sense there was some equivalence between them; they were broadly coeval developments. Now, in 2013, the network and its institutions have grown enormously and have come, in many ways, to characterise the era we live in, while strange things have happened to photography. We now live with the paradox, expressed repeatedly but in different ways throughout the chapters of this edition, that 'photo-graphy', the technology about which there was so much anxiety in the 1990s, has all but ceased to exist, yet there has been an exponential increase in photographic images: there is more 'photography' than ever. As the network has come to constitute a second nature, photography has become harder to grasp.

In the period between the two editions there has also, I believe, been a growing awareness of the way that photography (perhaps, more specifically, the camera) has extended outwards from its traditional centre, to interface or become part of other technologies, practices and cultural forms, and this is a work in progress (see Kember, and Giddings, this volume). There is an awareness that '(d)igital photography is a complex technological network in the making rather than a single fixed technology' (Larsen 2008: 142) or that we should approach photography as a 'socio-technical object' (Gómez Cruz and Meyer 2012: 210). Traditionally, photography has been studied as one of a number of kinds of object, each in relative isolation: most frequently as a form of visual representation, but also as a technology of mass reproduction and hence sociological significance, or as an object of social and anthropological interest. Its study, particularly when situated in a philosophical milieu, has repeatedly taken the form of a search for its ontological essence; its true and singular nature. The concept of a 'socio-technical object' arose within Science and Technology Studies and, appropriately, in respect to the way photography has changed, it seeks to understand things as the product of networks of agencies. It acknowledges non-human as well as human agency and in doing so has enabled us to think beyond both technological determinism and the humanist restriction of

agency and causality to only human intention and reason. Within Science and Technology Studies, and the version known as 'actor network theory', photography is understood as an always provisional outcome of a (possibly changing) alignment of factors, 'involving the creative presence of organic beings, technological devices and discursive codes, as well as people, in the fabrics of everyday living' (Whatmore 1999, quoted in Larsen 2008: 144).

Such a way of conceiving of photography, as hybrid and relational, as stabilising at moments in history, before changing again, also has implications for how we view how we may write its history (see Giddings, this volume). For instance, given our consciousness of the importance of the internet and the World Wide Web, Wi-Fi-equipped camera-phones and social media institutions such as Flickr to current photography, we are newly sensitised to a seldom mentioned aspect of photographic history: the postal service in the early twentieth century. Here a network of post offices, mail carriers (the internal combustion engine, the bicycle) and manual and mechanical sorting facilities were crucial to the viability of the Kodak system of snapshot photography even though the existence of this network owed nothing at all to 'any intention of supporting mass-market image creation' (Gómez Cruz and Meyer 2012: 210). It was an enabling alignment.

Photography as residual

The changes photography has undergone in the last two decades have created a degree of uncertainty about how we understand its contemporary status or condition. Indeed, that last phrase, 'contemporary status or condition', begs the question, is the photography we now have truly photography? Maybe it is photography, but photography by other (digital) means? If it is the latter, does this matter? Or, should we respect that 'photography' only makes sense as a now-displaced practice based uniquely on light and chemistry? In what sense does photography continue to exist? No doubt, these largely unanswered questions (we quickly tire of asking them, they become 'academic' and convoluted, and we move on – to make and consume) contribute to the way that photography is now frequently spoken about in paradoxical and quasi-supernatural terms. Photography appears to be everywhere and nowhere simultaneously. It is *everywhere* in that its ubiquity – so often noted with regard to its reach into every corner of life during the twentieth century – has become supercharged in the twenty-first as we struggle to comprehend mind-boggling statistics about digital photographic production, storage and display. If, in the 1970s, a pioneering curator of photography felt able to make the unverifiable observation that there were more photographs than there were bricks in the world (Szarkowski 1976, unpaginated), what analogy would serve us to characterise a time when 300 million photographs are uploaded daily to a single social network site (Murray, this volume) and a trillion JPEGs have been made (Palmer, this volume), and when, it is claimed, that in less than a decade the camera-phone has put more cameras in people's hands than in the whole history of photography? But, photography is *nowhere* in the sense that it has mutated or morphed; it is a shape

shifter. It has become a ghost medium that haunts us. As Nina Lager Vestberg writes (in this volume) it is a medium that has died many deaths but refuses to die. We might say that photography exemplifies the state of the 'undead' that the OED concisely defines as something that is technically dead but still animate. This is a language (echoing throughout chapters in this volume) that strives to catch something of the powerful continuities in photographic conventions, and its uses and values, while acknowledging that, strictly speaking, the historic means of photographic production now hardly exist and are practically unobtainable. As Andrew Dewdney puts it (this volume), 'the photograph is now apparently produced without photography?' Yet, as Paul Frosh warns, even to talk of 'trans-formation' could be 'to speak the language of alchemy, of magical alteration' (this volume).

Nina Lager Vestberg (this volume) reminds us that there is another, less melodramatic, term that we might use to speak of photography's condition, one that has held an important place in cultural theory: this is the idea of the 'residual' cultural form. This is one term in Raymond Williams' dynamic, tri-partite characterisation of cultural forms, which, he suggests, always need to be thought of as either domi-nant, residual or emergent. He distinguishes the 'residual' from the merely 'archaic' with its simpler connotations of very old things: the embalmed products or practices of another time. The residual, he explains, 'has been effectively formed in the past, but is still active in the cultural process', it is not simply an element of a past age, as it remains 'an effective element in the present' (Williams 1977: 122). Photography as 'one of the great emblematic artefacts of modernity' (Tomlinson 2007: 73) was overwhelmingly dominant as a means of image production throughout much of the nineteenth and twentieth centuries and may now be thought of as residual in this way. It is a 'flexible territory where the past overlaps with the present' (Lager Vestberg, this volume). Formed in the past yet displaced in many ways, it continues to be a kind of force field that pulls and tugs at practices even as they change or, indeed, as part of *how* they change. This is certainly a concept that could help us understand why the history of analogue photography might still interest 'digital natives', the generation who have no lived experience of loading film and long hours in darkrooms. Analogue photography may have been formed in the past but it exerts its influence in the present.

Thinking of photography as a ghostly medium or a residual cultural practice resonates with yet another way in which photography is currently being understood: as a simulation or a simulacrum of the thing that it once was. Invisible simulation machines (the work of computer software and the agency of algorithms) produce what we take as photography. They make images that have all the appearance and hallmarks of photographs without using photography's historical and physical apparatus. Hence, it is argued, the theory of photography must be drawn into a theory of software and computation, as they are the agents that are responsible for the dissolution of all physical media while ensuring their continuation; this surely is the state that invites the talk of the 'undead' and its many versions. This will be taken up shortly, but before that we should recognise that the photographs that we meet

in this 'continuation' are not identical to the products of the older, originary technology of optics, chemistry and mechanics.

Transient photographs

The methods and underpinning theories with which we have analysed or interpreted photographic images are no longer adequate for thinking about networked digital photographs. The kind of visual, textual or semiotic analysis that has dominated the theory of photography (and art history and visual cultural studies more generally) assumes that its objects of study are rich and complex artifacts attended to by viewers who scrutinise them with concentrated interest. They are grounded in conceptions of photography and its reception that assume framed, fixed and stable images viewed (or 'read') by equally centred and motivated viewers.

Remembering that there are plural photographies serves to remind us that there are enclaves of photographic images where such a paradigm is maintained. This is particularly the case where photographs are made and constituted as works of art, which become ever more monumental and spectacular as artifacts. Such images continue to attract the concentrated attention of art collectors and semiotically sophisticated art critics (see Dewdney in this volume). Indeed, an artist such as Thomas Ruff uses the gallery exhibit to draw the (concentrated) attention of the art-consuming public to the wider condition of the digital photographic image (see Palmer, this volume). An international festival of photojournalism, such as 'Visa: Pour L'Image' as is held annually in the city of Perpignan, testifies to the tenacity with which the historical documentary project of photography is held to in the face of overwhelming economic odds.[2] The 'slow photography' movement described by Susan Murray (this volume) speaks of a desire to return to a more deliberative practice, and is an example of where 'the residual' might just promise to return as 'the emergent' in Williams' terms (although he is wary of such tendencies and sets the bar very high for qualification as a genuinely emergent form). The question remains, as David Bate puts it (in this volume),

> How *do* we talk about the distinct institutional and discursive practices of fashion photography, news photography, advertising images, tourist iconography, public displays of private photographs, the specious genres of the pornographic image, tabloid and paparazzi photography, generic 'stock' images, art photographs or portraits of public figures all as simply 'digital photography'?

Indeed! Yet, as he suggests, 'digital' (or, as we meet in this book, 'algorithmic', 'simulated' photography or 'photography after photography') are abstractions for processes that have effects on all of these practices. This is important, because as Paul Frosh observes (in this volume and Frosh 2003: 195–97), digital technologies in the hands of the 'visual content industry' work to dismantle the discursive and

organisational boundaries between even 'the three great photographic fields of art photography, advertising photography and documentary photojournalism'.

It is now the case that the vast generality of photographic images enter fibre optic and telecommunication networks as numeric data and are transmitted, stored, and shared in this coded form. Invisible to human beings but readable by machines (computers), these images only rarely, if at all, take the form or 'output' of a stable physical print. The most common way of viewing such networked images is on the light emitting screens of cameras, camera-phones, PDAs of various kinds and laptop computers. These, of course, can be switched on and off, hence such images have duration; a quality new to photographs (Nardelli 2012: 159–78). Many such screens will be interactive and the images they display can be moved, resized and reformatted by a tap or stroke of a finger. We may say, then, that it is in the nature of digital networked images to exist in a number of states that are potential rather than actual in a fixed and physical kind of way. Such images are fugitive and transient, they come and they go, they may endure for only short periods of time and in different places, maybe many places simultaneously. Characteristically they exist in multiples; as strings, threads, sets, grids (see Frosh's thoughts on the 'thumbnail', this volume). We anticipate that behind an image we have alighted on there is another waiting or there is one, seen earlier, to be returned to. Rather than absorbing us in a singular manner each image seems to nudge us toward another. They have a kind of mobility as we scroll across them, clicking one or another in and out of the foreground of the screen's shallow space. We pay attention to such photographs in different, more fleeting or distracted ways than the kind of viewer that is imagined by traditional theories of photography, embodied now as the minority audiences of gallery-installed prints. (For further consideration of this transient image in respect of photographic exhibition and display, see Andrew Dewdney, in commercial and advertising contexts see Paul Frosh and for the way that the value of images now lies in their very depiction of transient states, see Murray, all in this volume).

Photography, information and attention

This fugitive and transient networked photograph and its restless viewer (or user) is more than an aesthetic form. It is part of a larger reconfiguration of experience and mediation of the world by information technologies. We may see what is at stake here if we think about what is meant when we say that photographs have become information. This does not mean that there is a proliferation of images that carry information of the kind that we might once have taken a traditional documentary photograph to give us; as a report on a specific event, thing or situation. The different kind of information that photographs have become had been laying in wait for some time, at least since 1949 when a theory of information as the transmission of unambiguous signals in telecommunication systems was outlined in Shannon and Weaver's foundational 'A Mathematical Theory of Communication'.[3] By the early 1950s, such a theory began to be operational with regard to

photographs as it became possible to scan and convert them into arrays of binary digits, and hence they became 'electronically processable digital information' (Mitchell 1992: 1) However, it was not until considerably later, in the early 2000s, that digital cameras supplied such 'processable' information automatically and fed it into the internet. The conversion of photography to information was complete: it became a default operation.

In his etymology of the word, Geoffrey Nunberg describes this kind of 'information' as a new kind of abstract, generic and intentional *substance* that is 'at large' in the world (Nunberg 1996: 110–11, see also Frosh 2003: 195–200). It can be moved around the world at high speed, it is a quantifiable, it is a commodity that can be traded in and it is separable from its instantiation in a medium (it is detachable from its substrates). As Bruno Latour (2004) wryly observes, this is information that can be weighed in kilobytes, that clogs email accounts and can make 'computers heat up'. The history of this release of information from the material substrates on which it was once inscribed has been described as the story of 'how information lost its body', a story that was not inevitable but was the product of selective research programmes (Hayles 1999: 22). Digital photography is part of that story; as a seamless analogue configuration bound to a physical surface is rendered into bits, having the physical form of electronic charges and the symbolic form of numbers. The chemical photograph, continuous tonal alterations to a field of silver salts carried on a physical and bounded substrate, became assimilated to a generic code. This, of course, is the kind of information indicated in a phrase like the 'information economy'.

There is a problem with the concept of such an information economy that arises with the vast scale of its production and includes digital photographic production that defeats comprehension as we count photographs and image files in their billions and trillions. The question has been asked as to what kind of economy this is: an economy that trades in a commodity of which there is an unmanageable and unimaginable excess. A key statement of the problem is Goldhaber's:

> (O)urs is not truly an information economy. By definition, economics is the study of how a society uses its scarce resources. ... We are drowning in information, yet constantly increasing our generation of it. ... There is something else that moves through the Net, flowing in the opposite direction from information, namely attention.
>
> *(Goldhaber 1997)*

This sense of the massive and continuing production of information (including, since the mid 1990s, the visual and the photographic) has a much longer history in an anxiety about 'information overload'. It was broached, albeit in different terms, with regard to photography, as early as 1926 by Siegfried Kracauer in his essay on photography as 'mass ornament' (Kracauer 1995). In 1945, Vannevar Bush, the pioneering electrical engineer and information scientist, envisaged an interactive, networked machine utilising a mobile camera and a 'dry' form of photography that

he hoped would play a major role in solving the problem.[4] He wrote, almost 70 years ago,

> There is a growing mountain of research ... there is increased evidence that we are being bogged down ... The investigator is staggered by the findings and conclusions of thousands of other workers – conclusions which he cannot find time to grasp, much less to remember ... publication has been extended far beyond our present ability to make real use of the record. The summation of human experience is being expanded at a prodigious rate, and the means we use for threading through the consequent maze ... is the same as was used in the days of square-rigged ships.
>
> *(Bush 1945)*

The continuing problem, a problem for the informational mode of capitalism (Castells 2000: 77–147) is that the massive (over)production of information places demands on the ability of people to attend to it. As Simon (1971: 40) put it, 'What information consumes is rather obvious ... the attention of its recipients. ... a wealth of information creates a poverty of attention' (Simon 1971: 40).

The question has become, how does any particular enterprise, owner or provider of information, corporate or public, commercial or educational, scientific or artistic, gain attention to 'their' information? How is a supply or measure of the scarce commodity that is human attention to be obtained? In the twentieth century the obvious site of this competition for attention was advertising and the selling of 'eyeballs' by commercial television channels. The predominant forms of twentieth-century 'mass media', the printed press (in which photography was paramount) and television, continue to battle for ratings and sales but the real ground has moved to networked digital media with its interactive push-pull strategies, niche markets, pop-ups, cookies and predictive operations. This is a complex issue, politically, within which photography continues to be centrally involved. Suffice it to say that what is at stake is a competition for the human capacity for paying attention; a commodification of our cognitive capacities (for a comprehensive discussion, see 'Paying Attention', the special issue of *Culture Machine* Vol 13, 2012 at www.culturemachine.net/index.php/cm).

An example of what this means for photography is given by Paul Frosh (in this volume). Companies whose aim is to sell stock photographs for advertising purposes through online image-banks face a conundrum.

> The challenge for photographers and stock agencies is to make every image an 'arresting' image ... amid the 'clutter' generated by all other images. Every image ... cries out for attention, and yet in so doing every image also threatens to become 'noise', distracting the viewer from neighbouring images.

As Frosh then suggests, the 'thumbnail' reduces this image noise and clutter to 'an instrumental grid on a screen'. The hope is that the viewer, whose gaze is

distracted by the many competing images that surround and confront them, can be helped to more effectively scan and choose, and hence be returned, to a degree, to the ideal (if now mythological) position of the attentive viewer. Another example, noted in several chapters in this book (see, for instance, Palmer and Murray, in this volume) might be the Instagram and Hipster applications whereby algorithms turn 'run of the mill' snapshots into retro-images, photographs bearing the characteristics of old photographs. This is a means of attaching the connotations of a 'look' with cultish values, to otherwise unremarkable images. The function and appeal of such applications is surely to distinguish some images within a sea of others. It is, ultimately, a self-defeating exercise but not perhaps until a temporarily profitable market becomes exhausted and a point is reached when no distinction is any longer offered.

Software, algorithm, automation

I noted above, in the discussion of photography as a residual cultural form, that a related view is to see photography as simulated; something that is achieved by computer software. In their informational state, photographs are processed and shaped by bodies of code in the form of software and its operative components: algorithms. Since the first edition of this book there has been a growing demand for theorists of media to take the social and cultural role of software seriously, hence some consideration is due in this introduction. Such 'Software Studies', urges Lev Manovich, should 'investigate both the role of software in forming contemporary culture, and (the) cultural, social, and economic forces which are shaping development of software itself' (2011 introduction to *Software Takes Command* www.manovich.net/DOCS/Manovich.Cultural_Software.2011.pdf).

Such a discipline is in its infancy and broad statements about its importance are easier to find than actual case studies (Fuller 2008). Rather like photography itself, we hear a good deal about the ubiquity of software and its place in running the world. However, where photography is concerned, software as an object of critical study will not be easy to access. The software and algorithms embedded in the cameras of Nikon or Canon or used by Flickr or Facebook to organise their business (and 'our' practice) are closely guarded corporate secrets and subject to policing by patents.

A claim that accompanies the call to study 'software' is that we (may) now live in a post-media age.

> 'What happens', asks Lev Manovich, 'to the idea of a "medium" after previously media-specific tools have been simulated and extended in software? Is it still meaningful to talk about different mediums at all? Or do we find ourselves in a brave new world of one single monomedium, or metamedium?'
> *(Software Studies Initiative 2012)*

This requires some thought, if only because it should be admitted that a 'medium' has always been a slippery and precarious concept. Its origins lie in an almost

metaphysical sense of 'an intervening substance' between a sense organ and an object (Williams 1976: 167–73); there is a mechanistic sense of a channel through which something (such as information) simply flows. In some hands, Marshal MacLuhan's for instance, it is little more than a synonym for technology (Lister *et al.* 2009: 81–88); and for yet others it is one element in something more complex: a practice. If we are to substitute 'medium' with 'software' then the sense of a medium as a 'channel' or a 'technology' makes that relatively easy to do, or think about. But, if a medium refers to an element of a practice, specifically the material that is worked by the skills of the producer, in relation to intentions and within institutions, the substitution is less readily made. As we will see, a software application that simulates a medium does so by borrowing or inheriting the work processes, decision making, conventions and procedures that constituted a media practice whether that be making a photograph, editing a video, designing a 3D structure or space, or writing and producing music. While we are clearly in a world where we can simulate and extend all older media through a single kind of machine, the computer and its software(s), we are surely a long way from being in a state where we have one metamedium. (See Kember, this volume, for the view that 'software study' is a kind of 'substitution trap'). We should, I suggest, stop well short of such a whole-sale substitution while recognising that the study of software has an important role to play in figuring out the condition of photography now.

Algorithms predate computing, having a long history in mathematics. If an algorithm is a set of instructions for a sequence of procedures that will achieve a specified result then we can reasonably suggest that photography has long been algorithmic-like (see also Rubinstein and Sluis, in this volume). This is the case in at least two ways; first, in the learnt and systematic technical expertise of professional and serious amateur photographers and, second, in the technology hidden inside automatic, consumer level cameras.

The algorithmic nature of professional (analogue) photography can be seen in the following notes made by Ansel Adams about the exposure and development of his famous photograph of 1941, 'Moonrise, Hernandez, New Mexico'. At each stage of the exposure calculations are made, even ones that anticipate future actions in the darkroom. Whether we are able to fully understand Ansel Adams' recall of these 'instructions to himself' is not the point, it is the sequence of precise stages in a process that results in a particular (pre-visualised) image that is of interest here.

> I set up the 10 x 8 camera … while visualising the image. I had to exchange the front and back elements of my Cooke lens, attaching the 23-inch element in the front, with a glass G filter (#15) behind the shutter … I knew that because of the focus shift of the single lens component, I had to advance the focus about 3/32 inch when I used f/32 … I remembered that the luminance of the moon at that position was about 250 c/ft^2 … With a film of ASA 64, the exposure would be 1/60 second at f/8. Allowing a 3x exposure factor for the filter, the basic exposure was 1/20

second at f/8 … I indicated water bath development … and (the negative)
was locally strengthened by intensification in the Kodak IN-5 formula …

(Adams 1981: 127)

A second way in which photography is algorithmic-like is in the manner that
processes or events may take place automatically and behind 'the scenes'. The
much-cited example here is the famous Kodak Brownie, which hid even its quite
simple operations from its user, to the complex electro-mechanical, sensor equipped
but pre-digital automatic 'point and shoot' cameras of the 1980s (see Maynard
1997: 3–4). These cameras offered their users a set of simplified controls for more
complex operations, usually in the form of small pictograms. Behind these graphic
'interfaces' lay the invisible internal working of the camera (see Slater 1995: 134,
141; Palmer, in this volume). Computational software and algorithms that carry out
specific tasks and operations are now not only built into cameras but also into
the extended apparatus of photography: the online organisations, social media
sites, data-bases and post-production 'lightrooms' where photographs are made,
stored, organised, classified and shared. As we have seen, these software 'machines'
(Rubinstein and Sluis, this volume) did not enter a vacuum. They take the place of
older technologies and procedures and as they do they simulate and emulate them
while bringing new capacities to the medium of photography.

In an attempt to show what software study might look like, Manovich has recently
offered a model in his study of the software package Photoshop (Photoshop Com-
putational Culture, 2011. http://computationalculture.net/article/inside-photoshop.
Accessed 19.01.13).

It may seem fortuitous (given we are interested in photography) that in his
advocacy of a wider discipline of 'Software Studies' Manovich has chosen a 'pho-
tographic' package as his example. But, where Photoshop is concerned, there is a
danger we will be returned to thinking about software only in terms of image
manipulation as Photoshop was closely associated with the anxiety of the 1990s
about the threat to photographic 'truth'. We still have the pejorative phrase 'it has
been photo-shopped'. However, bearing this in mind, Manovich's study yields
some useful general points about the work of software.

He proposes that software achieves four things: it automates, simulates, and
augments an existing medium, while adding its own functionality. Software, almost
without exception, simulates what were once physical media, 'every element of
computational media comes from some place outside of digital computers' (2011: 5).
These 'places' may be prior forms of physical media, or they may borrow from the
processes that were designed for earlier forms of telecommunication or television
transmission etc. The operations and structures that software simulates can be traced
'to previous physical or mechanical operations and to strategies of data, knowledge
and memory management that were already in place before the 1940s' (2011: 5).
Given that these simulations are quite real (they *do* produce images that fulfil the
role of photographs) and are in no way 'illusions' then photography is, we might
say, in safe hands. (For a fuller discussion of the several meanings of 'simulation'

and the need to free the concept from connotations of 'illusion', see Lister *et al.* 2009: 38–43)

However, software is not passive or neutral. It does not only simulate, it also automates and augments the processes that it simulates. The software contained in upmarket 'compact' digital cameras, such as that which is put to work when I select the 'intelligent auto' setting on my small camera (itself only one of 25 computed options it offers me), harnesses a range of sensors and algorithms to compute an image, the production of which would be beyond a human photographer whose standards fell much short of the technical wizardry of an Anselm Adams. The camera has indeed become a computer (see David Bate, this volume) yet the camera manufacturers have also sought to reassure me, as I trigger invisible algorithms, that I am a real photographer by retro-designing the camera body that I hold to resemble the iconic Leica.

The automation of complex procedures is a standard feature of digital cameras. As Michelle Henning observes, digital cameras have been constructed to replace analogue ones when they might have explored this alternative technology and its own qualities (in Acland 2007: 53). She suggests that this is in many ways a loss, as

> Downmarket and early digital cameras can produce digital effects different to film … but these qualities … are played down in camera design. The more upmarket cameras remediate photography so successfully that these distinctive characteristics are hardly noticeable.
>
> *(2007: 53)*

The 'loss' that Michelle Henning notes here, the opportunity to explore new and unfamiliar features of image making (if largely unknown due to the very simulation of photographic orthodoxy that supresses them) may, or may not, interest us; there is no imperative to experiment with lo-fi techniques. But, far more importantly, it alerts us to the active shaping of photographic practices and the potential for affording some options and closing down others by software.

Finally, software brings something of its own to the world of (simulated) photography. These are software functions that have nothing to do with the media that they simulate and automate but have everything to do with the traditions of software engineering itself. In exactly the same way as we can trace a genealogy for the photographic image, we can trace another for computing and software. All software for media creation and editing, no matter how successfully they simulate older physical media, also have a functionality that derives from modern software engineering in general. Manovich's example is the provision of the 'History' window in the menu bars of many software applications. Here numerical control of the various tools provided by the software (usually itself an augmentation or increase of the degree of control that is possible manually) and the settings chosen for the manner and degree of their use, can be saved and retrieved at will. The point is that such provisions (or 'functions') are significantly different from anything found in the media 'predecessor' that the software simulates. They belong to the

world of computing with which photography has converged. The some 1,300 differently exposed and 'dodged and burned' prints that Ansel Adams reputedly made from his 'Moonrise' negative would be 'saved as' versions in a computer/ camera's memory. Therefore, in Manovich's view, when a photographer uses a digital camera they use 'new media'. Hidden, but no doubt lively, algorithms automate and augment across the complex technological network that is now photography: they do so 'in-camera', in post-production applications, and, in the words of Jonas Larsen, they do so as photographs 'travel through and take (momentarily) hold in the wires, databases, emails, screens, photo albums and potentially many other places' (2008: 143).

Overview of the book

This second edition brings together a new collection of ten commissioned essays. The various chapters that these essays form were designed to cover what I took to be major issues for photography now it is deeply within a networked and digital culture, including digital archiving, online image banks, the gallery, museum and curation, the role of software, the convergence of photography and computation, digital photojournalism, the current state of photographic 'know how' and competency, vernacular photography and social media. It is not difficult to see that some of these topics appear to mainly concern institutions (archives, galleries), other practices (journalism, vernacular photography) and yet others that we might call processes (convergence, emergent forms of knowledge). As an editor it was tempting to group the chapters under such cognate headings to form sections of the book, as was done in the first edition. This might just have been possible but finally I judged it to be undesirable as the shoe-horning involved was a little too strenuous. Each chapter exceeds and resists these categories. Moreover, the majority of the chapters also have things to say, more or less boldly, about the identity, nature or ontology of photography either generally or as seen through the prism of their specific topic. My solution, therefore, has been twofold. I first arranged the chapters in a manner that tapers from those taking a broad conceptual view of issues (these come first) toward those whose focus on an aspect of photography is tighter. This, however, did not provide a complete plan, so within this overall tapering from wider to narrower focus, I looked for interesting connections or juxtapositions between adjacent chapters. This, of course, was not a watertight plan, but this explanation may give the reader a rough and ready way of navigating the content of this book.

Rather than the now familiar 'digital' image (which points merely to the coding of the analogue image), in their chapter Daniel Rubinstein and Katrina Sluis prefer to use the concepts of the 'algorithmic image' and 'computational photography' to address the profound changes they see taking place. The algorithmic image, they argue, needs to be thought of as 'a kind of program' or an 'image/software machine'. For them, the work of the algorithm and computation thoroughly recasts the photographic image in a number of fundamental ways. As with earlier

anxieties about the digital image, this 'algorithmic turn' sees the photograph's indexical link to reality broken as the image comes to be more the outcome of the invisible processes of its own algorithmic and software production than any relationship it has (or had) to the world. They argue that the computational image also leads us to question the historical nature of the photograph as a form of representation as any causal, empirical or secure relationship between the image and the world becomes unknowable. For them, this state is complicated by other (paradoxical) features of the algorithmic image. For Rubinstein and Sluis the photographic image is now always in process and never reaches a final destination or stable state as it is generated by 'black-boxed' software even though, in one of its several modes or 'layers', it produces images of 'incredible richness and overwhelming lusciousness'.

Seth Giddings pursues photography into a relatively new place: the gameworld of the videogame. Videogames, he notes, are haunted by photography. The first level of this is that they are frequently aesthetically photographic themselves as they employ photography's reality effect (photo-realism) in the form of motion blur, lens flare and depth of field. The 'flaws' of the older technology guarantee the 'realism' of the new form. Beyond this, many games have a built-in capacity to take photographs of the game world inhabited by the player. In others, the game player is cast as a photographer and the taking and collecting of photographs is a necessary task to be performed in the successful playing of the game. As real photographs of virtual places, game world 'snaps' now find their way onto Flickr alongside those of the real world. Giddings argues that many aspects of photography as an everyday practice, its conventions, aesthetics and passions, persist within videogames. But he also intends his reflections on gameworld photography to be a contribution to thinking about media technological change more generally. To this end he draws out fascinating parallels between Fox Talbot's reflections on photography and light ('the pencil of nature' drawing 'itself') and the work of the virtual camera in the lightless places of the videogame (where the computer code that is the virtual camera reports on its own current state – the database of which it is a part). In attempts to understand what is happening to photography, concepts such as remediation and the returns and hauntings found in media archaeologies will take us only so far, warns Giddings. He looks to Simondon's theory of individuation in biology and technology to argue that photography is best understood as a process of evolution and mutation, of continual and changing individuation. Differences in photographic instantiations should prompt a rethinking of photography and its histories, in which a tangled mesh of agencies and potentials, multiple and parallel lineages, tensions and fall out, replaces the steady developmental march (toward oblivion) of standard histories.

We are familiar with observations about the ubiquitous presence of photography in everyday life but, as Sarah Kember sees in her chapter, it is computing that now has ambitions to insinuate itself deeply into this existence in the form of ubiquitous computing, smart environments and 'ambient intelligence', and it is 'enrolling' photography to achieve this. Given such a scenario, she argues that discourses

about media, even 'new media', are too 'parochial' in their concern for the fate of a 'medium' and naïve, as if the networked dispersal of photography was simply 'democratic' and the 'everyday' did not have a politics. Kember looks to a time when photography becomes 'ambient and environmental', when it will lie outside of discourses about digital media because it will become part of a 're-ordering' of life, which needs to be understood as both social and biological. She pursues this proposal through a discussion of 'ambient intelligent photography' and its context of corporate techno-scientific research, high-tech industry and a case study of the history and current state of face recognition technology. She concludes her chapter with some thoughts about what kind of theory might be 'fit for purpose' in understanding 'photography after photography'. She proposes that such a cultural form, which is contingent, and never complete or discrete, is not likely to be understood by 'rigid off the peg' categories but by more intuitive approaches to be found within feminist science and technology studies.

In his chapter, David Bate asks what practical competencies and 'know how' do photographers (and consumers of photographs) need in our 'digital condition'? How, he asks, when the functions of making and transmitting photographs have converged and take place in the blink of eye, can we know who is distributing 'what' to 'whom' and why? In this way he places central questions addressed by the politics of representation firmly in the context of digital image technologies. He also asks how the broad abstraction 'digital photography' helps us talk about the many different kinds of contemporary photography. To think about these and other questions he identifies what he takes to be the three most significant technological changes for photography: that cameras have become computers; that the computer/camera has brought together photographic recording, processing and display in one device; and that the World Wide Web has become an inter-active means of disseminating and exhibiting photographs. Bate does not take any of these 'achievements' at face value and he teases out the continuities and paradoxes they contain and engender, in order to consider their implications for photographers and students in an age of data-based education.

In his chapter Andrew Dewdney poses some timely and difficult questions about the curation of photography in the art gallery and museum. Now that photography circulates ceaselessly as information and is mutable, fugitive and fleeting (terms that he shares with other contributors to this book), what could be the role of the museum or gallery in displaying photographs? What becomes the task of the curator of photographs? Ironically, these are questions that arise as analogue pho-tography is admitted to the art museum. Dewdney argues that the 'dispersal' of photography in networked computing simultaneously with the accumulation of photographs in digital archives and image-banks is a new version of an old problem for photography's identity: that it has been both a process that produces images valued for their singularity (the moment of the latent image) and a means of socio-technological reproduction. Now, photography as this 'contrary object' comes to the fore yet again at a time of the accelerated convergence of images, screens and networks. Dewdney sees that parallel to the remediation

of photography is the remediation of television. Emerging from different cultural locations, photography and television have come to share their means of image capture and screenic transmission. As television leaves the living room, as screens become the main site for looking at photographs, settled relations between public and private space are unsettled. Not only has the screen image become ubiquitous in everyday life, it also has a presence in the 'spaces of the public realm', which include the gallery and museum. It is within this wider context, together with an account of recent curatorial initiatives at London's Photographer's Gallery, that Dewdney poses his questions about how to curate the photographic image.

A former picture researcher, Nina Lager Vestberg offers a fascinating view of the changing practices of that profession as the role of mediating between 'the image and the user' shifted to that of mediating between 'the image and the system'. She suggests that we think of digitised photographic archives as an aspect of 'the rich afterlife of photography'; an afterlife in which the cultural status and value of analogue prints has changed in surprising ways. As her accounts of the loss and near loss of the Tate's and the Victoria and Albert Museum's photographic archives show, the '(t)he threat of "the skip" looms large'. But, the judgment of what is of value and what is not is far from straightforward; the landfill site is not simply the opposite of the archive. This is explored through her discussion of the *Guardian* newspaper's move to new premises fit for 'a digital age', which was marked by an exhibition, *The Lost Art of the Picture Library*. Here, Lager Vestberg shows how a preoccupation with 'the (analogue) photographic object' runs in parallel with its 'apparent (digital) dematerialisation'. In the second half of her paper she considers the significance of two photographs, one recent, the other from the 1950s, both drawn from archives and depicting picture researchers at work. In a detailed analysis of these two images and their metadata, she argues that they embody profound changes in the archive while representing the way that 'the digital archive turns its analogue predecessor into an object which is itself worth archiving'.

In his chapter Paul Frosh revisits his seminal study of stock photography or the 'visual content industry', paying attention to developments that have taken place since its publication in 2003. His chapter is singular among the chapters of this book (with the possible exception of Susan Murray's) in that he does not see photography, at least in the domain of the commercial photography with which he is concerned, as 'transformed'. He suggests, instead, that we think of it as a 'distressed' building, stretched, strained and fissured but not entirely reconstituted. For Frosh, digital technologies have destabilised, not transformed, visual culture. In this chapter, he proceeds by way of a 'thought-experiment' in which he explores an analogy between the totalitarian figure of Hobbes' Leviathan and the aspiration of Getty Images to be a 'total archive'. His survey of developments in the stock industry over the last decade reveals, among other factors, a proliferation of small niche agencies and community-based 'microstock' sites that develop a market and a brand for highly-specialised and marginal kinds of images only to be incorporated or purchased by the super agencies. Getty Images, Frosh finds, have

extended their interests and reach into a kind of 'crowd sourced' stock, to an arrangement to deal in Flickr images (see also Murray, this volume) and to photojournalism, hiring photographers from the traditional wire services such as Reuters or Associated Press. When asking what stock photographs now look like, Frosh finds that the aggregating capacities of the web and its search engines have only served to make apparent the way that the stock industry's search for the 'real' and the everyday, actually masks a replication of similar images of a 'repressive inanity'. He concludes that the analogy of Getty Images as Leviathan holds.

The place of software in the production of photographs, central to Rubinstein and Sluis' philosophical account, is explored in more historical and analytical detail in Daniel Palmer's chapter. He unravels the way in which JPEG image compression software, the product of an apparently instrumental and non-profit making organisation (the Joint Photographic Experts Group) has shaped photographic practice practically and ideologically. JPEG software is now built into digital photography at every stage of its production, circulation and use; into cameras, operating systems, browsers, editing programs and printers. The JPEG is part of the 'transformation of cameras into sensors and of images into actionable data' and it lies behind our experience of photographs on screen. So ubiquitous is the JPEG format that in order to become a part of networked, social media, 'images must become JPEGs'. Within a scenario of 'lossy compression' and the fast, efficient transfer of images, Palmer looks for the rhetorical and ideological dimensions of the JPEG and critically assesses its connection to an idea of visual democracy, its apparent accessibility and openness, its free-flowing universality, to a new scopic regime of the network and its association with empowerment and revolution in citizen journalism.

In her revisiting of the 'photo sharing' site Flickr, Susan Murray finds that since 2008 there has been 'considerable change in the online environment for digital photography'. The building of a community of photographers, both professional and amateur, through the site's architecture and tagging functions continues, as does its articulation of an 'aesthetics of the everyday'. But, as Flickr has been overtaken by Facebook as the most popular social networking and image sharing site, it has also taken on a new distinction and value. Flickr, she argues, is coming to distinguish itself by an emphasis on the practice of photography and the way it addresses its users as creative practitioners whose photos are more the products of 'aesthetic practice' than 'evidence of … online social identities'. Flickr might still be a photo-sharing site but it is also (increasingly) a place for connecting and reconnecting with the act of photography. It is here, she argues, that an anxiety about the massive accumulation of photographs online is being met with a renewed interest in a more reflective and deliberative kind of photographic practice. Murray locates her analysis of these changes in digital vernacular photography within a history of amateur and domestic photography in the late nineteenth and twentieth centuries where, despite changes in the relationship of photographers, cameras, spectators and images, she finds evidence of much continuity. However, she also sees the emergence of a changed temporality in online photography as the meaning of

photography as the preservation of moments in time gives way to an expression and acceptance of transience. According to Murray, this is to be seen, for instance, in the way that Flickr's photographers seek out the ephemeral, the manner in which the site's 'photostream' automatically replaces older images with newer ones, and in the Flickr photographer's apparent acceptance of the temporariness of their publicly-presented selves and shifting subjectivity.

Academic accounts and debates about the meaning (in theory) of digital photography for photojournalism are fairly well known. What is less well known is how the profession of journalism in general, and photojournalism in particular, understood the issues and responded practically in 'the field' and in the newsroom. This is what Stuart Allan offers us in his chapter through his detailed primary research into the coverage of the issues by the mainstream press and the perceptions and recollections of the practitioners themselves. Allan takes us through the early adoption of digital cameras and processes, where their promise was perceived, as much as their threat, as the speed of digital transmission could be seen as 'what photojournalism is all about'. Any threat to photojournalistic integrity was seen as not so much technological but as coming from tabloidisation, infotainment, the cult of celebrity and the activities of the 'fly-by-night Johnnie-come-lately' paparazzi. But Allan's main focus of attention is the 'citizen photo-journalist'. Here we are able to follow the developing and sometimes irreconcilable responses of journalists to their 'citizen' counterparts, as this figure emerges across the events of 9/11, the London bombings, Abu Ghraib, the South Asian tsunami, the Mumbai attacks and the London riots of 2011.

Notes

1 It seems to me that this generic term 'the network' is used to avoid the greater specificity of 'the internet' or 'the world wide web', and other networks such as 'intranets' for example. It has evolved as an abstract concept to denote a *condition*.

2 www.nytimes.com/2009/08/10/business/media/10photo.html?pagewanted=1&_r = 3& sq = photojournalism& st = cse& scp = 1.

3 This section draws upon a fuller discussion in my article 'A Sack in the Sand: Photography in the Age of Information' *Convergence: The International Journal of Research into New Media Technologies* Copyright © 2007 Sage Publications London, Los Angeles, New Delhi and Singapore Vol 13(3): 251–74.

4 This refers to Vannevar Bush's proposed machine, the Memex. See Bush (1954) 'As We May Think', *Atlantic Monthly*, and again, my article 'A Sack in the Sand: Photography in the Age of Information' (note 2).

Bibliography

Acland, C. (2007) *Residual Media*, Minneapolis and London, University of Minnesota Press.

Adams, A. (1981) *The Negative*, Boston, Little, Brown and Company.

Bush, V. (1999) 'As We May Think' [*Atlantic Monthly*, 1945], in P. Mayer (ed.) *Computer Media and Communication: A Reader*, Oxford, Oxford University Press.

Castells (2000) *The Rise of the Network Society*, 2nd edition, Vol 1, Oxford, Blackwell Publishers Ltd.

Frosh, P. (2003) *The Image Factory: Consumer Culture, Photography and the Visual Content Industry*, Oxford and New York, Berg.

Fuller, M. (2008) *Software Studies: A Lexicon*, Cambridge, Massachusetts, London, The MIT Press.

Goldhaber, M. (1997) 'The Attention Economy and the Net', *First Monday* Vol 4, at http://firstmonday.org/article/view/519/440 Accessed 15 April 2013.

Gómez Cruz, E. and Meyer, E. (2012) 'Creation and Control in the Photographic Process: iPhones and the Emerging Fifth Moment of Photography', *Photographies* Vol 5, No 2, 203–21.

Hayles, N. K. (1999) *How We Became Posthuman: Virtual Bodies in Cybernetics, Literature, and Informatics*, Chicago, University of Chicago Press.

Kracauer, S. (1995) *Photography: The Mass Ornamaet* (translated Levin, T. Y.), Cambridge, Masachusetts and London, Harvard University Press.

Larsen, J. (2008) 'Practices and Flows of Digital Photography: An Ethnographic Framework', *Mobilities* Vol 3, No 1, 141–60.

Latour, B. (2004) 'Alternative Digitality', at www.ensmp.fr/~latour/presse/presse_art/GB-05%20DOMUS%2005–04.html.

Lister, M., Dovey, J., Giddings, S., Grant, I. and Kelly, K. (2009) *New Media: A Critical Introduction*, 2nd edition, London, Routledge.

Manovich, L. (2011) 'Cultural Software', at www.manovich.net/DOCS/Manoich.Cultural_Software.2011.pdf Accessed 14 April 2013.

Maynard, P. (1997) *The Engine of Visualisation: Thinking through Photography*, Ithica and London, Cornell University.

Mitchell, W. J. (1992) *The Reconfigured Eye: Visual Truth in the Post-photographic Era*, Cambridge, MA, The MIT Press.

Nardelli, M. (2012) 'End(ur)ing Photography', *Photographies* Vol 5, No 2, 159–77.

Simon, H. A. (1971) 'Designing Organizations for an Information-Rich World', in Greenberger, M. (ed.) *Computers, Communication and the Public Interest*, Baltimore, MD: Johns Hopkins Press.

Slater, D. (1995) 'Domestic Photography and Digital Culture' in M. Lister (ed.) *The Photographic Image in Digital Culture*, London, Routledge, pp. 129–46.

Software Studies Initiative (2012) 'Does "Media" Still Exist?', The Graduate Center, City University of New York, at http://lab.softwarestudies.com/2012/09/does-media-still-exist.html Accessed 1 February 2013.

Szarkowski, J. (1976) 'Introduction to William Eggleston's Guide', at www.egglestontrust.com/ Accessed 21 March 2013.

Taffel, S. (2012) 'Escaping Attention: Digital Media Hardware, Materiality and Ecological Cost', *Culture Machine* Vol 13, at www.culturemachine.net/index.php/cm Accessed 21 March 2013.

Tagg, J. (1988) *The Burden of Representation*, Basingstoke and New York, Palgrave MacMillan.

Tomlinson, J. (2007) *The Culture of Speed*, London, Sage.

Whatmore, S. (1999) *Hybrid Geographies: Natures, Cultures and Spaces*, London, Sage.

Williams, R. (1976) *Keywords: A Vocabulary of Culture and Society*, Glasgow, Fontana.

——(1977) *Marxism and Literature*, Oxford, Oxford University Press.

2

THE DIGITAL IMAGE IN PHOTOGRAPHIC CULTURE

Algorithmic photography and the crisis of representation

Daniel Rubinstein and Katrina Sluis

Two conceptions of the image

In the penultimate scene of the movie *Titanic* (1997) there is a panning sequence that starts from a close-up of Rose DeWitt Bukater (played by Gloria Stuart), the elderly survivor of the shipwreck. Flooded in blue light, which indicates according to a cinematic convention the liminal space between living and dying, she seems peacefully asleep. Then the camera begins a slow sweep over her collection of photographic prints: Rose alone on horseback, Rose at the cockpit of a biplane, Rose standing tall on a yacht next to a dead shark; conveying in an economic gesture life lived to the full as a succession of privileged moments and solitary devotion to the man who died while saving her from becoming a shark's dinner. The elaborately framed prints serve yet another purpose. They make it known that Rose's life unfolded as a linear progression of structured moments just as Jack promised: she is dying peacefully in her bed after completing the course of pre-scribed adventures, while photographic memories gradually appear, come into focus and fade from view.

The succession of overlapping and fading snapshots is therefore not so much a film within a film but rather an image of a life comprised of perfectly framed, perfectly exquisite, motionless keepsakes. Not snapshots of a life, but a life that is being frozen, arrested and flattened until it itself becomes a photograph. Because visual representation here is subjected to unflappable rationality, the possibility of movement and change is precluded: photography has become the measure of time privatized in which the whole bio-technological assemblage otherwise known as life unfolds as a succession of images, each with a different narrative. Yet this variety of settings and locations is only a cover-up for identity: at the centre of it all there is one unified subjectivity with a known point of origin and a predetermined outcome ('you will die in a warm bed').

FIGURE 2.1 Film still from *Titanic* (James Cameron 1997).

What is being offered to the viewers of *Titanic* is life reduced to a sequence of frozen moments: bound to the world of emerging technological complexity, but ultimately detached from expressivity and spontaneity. When Foucault developed the concept of biopolitics he was concerned with specifically pointing out the conditions in which the human body was bound to the world through the mechanisms of representation. This was in order to underscore the indispensability of this binding to the development of capitalism:

> For millennia, man remained what he was for Aristotle: a living animal with the additional capacity for a political existence; modern man is an animal whose politics places his existence as a living being in question.
>
> *(Foucault 1990: 143)*

To slightly paraphrase Foucault: since Plato charted the course of Western civilization with the simile of the cave, the human being is someone who mistakes truth for the image on the wall. However, in the age of late capitalism it is the image that places modern man's existence as a living being in question.

Compare the linearity of time represented through photographs in *Titanic* with the movie *Memento* (Christopher Nolan 2000), in which the lead character Leonard (Guy Pearce) attempts to identify his wife's killers and overcome his short-term amnesia through the production of polaroids as aide memoirs. The film itself is structured as two parallel sequences: one in black-and-white that proceeds chronologically, and a second series shot in colour shown in reverse order. As Andy Klein (2010) has noted, *Memento* is edited in a way that establishes two temporal series that unfold in opposite directions, simultaneously revealing the future-past and the past-future. The stack of polaroids carried by Leonard are not encountered as a collection of memories, but function as points of access that allow movement from one temporality to another, following the

topology of a Möbius band. In order to present time as an infinite loop with a single surface and an imperceptibly blurred boundary between past and present, the movie had to be edited according to an algorithm that combined the last scene of the first series with the first scene of the second series, then the one-before-last scene of the first series with the second scene of the second series, and so forth (Klein 2010).

In this film photography is used to represent memory not as a succession of frozen moments but as a way to explore time directly through the ostensible incommensurability of lived time with cinematic time, of memory with photographs. Photography here is an image of time in crisis, produced by the overlapping temporalities that constitute multiple and simultaneous timelines that contradict, wipe out, supersede, re-create and cancel each other. The algorithmic structuring of the film allows time to be distributed evenly between different points of the story in a way that makes it both undecidable and somehow, strangely, still 'making sense'. Instead of the hierarchical space of Cartesian geometry, with its all-seeing eye in the centre of the visible universe and the clear-cut distinction between the viewer and the story, it produces a temporality that is not chronological but fragmented and recursive. Space is no longer drawn out of monocular perspective and there are no more privileged 'Kodak moments' as memories no longer imply linear chronology. As there is no spatio-temporal continuity, the meaning of each polaroid is established not only by its visible content but also by its place within sequences: meaning is never stable but changes depending on the location of the event within the narrative.

While in *Titanic* the photograph is the visual marker of linear time, the photograph in *Memento* questions the status of photography as an archive and a memory prosthetic. Or in other words, the photograph allows for the existence of a multiplicity of narrations and storylines without privileging a single one by referring to some pre-defined notion of 'truth'. Gilles Deleuze's concept of 'difference' is relevant here as it is a model that challenges a singular unified identity as the foundation of rational thinking. With respect to *Memento* one could draw parallels with Deleuze's analysis of *Last year in Marienbad* (Alain Resnais 1961) where he states: 'This is no longer, or no longer only, the *indiscernible becoming* of distinct images; it is *undecidable alternatives* between circles of past, *inextricable differences* between peaks of present' (Deleuze 1989). The salient point to bear in mind is, of course, that both *Titanic* and *Memento* are high-budget productions of the same entertainment industry. However, they imply that technologies of representation have the potential either to stultify life by reducing it to endless repetition of essentially identical moments and actions or that the same technologies and energies can be harnessed towards a view of life that embraces change, uncertainty, spontaneous becoming and difference.

It is important to bear this in mind in coming to discuss the fate of the digital image online, for here too technologies of the network and forces of capital are equally capable of stasis, dogmatism and identity or, on the other hand, of expressive, dynamic and non-identical singularities. The distinction between

photography as an archive of memory and photography as an image of time in crisis allows us to suggest that the technologies that create interactive image systems also threaten photography's representational paradigm through the production of a computational image. As we will explain in this chapter, the digital image is an image/software machine that operates on several levels at once, some visual, others computational, operating within media ecologies involving both human and non-human actors. Like a two faced Janus, photography points in two directions at once: one side faces the objects, people and situations as they appear in the 'real' world, and is occupied with the representation of events by flattening their four dimensional space onto the two dimensional plane of the photograph (Flusser 2011). The other side points towards photography's own conditions of manufacturing, which is to say towards the repetition and serial reproduction of the photographic image. When software and image collide the result is not just a different, processual image, but also a paradigm shift with implications for thinking about the ontological link between representation, memory, time and identity.

Genealogies of representation

Before we discuss the implications of photography's algorithmic turn, we need to show what is at stake in transgressing the representational paradigm. In his famous essay *The Age of the World Picture* Martin Heidegger positions representation as the key characteristic of the modern age. He describes the essence of modernity as inaugurated by two interconnected events: the world becomes a picture and the human being becomes a subject. Heidegger traces the origin of both these events to the metaphysics of Descartes because there, for the first time, representation is established as the basis of all true knowledge:

> We first arrive at science as research when and only when truth has been transformed into the certainty of representation. What it is to be is for the first time defined as the objectiveness of representing, and truth is first defined as the certainty of representing, in the metaphysics of Descartes.
>
> *(Heidegger 1977: 127)*

Descartes was able to make representation the cornerstone of modernity because he refashioned it as founded on abstract and rational rather than phenomenological and aesthetic principles. For earlier writers and artists of the Baroque, the Renaissance and even for the Greeks, representation was an allegorical image, an illustration or a metaphor, but after Descartes it acquired the status of scientific method capable of producing objective, verifiable and repeatable results. As Judovitz (1988: 67–68) explains, with Descartes, representation loses its mimetic and phenomenological value and becomes the guarantor of truth. From this point onwards in the history of Occidental thought, representation does not mean *showing* or *viewing* a picture, but rather it is treated as a diagram that defines

the conditions of possibility that allow one to grasp the world as an image. Representation therefore performs a dual function: on the one hand it establishes the human subject as a rational being capable of objectifying the world, yet on the other hand it limits the ability to know the world only to those aspects of it that can be rationally represented (Judovitz 1988: 69).

It is probably important to clarify that when Heidegger says that the world became a picture, he does not mean a picture as in a painting or even a photograph. What he means is that the *technē* of the age is such that it deals with the world as representation: to know something means to have an image of it, and only knowledge given as an image is validated as rational and correct. Claire Colebrook echoes this point, and argues that 'representation is the condition of finitude. Because knowledge is received from without it must be taken up and re-presented. What can be known is therefore determined and delimited by the representational powers of the subject' (1999: 1). What Heidegger says therefore is that modern subjectivity is established through making representation the ground of the Cartesian model of rational knowledge. This is not to suggest that the long history of representation did not produce fascinating, subtle, politically promising and otherwise magnificent outcomes in art and literature, but it is important to emphasise that the representational models that animated the work of philosophers and artists since Descartes are closely intertwined with the way subjectivity became the cornerstone of Western metaphysics.[1]

As a product of the technological age, photography occupies a privileged place within the Cartesian representational schema, for it is an image the truthfulness of which is underwritten by the scientific procedure that created it. By situating visual representation within a framework of empirical knowledge supported by automatism on the one hand, and by logical and rational use of light, optics and chemistry on the other, photography has been framed as an offshoot of objectivity and empiricism. This epistemological connection between automatism, rationality and indexicality is captured succinctly by André Bazin in 'The Ontology of the Photographic Image':

> This production by automatic means has radically affected our psychology of the image. The objective nature of photography confers on it a quality of credibility absent from all other picture-making. In spite of any objections our critical spirit may offer, we are forced to accept as real the existence of the object reproduced, actually re-presented, set before us, that is to say, in time and space. Photography enjoys a certain advantage in virtue of this transference of reality from the thing to its representation.
>
> *(Bazin 2004: 13–14)*

Bazin here expresses a view that informed a dominant strand of photography theory that accepts realism and verisimilitude as primary qualities of the medium. One consequence of this view was the further cementing of the rational human agent as the sole author of the image. Although photography's truth claims have

since been recontextualized to situate them within dominant narratives of power and discipline, the thing that remains unchanged and unexamined is the acceptance of photography 'as a process whereby a purely informal idea (the world as it is) mediates itself through light and shapes the unstable matter of the chemical emulsion into an analogical print' (Petersson 2005).

The porridge of the index

While the digital image can be seen as the fulfilment of Descartes' dream to represent all knowledge in an abstractly mathematical form and therefore to eliminate distortions, inconsistencies and material imperfections inherent in analogue reproduction, it is crucial to recognize this as an extreme form of idealism. As we will discuss in this chapter, the materiality of the digital image is deeply intertwined with its inherent undecidability and underpinned by computational processes that are largely unknowable or inaccessible. While this approach problematizes the photograph as a cultural or linguistic object, the crucial point is that the intelligence that makes the network tick is not (or at least not entirely) a straightforwardly human one. For that reason, we argue that the materiality of the digital image is not to be found in its indexical adherence to objects in the world, or in signifying and iconic schemas as these frameworks are ultimately based on considering photography as a cultural and textual object and as part of the linguistic turn.

This is not to suggest that these paradigms held true for the analogue image and then were made redundant when the image became digital. Rather, the algorithmic turn affords us a vantage point from which we can look back at the history of photographic theory and see the assumptions that underline the linguistic approach to photography. This approach is characterized by the belief that 'the photograph is thus a type of icon or visual likeness, which bears an indexical relationship to its object' (Krauss cited in Elkins 2007: 27) in which 'photographs are first and foremost bound to the world itself rather than to cultural systems' (Elkins 2007: 27). One of the insights afforded to us by computational photography, is the understanding that whether the image has a resemblance to an object or not has little to do with indexicality. Rather, it has everything to do with the algorithmic processes that operate on the raw data collected by the light-sensitive sensors in a camera. The same data could be just as easily output as a text file, a sound, a string of numbers or remain unprocessed.

These insights allow us to revisit the 'indexicality' of the analogue photograph and to suggest that here too there is a sort of computation at work; for instance, Roland Barthes asserts: 'The photograph is literally an emanation of the referent. From a real body, which was there, proceed radiations which ultimately touch me, who am here' (Barthes 1981: 80). What is being forgotten by Barthes is that the very thing that he considers to be photography's essence (noeme), its adherence to the referent, is the outcome of very precise algorithmic instructions that involve a string of operations performed by the laboratory technician who

processes the film. Consider for instance what would happen to the indexicality of the image if the film chemistry was not at 20°C but at 90°C – instead of indexicality there would be porridge! Or ask, what is the state of the indexicality if the photographic film contains only the latent image, i.e. it remains undeveloped in its film canister or in the dark slide. Is it still possible to speak of indexicality of the 'latent image'? Perhaps it is not insignificant for the history of subsequent theorisations that Barthes admits in the opening pages of *Camera Lucida* that he knows nothing of photography from the perspective of the photographer, and his insights are derived only from the perspectives of a viewer and a subject of photographs (Barthes 1981: 9). Had he spent some time in a photographic darkroom he would notice that the 'image without a code' (Barthes 1997: 43) is an outcome of a very elaborate code designed to produce a specific outcome. He may also notice that the mystery and 'magic' of photography is not 'literally the emanation of the referent' but the mystery and unknowability of the latent image (Barthes 1981: 88, 80).

For if we consider the unknowability of the latent image seriously, we will have to admit that the relationship between the 'real' and the image has slipped from our grasp. If the image and the object share a commonality then this commonality contains within it something radically unknowable that cannot be accounted for by visuality alone, but by the presence of the invisible within the visible as well as of the sensory within the intelligible. In fact, the old binary model 'object – image', has to be replaced by the ternary 'object – unknowable – image' where the unknowable makes room for the processing operations that convert events in the physical world into something we recognize as an image. This observation applies equally to the analogue and to the computational image.

Computational photography and the crisis of representation

Causality was always central to photography's truth claims as the rationality of the process served to underwrite its veracity and to establish its status as an archive of moments in the past. However, this causal relationship itself is questioned in relation to the algorithmic operation of software and substituted by an open-ended, unknowable processuality.[2] An image on the screen of a smartphone or a laptop looks like a photograph not because it has some ontological relationship to an object in the world, but because of algorithmic interventions that ensure that what is registered on the camera's CCD/CMOS sensor is eventually output as something that a human would understand as a photograph. As Eivind Røssaak indicates:

> within analogue culture there is usually a causal relationship between storage and display, say between negative and print, but in algorithmic culture, the relationship has become not simply arbitrary, but dependent on the new interstice of software or what I would call algorithmically enabled work process.

(2011: 193)

When offering an overview of the emerging field of computational photography (responsible for such innovations as the Lytro Camera), Brian Hayes notes that:

> ... a digital camera is not simply a passive recording device. It doesn't *take* pictures; it *makes* them. The sensor array intercepts a pattern of illumination, just as film used to do, but that's only the start of the process that creates the image. In existing digital cameras, all the algorithmic wizardry is directed toward making digital pictures look as much as possible like their wet-chemistry forebears.
>
> *(Hayes 2008: 94)*

When a photograph, film or song is only one of many possible 'option[s] inscribed by the algorithms' (Røssaak 2011: 191) it becomes harder to talk about photography as a singular cultural form. Instead, the photograph is now a type of 'algorithmic image'; a term we use in order to indicate that the image has to be considered as a kind of program, a process expressed *as, with, in* or *through* software. When the photograph became digital information, it not only became malleable and non-indexical, it became *computational* and *programmable*. Whatever seems familiar, homey and continuous with the aesthetics of analogue photography is the design of computations: Instagram and Hipstamatic are ready examples of the way algorithms can be used to create the impression of faded and old-fashioned snapshots, but what is often overlooked is that all digital photographs regardless of the final 'look' are algorithmically processed. Professional photographers who often treat these nostalgic apps with contempt forget that their top-of-the-line DSLRs use the same principles in recreating the look of 'professional' photographs.[3] It is also worth noting the role of algorithms in the production of a seamless online viewing experience by retrieving and arranging multiple data streams with radically different temporalities, origins and histories.[4]

The breakdown of the 'causal relationship between storage and display' (Røssaak 2011: 23) suggests that the digital image cannot be fully understood through the premises of indexicality and ocularcentrism as its final appearance is the result of computation rather than the direct agency of light.[5] However, what comes instead of causality is not chaos or randomness, for the dissolution of indexicality does not render the image as meaningless noise; rather, the image is both formed and deformed at the same time through the agency of computation. The cultural shift away from the visual and towards algorithmic images is not merely a technological change along the lines of increased efficiency and rationality but a distinction between two forms of reason, which David M. Berry names as 'instrumentalist' and 'computationalist' (2011: 13).[6] Considered as a visual image, photography is subordinated to the instrumentalist rationality in which the image is the outcome of an application of a set of rules designed for maximum efficiency in producing the best possible resemblance. On the other hand, considered computationally or algorithmically the image is never finalized, never achieves a state of finitude, operating in a constant state of deferral.

The overwhelming arrival of the algorithmic image

Previous understandings of the photographic image as an indexical, discrete or enframed semantic unit appear increasingly inadequate when faced with the inter-network with its boundlessness, simultaneity and processuality. One important consequence of photography's diffusion into general computing is that it is no longer clear 'where' the image is. Online, there is no point at which the image ends; rather, there is an endless succession of temporary constellations of images, held together by a certain correlation of metadata, distribution of pixels or Boolean query. The very technologies that underscore the veracity of representation also produce the possibility of serial duplication. For Lev Manovich, the logic of the web is best observed in the operation of pornography websites, in which the same few images are re-used and repeated across the thousands of sites where 'the same data would give rise to more indexes than the number of data elements themselves' (2001: 225). Writing about the pornography industry, Laura Kipnis suggests that there is a connection between infinite repetition and human desire:

> [P]erhaps the abundance of pornography – such an inherent aspect of the genre – resonates with a primary desire for plentitude, a desire for counter-scarcity economies in any number of registers: economic, emotional, or sexual. Pornography proposes an economy of pleasure in which not only is there always enough, there's even more than you could possibly want.
>
> *(Kipnis 1996: 202)*

This connection between pleasure and superabundance can be reversed: pornography thrives on the notion of plenitude precisely because plenitude itself is sensual, erotic and lustful. Proliferation and abundance create a pornographic effect whether in the context of the App Store, Facebook timeline or Twitter stream. For that reason it becomes misleading to talk about the photographic 'frame' or the singular image as the image is everywhere all at once, accessible from any point in the network, establishing a regime of intoxication and plenitude through its rapid multiplication and profusion.

The present tendency of the image to move through the network in several directions at once, decomposing and recombining, multiplying and aggregating into different contexts, further undermines the notion of the photograph as a singular cultural unit that operates as an archive of time. When Heraclitus said 'you cannot step into the same river twice' he indicated that some things are unarchivable and cannot be committed to either memory or any form of record. This issue becomes apparent in relation to platforms such as Twitter. Consider, for instance, the inadequacy of archiving tweets in a database because the real experience of using Twitter is one of continuous flow in which you can never go back and revisit something that was already spoken. Or, for example, the way in which Twitter allows you to create a statement but change the direction of its flow through the network via hashtags. In these information ecologies the image itself is

inseparable form the context and milieu of its utterance, underlining the impossibility of locating and therefore archiving the image content that flows through the network. The question remains for the artist, curator, archivist, philosopher: where is the image? Which copy to attend to, and in which context – embedded in a tweet; forwarded to a blog; collapsed to a meme; revisited in a YouTube megamix? There is a shift here away from content to the rhythm, circulation, and proliferation of the utterance, which, as Jodi Dean notes, 'exerts a force, a compulsion; repetition has effects independent of the meaning of what is repeated' (2010: 26).

The fractal structure that underpins the network suggests a very different kind of temporality that is based around non-linear, fragmented and instantaneous time. The network does not have opening hours, holidays, weekends, past or future. It is always in the present and it is everywhere at the same time. The time of the network is different from the time of the ticking clock and from the biological time of the living organism. Each packet of data it carries is inscribed with its own time frame, its own 'time to live' (TTL), its own internal duration (Cubitt 2012: 8–15). In contrast, photography has traditionally been understood as having a very straightforward relationship to time: as a placeholder of memories, a frozen slice of the past, or to paraphrase Barthes, *that was there*. For Barthes (1981: 5) there was a sense of continuity between the moment in the past when the picture was taken and the moment in the present when the picture is viewed, because '[w]hat the photograph reproduces to infinity has occurred only once; the photograph mechanically repeats what could never be repeated existentially'. This connection reinforced the belief in the humanity of photography, in the similarity between the ability of photography to preserve a memory and the human ability to remember. According to this human-centred phenomenology an image can be described as a moment in time or a part of the whole, a piece of the puzzle, a death mask, a shadow on the wall of Plato's cave or a signifier floating or otherwise. But when the image is born digital, this connection to a point of origin in the past is less certain. The profusion of perspectives the networked image reveals suggests that Cartesian linear time is inadequate in accounting for the form of temporality created by the network.

Because the image is continuous, frameless, multiple and processual, it cannot be unpacked with the tools of semiotics and structuralism that were developed to deal with finite, framed, singular and static images. Even at the level of the photoblog, there is a trend to present the image feed as an infinite downward scroll, which auto-updates and liberates viewers from the inconvenience of having to click 'next'.[7] Or consider the world-view of Google Earth, a mashed-up interactive palimpsest derived from satellite photographs of the Earth, in which adjacent images might be taken years apart. In these database-driven image systems linear narrative becomes subservient to the logic of computer-based database modelling in which the cinematic world of montage collapses into that of correlation – of similar size, similar patterning, similar tags, similar metadata, similar location (Uricchio 2011). For Tiziana Terranova, this is the character of informational culture, which 'marks the point where meaningful experience are under siege,

continuously undermined by a proliferation of signs that have no reference, only statistical patterns of frequency, redundancy and resonance' (cited in Dean 2010: 26).

The undecidability of the networked image

It is quite common to think about software as rational and mathematically determined. However, some software theorists take issue with this approach and point out that there is something inherently impenetrable, even ghostly or spectral in the way software is structured. Wendy Chun writes:

> As our machines increasingly read and write without us, as our machines become more and more unreadable so that seeing no longer guarantees knowing (if it ever did), we the so-called users are offered more to see, more to read. As our machines disappear getting flatter and flatter, the density and opacity of their computation increases. Every use is also an act of faith: we believe these images and systems render us transparent not for technological, but rather for metaphorical, or more strongly ideological reasons.
>
> *(Chun 2011: 17)*

The present 'frenzy' of image making and the parallel decline of visual knowledge is related to the paradox of software Chun describes. This is due to two competing phenomena: the proliferation of digital images and visual culture and the decline in the transparency of total information systems (Chun 2011: 15). There is continuity here with earlier concerns about the opacity of the photographic apparatus. As Flusser suggests, photography was always a black box operated by a photographer according to a program that fulfils the aims of the military-industrial-entertainment complex that makes the camera. He notes that 'Anyone who takes snaps has to adhere to the instructions for use – becoming simpler and simpler – that are programmed to control the output end of the camera' (2000: 59).

The blackboxing of the networked image is also established by the destabilization of the author-audience paradigm, as every participant within the network is simultaneously a viewer and a performer of the image. This is not so much the death of the author per se, but a reconfiguration of the notion of authorship as happening in several parallel instances and potentially simultaneous contexts (by both human and non-human actors).[8] Because the image is not pre-given but must be extracted out of an endless stream of data and then re-inserted into sequences and processes, it acts as a connector between signifying chains, power flows and situations (Deleuze and Guattari 2003: 7). What O'Sullivan suggests about the encounter with a range of contemporary artworks also applies to the networked image: '[such processes] do not offer a reassuring mirror reflection of a subjectivity already in place' (2012: 4). Because the image is not given as meaning to an existing audience but establishes the idea of audience by demanding participation, a

certain reversal is taking place: it is not the human subject who receives a ready-made image but the image that makes (or unmakes) the subject. In a similar vein, Georgio Agamben (2009) suggests that subjectivity is formed (and de-formed) through the encounter with the apparatus. The familiar paradigm is once more reversed: it is not the subject who masters technology, but technology that produces the cultural and linguistic forms that construct subjectivity. The technologies that place all these images on the screens of computers and phones are not accidents of industrial processes, but rather, they are part of the technological framework that governs, measures, orients and controls the behaviour of human beings. With this in mind, Agamben argues that 'apparatuses are not a mere accident in which humans are caught by chance, but rather are rooted in the very process of "humanization" that made "humans" … ' (2009: 12).

We therefore propose that undecidability becomes fundamental in considering how the apparatus conditions human behaviour. The networked image is undecidable, as opposed to 'immaterial' or 'indeterminate' because the latter implies nothingness and absence, while the former names the incomplete and the unresolved. The networked image is undecidable because the meaning of the image is not fixed to any specific event but to the progressive accumulation of a 'data shadow' that determines its visibility and currency in a range of situations.[9] For instance, the practice of 'folksonomy' opens the image to an ongoing negotiation of meaning creation through tagging, commenting and syndication. Here, too, the question of undecidability goes to the heart of the political currency of the image, as it makes room for the possibility of authorship extending beyond the act of taking the photograph. Due to the participatory character of folksonomy, tagging transfers the burden of responsibility for the meaning of the image from the figure of the photographer to each and every subject (both human and non human) that comes into contact with the image. Jacques Derrida in *Limited Inc* developed the way the undecidable operates:

> undecidability is always a *determinate* oscillation between possibilities (for example, of meaning, but also of acts). These possibilities are themselves highly *determined* in strictly *defined* situations … they are *pragmatically* determined. […] I say 'undecidability' rather than 'indeterminacy' because I am interested more in relations of force, in differences of force, in everything that allows, precisely, determinations in given situation to be stabilized through a decision of writing (in the broad sense I give to this word, which also includes political action and experience in general).
>
> *(1988: 148)*

When Derrida describes the political significance of undecidability, he emphasizes that it is not a question of total indeterminacy or some kind of abrogation of responsibility; on the contrary, the object of undecidability is to assert the radical freedom and struggle involved in making a decision. Without an element of undecidability, the main precondition for an ethical decision is not being met.

What Derrida helps to delineate is the way by which an image maintains within itself a heterogeneity that does not reach a limit or an end, preventing it from becoming pre-determined, or conditioned on some kind of moral imperative, logical necessity or instrumental indexicality.

The excess of the algorithmic

It is crucial to note that in becoming processual and non-indexical the image did not lose its succulent visuality. While the algorithmic process undermines the iconicity of the image by breaking the causal relation between the representation and the thing represented, images are increasingly presented to the eye with over-whelming richness and lusciousness, on screens designed for hyperrealism (retina displays, 4K screens, 3D cinema). The paradox of the algorithmic turn, therefore, is that while the image becomes undecidable and its meaning ever more elusive, it also becomes more visually seductive and tactile. As the screen serves up the image of the photograph, the operations that deliver them to the screen are increasingly unseen and unknowable.

As Friedrich Kittler observes, computers do not replace analogue representation with digital, but abolish representation altogether by reducing it to 0 (2010: 226–27); digitization takes the image into the zero-dimensional territory of numbers. Considered in this way, digitization signals a break in the infinite chain of signification in which every signifier can be represented by another signifier: once the signifier is a number (or a bit) it cannot be represented as anything else. What this means for photography is that we shouldn't read too much (or too little) into the apparent hyperrealism of retina displays, video walls and VR imaging systems, for, as Kittler says,

> The hunt for visual realism should not deceive us with regard to the basic principles of computer graphics … computers must calculate all optical or acoustic data on their own precisely because they are born dimensionless and thus imageless. For this reason, images on computer monitors … do not reproduce any extant things, surfaces or spaces at all. They emerge on the surface of the monitor through the application of mathematical systems of equations.
>
> *(2010: 228)*

For Kittler, the digital image is the final frontier in 'the war of technology and natural science against a textual concept of reality' (Kittler 2010: 227) in which the digital is mathematical, immaterial, zero-dimensional and infinitely precise. It is also disembodied, stripped of authorship on the one hand and social agency on the other.[10] However, despite the lucidity of Kittler's account, it does leave something out: namely, that while technologies of digitization break the chain of signifiers and put an end to linguistic (semiotic) interpretations of the image, these very

technologies also create an excess, a supplement and a kind of after image, which is not representational but sensual and affective.[11]

The recursive fragment

It is important to note that the representational logic that informs an understanding of photography as an archive or representation is not dissipated or overcome by the multiplicities put forward by the web: a picture of a cat is still a picture of a cat, even if it is not on our desk but on our Facebook page. However, the instaneity and simultaneity with which the cat becomes available everywhere both as a single image and as part of an always incomplete assemblage causes the image to be both self-referential, recursive and undecidable. The networked image therefore embodies the paradoxical co-existence of two incommensurable logics: rational, visual representational logic according to which the image on our screen refers to a cat somewhere in the universe, and recursive, viral logic of intensity, multiplicity and incompleteness in which the image refers only to itself. It is precisely this 'double articulation' that suggests the possibility of a different subjectivity that might coalesce around the digital image.[12]

If we are to take seriously this paradox, we might want to ask what that means for the politics and the aesthetics of the image. For all its problems, representational logic provides the photographic image with a powerful political rhetoric that makes it indispensible for a broad range of critiques and discourses. If we are to strip photography from its indexical force, are we not reducing it to something rather meaningless and weak? Isn't there something to be said for the effectiveness of the photographic image in documenting, in archiving and in witnessing? In other words, what is the political power of the undecidable digital image? The answer might be found in the ability of the digital image to capture the modes of production, the organization and the structure of the network. As Agamben suggests, the digital image needs to be rethought in light of the way in which identity and subjectivity are formed through the technologies of the network.

In attempting to explore the construction of subjectivity through online or networked environments, it is useful to draw on the argument put forth by neuroscientist Merlin Donald, who suggests that when overwhelmed by a relentless stream of images, the conscious mind is only able to grasp a tiny portion of the stimulants it receives. However, this is not to say that everything that was not grasped simply goes away. As recent research into cognition demonstrates, what is not consciously grasped becomes lodged in 'non-cognitive relays' that are 'unconscious or automatic cognitive processes' (Donald cited in Thrift 2008: 36). These processes are boosted and backed up by the technological systems and environments that operate in the background, being themselves invisible yet configuring, channelling and regulating the conscious perception of images (Donald in Thrift 2008). In such a climate it becomes even more important to direct one's attention not to the image as it appears on the screen but to the

rhythms of repetition and recurrence, to the time signatures, to the gaps and pauses, the stuttering, the noise, the immoderate abundance that constitute the image because these are the mechanisms that make it cohere (Lingis 2000, Nechvatal 2009).

One of the most well-known critiques of representation is articulated in the work of Michael Bakhtin (1895–1975) through the concept of the 'dialogic'. While Bakhtin developed his critique in a different cultural environment, the dialogic model is particularly illuminating within the context of the networked image. The basic premise of the dialogic model is very simple: every utterance gets its meaning from the context within which it is pronounced. Meaning is not pre-determined or given in advance, but constructed from the network of relations in which the utterance came into being, the utterances it responds to and the ones it anticipates. Considered dialogically an image cannot be reduced to the intentions vested in it by the photographer or the author, because 'when a speaker produces an utterance at least two voices can be heard simultaneously' (Wertsch 1991: 13). The question then becomes, how can we ultimately know what is the meaning of the networked image? According to the dialogic model there can never be a final and definitive interpretation of any image because in each new situation, in each new encounter with an audience or viewers, the image will acquire new interpretations and meanings. An image does not receive its meaning from its indexicality nor from its iconicity, but from the network of relations around it. This implies, as Rupert Wegerif says, that 'meaning cannot be grounded upon any fixed or stable identities but is the product of difference' (Wegerif 2008: 349).

Algorithmic imagination

When Descartes posited representation as the basis for finite, universal and rational worldview he was able to do so by defining subjectivity as rational and autonomous. In this way knowledge became limited to that which can be determined by the representational powers of the subject. As we have argued, the network creates conditions of production and dissemination that allow the image to be both formed and formless, both finite and infinite, both rational and irrational. The image does not cease to be mimetic, or have content, but this content consists of self-replicating images that create meaning by operating in the register of intensity rather than representation. This is not the ocularcentric image anchored in Cartesian rationality, Brunelleschian perspective, Albertian frame, but an image that is subject to a logic of instant multiplicity where it can appear simultaneously in any point whatever of the network. While replication has always been an inherent characteristic of photography, the simultaneity of the image creates a climate of pluralism and abundance, of visual excess and of sensorial overload that remains unaccounted for by the semiotics of representation, sign, signifier and signified. Or, as Deleuze (1989: 139) suggests: 'The diversity of narrations cannot be explained by the avatars of the signifier, by the states of a linguistic structure which is assumed to underlie images in general.'

The algorithmic image therefore calls for pluralism in the way images are read, experienced and explored. At the very least, it suggests that 'there is more than one way to skin an *image*': one can treat the surface of the screen as 'moving wallpaper', one can concern oneself solely with the hermeneutics of the visual, with the image produced by the light diodes, shaped by the shiny plastic or metal into the familiar rectangular frame. As the screen never ceases to supply visual images this road is always open, yet it harbours two hazards: first is the narrow interpretation of the network as a text to be seen, to be read, to be interpreted through a rigid and universal model of linguistic analysis. Such a reading risks missing out on those aspects of life that changed drastically with the expansion of global communication technologies with their particular mixture of mega-universalism and hyper-localism. They are those aspects of experience that Nigel Thrift characterizes as 'the art of producing a permanent supplement to the ordinary, a sacrament for the everyday, a hymn to the superfluous' (2008: 2). Thrift stresses how the focus on the cognitive aspects of the image precludes one from being alert to the gap between sensation and perception, possibility and virtuality and the different time-images of repetition and recurrence (Thrift 2008: 18). The other – related – danger lies in the tacit compliance with the dominance of a single model of representation. By accepting the configuration of the image in terms of its visual content, in other words, by viewing the image as a picture of something, all other non-cognitive, not visual possibilities become suppressed. Such lack of pluralism is perilous because absolute privileging of one mode of interpretation over all others is likely to lead to totalizing conceptual paradigms centred on human consciousness. Such under- standing of the image precludes any possibility of movement as it posits clear separation between the viewing subject and the object that is being viewed. When representation is understood from this essentialist, anthropocentric perspective, what is being taken for granted is not only the separation between subject and object but also the identity between thought and truth expressed through the verisimilitude of the image.

As the product of pluralism and multiplicity, the digital image is no doubt a paradoxical object (if it is an object): neither visible nor invisible, neither fully present nor absent, embodying both the linear representational logic of the Cartesian space and the recursivity of the algorithm. However, these paradoxes are deeply relevant to the most mundane and ephemeral events of all: the event of the human hand touching a key on the computer keyboard, a finger gently sliding across the tablet or when the light from a retina display mingles with the retina of the eye. Or when a Wi-Fi router relays a signal about the event of someone's birth, or that someone just died or that somewhere, someone posted a message on Facebook before going out for a pizza or going out to jump off a bridge, or that someone somewhere downloads a song, a porn clip, a bomb manual. And when the pre-paid Wi-Fi dongle expires, a server room's Uninterruptable Power Supply is interrupted or the phone is dead, someone sits there in the dark or next to a dead screen, not quite knowing what has just happened to them.

Notes

1 This is not to ignore the fact that many artists of the nineteenth and twentieth centuries have also challenged Cartesianism – from Turner to the abstract expressionists. But what is interesting to consider is that it was the invention of photography that allowed a whole generation of artists to develop work that offered a different approach and to take issue with the ideologies contained in the representational worldview that they inherited. It is our suggestion that the algorithmic turn affords photography the same opportunity that photography afforded painting, namely to ask questions regarding its own internal structure and mode of production. This point is taken up by Jean-François Lyotard in 'Representation, Presentation, Unpresentable' in *The Inhuman* (1993: 119–28).

2 It is worth noting that the algorithms that assist the CCD to translate light into information inside a camera are closely guarded trade secrets (see Canon Europe: n.d.).

3 An algorithm is a process with two main characteristics: it is finite and it is repeatable. William Uricchio describes it as 'a (finite) process, a formula capable of accommodating different values and yielding different results' (2011: 26).

4 Examples of this include the Facebook feed (EdgeRank algorithm), Search Engine (ImageRank/PageRank algorithm) and the Flickr Explore page (Interestingness algorithm).

5 Several commentators pointed out the falsity of the familiar definition of photography as 'painting with light'. For instance, Peter Geimer suggests that the minimal definition of photography is 'a body [that] inscribes its image onto another body' (2011: 36).

6 This notion is also inherent in the philosophy of Theodor Adorno (1973: 265–70) who argues that causality is unsuitable for the understanding of culture, because social phenomena are inherently irrational and any sociology that takes rational causality as its guiding principle is bound to distort the true picture of society.

7 Writing about Google Street View, Sarah Pink (2011) suggests that digital photography must be understood as progressively given and experienced through movement.

8 Consider for example the automated operation of the Central London Congestion Charge Zone, in which 'cameras, records, files and computers are all involved but, except where enforcement proceeds to the courts, there is never a visual presentation' (Tagg 2009: 20–21).

9 This is taken up and expanded in relation to metadata and search engine optimization in Rubinstein and Sluis (2013).

10 Johanna Drucker takes issue with precisely this kind of mathematical analysis of the digital image, warning that when the image is considered as immaterial, i.e. as information that is identical to itself, 'it precludes any critical intervention in the investigation of terms of being and their reception in cultural frameworks … ' (2001: 141).

11 Simon O'Sullivan names this excess to representation 'affective-event'. He draws on the works of Guattari and Bakhtin to define it as 'The partial object [that] operates as a point of entry into a different incorporeal universe. A point around which a different kind of subjectivity might crystallize' (2012: 6).

12 In *A Thousand Plateaus* 'Double Articulation' is a concept that allows the conception of systems as dynamic both/and abstract machines (as opposed to binary and oppositional either/or systems). It involves both chaotic and structured elements and is responsible for the creation of identities and for the transformation and becoming of these identities (Bell 2006: 4; Deleuze and Guattari 2003: 39–73).

Bibliography

Adorno, T.W. (1973) *Negative Dialectics*, Trans. E.B. Ashton. New York: Continuum.
——(2004) *Aesthetic Theory*, R. Tiedemann and G. Adorno (eds), Trans. R. Kentor–Hullot. London: Continuum.
Agamben, G. (2009) *What is an Apparatus? And Other Essays*, Trans. D. Kishik and S. Pedatella. Stanford, CA: Stanford University Press.

Bakhtin, M. (1973) *Problems of Dostoevsky's Poetics*, Trans. M. Rotsel. Michigan, MI: Ann Arbor.

Barthes, R. (1977) *Image, Music, Text*, Trans. S. Heath. London: Fontana.

Barthes, R. (1981) *Camera Lucida: Reflections on Photography*, Trans. R. Howard. London: Vintage.

Bazin, A. (2004) *What is Cinema?* Trans. H. Gray. Berkeley, CA: University Of California Press.

Bell, J. A. (2006) *Philosophy at the Edge of Chaos*, Toronto: University of Toronto Press.

Berry, D.M. (2011) *The Philosophy of Software: Code and Mediation in the Digital Age*, Basingstoke, Hampshire: Palgrave Macmillan.

Cameron, J. (1997) *Titanic* [Film], US: Twentieth Century Fox.

Canon Europe. (n.d). 'Photo Sensors.' *Canon Professional Network*. Available at: http://cpn. canon-europe.com/content/education/infobank/capturing_the_image/photo_sensors.do (accessed 4 December 2012).

Chun, W.H.K. (2011) *Programmed Visions: Software and Memory*, Cambridge, MA: MIT Press.

Colebrook, C. (1999) *Ethics and Representation: From Kant to Post-structuralism*, Edinburgh: Edinburgh University Press.

Cubitt, S. (2011) 'Time to Live', *ISEA International Symposium Proceedings*, San Francisco, CA: Leonardo. Available at: www.leoalmanac.org/wp-content/uploads/2012/04/ISEA_pro ceedings-sean-cubitt.pdf (accessed 4 September 2012).

Dean, J. (2010) 'Affective Networks', *MediaTropes*, 2 (2), 19–44. Available at: www.mediatropes. com/index.php/Mediatropes/article/view/11932 (accessed 23 September 2012).

Deleuze, G. (1989) *Cinema 2; The Time-Image*, Trans. H. Tomlinson and R. Galeta. London: Athlone Press.

Deleuze, G. and Guattari, F. (2003) *A Thousand Plateaus*, Trans. B. Massumi. London: Continuum.

Derrida, J. (1988) *Limited Inc*, Trans. J. Mehlman and S. Webber. Evanston, IL: Northwestern University Press.

Drucker, J. (2001) 'Digital Ontologies: The Ideality of Form in/and Code Storage–or–Can Graphesis Challenge Mathesis?' *Leonardo*, 34 (2), 141–45.

Elkins, J. (2007) *Photography Theory*, New York: Routledge.

Flusser, V. (2000) *Towards a Philosophy of Photography*, London: Reaktion Books.

——(2011) 'The Gesture of Photographing', *Journal of Visual Culture*, 10 (3), 279–93.

Foucault, M. (1990) *The Will to Knowledge; The History of Sexuality: 1*, Trans. R. Hurley. London: Penguin Books.

Geimer, P. (2011) '"Self-Generated" Images' in J. Khalip and R. Mitchell (eds) *Releasing the Image: From Literature to New Media*, Stanford, CA: Stanford University Press.

Hayes, B. (2008) 'Computational Photography', *American Scientist*, 2 (96), 94–99.

Heidegger, M. (1977) *The Question Concerning Technology, and Other Essays*, Trans. W. Lovitt. New York: Harper and Row.

Judovitz, J.D. (1988) 'Representation and its Limits in Descartes', in S.H. Silverman (ed.) *Postmodernism and Continental Philosophy*, New York: State University of New York Press.

Kipnis, L. (1996) *Bound and Gagged: Pornography and the Politics of Fantasy in America*, New York: Grove Press.

Kittler, F.A. (2010) *Optical Media: Berlin Lectures 1999*, Trans. A. Enns. Cambridge: Polity.

Klein, A. (2010) 'Everything You Wanted to Know about "Memento"', *Salon*. Available at: www.salon.com/2001/06/28/memento_analysis/ (accessed 4 September 2012).

Lingis, A. (2000) 'The Murmur of the World', in W. Brogan and J. Risser (eds), *American Continental Philosophy: A Reader*, Bloomington: Indiana University Press.

Lyotard, J.-F. (1993) *The Inhuman: Reflections on time*, Trans. R. Bowlby and G. Bennington. Cambridge: Polity Press.

Manovich, L. (2001) *The Language of New Media*, Cambridge, MA: MIT Press.

Nechvatal, J. (2009) *Towards an Immersive Intelligence: Essays on the Work of Art in the Age of Computer Technology and Virtual Reality 1993–2006*, New York: Edgewise Press.

Nolan, C. (2000) *Memento* [Film], US: Newmarket Films.

O'Sullivan, S. (2012) 'From Stuttering and Stammering to the Diagram', in M. Bleyen (ed.) *Minor Photography. Connecting Deleuze and Guattari to Photography Theory*, Leuven: Leuven University Press.

Petersson, D. (2005) 'Transformations of Readability and Time; A case of Reproducibility and Cloning', in E. Steinskog and D. Petersson (eds) *Actualities of Aura: Twelve Studies of Walter Benjamin*, Sweden: Nordisk Sommeruniversitet.

Pink, S. (2011) 'Sensory Digital Photography: Re-Thinking "Moving" and the Image', *Visual Studies*, 26 (1), 4–13.

Røssaak, E. (2011) 'Algorithmic Culture: Beyond the Photo/Film-Divide', in E. Røssaak (ed.) *Between Stillness and Motion: Film, Photography, Algorithms*, Amsterdam: Amsterdam University Press.

Rubinstein, D. and Sluis, K. (2013) 'Notes on the Margins of Metadata; Concerning the Undecidability of the Digital Image', *Photographies*, 6 (1).

Tagg, J. (2009) 'Mindless Photography', in J.J. Long, A. Noble and E. Welch (eds) *Photography: Theoretical Snapshots*, London: Routledge.

Thrift, N. (2008) *Non-representational Theory: Space, Politics, Affect*, Abingdon: Routledge.

Uricchio, W. (2011) 'The Algorithmic Turn: Photosynth, augmented reality and the changing implications of the image', *Visual Studies*, 26 (1), 25–35.

Wegerif, R. (2008) 'Dialogic or dialectic? The significance of ontological assumptions in research on educational dialogue', *British Educational Research Journal*, 34 (3), 347–61.

Wertsch, J.V. (1991) *Voices of the Mind: A Sociological Approach to Mediated Action*, Cambridge, MA: Harvard University Press.

3

DRAWING WITHOUT LIGHT

Simulated photography in videogames

Seth Giddings

Pokémon Snap loads on the Nintendo Wii console. The game's title music has the familiar sound of an SLR camera's shutter mixed into its cheerful melody, an audio hint at the game's theme and – perhaps – a ghostly echo of a passing technology. Its registration screen is a 'photographer card', reminiscent of a journalist's press credentials, but the player is positioned more as a tourist on safari than a jobbing photojournalist. We are transported around a 3D rendered island beach on a little train, our eyes drawn to the reticule, the focal point of the interface's first-person view point.

'Press Z to aim, press A to shoot, zoom in with L' the game instructs us, 'Try to take a lot of *Pokémon* pictures'.

The Pokémon themselves leap from behind rocks and trees as we trundle along the tracks. One particular species, a Pidgey, flutters into view. Pressing Z and A, we trigger the shutter sound again and hope to have framed a successful photograph.

'How's the size?' the game asks itself at the end of the first level; '310 – hmm so so.' 'How's the pose? 750', the automaton/critic continues. 'How's the technique? OK! The Pokémon is in the middle of the frame!'

Hand-eye co-ordination is transcribed into a simulacrum of formal and aesthetic judgement, itself rendered numerically; centring the Pokémon doubles the score for that picture.

> 'Wow! There are other Pidgey in the picture. I'll give you an extra 20 points. Wonderful! Your work is impeccable. Keep up the good work!'

The mechanic of the game is almost identical to an on-rails arcade shooter with first-person perspective and crosshairs head-up display. The wariness of violent action in this videogame for younger children echoes twentieth-century sensibilities

in big-game hunting, and a similar shift from gun to camera. As with the photo-safari, we might assume, the Pokémon hunter's challenge is to snap their subject from the front, lightning reactions in play before the animal or monster turns and flees.

The first level (or 'course') completed, we are presented with all our photos, displayed like a contact sheet. 'I've shown that one to Prof. Oak, but is this better? Press z to compare.'

It would be easy to regard the shutter sound, a digital audio file ubiquitous now across digital photography in all its forms and modes of capture, as a mere trace, an aural ghost of its departed medium, technology and technics. Photography, dominant in image-making for 150 years, now lost in a digital maelstrom that has wiped away its mechanical and chemical apparatus of production and its material and affective presence as a printed object. From this perspective videogame photography might mark the medium's final disappearance, as these images remove its defining essence, light itself, the *photo*-of photography. Unlike digital cameras and camera-phones, the making of images in, and of, computer game worlds operates without key processes and phenomena that constitute the specificity of photography. The pictures we showed to Prof. Oak may be displayed as light and colour on the monitor screen, but are in effect a mere graphical output from a set of invisible and intangible software processes and variables. The simulated photograph is produced not by the fixing of light from the phenomenal world, whether that capture of light be chemical, electronic or digital. Rather, it is a rendering of events from a virtual world that is sunless, a dark chamber, a true camera obscura. The sun never shines on Pidgey.

If the videogame photograph is indeed a ghost, then, like the shutter sound, it is energetic and prolific in its haunting. Numerous videogames offer their players opportunities for the production and collection of images displayed and understood as photographs. For some games, such as *Pokémon Snap*, the production of photograph-like images is central to the gameplay, for others it is an add-on activity, an option for the completist or aesthetically minded. Some games do not offer a photographic feature, yet something in the quality of their graphics, virtual landscapes or virtual camera stimulates in their players the desire for image capture through screen grabs.

But what is the nature of this simulation of photography? Perhaps it is not even a ghost, but merely a metaphor, offering a familiar frame to activities and processes that are quite different to photography? This essay will argue that neither the gothic rhetoric of death and afterlife that attends new media, nor an unqualified application of the notion of remediation, are adequate for understanding the persistence and mutation of photographic media and aesthetics in the post-digital era. For other facets of photography, at least of photography as an everyday practice and experience, persist in videogames. The image that glows only with the electrons of the cathode ray tube or liquid crystal of the flat screen may still capture a *moment*, a frozen instant in the unfolding of a dynamic, kinetic environment. The virtual camera organizes the flux of digital data in time and as space, from as fixed a viewpoint as that established by the photographic lens and the camera obscura before it.

Though videogame worlds will be the focus, this essay makes suggestions for the theorization and study of media technological change more generally.

Light drawings and the pencil of nature

In January 1839, the British pioneer in the development of photographic techniques and technologies William Henry Fox Talbot described his images to the Royal Society as 'photogenic drawings'. Sunlight was central to both the material possibilities of the first photography and to its discursive and descriptive framing – to the extent that the development of key techniques and processes could be helped or hindered by the vagaries of sunlight, not least Fox Talbot's good fortune of a 'brilliant summer' in 1835 during which signficant advances were made. Sunlight is the medium, in a number of senses of the word, producing 'sun pictures', 'photogenic drawings', sciagraphs (shadow drawings) or – the name given by Nicéphore Niépce to his own inventions in this field – heliographs, 'sun drawings'.

> This view was taken from one of the upper windows of the Hotel de Douvres. The time is the afternoon. The sun is just quitting the range of buildings adorned with columns: its façade is already in the shade, but a single shutter standing open projects far enough forward to catch a gleam of sunshine. They have just been watering the road, which has produced two broad bands of shade upon it. A whole forest of chimneys borders the horizon: for, the instrument chronicles whatever it sees, and certainly would delineate a chimney-pot or a chimney-sweeper with the same impartiality as it would the Apollo of Belvedere.
>
> *(Fox Talbot 1844)*

This famous description of a plate in his book *The Pencil of Nature* explains the photograph in terms that bind together nature and artifice; painted by light and shade, chronicled by an impartial instrument. Elsewhere in the book, a building (Lacock Abbey in Wiltshire, Fox Talbot's home) became the first 'that was ever yet known to have drawn its own picture' (Fox Talbot 1844). Whereas the optics of the camera obscura had been understood as the simulation of human vision, a technology of perception and art, for the early photographers technology disappeared in the heliocentric poetry of their self-publicity. If nature paints herself through the play of light across the world, through slivers of glass and into silver crystals, then the apparatus of the camera is the stuff of nature itself, fragments of wood, minerals and glass, drawing the world of which they are themselves part.

Virtual image to virtual camera

Digital imaging, particularly in the generation of moving images, has seen a new dissolution of the photographic camera into a new environment. The *virtual* camera is made of the same material as that which it depicts: code. It too simulates vision,

but now it is the optics of the camera apparatus itself that is the aim of this simulation, not biological vision. As many theorists of digital cinema have noted, the 'realism' of computer-generated imagery has been the replication not of the phenomenal world, but rather the look of the photographic image (Prince 1996, Manovich 2001). The widespread simulation of lens flare in computer-generated special effects, animation and videogames is one example of the curious aesthetic and conventional interplay between analogue cinematography and computer-generated imagery. These points of animated light spreading across the screen lend to their virtual worlds a sense that they are physically dynamic and complex, that we might actually experience them. The irony – or joke – is of course that lens flare in photographed television and cinema is the product of a technological rather than human lens, of the camera, not the eye. We see lens flare only in the mechanical image, but read it as actual. As CGI removes the need for cameras and cinematic photography, it simultaneously replicates the camera's technical shortcomings in the name of realism.

Whereas the early challenge of CGI photorealism was to render the detail of texture, light and complex bodies (from hair and fur to water and smoke), more recent movies have had to reverse this. The addition of motion blur is a good example of photorealism exceeding its referent. The clarity of CGI, especially in its depiction of fast-moving objects and action, now shows up the weaknesses of traditional photography. Recording a dynamic world at 24 or 25 fps can only capture fast-moving objects as a blur, but it is indicative of the hold photography has over our way of seeing the world that this technical failing seems instead, like lens flare, to be an aspect of the phenomenal world around us and our perception of it. Watch a live action film with analogue animation stop-motion sequences, for example the ED-209 robots in *Robocop* (Verhoeven 1987). As each frame is a shot of a still object, the object being moved only between shots, the resulting sequence has a clarity quite different from live action footage. A typical response to the appearance of stop-motion effects in live action cinema is that they look 'jerky', whereas they are often the opposite; they are too smooth, they are caught fully by light, frozen by it, frame by frame. The extensive compositing of CGI elements in recent action cinema has necessitated the replication of the weaknesses of the movie camera's capture of light, from focussing up, crash zooming and the addition of shallow depth of field, to shaking and blurring (Mather 2004). The reality effect of the virtual camera in CGI clings to the reassuring inadequacy of the mechanical and the chemical. The scene of a live action film with CGI effects is a mixed environment of sunlit and 'dark' objects and it is not the photographic image as such that is the object of remediation and simulation, but rather the camera.

Though shaped by the histories and technocultural forms of photography, the virtual camera should not be reduced to a familiar media object like those McLuhan saw in his rear view mirror, nor seen as a mere reality effect, an ideological residue of the waning yet still dominant codes of twentieth-century visual culture. The play between artifice and reality precedes all the technocultural forms of cinema

and television, and will no doubt supercede them. The videogame is a key example of this.

Videogames and the remediation of photography

The technics of any medium are not exhausted by the mechanisms of the recording device and dissemination networks, but include the knowledge, experience, historical and cultural milieu of its users. In her essential essay on the subject of computer game photography, Cindy Poremba asks us to understand digital photography not only as a set of new technologies and remediated aesthetics, but as – in important ways – continuous with the social and cultural *practices* of predigital photography (Poremba 2007). For instance, she notes marked similarities with photographic practices in physical environments, particularly tourists' photos. Online game players often upload their screenshots of dramatic moments of play or spectacular scenery from online games such as *World of Warcraft* to online galleries such as Flickr. These images from the sunless virtual world will mix there with conventional actual world snapshots of family and friends, travels and occasions. As in the actual world, photographers capture significant places, events and individuals, and these images both look like actual world photography and are collected and displayed in albums and slideshows that draw their interfaces from the physical storage and display media of photographic albums and domestic slide projection:

> Photography here manifests itself in both cultural and technical modes: remediating the screenshot in cultural practice and playing out the technical role of photographic production.
>
> *(Poremba 2007: 50)*

That these images remain 'photographs' to their creators is no doubt, in part, the rendering of the new in the familiar and reassuring frames of the medium that is being displaced or superseded Yet, as Poremba demonstrates, we can read the continuities of everyday media practice established in over a century of domestic photography as both preceding and succeeding the particular period of image production characterized by the nonhuman fixing of light. From domestic scrapbooks pasted together in Victorian parlours to the dynamics of the amateur image as trophy ('I was here, I did this'), the aesthetics and passions of collecting and display, and the performance of technical virtuosity, all persist in the making and storage of virtual images:

> If the process and ritual behind this image making is similar, the players themselves are validating the reality of their subjects simply by creating a document of these experiences. In this sense, players are taking real photographs, just in virtual spaces. The image itself does not discriminate with regard to the perceived reality of its contents.
>
> *(Poremba 2007: 50)*

Videogames and their worlds offer vivid, complicated and compelling experience for players and playing communities. Photographs taken of, or in, them may not be written with light but in their conventions, their affects, their intentionality; they are simulations and all the more real for that.

The mutation of the virtual camera

This tracing of continuities of the photograph (as cultural object) and photographer (as subject) across the technological and cultural change at the end of the twentieth century usefully undermines widespread pessimistic readings of these changes in terms only of loss; the loss of tactile processes and objects, of authentic cultural and artistic creation, whether professional or amateur, the loss of reality itself. J. David Bolter and Richard Grusin's notion of *remediation* offers a more nuanced model of media technological change. It develops Marshall McLuhan's observation that new media tend to take existing media as either their content – for instance early cinema remediating theatre – or as a familiar frame or interface – web pages remediating the printed page, for example (Bolter and Grusin 2000). However, over-reliance on remediation as an underlying model of technocultural change shares with the pessimistic attitude the risk of ignoring significant novelty, the emergent and the new as well as the obsolete and archaic. For all the remediations and continuities between actual and videogame photography, there are also profound differences that demand a rethinking of the nature of photography rather than a mourning of its demise into simulacra. Gameworld photographs are real images of a virtual space, but as I hope this essay's emphasis on light keeps in mind, a virtual space is a strange and new environment and so its drawing of itself must also be seen in this dark light. Against a model of continuity and rupture, or the remediational framing of the new in the vignette fade and sepia of medium-specific familiarity, or the quasi-supernatural repeats/hauntings across time and space of media archaeology, I would posit an insistence on mutation and non-linearity. To do so I will draw on Gilbert Simondon's notion of individuation.

With 3D game engines the virtual camera has become much more than a reality effect; rather, it is a key gameplay element, it shapes the game, makes it possible. Though some games consciously draw on cinematographic camera angles (most famously the early games in the *Resident Evil* series), whether the game controls the player's point of view is generally more to do with gameplay dynamics than with the remediation of film. In many games, *Super Mario 64* and *Legend of Zelda: the windwaker* to name just two, the camera is freely controllable by the player and swoops around the avatar at will. These virtual cameras are weightless, immaterial, no longer a remediation of cinematography or a photorealist reality effect. In all games with a three-dimensional virtual world the 'camera' is absolutely central to the gameplay; indeed, it is the device through which the player at once views and explores their world. As Melanie Swalwell notes of her experience of first-person shooters such as *Quake*:

One of the specific ways in which games of this genre mobilize their players is through the use of the mobile camera; the resultant mobile (visual) perception is demanding because of its kineticism ... I found the fast paced twisting and turning through (what seemed to be) mazelike architecture extremely disconcerting. I was unaccustomed to having my vision guided by a mobile camera. It felt as if my body could not keep up with my vision. After watching it for a while, the twisting mobile perspective began to colonize my vision so that I would see it in places where it wasn't present (the carpet began to swirl).

(Swalwell 2008: 75)

As Cindy Poremba puts it, a new hybrid has been created: 'as camera avatar, players not only navigate through the game world, they film it as well' (Poremba 2007: 49).

Cameras obscura: x-rays to XBox

Plate VIII. A scene in a Library

Among the many novel ideas which the discovery of photography has suggested, is the following rather curious experiment or speculation. I have never tried it, indeed, nor am I aware that any one else has either tried or proposed it, yet I think it is one which, if properly managed, must inevitably succeed.

When a ray of solar light is refracted by a prism and thrown upon a screen, it forms there the very beautiful coloured band known by the name of the solar spectrum.

Experimenters have found that if this spectrum is thrown upon a sheet of sensitive paper, the violet end of it produces the principal effect: and, what is truly remarkable, a similar effect is produced by certain *invisible rays* which lie beyond the violet, and beyond the limits of the spectrum, and whose existence is only revealed to us by this action which they exert.

Now, I would propose to separate these invisible rays from the rest, by suffering them to pass into an adjoining apartment through an aperture in a wall or screen of partition. This apartment would thus become filled (we must not call it *illuminated*) with invisible rays, which might be scattered in all directions by a convex lens placed behind the aperture. If there were a number of persons in the room, no one would see the other: and yet nevertheless if a *camera* were so placed as to point in the direction in which any one were standing, it would take his portrait, and reveal his actions.

For to use a metaphor we have already employed, the eye of the camera would see plainly where the human eye would find nothing but darkness.

Alas! that this speculation is somewhat too refined to be introduced with effect into a modern novel or romance; for what a *dénouement* we should

> have, if we could suppose the secrets of the darkened chamber to be revealed
> by the testimony of the imprinted paper.
>
> *(Fox Talbot 1844)*

At the moment the sun drawing was invented, new technologies were imagined
that would bring the invisible to human sight. The dark light of the electro-
magnetic spectrum has since been visualized in medical and scientific photography,
and scientific definitions of photography refer to the action of *radiant energy* on a
sensitized surface, not necessarily *light* in the limited spectrum detectable by
the mechanism of the human eye. Nicola Teffer has examined the implications of
medical imaging for a contemporary understanding of photography, technologies
such as ultrasound and x-ray that rummage in the dark interior of the living
human body, a synaesthetic process that visualizes sound, touch, or chemical
activity on a cathode ray tube:

> The images they produce are the result of a blind feeling in the dark, using
> the echoes of soundwaves, the absorption of x-rays and the excitation of
> hydrogen atoms to fathom the unseen reaches of the body ... These are
> images produced without light, of things which lie beneath the opacity of
> the skin, and so they derange our understanding of what it is to see, what is a
> visible thing ... Part of the profound strangeness of medical imaging tech-
> nologies is not only that they make the invisible visible, but that they do so by
> a translation of haptic and sonic information into something that we see.
>
> *(Teffer 2012: 122)*

From this perspective, the shift from a surface coated with sensitive chemicals to
one that detects light electronically seems less profound and ruptural than the
generation of photo-realistic images with no visible referent. Fox Talbot's evoca-
tive speculation hints at the ends or edges of the sun-drawing almost at the
moment of its emergence. A videogame world is at once Fox Talbot's imaginary
dark chamber, filled with (though not illuminated by) invisible rays, and a virtual
camera obscura – a room that draws its own picture, at once recording device and
object of capture. As computer code, the virtual camera does not exist as a distinct
apparatus – it is just one mode of the gameworld or database reporting on its own
current state. It is a black box that has photography-like effects, the video game-
world a new mutation of the dark chamber. This questioning of the essence of
photography – before and after its technocultural dominance – and terms such as
'mutation' demand a closer conceptual attention to the nature of technocultural
development and change.

Virtual heliography

Gilbert Simondon's theory of individuation, published in the 1950s, has proved
influential in recent thought on technology and culture, through, in part, his

influence on Gilles Deleuze, Bruno Latour and Bernard Stiegler. Simondon was concerned with how an entity came to be, and to be recognized as such. These 'individuals' could be a crystal growing from a supersaturated solution, a biological species from the processes of evolution, or a technological system from other technological systems and processes. His concept of individuation is explicit in its rejection of teleology, that we could look back to the milieu from which a particular stable (though only momentarily stable) technology emerged and see a linear process of its design and realization traced back into its prehistory. Simondon challenges the assumption that

> we can discover a principle of individuation exercising its influence before the actual individuation itself has occurred, one that is able to explain, produce and determine the subsequent course of individuation. Taking the constituted individual as a given, we are then led to try to recreate the conditions that have made its existence possible.
>
> *(Simondon 1992: 297)*

An analogy with direct relevance to this essay would be recent work on the early history of the cinema, particularly in the context of the contemporary post-cinematic moment. Tom Gunning (1990), for instance, questions the widespread assumption that dominant cinema (in particular the dramatic feature films of Hollywood's classical era, Metz's 'meta-genre' that set the model for global film production for a century) was somehow inevitable, that its precursors from the magic lantern to Muybridge's experiments were gradually honed, combined and perfected to realize a potential that had always existed. In Simondon's terms, the assumption of the inevitability of classical cinema is (erroneously) used to explain the historical process of its emergence, and this is

> because the received way of thinking is always oriented toward the successfully individuated being, which it then seeks to account for, bypassing the stage where individuation takes place, in order to reach the individual that is the result of this process.
>
> *(Simondon 1992: 299)*

In applying Simondon's position to our cinematic analogy, Gunning then can be seen as celebrating early 'primitive' cinema (the 'cinema of attractions') for its own characteristics and achievements rather than as a stage towards a more sophisticated cultural form. He finds the explanation in the processes of innovation and experimentation in both audiences and apparatus, not in classical Hollywood as 'successful individual'.

Significantly, commentators on Gunning's work have identified something of these characteristics in digital moving image culture – notably an address to audience that is visceral rather than contemplative, an aesthetics of shock and spectacle, and a fascination as much with the technology of the camera and projector as with the

stories they tell (Lister *et al.* 2009, Mactavish 2006, Strauven 2006). Simondon argues that any individuation may have 'left overs', aspects and bodies not included in the new individual but which do not necessarily disappear:

> Individuation must therefore be thought of as a partial and relative resolution manifested in a system that contains latent potentials and harbors a certain incompatibility due at once to forces in tension as well as to the impossibility of interaction between terms of extremely disparate dimensions.
>
> *(Simondon 1992: 300)*

For instance, cameras and photography were put to all sorts of different uses throughout the twentieth century. In entertainment the cinema of attractions persisted in special effects, theme parks, advertising and animation, fully returning – albeit in mutated form – to the centre of mainstream cinema with CGI effects, animation and post-production (Lister et al. 2009: 146–50). The dominance of a species or individual (in this case the production of sequences of photographic prints of the visible light spectrum) neither supersedes nor exhausts other lineages.

A history of the virtual camera in videogames might then trace a primitive moment in the fixed depthlessness of the *Space Invaders* screen, through the simulation of parallax vision in the side-scrolling *Sonic the Hedgehog*, with the virtual camera emerging properly with the '3D' First-Person Shooter (FPS) and *Castle Wolfenstein 3D* in the early 1990s. Yet no one would have thought of this graphic output as camera-like *until* the FPS. Even the imaginary of vision and perception bound up in the FPS flickers between a notion of the virtual camera and of virtual vision. The 'first-person' is at once a simulation of subjective vision (with the gun at the bottom of the screen as a joke on this simulation) and the first-person of film-making language, the kino-eye.

The despair over the supercession of chemical by digital photography in the 1990s is bound up in the assumptions of technological inevitability and completeness that Simondon challenges. If photography is seen instead as *never* having had an ideal technocultural coherence, if its status as the privileged indexer of reality and truth is understood to have been more complex, partial, contested and contingent, then recent dramatic transformations can be seen as *evolutionary* rather than apocalyptic. The pessimism over recent changes is only sustainable if photography is seen to have been an individual with no latent potentials or incompatibilities.

In 1822, more than ten years before Talbot's experiments with silver salts, Joseph Nicéphore Niépce spread bitumen on a glass plate and laid on top of it an engraving of Pope Pius VII, the paper oiled to render it translucent. Light passing through the translucent paper hardened the bitumen, and the inked lines of the engraving left hidden sections, which – still soft – were washed away with oil of lavender. There was no pinhole or lens in this precursor to the photogram, subject and copy and sticky media pressed together and bathed in light. This heliograph – sun drawing, to use Niépce's own term – was always already a copy of a copy, a replication of an earlier printed artefact. Moreover the process entailed the

degradation and destruction of the 'original' print, soaked in oil. Friedrich Kittler notes that these early developments of heliography by Niépce were driven by a desire to innovate in lithographic printing, and to automate image-making rather than any prefiguration of lens-based photography (Kittler and Rickels 2009). If anything it could be regarded as of a logic of mass media reproduction to come, and therefore anticipated the multiple and proximate encodings of twentieth-century print media, photolithography, halftone and stochastic screening. This was not the distanced and painterly technics and aesthetics of Daguerre and Talbot's light-filled rooms, streets and landscapes, but image-making through contact and proximity. In this, the heliograph finds a descendant in medical imaging – a haptic 'blind feeling in the dark' (Teffer 2012: 131). For Teffer this trope in photography and imaging is nothing less than an alternative history of vision and representation, 'one which proceeds in terms of proximal engagement with reality rather than a distanced observation, which operates through intervention rather than reflection' (Teffer 2012: 124).

This language of the proximate, the haptic, the interventional, resonates with the imaging technologies of virtual worlds, first as an evocation of the intense interfaces and feedback loops of the videogame, and second through the particular ways in which virtual photographs are generated. If these images are an index of anything it is data or code, one momentary state of a dynamic artificial system, its variables and objects translated and rendered in a simulation of lens-derived perspective. Moreover, the virtual camera itself is code, one element of the same stuff that it is recording. This insight raises two useful observations. First, gameworld photography must be thought of differently from actual world photography in at least this respect: there is no material separation of camera apparatus and environment. There are strange echoes here of Fox Talbot's pencil of nature, artifice drawing itself. Second, it supports the application of Simondon's individuation to the genealogy of photography. Rather than a story of the gradual perfection of the capture of light through lens and silver, what emerges is a tangled mesh in which both commodified print media and information media are present *before* photography, not only *after* it.

The time of the Picto Box

The Legend of Zelda is a long-running and popular series of videogames produced for a variety of Nintendo consoles. The games' world is a Japanese take on the generic alternative 'middle ages' familiar from fantasy fiction and games, from Tolkein and *Dungeons & Dragons* to *World of Warcraft*. Full of magic and spirits, the games also feature anachronistic technologies such as steam trains, clocks and photography. In *The Legend of Zelda: the windwaker*, the protagonist Link finds a 'Picto Box', a camera that can be used in a set of sub-quests and tasks. The operations of the Picto Box highlight the mutational nature of virtual photography. On the one hand they generate precise snapshots of the dynamic 3D world and its subjects, captured at the instant and from the vantage point of the avatar. On the other hand

they are something new – as well as capturing events in virtual space, tasks requiring the Picto Box highlight the artificial temporality of the gameworld. For example, Link is instructed to photograph a man in a red tunic as he delivers a letter. Clear instructions are given in the walkthrough:

> Windfall Island: Picto Box Quest
>
> Talk to the Lenzo, the photographer, check out his photos upstairs, and show him some pictures of your own, and he will soon sign you on as an apprentice (he will do so once he's standing behind the counter). He will instruct you to take specific pictures. Make sure your camera isn't full and get the following shots:
>
> 1. Snap a shot of the man in red when he sends off a love letter. During the day, follow the man with the moustache who slowly walks down the stairs from the upper portion of Windfall. Don't get close or he will stop. Wait by the mailbox and take a picture of the whole guy (from head to toes) while he is putting the letter in the box. If the letter is already in the box, it's too late.
>
> *(IGN Walkthrough and FAQ no date)*

What isn't clear from these sparse instructions is that this task can be attempted on *any* day. The player can travel away from Windfall Island, complete other quests, and return to find that the man in red will always be sending the love letter at the particular time of day; or rather, he will only send the letter when Link is there to photograph the action. Each task outlined by the walkthrough reveals a community and individuals animated only by the act of photography, lives and loves that exist only to be captured:

> 2. Go to the coffee shop up the stairs. Startle the lone old man in the corner and get his surprised look on camera. You can roll into his table or make him drop the dishes, but the easiest way is to stand in the spot shown in the picture and toss a pot towards him. Immediately get out your camera and take a picture of the man (don't cut his feet or head off) while he's shaking.
>
> 3. Find the girl with the orange dress close to the stairs that lead up to the windmill. Position yourself as shown in the pic above and wait for a guy in green to come along. It'll take a while, don't give up. When the two make eye contact, snap your picture.

The photographic instant must be exact, but it is also predetermined, coded, inevitable (as long as Link doesn't get too close and change fate). In Henri Cartier-Bresson's famous photograph 'Behind the Gare Saint Lazare' (1932), the rail worker will never jump the puddle and his reflection again, the chance encounter of light, photographer, subject and all the contingencies of everyday life and history tangled at this point. In contrast, the posting of the love letter in this videogame will always

have happened and will always happen, as long as the virtual camera auto-activates it. It is inevitable, even if never realized. The man in red will walk slowly to the post box every day that Link is on the island, his purpose and existence only to be photographed.

Successful images do not serve, as they have done traditionally, as trophies or displays of aesthetic accomplishment; rather, they function as correct solutions to challenges or puzzles, tasks to be rewarded with maps or tokens useful in the player's progress through the game. Photography here is instrumental, answering the demands of the game; it is not an aesthetic or performative practice:

> Bring each picture to the picto store owner (one by one) and you will be rewarded with a Joy Pendant and an apprenticeship.
>
> *(IGN Walkthrough and FAQ no date)*

Persist with photographic practice in *the windwaker* and new mutational possibilities open up. The magical mise-en-scene leads photography down new bizarre representational and transductional paths:

> Give it to the photographer and you will receive the Picto Box DX – capable of color photos. The benefits of this box are manifold. First, you can now partake in collecting pictures of characters and turning them into statues in the hidden gallery on Dragon Roost Island. For those characters that you can't photograph because they only appear in cutscenes, you can go to Lenzo and buy the photos for 50 rupees each.

To mourn the loss of photography in the digital age then is to miss new and strange emergences:

> were we able to see that in the process of individuation other things were produced beside the individual there would be no such attempt to hurry past the stage where individuation takes place in order to arrive at the ultimate reality that is the individual. Instead, we would try to grasp the entire unfolding of ontogenesis in all its variety, and *to understand the individual from the perspective of the process of individuation rather than the process of individuation by means of the individual.*
>
> *(Simondon 1992: 299–300)*

The capturing of images of and in a videogame world emerges not from 'photography' as a stable black box technocultural form, whether threatened by digital technology or not, but from a process of evolution or mutation, of multiple and incessant individuation within the chemicals, lens, sensors, wood, brass and lithographic stone, and in the practices and intentions of preserving instants, analyzing environments and presenting techniques.

Conclusion

Though light is extinguished, other facets of photography persist in videogame worlds. The virtual camera freezes a dynamic environment and its animated objects, capturing a moment in time. Moreover, it organizes the flux of digital data in space, with as fixed a viewpoint as that of the lens or pinhole. In this sense its images are indexical, they say that 'this did (sort of) happen'. Videogames and their worlds offer vivid, complicated and compelling experiences for players and playing communities. Images taken in them may not be written with light, but in their conventions, their uses, effects and affects, they function, and are understood as, photographs of the virtual.

In the digital milieu, both within the gameworld as microcosm and contemporary technoculture at large, new entities emerge. If many of these, like the virtual photograph, look or behave like earlier creatures, we should not assume either that they are merely remediations or returns or that they are the only ones. They should not distract us from the profoundly mutational and the very new. If we pay attention to what the residues of photography and photographic practices facilitate in the new milieu of the virtual gameworld and the digital network, we might see new quite different media technocultural individuals emerging. Not remediated, not rupture per se, but an evolution, a mutation – as it ever was.

Bibliography

Fox Talbot, William Henry (1844), *The Pencil of Nature*. Online at: www.thepencilofnature. com. Accessed 21 March 2013.
——(1845), *Sun Pictures of Scotland*. Online at: www.thepencilofnature.com. Accessed 21 March 2013.
Gunning, Tom (1990), 'The cinema of attraction: early film, its spectator and the avantgarde', in Thomas Elsaesser (ed.) *Early Cinema: Space Frame Narrative*, London: BFI, pp. 56–62.
Kittler, Friedrich and Rickels, Laurence (2009), 'A mathematics of finitude: on E.T.A. Hoffmann's "Jesuit Church in G"', *Discourse* 31(1&2), Winter and Spring, 9–27.
Lister, Martin; Dovey, Jon; Giddings, Seth; Grant, Iain and Kelly, Kieran (2009), *New Media: A Critical Introduction* (2nd ed.), London: Routledge.
Mactavish, Andrew (2006), 'Technological pleasure: the performance and narrative of pleasure in *Half-Life* and other high-tech games', in Geoff King and Tanya Krzywinska (eds) *ScreenPlay: Videogames/Cinema/Interfaces*, London: Wallflower, pp. 33–49.
Manovich, Lev (2001), *The Language of New Media*, Cambridge MA: MIT Press.
Mather, James (2004), 'The making of *Prey Alone*'. Online at: www.saintandmather.com/ the-making-of-prey-alone. Accessed 15 Jan 2013.
Poremba, Cindy (2007), 'Point and shoot: remediating photography in gamespace', *Games and Culture* 2 (1), 49–58.
Prince, Stephen (1996), 'True lies: perceptual realism, digital images and film theory' *Film Quarterly* 49 (3), 27–37.
Simondon, Gilbert (1992 [c.1958]), 'The genesis of the individual', in Jonathan Crary and Sandford Kwinter (eds) *Incorporations*, New York: Zone Books, pp. 297–319.
Strauven, Wanda (2006), *The Cinema of Attractions Reloaded*, Amsterdam: Amsterdam University Press.

Swalwell, Melanie (2008), 'Movement and kinaesthetic responsiveness: a neglected pleasure', in Melanie Swalwell and Jason Wilson (eds) *The Pleasures of Computer Gaming: Essays on Cultural History, Theory and Aesthetics*, Jefferson NC: McFarland, pp. 72–93.

Teffer, Nicola (2012), 'Touching images: photography, medical imaging and the incarnation of light', *Photographies* 5 (2), 121–33.

IGN Walkthrough and FAQ (n.d.) *Legend of Zelda: The Windwaker*. Online at: http://uk.ign.com/games/action-replay-ultimate-codes-legend-of-zelda-the-wind-waker/gcn-17012. Accessed 21 March 2013.

4

AMBIENT INTELLIGENT PHOTOGRAPHY

Sarah Kember

Introduction: The politics of life after photography

The start point of this chapter is a phenomenon only recently referred to as ubiquitous photography.[1] This phenomenon can be understood by means of two related but distinct contexts that we might summarize as follows: the networked *computer* and distributed, embedded, intelligent *computing*. The substitution of one context for another – of the computer as an object with computationally-enabled intelligent or smart environments – is the goal of the still futuristic, still evolving project of ubiquitous computing. While I have explored the relation between ubiquitous photography and ubiquitous computing elsewhere,[2] what I aim to do here is to track both the goal and the evolution of the ubiquitous computing project as it enrolls photography and strives to transfer – or, as Martin Hand suggests, 'morph' – it from a context in which it is *everywhere* to one in which it becomes, in Adam Greenfield's term, *'everyware'* (Greenfield 2006: 9; Hand 2012: 12). Greenfield's synonym for ubiquity, 'everyware' is 'ever more pervasive, ever harder to perceive' and evokes a scenario in which 'computing has leapt off the desktop and insinuated itself into everyday life' (9). The key question then is what is at stake as and when computing – and its morphological designs on photography – insinuates itself into something we too blithely refer to as everyday life? So far, I suggest, our answer to this question has been rather too parochial (concerned with the fate of photography as a medium), politically naïve (as if the manifestation of photography everywhere was itself democratic, or as if the everyday was a neutral, uncontested, or even inherently politicized realm) and constrained by disciplinary boundaries unable to address the life in everyday life (as being biologically as well as socially mediated) or to respond adequately to the technology industry's seemingly all-encompassing vision.

New media studies (including 'new' new media or social media), concerned with the relation between mass media and the networked computer (Lister *et al.*

2003), has addressed the proliferation, diversification and dispersal of photography in and across private and public, amateur and professional realms. In conjunction with related disciplines[3] it has contributed to a sense that photography is no longer a discrete medium, but rather one that has converged with, or become remediated by, the computer. Just as the identity of photography as a separate medium appears to be at an end, the endurance of photographic codes and conventions is conveyed through designations such as 'post-photography' (Batchen 2002) and 'after photography' (Ritchin 2008). In *After Photography*, Ritchin modifies his earlier, rather deterministic and apocalyptic prediction that digitization would mark the end of photography as we have known it. Instead, he writes that 'photography as we have known it is both ending and enlarging' (15). Reassuring in its guise as something quite familiar, digital photography spreads like a virus, invading, Ritchin suggests, all aspects of contemporary life so that everything (everywhere) from politics to particles becomes as easy to manipulate as a pixelated image. Everything, for Ritchin, includes us: 'we are also changed, turned into potential [manipulable] image' (21). Ritchin's physicalism – his concern with the material as well as metaphorical alignment of politics, particles, pixels and people – is underdeveloped but derives from a willingness to engage the fields of technoscience (cybernetics, artificial intelligence, particle physics, genetics and so on) that is still unusual in the context of debates on photography. As a consequence, he characterizes life after photography in terms that, in my view, deserve further consideration, not least because they exceed his own preoccupation with manipulation. These terms include automation, animation, augmentation and ambience.

Photography, Ritchin suggests, becomes automated when machines offer to do it for us, 'using face recognition to remind us with whom we are talking at a party, or recording what we missed when inebriated' (163). Photography is animated by means of the tropes of liveness conveyed in part through the remediation of photography with moving images and also by the current trend towards what Geert Lovink calls 'real-time' (think Skype, video streaming or live monitoring of the Olympics) (2011: 11). What is more, the once self-contained image, at most supplemented or anchored by textual information can now be overlaid or augmented with visual, textual or aural information individually tailored to the viewer's exact location and specification.[4] Finally, the digital camera itself 'will be further absorbed into other devices' apart from mobile phones. These devices may include 'refrigerators, walls, tables, jewelry, and ultimately our skin' (Ritchin 2008:143). At this point, photography is ambient, environmental and associated with a set of discourses, I would suggest, that lie outside those of digitization, new media or indeed social media. The proliferation and dispersal of photography after photography has of course raised questions about photography theory (Elkins 2007) and led to arguments, my own included, for a more expanded and expansive discipline (Kember 2008). Crucially, this expansion exceeds an account of photography as a new, new medium: social, networked, user-based, amateur, personal and vernacular (Batchen 2002; Rubenstein and Sluis 2008; Van House 2011). The start point of this chapter, as I indicated, is that ubiquitous photography is increasingly

incorporated within the claims and innovations associated with the wider discourse of ubiquitous computing. Here, media are realigned within the terms of the technoscience industries and their quest to generate ambient intelligence (smart environments), automated systems, animated artifacts and augmented realties. In terms of its relation with developments in ubiquitous computing, ubiquitous photography is not crossing always unstable boundaries between public and private, professional and amateur realms as much as it is becoming part of a re-ordering of life (biological and social) under the cover of practices of media and communication that are deemed ordinary, everyday, user-based, personal, private and vernacular. The everyday then is a highly contested realm – a realm of biopower. In order to analyze the biopolitics of life after photography, we need to move beyond new new media studies and its preoccupation with photography everywhere in order to take account of technoscience studies of ubiquitous computing as 'everyware'.

Photography as biotechnology

Such a move was perhaps already implicit in the concept of convergence and especially of convergence as another name for remediation (Bolter and Grusin 2000). My own interest in convergence lies not so much in the relative prevalence of technological, cultural or economic forms, but in a level or degree of convergence that is largely overlooked in media, communication and cultural studies, namely that between media and communication technologies, information technologies and *biotechnologies*. Put simply, computing has long been informed by attempts to model biological forms and processes, and media have long been informed by computing. It is Donna Haraway who insists on the hegemony of biology 'woven in and through information technologies and systems' (2000: 26) and governing multiple sectors of society including, for her, health, management, intellectual property and so on; for me, media. In as far as convergence is deployed in progressive, teleological accounts of media and technology,[5] it is better to speak of the remediation of media and biotechnology in an environment constituted of 'biological and technological things' (Lister *et al.* 2003), of technologies and users and of human and non-human agents. Haraway and other technoscience theorists such as Katherine Hayles and Karen Barad are interested in the entanglements or dynamic intra-actions that constitute posthuman agencies and contradict the autonomies, or what I call (after Bergson) 'false divisions', that characterize humanism and its manifestation in media studies, new and newer (Barad 2007; Hayles 1999). For Barad, 'existence is not an individual affair' and 'to be entangled is not simply to be intertwined with another, as in the joining of separate entities, but to lack an independent, self-contained existence' (2007: ix). Entities such as technologies and users do not therefore interact – as this presumes a prior separation – but rather, intra-act where intra-action 'signifies the mutual constitution of entangled agencies' (33).

The entanglement of technologies and users belies the false divisions that persist through new, social and what is sometimes referred to as cross media. If cross media designates a primarily technologically-driven phenomenon whereby content

is delivered across a range of different platforms,[6] social media, associated with Web 2.0, somewhat over-emphasizes the autonomy of media use and users. Lovink refers to social media as 'networks without a cause', or networking for the sake of networking, photo and file sharing for the sake of sharing (2011). He suggests that this purposeless proliferation of digital communication obscures not only continuities of predominantly commercial interest but, more specifically, an enhanced and renewed investment that is far from user-centric, participatory or bottom-up. 'We should judge Web 2.0 for what it is', he says: 'a renaissance in Silicon Valley which nearly vanished due to the 2000–2001 financial crisis, the political reorientation of G.W. Bush's election, the 9/11 attacks and successive US invasions in Afganistan and Iraq' (4). In order to gain a hold on the market, internet start-ups needed to change their approach from 'quick and greedy IPOs (flotation on the stock market)' to what Jenkins calls a 'participatory culture' in which 'users (also called prosumers), and not venture capitalists or bankers, had the final say' (4). The resultant freer and more open business models, Lovink suggests, repackaged or revised the attitudes of the past without any real change in the balance of power and profit. User-generated content 'aggregates profiles that can be sold to advertisers as direct marketing data' allowing companies to profit 'through the control of distribution channels' while users remain largely unaware of how 'their free labour and online socializing is being monetized by Apple, Amazon, eBay, and Google' (5). Currently, Lovink writes '*as the IT sector takes on the media industry*, the cult of free and open is nothing more than dubious revenge on the e-commerce madness that almost ruined the internet' (5) [my emphasis].

If, for Lovink, we remain lost (pointlessly) in MySpace, Twitter, Facebook and Flickr we cannot, in my view, find our way out through a critique or rejection of social media alone. The point *is* that the IT sector or technoscience industries are taking on the media industries, incorporating them in ways that are utterly asymmetric and exploiting our agential intra-actions, or dynamic relations with technology in order to derive value from them. Where Lovink is right to argue that the strategy of the technology industries is to revive and repackage e-commerce, the point he misses is that they do so by making direct claims on the everyday and on social environments constituted by users and intelligent artifacts alike. Such claims have come from research in ubiquitous computing and they materialize through new discourses and innovations that, by means of the media and technologies of (everyday) life, seek to change the very meaning of it. One such discourse is ambient intelligence, a hybrid of ubiquitous computing and artificial intelligence that is already evolving its own version, its own vision of media.

Ambient intelligent photography

Ambient intelligence (AmI) is, as Marc Böhlen points out, 'still a comparatively new field of research' (2009: 1). For Stefano Marzano it seeks to become a different kind of artificial intelligence or 'an AI that could soon form a natural part of our everyday lives' (2003: 8) and for Emile Aarts and co-authors, it remains continuous

with Mark Weiser's ubiquitous computing project of replacing computers with computing and placing the user centre-stage:

> After fifty years of technology development for designing computers that require users to adapt to them, we must now enter the era of designing equipment that adapts to users.
>
> (Aarts, Korst and Verhaegh 2004: 4)

User-centrism is about user-friendly computing that connects ordinary artifacts and things in familiar environments such as the home, city, transport, shop, airport and clothing (8). An environment that is ambient *intelligent* can recognize its inhabitants, adapt to them, 'learn from their behavior, and possibly show emotion' (6). Incorporating elements of research in affective or emotional computing and embodying the key features of embeddedness, context awareness, personalization, adaptation and anticipation, the overall vision of ambient intelligence is of a form of computing that is chastened, servile and very much about 'you' as an individual user. A prevalent metaphor of the ambient intelligent artifact has been that of the butler (Aarts *et al.* 2004; Suchman 2007). However, as this still-new field has continued to develop, the metaphor has shifted from the butler to the nurse. This has happened in conjunction with the development of research in ambient media, or rather with the expansion of ambient media from the context of advertising to that of assisted living and health-monitoring. As Bogdan Pogorelc *et al.* reveal, ambient media 'is the name given to a new breed of out-of-home products and services' (2012: 340). Research funded by the European Union aims to 'enhance the quality of life of the elderly, release the burden on the supporting population, and strengthen the industrial base in Europe' (340). Funding is motivated and justified by 'demographic changes, in particular the ageing of the European popu-lation, which implies not only challenges, but also opportunities for the citizens, the social and healthcare systems as well as industry and the European market' (340). Alongside social media and the wider field of ambient intelligence, ambient media articulate and disarticulate, avow and disavow the entanglement of life and capital. As new forms of profit accrue from our being, becoming and behaviour online and at home our environments are increasingly naturalized by means of invisible, embedded computing and intimate, agential, emotional technologies personified as butlers and nurses. 'On a larger scale,' Pogorelc *et al.* write, 'the field of ambient media defines the media environment and the communication of information in ubiquitous and pervasive environments' (340). Key to this communication is the 'interaction [sic] between people and machines' facilitated by more affordable (if not yet more efficient) sensors, actuators and processing units (340).

If there is a general level of awareness that 'cars now have dozens of sensor and actuator systems that make decisions on behalf of or to assist the driver' there is perhaps less awareness that 'public spaces have become increasingly occupied with tracking devices which enable a range of applications such as sensing shoplifted object [sic] and crowd behavior monitoring in a shopping mall'

(Nakashima *et al.* 2010: 4). Ambient intelligent environments are sensory environments and they attempt to become more user-centric by diverting attention away from themselves to the services they are able to provide. This goal has necessitated the development of something called middleware. Middleware is an operating system that connects sensors and actuators and enables seamless communication between devices and users:

> For context-aware computation, some of the context information such as location, time, temperature, etc. must be handed over to application software modules in some predefined format. To accomplish this, data conversion and even data fusion from many different devices must be handled by the middleware.
>
> *(Nakashima* et al. *2010: 10)*

Middleware mediates[7] between users of services and applications and sensory rich environments and constitutes a new computing infrastructure making it possible to 'hide the complexities in ambient intelligent environments' (11). Those same environments are also increasingly augmented or overlaid with information, and while this overlayering might seem contrary to the creation of naturalistic, invisible and embedded computing, it is actually quite consistent with it. The idea is that mobile augmented reality (AR) browsers should be able to provide 'convenient real-time processing of web-based information that the user perceives *through* the phone, rather than *on* it' (Jackson *et al.* 2011: 410). The effect, as Jackson *et al.* see it, is to effectively be able to walk through information and engage with it more intuitively (410). This vision, based on directing camera-equipped devices at cinemas, road intersections, guidebooks and so on and being able to engage as it were directly with show times and film synopses, live traffic information and animated photographs of tourist spots, finds its apogee in MIT's project to develop sixth-sense technology. If AR, facilitated by camera-equipped mobile phones, head-mounted display units or Google's goggles refuses to be limited to the sense of sight and 'can potentially apply to all senses, augmenting smell, touch and hearing as well' (Carmigniani and Furht 2011: 3) then sixth-sense technology attempts to access something like intuition itself[8] understood as the totality of data, information and knowledge that has been collectively accumulated online. The means for doing so, while actually comprised of a specific set of miniaturized off-the-shelf technologies – a webcam, mirrors, a smartphone and a micro-projector hung from a lanyard worn around the user's neck – appears to be the user's body itself. The sixth-sense device 'recognizes the movements of the user's hands via the webcam (and colour-coded finger-gloves worn on index finger and thumb) enabling gesture-commands like the classic "frame" gesture which makes the device snap a photo'.[9] Although it is the device that takes the photo, it seems like it is the photographer's fingers and in this sense, sixth-sense technology strives to fulfill what for Bolter and Grusin is the (apparently universal) desire for immediacy (2000), and for me is a more top-down quest to make media and technological

objects disappear into ambient and augmented environments that are increasingly constituted as smart – or that reconstitute smart as something that is user-friendly, serves us rather than supersedes us and is ultimately ordinary.

From AI to AmI: contesting the quotidian

In earlier forms of technoscience, notably artificial intelligence (AI) and artificial life (ALife), smart was constituted as something extraordinary, likely to generate successor forms of intelligence and life that, at least in the popular imagination, turned out to be markedly unfriendly. AI, the attempt to programme intelligence into machines as it were from the top-down, focuses on expert systems and, historically, framed intelligence in terms of the ability to speak. A short film on Youtube entitled 'AI vs AI' is testament to sentiments such as those of Hubert Dreyfus that the ability to speak does not necessarily imply that the speaker has anything particularly interesting – or intelligent – to say (1999). Lucy Suchman similarly examines her dialogue with Stelarc's head – an AI simulation – and finds it engaging only to the extent that it is largely nonsensical (2007). The icon of AI in popular culture is Hal 9000 in *2001: A Space Odyssey*. This spacecraft-flying, chess-playing, softly-spoken companionate computer turns notoriously nasty, turning off life-support systems, jetisoning Frank into deep space and refusing to open the door and let Dave, who has retrieved Frank's body, back inside the craft. The story of Hal, his actions and their consequences, and particularly the calculated and treacherous 'I'm sorry Dave, I'm afraid I can't do that' struck fear into a generation of computer scientists and was instrumental in signaling the failure of AI and the subsequent emergence of ALife (Kember 2003; Stork 1996). For ALife engineer Steve Grand, Hal's expertise proved to be not inadequate but irrelevant as the complex demands of the mission demonstrated his lack of flexibility as well as friendliness. As he put it, a computer may be able to beat a mouse at chess, but try throwing them both in the water and see how they get on (in Kember 2003). ALife proposes that flexibility might be acquired by embodying and situating intelligence and by allowing it to grow or evolve from the bottom-up rather than trying to programme it – when we don't even really know what 'it' is. I have argued that ALife is a revisionist form of AI rather than a replacement for it. If its methods are different, its goals are fundamentally similar and, significantly, it seeks to achieve them by adapting to critiques of AI that came from both inside and outside the field. Where AI is top-down, ALife is bottom-up; where AI is based on command and control principles, ALife, in contrast, is based on the principles of 'nudge and cajole' (Grand in Kember 2003). If AI is masculinist and disembodied, ALife can be positioned as feminized and re-embodied, thereby addressing an epistemological and political intervention similar to that faced by the field of sociobiology. Such revisionism or adaptability raises questions about modes and methods of critique, which I will address later on and that include genealogy as a way of tracing not only the nonlinear story of the technosciences but what might be at stake in its telling.

The icon of ALife in popular culture is the unspeakably saccharine David in *AI*. David is a robot who loves and who honestly believes he is a real boy. Suchman examines the tendency towards mimicry and anthropomorphism in human–computer interaction (HCI) and highlights the paranoid master/slave narrative that traps our relationship to machines in an endless cycle of love and hatred, friendliness and enmity. I have argued that this potential for paranoia is heightened not reduced by the apparent shift or downsizing in the technosciences from claims to artifice to those of ambience and augmentation.

If AI fails in part because we don't know what intelligence is (thus making it difficult to programme in to hardware or software) then ALife fails in part because there isn't, and arguably never will be, any agreement as to what exactly life is. Attempts to generate humanoid artificial life never actually managed to scale up even as far as ant-like artificial life. In this context, Grand's achievement in getting his robot baby orangutan to distinguish between an apple and a banana is not to be underestimated (Kember 2003). The technosciences of artifice were and remain highly hubristic and what is interesting in the story of a shift from artifice to ambience is the apparent, but not actual, relinquishment of hubris and/or its all too apparent consequences. As the lofty, even metaphysical goals of AI and ALife – to grapple with the meaning of intelligent life and ultimately reproduce it – fall flat, we witness a recourse to the quotidian courtesy of the developing discourse of ubiquitous computing and specifically its manifestation as AmI. AmI continues to employ the psychological principles of AI and the biological principles of ALife. Specifically, it continues to mobilize a notion of intelligence, albeit one transferred from a single machine entity to a machinic environment populated by animated and emergent (learning, adapting, evolving) artifacts whose status as artificial life forms is rendered secondary to their desire to serve us and to reassure us of our sovereign ontology and individual identity. If AmI's servility is rendered through embodied and conversational agents that may take the form of a software butler[10] or a robot nurse, its ability to reassure us comes courtesy of what Cass *et al.* call 'intimate media' (2003).

The photographic lies at the heart of intimate media

In 'Intimate Media: emotional needs and ambient intelligence' John Cass, Lorna Goulden and Slava Kozlov enrol digital photographic practices into ambient intelligent environments that enable – and oblige – us to self-build. Factors contributing to the process of self-building include memory, evoked through 'collections of objects', storytelling and the nurturing of relations within a network (2003: 219). Evoking Maslow's hierarchy of human needs,[11] the authors suggest that objects such as networked photographic images address the (again, presumably universal) need 'to represent roots and heritage, to create a sense of belonging and connectedness and to demonstrate personal identity and achievement' (218). In conjunction with other objects and artefacts of ambient intelligence, the networked image constitutes an 'extended self' and a 'cycle of self-reinforcement' that

crisscrosses online and offline space and helps to ensure a feeling of being 'at home in the world' (220). From a more critical perspective, Suchman also points out that 'smart' devices are the current expression of a long-standing dream of artifacts that know us, accompany us and ensure that we are always 'at home' (2007: 206). Intimate media that 'can also be animated, or given behaviour' – such as avatars, or embodied conversational agents – offer to serve, comfort and protect us from a hostile world (2003: 222 and Suchman 2007: 213). While enabling and/or obliging us 'to maintain an almost constant low level of communication', the apparently humanistic cycle of self-reinforcement has the capacity for autonomy or the sort of machine-machine relationality that transforms and re-orders individual subjects as data objects within what David Lyon refers to as integrated systems of surveillance and marketing (Cass *et al.* 2003; Lyon 2008). Within systems of intimacy and also geolocality, it is not just a question of linking information to individual users but rather of individual users becoming information within a self-regulated economy of information exchange. In its simultaneous making over and metamorphosis of the individual, AmI's hubris may even be of a different order to that of its predecessors.

The photographic lies at the heart of intimate media and also what Francesco Lapenta calls geomedia:

> Geomedia are not new media per se, but platforms that merge existing electric media + the Internet + location-based technologies (or locative media) + AR (Augmented Reality) technologies in a new mode of digital composite imaging, data association and socially maintained data exchange and communication.
>
> *(2011: 14)*

Referring for example to Google Earth, Google Maps, Layar and Photosynth,[12] he posits the emergence of a new genre of photographic mapping that exchanges the principle of indexicality, based on the single image 'taken at a specific time, in a specific place', for one of geolocality derived from a composite, synthesized image 'that merges different times and connects contiguous spaces' (17). Virtual maps, Lapenta suggests, at once underline the realist claim of photography and challenge it, by 'transforming a physical relation, that between the image and the object of its representation, into a cognitive relation' in which the real-world object – a street, a square, a town, a building – is always already presented as an image on the map (18). Significantly, for Lapenta, the virtual photographic map answers to the dilemma of what Frederick Jameson refers to as 'cognitive mapping', or the attempt by subjects to create meaningful representations out of an unrepresentable totality of events and experiences (1991). If Lapenta recognizes this 'projection' or 'realisation' of the cognitive mapping dilemma as being rather utopian, I would seek to characterize it as defensive and compensatory because its guiding principle is one of the impossibility of representation. Virtual photographic mapping is therefore an expression of an ongoing quest – associated with both photography and cartography – to represent the unrepresentable and map the unmappable. As

an expression of what Borges refers to as 'exactitude in science', it is an absurdity that is arguably more productive than it is nihilistic, generating rather than absorbing terrain[13] that is increasingly ordinary, and helping to constitute the everyday lives of 'the new generation of cartographers' and photographers (18). Geomedia enable individual users to 'navigate their social worlds', manage complexity and create reassurance out of anxiety. In other words, they function as forms of self-regulation:

> Along with traditional search engines (the regulatory systems of WEB 1.0) and social networking sites (the social organizational tools of WEB 2.0), geomedia provide one more tool to link and navigate the geosphere and the infosphere for data relevant to the subject and his or her relevant others in a live and continuous exchange of information.
>
> *(2011: 21)*

This live and continuous exchange of information literally incorporates the 'physical reality' and 'digital identity' of the individual and ensures that we suture ourselves in to the environment of real-time media we otherwise prosume.

If intimate media and geomedia constitute the parameters of ambient intelligence as 'everyware' (ever more pervasive and ever harder to perceive) then Greenfield urges us to be aware of limitations that may be severe enough for us to assert that everyware is currently nowhere in particular (Kember and Zylinska 2012). Notwithstanding the existence of portable devices with wireless internet access, cars and phones with GPS technology, Radio Frequency Identification Devices (RFIDs are forms of tagging products and potentially people), a host of online monitoring and tracking devices, biometrics such as iris and face recognition plus of course an increasingly available range of sensors, we still, Greenfield pointed out in 2006, have a problem in the form of a lack of public awareness and demand. How interesting then, that more recent developments, including in the direction of ambient media, have taken this problem to heart. Pogorelc *et al.* associate demand for everyware technologies with the requirement to manage an ageing population:

> Because of increasing numbers of elderly people and not enough younger people to take care of the elderly, AAL [ambient assisted living] systems to support the independent living of the elderly ... are not only acceptable, but necessary.
>
> *(Pogorelc et al. 2012: 342)*

The individualization of responsibility in a number of contexts, including health care, is of course consistent with neoliberal rationality and is manifest in policies of decentralization and privatization. Juan Carlos Augusto describes how governments are moving away from 'hospital-centric health care' towards care in the community and at home. The smart home is an example 'of a technological development which facilitates this trend of bringing the health and social care system to the

patient as opposed to bringing the patient into the health system' (2010: 2). Similar demands are expected in the context of public transport and the use of, for example, GPS and vehicle identification technologies to regulate traffic flow; education – 'education-related institutions may use technology to create smart classrooms where the modes of learning are enhanced'; and emergency services and manufacturing. In addition to using RFID tags to track products and their uses, companies are showing interest in smart offices geared to enhanced efficiency (9). This might be enforced courtesy of webcams and other technologies of surveillance but also, as the *New Scientist* has recently discussed, through the doubling or duplication of the employee-as-avatar:

> In the past year or two, Apple has filed a series of patents related to using animated avatars in social networking and video conferencing. Microsoft, too, is interested. It has been exploring how its Kinect motion-tracking device could map a user's face so it can be reproduced and animated digitally. The firm also plans to extend the avatars that millions of people use in its Xbox gaming system into Windows and the work environment.
>
> *(Adee 2012: 40)*

Animated, and indeed automated avatars need not be bona fide AIs let alone ALifes provided they can fulfill specific low-level tasks. Future, or what Böhlen calls second order AmI combines and reformulates the goals of earlier technosciences, revealing more of the market values that always already underlined those of metaphysics. Significantly, the market is seen to be threatened by increasing public awareness of privacy infringements and the ongoing internal revision and reform of technoscience is now focused on this:

> Sensitive private data about our habits and illnesses can be accessible to groups of people who are eager to take profit of that knowledge. Users will become more and more aware of this and extra measures have to be provided to bring peace of mind to the market. If the market is label [sic] as unsafe by the users then all those involved will lose a fantastic opportunity …
>
> *(Augusto 2010: 10)*

The technosciences of ambience and augmentation regenerate hubris in their attempts to denounce it, going beyond the technological embodiment of intelligence and life to the animation and automation of sense (including sixth sense), self and the social environment. The characterization of identities and environments as quotidian, ordinary and everyday is an attempt (at times thinly veiled) to depoliticize the interventions and transformations made by an increasingly marketized, residually metaphysical set of discourses and practices. The following section will look more closely at how contemporary technoscience enrolls photography after photography, re-cognizing and reconstituting it within animated and automated systems made vulnerable by virtue of their own (hidden) hubris.

Re-cognizing photography

Face recognition technology is fundamentally photographic

Face recognition technology (FRT) can be understood with reference to both intimate and geomedia, AmI and AR and is, moreover, fundamentally photographic. As such, it provides a case study into how to think of ubiquitous photography as more than everywhere and to re-cognize or rethink it in relation to the claims of 'everyware'. The question we can address here pertains to what photography after photography is becoming within – as part of – an integrated system of marketing and/as surveillance. The first thing to note is that this system implements photographic codes and conventions that were established in the nineteenth century and associated with disciplinary institutions such as prisons, schools, hospitals and asylums. There is a marked continuity between nineteenth, twentieth and twenty-first century photographic mechanisms of surveillance and control – mechanisms within which photography itself becomes consolidated as a targeted yet ultimately elusive (id)entity superseded by systems deemed to be intelligent.

FRT, along with other biometric technologies such as iris scanning or finger-printing, stakes a claim to indexicality: the symbolic presence of an object (eye, finger, face) in an image. In the case of FRT, the image is twice removed from the object. It is a photograph of a photograph – a digitized digital image of a face. The aim of FRT is to identify or recognize someone from either a still or video image. This image is referred to as a probe image. Once it has been acquired, the system seeks to detect the face by distinguishing it from its surroundings. This is more difficult than it sounds since a computer has no inherent knowledge of what a face actually is. Consequently the system targets the components of a face; features such as the nose, eyes and mouth. The particular cartography of these features is then compared with those available within a database. Alternatively the system generates standard feature templates composed of averages or types. Once detected, the face, or rather probe image, is normalized in terms of lighting, format, expression and pose. Since the normalization algorithm can only compensate for slight variations, for example in expression, the probe image has to be 'as close as possible to a standardized face.'[14] This already standardized image of a face is subsequently translated and transformed into something called a biometric template, which should have enough information to facilitate face recognition, understood as the ability to distinguish one template from another without creating the sort of 'biometric doubles' that produce false positive identifications. Within FRT at least, one digital doppelganger is considered quite enough and two is a signal of system failure.

FRT is consistent with the earliest criminal identification system devised by Alphonse Bertillon. This, as Allan Sekula points out, employed statistics (along with a discriminatory social law of norms and deviants) as a means of supplementing and organizing a growing archive of photographic images. Photography then, as now, could not secure the identities of criminals, requiring additional verbal,

anthropometric and statistical information. For Sekula, the authority of Bertillon's system rested not on the camera but on a 'bureaucratic-clerical-statistical system of "intelligence"' (1986: 16). This system has been updated ever since and notably via the first computerized identification systems used towards the end of the twentieth century. Designed to assist eyewitnesses, these were based on two forms of coding. Geometric coding was a technique based on measuring features from images and is still very much the basis of FRT. Syntactic coding was based on descriptions rather than measurements of faces and attempted to systematize witness observations about the size, colour and shape of features. This proved difficult and arduous for the witness, as an image was built up feature by feature. The outcome was often witness fatigue followed by a failure of identification. Significantly, the effectiveness of these systems was questioned at the time but did little to interrupt production motivated predominantly by market forces (Kember 1998). Twenty-first century systems carry this legacy of technologically limited (and politically problematic) ways of seeing. Demand for them has, if anything, increased, due in no small part to the events of 9/11 and a desire to rationalize them through targeting, tracking and location systems such as FRT. The problem of witness fatigue and failure that had marred earlier systems was exemplified in the narrative of 9/11 (Lyon 2008) and since then, the role of the eyewitness has been slowly eliminated from systems that are increasingly automated.

Even though it was based on anthropometric measurements of the individual, Bertillon's system related the individual to the group by establishing statistical/social norms and deviants. FRT functions in a similar way, whether the context is institutional or commercial, classifying and segregating individuals into groups and types depending on their appearance as an indicator of behaviour, and evincing a form of biopolitics[15] that is no less effective for being more at a distance, more user-friendly or ever harder to perceive. FRT as a system of what Kelly Gates refers to as 'mass individuation' (2011) is still essentially Bertillon's, but in addition, an algorithm used in FRT produces images that are strangely familiar from Francis Galton's eugenicist composites of the nineteenth century. It does so by removing extraneous information and decomposing faces into standardized types called eigenfaces[16] (Figure 4.1).

Another algorithm generates classes of faces, rather as Havelock Ellis did in his physiognomy of criminals (Figure 4.2) (1901). Outmoded beliefs and prejudices[17] are sustained by the persistence of ways of seeing that surface in times of crisis – producing for example the racialized 'face of terror' – and then submerge into the seemingly innocuous, depoliticized sphere of everyday life where faces are in fact big business and subjects re-order themselves as they are re-ordered as data objects for markets.

The technological limitations of FRT as a total machine (Tagg 1989) offer one opportunity for critical intervention. The limitations range from failure due to poor lighting, non-standard viewing angles (frontal and profile remain the only viable ones), obstacles such as facial hair and glasses, low image resolution and expressions in excess of the average mug shot. Nevertheless, the system as a whole – comprised as it is of technologies and users, images, infrastructure, investments, expectation

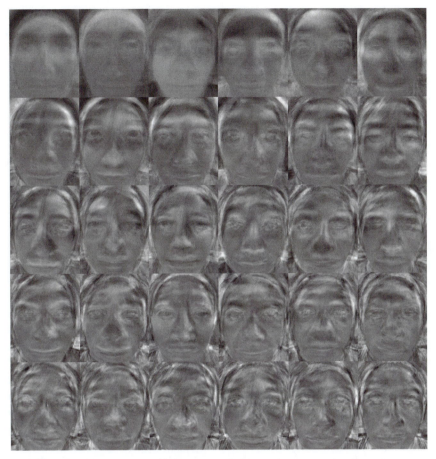

FIGURE 4.1 Eigenfaces. Image copyright FaceAccess at Cornell University.

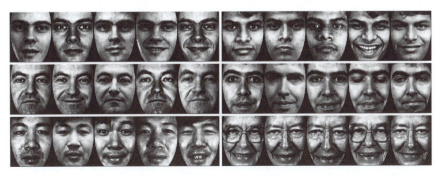

FIGURE 4.2 Linear Discriminant Analysis from 'Boosting Linear Discriminant Analysis for Face Recognition' by Juwei Lu, K.N. Plataniotis and A.N. Venetsanopoulos. © IEEE 2003.

and belief – remains highly productive. What does it produce? FRT produces faces as quasi-objects, at once detached from, and conflated with, bodies that are, in turn, detached from and conflated with identities. These faces are literally recoded as static photographic images, fixed in the nineteenth century and wrongly divided by Sekula into categories of honorific and repressive. Now, as ever, those categories dissolve into each other, making mug shots of us all. FRT also produces the ongoing history of photography as an imaging technology entangled with others and now enrolled into ambient 'intelligent' systems. These systems in turn re-cognize, rethink what photography is, specifically by distancing, digitizing and hybridizing it, and turning it, finally, into the kind of elusive identity (like that of the criminal and consumer) it still strives to represent.

Conclusion: After photography theory

How do we approach photography after photography without recourse to parochialism and pathos (wither photography?) or indeed a sort of perverse pro-gressivism whereby we reluctantly accept the determinists' celebratory rhetoric of substitution: the substitution of the camera by computing or of the image by the algorithm. I do not propose to swap or substitute photography theory for technoscience studies even though the latter is now, I hope to have established, indispensible to understanding the current ubiquity of a medium that is no more, or rather that is more dynamic, more engaged in boundary work than ever before.

It is this question of dynamics, of entanglements that are never quite complete and that produce entities – including cultural forms – that are contingent and never discrete that leads me to wonder whether 'theory' is simply too sluggish to account for modes and methods of critique that might be considered fit for purpose. This kind of quandary is of course not new. It is integral to all areas of theory, not least photography theory, as it searches within and at times even outside of itself for a solution (Elkins 2007). Debates on new and social media have at times fallen into the substitution trap, for example, of media studies by software studies (Manovich 2001; Lovink 2011) where philosophy – though by no means a destination in itself – is more deft at handling the quandaries of knowledge per se, but also knowledge as it relates to what we call, in this context, everyday life. Bergson, for example, argues that intuition, or more specifically, an intuitive method, might enable us to reconnect knowledge with what it is trying to know because not only does it enable us to ask better questions (and think more clearly about how things are really distinguished from other things) *it is also more dynamic,* more attentive to time understood, by him, as creative evolution (Bergson 1998; Deleuze 2002). Not only does intuition enable us to get dynamics in a way that our Cartesian, intel-lectual habits of mind do not,[18] for Bergson it requires modes of communication that are in themselves more dynamic, more rooted in images rather than just ideas, in stories as much as science. This kind of philosophy finds its way through con-temporary feminism where, for example, Rosi Braidotti asks us to consider a mode of communication that is less reliant on rigid off the peg categories and concepts of

thought (humans and machines, technologies and users) and therefore more attuned to the complex entanglements around us and of which we are a part (2002). This seems to me to be more important than ever as the media environments that we co-constitute are being named and claimed by the technoscience industries.

Rather than worrying about the efficacy of theory, perhaps we should start (as Bergson suggests) by asking ourselves what we think the problem is. For Bergson there are true and false problems, and even lacking his epistemological and ontological certainties, I wonder whether the fate of photography as a medium isn't something of a false problem masking the 'true' or truer, or better problem of the role of photography and the photographic within systems of ambient intelligence that might be construed as dynamic in various ways. FRT, for example, contributes to the constitution of faces as photographs. Characteristic of this and other biotechnological systems is a tendency to adapt and evolve in such a way as to contain threats to the system itself. Such a tendency is not natural but rather naturalized. Think about face distortion software, which codes for what the system seeks to eliminate or, through automated expression analysis, reduce to more standardized templates. Then think about Apple's Photo Booth that encourages you to select your distorted face from a safe set menu that includes – literally in the center of the screen – the 'normal' face. So you can have a distorted face as long as it conforms to certain effects (stretched, twisted, squeezed, etc.) that have already been prescribed. The market is the means and the motivation for containing face distortion or, if you like, for delimiting the possibilities of what faces can be. Faces stand for identities in FRT, and specifically for the axis of criminal and consumer. The containment of identity within biotechnological systems that open out the possibilities of identity illustrates what I've called the central paradox of the biotechnologies, which is, increasingly, the new (meaning additional) paradox of photography. While it continues to appear to be a message without a code, photography plays its part in coding everyday life and everyday lives as we know them rather than everyday life and lives as they could be. The re-orderings of subjects as data that remain very much at stake here are, as I've suggested, hidden acts of hubris that speak to the *potential of capital alone*. That is to say, that the potential of capital is realized by harnessing life in a double and paradoxical way that embraces change in the form of continuity.

How do we (out) face photographic configurations of capital, technology and life that are generative but not progressive, evolving but not becoming?[19] What modes and methods of critique might be considered fit for purpose? Without turning from photography to technoscience theory (and this chapter has used elements of both), how do we get close enough to the dynamics of ambient intelligent photography to understand and intervene? This last question is a loaded one, always already informed by feminist methods and modes of critique across disciplines. Feminist philosophy and science and technology studies, in particular, have given us the concept of figuration; the use of an image-idea such as the cyborg or nomadic subject as a means of both critiquing and re-imagining a

specific field such as cybernetics and the worlds it threatens or promises to make. Haraway's project of re-worlding through figurations is ongoing and underpinned not only by the use of the specific image-idea but more broadly by her sense of the alignment of technoscience and storytelling (in Gane 2006).

If ambient intelligent photography is an instance of technoscientific storytelling, then to what extent can that story be retold? It helps to recognize that any possible retelling (meaning different telling) might be aided and abetted by the inherent un-telling of the story within technoscience itself. Derrida gives us the concept of dissention that describes the internal revolutions, the contradictions, 'the gaps and fissures' that, in the context of ambient intelligence, Crang and Graham rightly identify as a point of intervention (Derrida 1978; Crang and Graham 2007). How might we characterize these dissentions? I've already indicated some characteristics, but broadly, they might include: the non-homogeneity of the field; principle technological limitations; hubris and hubristic absurdity plus an all-too evident inability and, at times, unwillingness to disentangle fact from fiction. In the lead article for the new *Journal of Ambient Intelligence and Smart Environments*, Marc Böhlen effectively demonstrates all of these attributes. He starts with an anecdote:

> I recently visited a smart house that has wall to wall voice control to activate curtains and open windows. Speech recognition is notorious for its unreliability in noisy environments and unconstrained vocabularies. The proud home inhabitant, hired by a company to demonstratively live in this smart house, used a microphone headset in an attempt to keep the signal to noise ratio between his voice and the inevitable background noise at a level the voice recognition system could cope with. The system designers were well aware of the potential of miscommunication between speakers and voice activated control systems, and added an additional level of robustness in the usage scenario. Each voice command was preceded by a signature prompt that cued the listening system to the incoming command. The signature prompt was cast into a form of addressing people are fAmIliar with: a name.
>
> (Böhlen 2009: 1)

The presenter, Böhlen goes on, had to repeat various commands during his demonstration. Each command 'was preceded by the house name as if he were calling a disobedient dog'. Moreover, audience participation, and perhaps some rather unhelpful comments just made the situation worse. 'The window shades opened and closed out of sync not unlike the gadgets in the Villa Arpel of Jacques Tati's *Mon Oncle*' (1). Non-celebratory science-fiction also has its role here (think of Douglas Adams' obsequious lift or, better, Phillip K. Dick's libelous door that demands cash for opening and threatens to sue you if you can't or won't pay),[20] helping to ensure the non-inevitability of the field with which it is inextricably bound. What's more, AmI researchers, with their absurd designs on 'fAmIly' life, are themselves writing science-fiction and not even always by another name. Having acknowledged that there are critiques of AmI, not least 'vis-à-vis ubiquitous surveillance technologies',

Böhlen offers us a discussion geared toward overcoming them. He does so in the form of a 'short story on the future of ambient intelligence' (2). This highlights better sensors, better algorithms and fewer false positives of the sort that plague FRT systems. Future photographic 'facial emotion recognition systems will be able to distinguish between subtle expressions' and 'the clownesque facial distortions of anger, fear and pleasure that machine vision can detect today will be material for comedy shows tomorrow' (2). Böhlen seeks to circumvent both hubristic absurdities and failures, returning what he calls second-order AmI to AI and to ALife with its inherent interest in other species. Where ALife researchers longed to study alien life forms but settled for generating their own in software, better sensors 'that can see beyond our limited visual spectrum and listen in on audio signals far beyond our own limits' should 'allow us to watch out for alien life forms in remote places' and also 'watch and listen to life forms in our own AmI backyard' (4).

Böhlen's contribution to the future of AmI reminds us of the importance of genealogical methods that for me are always feminist genealogies, alert to the particular gender ironies of AmI's – as of ALife's – designs on emotional and social intelligence. Just as ALife failed to scale up from insect to humanoid intelligence, AmI struggles to scale up from one to many smart home users: 'Funny examples are known where systems were not prepared for the complexity of a user having a pet wandering around the house triggering sensors here and there' (Augusto 2010: 11). This helps to put plans for ambient assisted living into perspective, and as for fAmIlies:

> consider for example a family living under the same roof and a system that tries to provide services for all them [sic]. Choosing a T.V. program may be a situation of conflict, should the system stay away from such domestic rows or should it have a duty to advise and mediate? How the system should react when there are irreconcilable positions?
>
> *(Augusto 2010: 11)*

How indeed.

Notes

1 See Hand (2012) and Kember (forthcoming).
2 Kember (forthcoming).
3 Such as visual cultures and photography theory.
4 See the Layar app for example.
5 Such progressive accounts are evident in government white papers, but also in technologically deterministic academic texts such as, for example, Manovich (2001).
6 See http://en.wikipedia.org/wiki/Crossmedia#Further_reading. This is a designation that belongs primarily to industry while academic research is more focused on notions such as x reality, referring to media that cross online and offline realities (see Coleman 2011).
7 Here I use the term mediation in the conventional sense, i.e. in which media and technology function as a third party or mediator. However, all such functioning is

non-innocent and non-transparent, meaning that the process of mediation is agential and co-constitutive of the entities or events that are mediated (Kember and Zylinska 2012).

8 Although note that for Bergson intuition is not a sense but an atrophied form of non-intellectual knowledge (Deleuze 2002).

9 Kit Eaton 'MIT's 6th Sense Technology Makes Reality Better', *Fast Company*, May 2, 2009 www.fastcompany.com/blog/kit-eaton/technomix/mits-sixth-sense-machine-makes-reality-better

10 Suchman discusses (www.) Ask Jeeves.

11 Maslow (1987).

12 Layar is an augmented reality app and Photosynth synthesizes images from different sources in order to supply a virtual map of an object or area.

13 Baudrillard relates his nihilistic view of the absorption of events by media to a one-paragraph short story by Borges in which the cartographer's map exactly covers terrain it is mapping (Baudrillard 1983; Borges 1999).

14 Lucas D. Introna and Helen Nissenbaum, *Facial Recognition Technology. A Survey of Policy and Implementation Issues*, New York University, the Centre for Catastrophe Preparedness and Response, www.nyu.edu/projects/nissenbaum/papers/facialrecognitionreport.pdf, p. 16.

15 See Foucault (2008). Biopolitics describes the operation of power at corporeal levels including those of the individual and social body. For Haraway, Foucault's sense of the biopolitics of populations 'has not gone away, but it has been reworked, mutated, trans-ed, technologized and instrumentalized differently' so that we need to think more of something she calls 'technobiocapital' (Haraway in Gane 2006: 148).

16 National Science and Technology Council (Committee on Technology, Committee on Homeland and National Security, Subcommittee on Biometrics), *Face Recognition*, www.biometrics.gov.

17 Based on the quasi-sciences of physiognomy and phrenology.

18 See both Barad (2007) and Bergson (1998) for a critique.

19 In *Creative Evolution* Bergson aligns becoming with his concept of creative evolution (non-mechanistic, open-ended, with no apparent purpose or utility). But he counterposes this notion of creative evolution with something more conservative; a form of evolutionism that I'm alluding to here as a strategy of what Haraway would call 'technobiocapital' (see note 16).

20 Adams (1981), Dick (2004).

Bibliography

Aarts, E., Korst, J. and Verhaegh, W.F.J. (2004) 'Algorithms in Ambient Intelligence' in W.F.J. Verhaegh, E. Aarts and J. Korst (eds) *Algorithms in Ambient Intelligence*, Boston, Dordrecht, London: Kluwer Academic Publishers.

Adams, D. (1981) *The Hitch-Hiker's Guide to the Galaxy*, London: Pan Books Ltd.

Adee, S. (2012) 'Me, Myself, I', *New Scientist*, 11 August 2012, pp. 39–41.

Augusto, J.C. (2010) 'Past, Present and Future of Ambient Intelligence and Smart Environments', *Agents and Artificial Intelligence*, 67, pp. 3–15.

Barad, K. (2007) *Meeting the Universe Halfway*, Durham, NC: Duke University Press.

Batchen, J. (2002) *Each Wild Idea. Writing, Photography, History*, Cambridge, MA and London, England: The MIT Press.

Baudrillard, J. (1983) *Simulations*, trans. Paul Foss, Paul Patton and Philip Beitchman, Los Angeles: Semiotext(e).

Bergson, H. (1998) *Creative Evolution*, New York: Dover Publications.

Böhlen, M. (2009) 'Second Order Ambient Intelligence', *Journal of Ambient Intelligence and Smart Environments,* 1, pp. 1–5.

Bolter, J.D. and Grusin, R. (2000) *Remediation: Understanding New Media*, Cambridge, MA: The MIT Press.

Borges, J.L. (1999) 'On Exactitude in Science', in *Collected Fictions*, London: Penguin Books.

Braidotti, R. (2002) *Metamorphoses*, Cambridge: Polity.

Carmigniani, J. and Furht, B. (2011) 'Augmented Reality: An Overview', in B. Furht (ed.) (2011) *Handbook of Augmented Reality*, New York, London: Springer.

Cass, J., Goulden, L. and Koslov, S. (2003) 'Intimate Media. Emotional Needs and Ambient Intelligence', in S. Marzano and E. Aarts (eds) *The New Everyday: Views on Ambient Intelligence*, Rotterdam: 010 Publishers.

Coleman, B. (2011) *Hello Avatar. Rise of the Networked Generation*, Cambridge, MA and London, England: The MIT Press.

Crang, M. and Graham, S. (2007) 'Sentient Cities. Ambient intelligence and the Politics of Urban Space', *Information, Communication & Society*, 10(6), pp. 789–817.

Deleuze, G. (2002) *Bergsonism*, trans. H. Tomlinson and B. Habberjam, New York: Zone Books

Derrida, J. (1978) *Writing and Difference*, London: Routledge and Kegan Paul Ltd.

Dick, P.K. (2004) *UBIK*, London: Orion.

Dreyfus, H.L. (1999) *What Computers Still Can't Do. A Critique of Artificial Reason*, Cambridge, MA and London: The MIT Press.

Elkins, J. (2007) *Photography Theory*, New York and London: Routledge.

Ellis, H. (1901) *The Criminal*, London: Walter Scott.

Foucault, M. (2008) *The Birth of Biopolitics: Lectures at the College de France, 1978–79*, trans. G. Burchell, London: Palgrave Macmillan.

Furht, B. (ed.) (2011) *Handbook of Augmented Reality*, New York, London: Springer.

Gane, N. (2006) 'When We Have Never Been Human, What Is To Be Done? Interview with Donna Haraway', *Theory, Culture and Society*, 23, (7–8), pp. 135–58.

Gates, K. (2011) *Our Biometric Future: Facial Recognition Technology and the Culture of Surveillance*, New York: New York University Press.

Greenfield, A. (2006) *Everyware: The Dawning Age of Ubiquitous Computing*, Berkeley, CA: New Riders Publishing.

Hand, M. (2012) *Ubiquitous Photography*, Cambridge: Polity Press

Haraway, D.J. (2000) *How Like a Leaf*, an interview with Thyrza Nichols Goodeve, New York and London: Routledge.

Hayles, N.K. (1999) *How We Became Posthuman: Virtual Bodies in Cybernetics, Literature and Informatics*, Chicago and London: University of Chicago Press.

Introna, L.D. and Nissenbaum, H. (n.d.) *Facial Recognition Technology. A Survey of Policy and Implementation Issues*, New York University, the Centre for Catastrophe Preparedness and Response, www.nyu.edu/projects/nissenbaum/papers/facialrecognitionreport.pdf (accessed July 2010).

Jackson, T., Angermann, F. and Meier, P. (2011) 'Survey of Use Cases for Mobile Augmented Reality Browsers', in B. Furht (ed.) *Handbook of Augmented Reality*, New York, London: Springer.

Jameson, F. (1991) *Postmodernism, or, the Cultural Logic of Late Capitalism*, London: Verso.

Kember, S. (forthcoming) 'Ubiquitous Photography', in S. Bull (ed.) *Companion to Photography*, UK: Blackwell.

——(1998) *Virtual Anxiety. Photography, New Technologies and Subjectivity*, Manchester: Manchester University Press.

——(2003) *Cyberfeminism and Artificial Life*, London and New York: Routledge.

——(2008) 'The Virtual Life of Photography', *Photographies*,1, (2), pp. 175–88.

Kember, S. and Zylinska, J. (2012) *Life After New Media. Mediation as a Vital Process*, Cambridge, MA and London: The MIT Press

Lapenta, F. (2011) 'Geomedia: On Location-Based Media, the Changing Status of Collective Image Production and the Emergence of Social Navigation Systems', *Visual Studies*, 26 (1), pp. 14–23.

Lister, M., Dovey, J., Giddings, S., Grant, I. and Kelly, K. (2003) *New Media: A Critical Introduction*, London and New York: Routledge.

Lovink, G. (2011) *Networks Without a Cause. A Critique of Social Media*, Cambridge: Polity Press.

Lyon, D. (2008) *Surveillance after September 11*, Cambridge: Polity.

Manovich, (2001) *The Language of New Media*, Cambridge, MA and London: The MIT Press.

Marzano, S. (2003) 'Cultural Issues in AI', in S. Marzano and E. Aarts (eds) *The New Everyday: Views on Ambient Intelligence*, Rotterdam: 010 Publishers.

Maslow, A. (1987) *Motivation and Personality*, New York: Longman.

Nakashima, H., Aghajan, H. and Augusto, J.C. (eds)(2010) *Handbook of Ambient Intelligence and Smart Environments*, New York, London: Springer.

Pogorelc, B., Vatavu, R.D., Lugmayr, A., Stockleben, B., Risse, T., Kaario, J., Lomonaco, E.C. and Gams, M. (2012) 'Semantic Ambient Media: From Ambient Advertising to Ambient-Assisted Living', *Multimedia Tools and Applications*, 58(2), pp. 399–425.

Ritchin, F. (2008) *After Photography*, New York: W.W. Norton & Company, Inc.

Rubenstein, D. and Sluis, K. (2008) 'A Life More Photographic: Mapping the Networked Image', *Photographies*, 1(1), pp. 9–29.

Sekula, A. (1986) 'The Body and the Archive', *October*, 39, Winter.

Suchman, L. (2007) *Human-Machine Reconfigurations*, Cambridge: Cambridge University Press.

Tagg, J. (1988) *The Burden of Representation: Essays on Photographies and Histories*, London: Macmillan Education.

——(1989) 'Totalled Machines. Criticism, Photography and Technological Change', *New Formations*, 7, pp. 21–34.

Uricchio, W. (2011) 'The Algorithmic Turn: Photosynth, Augmented Reality and the Changing Implications of the Image', *Visual Studies*, 26(1), pp. 25–35.

Van House, N. A. (2011) 'Personal Photography, Digital Technologies and the Uses of the Visual', *Visual Studies*, 26(2), pp. 125–34.

5

THE DIGITAL CONDITION OF PHOTOGRAPHY

Cameras, computers and display

David Bate

In a stream of old fast one-line jokes from the 1970s, a comedian announces that he has just purchased a new 'digital' watch. The punch line is that it has to be wound up with 'digits' (his fingers). The joke and the small ripple of laughter that it evoked among the audience implicitly acknowledged a barely concealed anxiety about the impact of new technology on the human body. The computerization of familiar everyday objects such as the humble watch means that the human body is no longer required to maintain their operation, machines are automated and 'work by themselves'. As old media forms are integrated into new media devices (the time-piece is a good example) it is commonplace to summarize all these different changes to modern life as a 'digital revolution'. The word 'digital' features heavily in the description of these technological processes and the social changes that embody them. Convenient as these terms such as 'digital culture', 'digital media' or even a 'digital future' are, they nevertheless inevitably compress together the different processes of a highly complex technological social formation. The danger here is that the idea of digitalization is used easily to generate a reductive narrative of technology, of one simply superseded by another, whereas the actual history is more complex and uneven. Even in a simple technical history of early photography, the question of its use is far from singular or the affect achieved absolutely certain. Multiple histories of photography have done little to clarify the muddled scope of its beginnings, the different ambitions and aims, or the subsequent and different developments of photography in its many varied uses. In a way, the term 'digital photography' only amplifies this problematic

by bringing it forward into a different contemporary situation. On the other hand, 'digitization' or its less popular synonym 'computerization' should not be separated from what is undeniably also a cultural, economic, political and social process of change. To speak of a 'digital condition' then is not to ask what a technological development means to society, or what changes of society means for a technology, but rather to consider their heterogeneous and uneven reciprocal affects on one other.

 Rather than line up alongside the class of people who seek to become the new 'digital' intellectuals and commentators that uncritically promote 'digital culture' to be in step with the times, or conversely, the critics who stand back amid cultural conservatives and attack it at every opportunity in the defense of a superior 'analogue' culture (while bemoaning the diminishing production of film), perhaps there is another position; one more materialist that enquires into and considers the specific 'digital' condition of the photographic image in relation to the social identity of 'photography' as a system for the inscription of visual images. In short, the question is: what kind of functions of 'photography' does a digital condition affect? How does it change the experience of photography, or conversely, how do uses of photography change a 'digital condition'? Then we may ask, what kind of competencies, knowledge or 'know-how' and types of practical skill are required of those who produce and consume photographic-based visual images in computerized societies? If these questions are important it is because, in many already obvious ways in the contemporary global dissemination of photographic images, digital transmission is already the dominant form of processing and distributing photographic images (even if the original image was analogic). In the case of a hand-held computer device, for instance (a laptop, phone, display device), which can distribute an image globally in an electronic instant as easily as a blink of the human eye, it is also to ask the question: who is distributing what to whom, where and why? Yet this type of abstract question is not so easy to answer. Unlike the cinema or newspaper, which are more easily located as institutions with their discrete sets of practices and discourses, photographs appear precisely as an *environment*; they permeate streets, the home, the shop, the museum, etc. In this respect, the visibility of the forces operating in and on them is often less visible, remaining hidden, out of sight. We are left with the appearance of images. So we may ask in what way does a digital condition affect these already existing issues and problems for understanding photography? How *do* we talk about the distinct institutional and discursive practices of fashion photography, news photography, advertising images, tourist iconography, public displays of private photographs, the specious genres of pornographic image, tabloid and paparazzi photography, generic 'stock' images, art photographs or portraits of public figures all as simply 'digital photography'? Yet the abstraction of 'digital photography' may still be useful if, instead of being used to repress the distinct institutional and discursive practices of photography indicated here, it is seen like an umbrella, a thing that affects them while remaining distinct in its own terms. How might we conceive its effects?

FIGURE 5.1 *Zoo*, David Bate, 2012.

I

Certainly the architecture of electronic transformations of photographic imaging has become more familiar, even if the developments are far from over and their social and cultural impact remains uncertain, or to some extent uncharted. In a provisional ground clearing, I will start with the most familiar aspects, defined here as three key significant factors of technological change for photography. Then perhaps we can move beyond them to consider their significance and consequence.

1. Cameras are now computers

To recognize that cameras and computers now belong together is also to de-centre the role of the 'photographer'. The technical production of photographs is more easily automated, or even operated without any human 'operator' present at all. While in some practical cases this is already true it in no way means that photo-graphers or camera operators are no longer needed. It simply means that the function of the photographer is different; they have become computer operators, whether 'in the field' with the camera, by remote control from an office computer or at home on a sofa. In fact it is easier to see the significance of all this by reversing the initial formula: computers are now cameras.

In this discourse it is the computer, in miniaturized forms, which becomes the hub or 'brain' for sensors of various kinds. The sensors can take many forms, not only as optical cameras of various kinds (infra-red, x-ray and so on) but

also microphones, sound movement, sonar, temperature or smell sensors etc. All these sensors, visual, tactile, acoustic, spatial, geographic or even olfactory, can be 'remote' to the computer 'brain' hub (as in drones, satellites, CCTV or medical implants inside a body) or integrated within the computer, as in a mobile phone. In fact, as most modern 'users' already know, the 'phone' is now essentially a computer with an extraordinary bundle of sensors and data functions integrated to it.

Important to this is the computer software that renders the data, with its ability to 'interpret' the raw data into a visible image. 'Apps' have added to this a variety of different filters or codes for their images. The rendering process may be one that is completely automated (i.e. controlled by the computer), or require some human agency in varying degrees of responsibility to make interpretations. It may be claimed that picture editing, cropping, post-production modifications, aesthetic values, printing qualities, etc. are all much more easily adjusted or modified now. Normally, in professional photography there is a greater degree of human control exercised than in everyday personal uses of photography, where most if not all of the process is automated in a 'point-and-shoot' ideology (except amateur club photographers, who anyway aspire to professional values). This distinction has not fundamentally changed with digital photography. It may be argued that the distinction between professional and amateur photography has been diminished or weakened by the electronic automation of technical processes, which enables 'anyone' to achieve better, more consistent results with a quality that was once laborious, time-consuming and expensive. If this was true it would mean that the distinction between amateur/professional images is diminished, dissolved even, but it remains clear that professional photography still looks different, even when it is 'referring' to amateur photography, as in some styles of advertising image, fashion or art photography. Yet there is also a growing sense of a visibly common or generic look to DSLR (Digital Single Lens Reflex) photographs, all taken with similar cameras, similar lenses, flash settings, averaged exposures, depth-of-field and focus, which produce and organize similar compositions, whatever the subject-matter, in a kind of nonspecific 'pro/am' photography.

In contrast, it may then be counter-argued that the variety of new devices, most significantly the mobile phone, have themselves had an impact on professional practices. This is indeed true, but it is not new. Professional creatives have always looked at different processes and new techniques to achieve new ends. It might similarly be argued that new technologies have diminished the power of the old professional institutions. 'Citizen (photo) journalism', for example, so often praised as a form of independent news gathering, nevertheless mostly offers images to established media industries: institutions who still edit and control the editorial messages and captions that accompany the pictures. A wider source of images available in news gathering may in fact strengthen the dominant institutions' position in a supply and demand economy of pictures, despite the new plurality of 'user' forums such as Twitter and subject-specific web social forums.

I give these here as examples of ways in which digital camera devices are mythologized as a form that produces social democracy in its own right. Just as easily,

and in contradiction to this idea of the mobile phone camera as liberator, it is also seen as an instrument of surveillance too, providing metadata traces that can be tracked. Yet, for all the talk of the non-visual 'metadata' that camera/phones and their transmissions leave behind them, the user knowledge of these data traces has had no impact on the actual visual images produced. More interestingly and socially significant is the way that, in a visual sense, the unorthodox use of small mobile cameras enables new optical points-of-view and new types of subject matter. Yet this too is a development that belongs to a longer history of photography, most clearly marked by the popular 1950s work of Robert Frank's book of 35mm film photographs, *The Americans*. In Frank's book the viewer is positioned inside the subjective movement of the photographer's trip across the USA, introducing innovative viewpoints 'inside' situations and events, rather than seen from an outsider's viewpoint. Mobile phones and the new digital cameras offer to their operators this mobile viewpoint once reserved only for professionals with small Leica cameras. Today much smaller devices mean a less obvious intrusion into actual events and situations. Furthermore, the greater sensitivity of light capture sensors over film means that taking pictures at much lower levels of light facilitates the recording of behaviour in ways that artificial lighting may not have enabled. In this sense, the mobile phone camera has extended the old analogy of photographic vision from the modern era of photography of the 1920s: the camera as a human eye.[1] Yet it is indeed striking that no new metaphor has really appeared to replace this old metaphor of photographic vision as the human eye, even though the new 'digital eye' liberalizes that idea, with the possibility of extraordinarily multiple non-human viewpoints, limited only by the imagination of the viewer or circum-scribed by their intention. There is a parallel argument to be made here with cinema too, along the lines that the weighty camera tended not to be moved or waved about, until cranes and other devices for mobility enabled the use of more fluid camera positions and viewpoints. This has a correspondence in the history of cinema, and the way in which at some point (Hitchcock is one example) the camera begins to be used not only as a way to position the spectator *inside* a scene (instead of looking into it), but for the camera to be almost a character in its own right.

There is much more to be said about these transformations in and of the camera, but I will not venture here further into, for example, the pros and cons of 'control' and the issues of technical decisions, lenses, perspective and technical matters such as 8, 12, 16 or 32 bit processing. These become matters of technological 'improvements' rather than significant digital developments, although they will return via the similitude of digital and analogue aesthetics. I thus move to the second significant digital development.

2. The computer-camera is an instrument for recording, processing, distribution and display.

This can be understood in three senses. First, irrespective of the type of data capture file, the image displayed directly on the computer itself via an attached screen display is a JPEG image (Joint Photographic Experts Group), which makes

the camera an immediate site of display for the consumption of images. Although the playback image is a JPEG generated from buffer memory and thus is not necessarily permanent, the image formed creates an immediate viewing of the captured data as a visual image, and in this sense is a first point of display/exhibition/consumption, even if it is only the operator who sees it.

Second, virtually all consumer cameras have the feature that the latent image (e.g. a RAW data file) can immediately become a manifest picture as a JPEG or TIFF, PSD format, etc. In communication and media industries these are important economic factors (time and money); a photographer can shoot, process and re-shoot 'instantly' if they wish to change the image created in some way or another. This has an impact on the thinking of the photographer-operator, because they can immediately inspect the data as a 'picture'. Such immediacy is not new. Polaroid was extensively used for instant feedback in expensive professional studio work or on exotic outdoor location shoots to test image composition, exposures, etc. The processing of films on the spot was already long ago a normal practice in the photojournalism profession. In 1919, the Italian professional photographer-journalist Adolfo Porry-Pastorel (the 'father of paparazzi' photography) boasted a 15-minute turn around from shoot to the final print (Mormorio, 1999: 11). Amateur film and print processing laboratories moved more slowly, famously to a 'one-hour' processing in their heyday during the 1990s. With digital images, the recording and processing of the image is much closer together, almost a singular event as simultaneous, not separated, stages. Instead of the exposed latent image on a film being chemically processed to produce a manifest image, in positive or negative form, those processes are now all compressed into a speedier electronic process. The significant difference in the digitization of the image process here is less the 'speed' of the process than the effect that instantaneous feedback has on the image capture process, because it turns the camera into an instrument of display. In effect this means that the computer-camera incorporates what happened in the analogue darkroom, a place where evaluation, processing and finishing of a picture for its display took place. Of course, at one level, the operator can now, if so desired, continue re-shooting until the picture looks 'right'; this offers a means to reflect on and change the image, to shoot another one, again and again in a 'feedback loop' until it looks right. The instant rendering of data into an optical picture gives every amateur the tools for technical reflection and analysis, but equally if not more importantly, the potential for immediate digital processing of the image and its 'correction' also opens up a means to distribute the image 'instantly'.

Thus, third, the distribution of the image from a computer-camera can be immediate. The impact of this 'immediatization' of the pictures of any social event is itself new; it is now not only the photographer or technicians who can see the image, but, theoretically speaking, anyone in the world connected to a computer screen. This is distinctly new, an image system that political pamphleteers of the last centuries could only have dreamed of. A picture can be sent via transmission as a data file to any other computer, data screen display or other computing devices, a myriad range of digital screens and other terminals, website feeds, or even sets of

different printers. The electronic process links image production to immediate processing, display and transmission. Usually invisible in discussions of this situation is the crucial factor of the costs of data storage, transmission and retrieval systems. The monetary cost of data storage and processing software has more or less replaced the expense of film materials and associated chemical processing. This new industry of 'data memory', where memory banks become the new repositories of information, are a crucial aspect of 'accessibility' to images and other data that is held: ownership, how to label or tag data files? How to access them? The 'fluidity' of image movement across and between these data storage sites and use, and the associated issues of 'access' and 'digital archaeology' of these data forms are certainly enhanced and affected by the third significant factor of social-technological change.

3. The World Wide Web – a network for interactive processing, dissemination and exhibition of photographs

What we call 'the web', the technological 'language' of the link between computers on the internet, has been developed for an increasingly sophisticated interactive network. Perhaps 'the net' is an appropriate name for it, given the way so many are caught up in it. Newer software designs and automation of processing data have improved the sophistication of the network and facilitate easier image links and distributions. These developments have, perhaps inevitably, led to many claims about the internet, from the idea of it as a place to 'live' in new positive and idealized 'virtual communities', through to paranoid versions of the machines taking over the world to look after their own interests. This latter idea was long ago exemplified, for example in James Cameron's famous science fiction movie, *The Terminator* (1984). A military computer system called 'Skynet' becomes, as the film puts it, 'self-aware' and starts a war to destroy humans. It is a fantasy that is not new, as the anxieties of human extinction or redundancy at the hands of machines find an outlet in science fiction.

What is clear is that, as was already occurring with radio 'wireless' broadcasts, TV transatlantic cable transmissions and satellite links, the web provides another opportunity to challenge existing national boundaries, by both exceeding and reinforcing them. Different ideological content and cultural materials can be transmitted and received. Language, so crucial to television, radio and newspapers, now has to compete with visual forms, primarily photographic, that are easily up and downloaded and not constrained by linguistic knowledge. The older corporate conception of mass media and social markets as 'national' communities has given way to supra-national markets, global in conception, if not yet complete in reach or outlook. On one hand it is easy to see that the space of the internet provides the 'opportunity' for new models of marketing, based on data collection from commodities sold to globalized consumers. Online marketing and their retail outlets can access massive numbers of people across different markets, targeted 'locally' with the same global urban cultural values (the global brands, McDonalds, Ferrari, Coca-Cola, Levi jeans, BBC, Sky). On the other hand, the internet can be

claimed to liberate users from all such dominant institutional spaces, including governmental, media and corporate-led global/local domains. The 'surfer' can operate a highly individualized media environment, following their own personal or worldly interests, and according to their own time frame, implicit rules and browsing habits. No longer governed by national time schedules or geographical boundaries, images can flow in an unspecified plural 'web', fragmented, partial, like a dream reverie – where the only interruptions are bodily needs or pop up messages on the screen from others. Such routes are organized around highly individual and specific interests, according to cultural, social, political, economic, professional, business and other various 'leisure' activities (hobbies, sports, religious beliefs, erotics, health and life ambitions, etc). The role of digital photography here is crucial; the images available make any of these topics 'visible' anywhere and at any time that you wish to see them. Perhaps here is something genuinely new: this surfer confounds the old dichotomy of active and passive looking; voyeurism and exhibitionism becomes an interactive negotiation. The user is like a photographer, hunting images, but is also a spectator, consuming images along the way. The user/viewer is thus integrated into a regime of visuality, structured as a realm for imagined control.

The contrasting views about this new user, between one duped by new capitalist markets or as the new agent of social/political liberation, are sometimes combined into one general mythologized idea, of what we might call a neo-liberal humanist subject. The liberty of this subject is of a 'user' who is conceived abstractly as simply an individual who makes their 'own personal choice' of their use of the internet. This neo-humanism, a phenomenological effect of the experience of the web, operates most strongly where the ideology of institutions has become most invisible, and their definition of values disappear or are camouflaged behind surface appearances on the web. In advice and criticism, institutions vanish behind their products, for example, where a pharmaceutical company sponsors health advice on websites that leads to their products, or where advertising promotion is conflated with cultural content as in music videos, or when gossip become confused as news so that journalism disappears as such, and these things appear as 'the same'.

In a real sense, the difficulty in the positions often taken towards the internet as a technology is because the uses of this technology are not a 'technological' issue at all. The real questions about the internet relate to the way it has reconfigured the previous existing distinctions between institutions, discourses and practices, and a potential for new hybrids of these (some surely not yet anticipated); it is the social and cultural dimension of its use that is really the key question. In terms of photography, the conspicuous effect is primarily seen in the massive new display of what would once have been called, quaintly, 'domestic' or family photography, which has been brought into view as a new 'public' domain on websites. This is the expansive field of personal photographs, from phones to camera snaps and videos that have opened up 'private photography' as a dimension of public culture. The estimates of the number of such images uploaded have so dramatically increased from millions to billions on a regular basis that it is no longer even a

matter of simply trying to count them. These pictures offer a challenge to the already legitimated codes and genres of professional photography, not only through the sheer mass of them, but the sense that this domain tends to explore things that have been overlooked by the legitimate industries of photography, or at least can offer different visions of them. The situation opens up the potential for other types of image, for example, either through amateurism (interesting 'failures') or as a more explicit exploration of alternative images or counter-cultural picture making habits (see Murray, this volume). Either way, the emergence of these new quasi-public fields of image affects the older legitimated discourses of photography: from advertising, fashion, media and celebrity industries, cinema, news and journalism to art and the ever-massive mutative field of global tourism. Who could ignore the fact that distinctions between inside and outside, public and private and intimate and social are affected or modified by these emergent practices of 'social media'? Why would they not have an impact on other domains of image-making? All that said, it remains yet to be seen how dispersed or varied all these new activities really are, whether they are 'new' or whether their patterns are actually quite conventional.

II

Thus far, the conversion of film to the digital camera, the computerized camera function of processing, display and distribution, and the separate development of the web display of images represent the key three factors of technological change in the digital condition of photographic images. If these are given recognition as the main factors, even as somewhat schematically sketched here, it is only then that the problems really start. The next issue to appear is usually a claim that these technological developments have simply superseded analogue photography. Yet we cannot leave behind this question of analogue photography as simply as that, not just because its vocabulary still haunts so many of the debates on digital photography, but because of the contradictory way such discourses also make an assumption that digital photography constitutes a break with it. As always with a 'new' technology it is not simply a matter of succession, but uneven development.

Certainly, the demise of (celluloid) film as the standard popular material of photographic practice and the sense of anxiety and uncertainty that it caused (at least, among those many who grew up with it) has done much to obscure continuities between new technologies and older ones. It should also be admitted that the success of the corporate speech that constantly promotes new technologies (i.e. in the high turnover of new cameras and electronic products) and the alignment of many critics (who should know better) with these positions of corporate discourse as cultural advocacy and policy, have added fuel to the bonfire of the old photograph*ies*. These people and their new jargon discourses have often acted as though analogue photography no longer existed. Yet as is well known in the history of photography, but weirdly rarely acknowledged in discussions on digital photography, 'analogue' photography was never only one thing. Amnesia (rather than history)

allows analogue and digital to inhabit a binary logic. Instead, I want to consider the heterogeneous effects of digital technology on the forms of analogue photography.

'Analogue' photography, as we must now call it since that there is something else (digital photography), was a constantly evolving technology. The changes involved the invention of different cameras, optics and lenses, various film materials, chemical mixtures and printing papers, forms of measurement, shutters, focus mechanisms, flash light systems and so on. The list could go on, but the point is that the simple ontological definition of photography so often given in theoretical discussions tends to ignore the specific effects, even the aesthetic variations that any historically-given specific phase of photography has had. It is as though there is no difference whatsoever between a nineteenth-century half-plate camera and a twentieth-century throw-away snapshot camera either in their condition of use or their cultural effect. These specificities *are* the intersection of culture and technology, their mutual impact on human subjectivity. Any period had a particular 'date-stamp' to the codes and conventions of visual appearance in the dynamics of that cultural field of image. The effect of the re-coding of some of these analogue conventions into digital photography has effectively conflated some of those different social-historical conventions together, now mixed in new ways. A common example would be the so-called 'nostalgia mode' of Instagram or Hipstamatic with their simple approximations of a Polaroid look-a-like picture, a pre-faded version of the look of 1950–70s photographs. These apps copy the vague softened focus and unstable colour chemistry of certain old analogue materials and make them into a fixed digital code, oddly producing new instant 'historicist' forms, paradoxical in their interruption to historical forms as pastiche.

However, it would be wrong to say that the heterogeneity of all analogue photography has been simply homogenized into digital technology (I am still awaiting a 'Dagurreotype' app), even if it is quite clear that there are strong continuities across and between digital and analogue pictures. Photographic realism remains a significant standard for digital imaging as both a technological and cultural issue. Technologically, the digital simulation of analogue photography as its modes were developed in twentieth-century camera systems, lenses, perspective and film, represents a strong continuity not simply as an electronic version of older technological forms of photography, but of its optical realism and 'realistic' codes of picturing too. Culturally, digital cameras in their dominant forms (pro/am cameras, point-and-shoot, camera phones) simulate the look of analogue photography, even down to their appearance as certain types of film, which may or may not still be commercially available. In the digital simulation of these analogue codes and conventions, their forms and pictorial values, it would be hard to discern any significant difference at all in some cases, if taking a picture at 'face value'. Furthermore, it would often be hard to identify any specifically different type of 'digital' seeing, without the obvious appearance of pixels or the bright hyper-colours (from digital processing) that some seem to love. This can be seen as an absolute continuity of the values of analogue photography. The continuity in visual realism, its dominance in digital images, however, does not

mean that everything is simply the same. There is a distinction, which may not be visible in the digital photograph and does not necessarily affect the perceptual experience, but is visible at the level of theory. In other words, the distinction between analogue and digital conditions of photographic production are not necessarily visible explicitly by the spectator in the perceptual values of the picture, or in its relation to the referent. In such cases, digital photography assumes 'similar' visual properties to the analogue image. This *invisibility* of the difference only goes to show the success of digital photography, its triumph in mimicking analogue photography.

Yet in digital photography it is the computer (the hardware) that is the media, and digital code (the software) that is theoretically the 'medium'. (A modernist stance might make the proposal that the medium should remain specific to its computational logic of the media, as a digital 'code'.) Digital photography and the digital photographs it generates are mathematical simulacrums of an analogue code, whose aim was primarily to achieve a perspectival realism, a system inherited from European painting since the 1400s. As is well known in the theory of photography, the photographic code is analogous and continuous; it operates as a system of analogy with its referent. Whereas photography theory often agonized over this ontological status of the analogue photograph as continuous and its offer of 'realism' (often confused with the issue of 'reality') was contested, digital theory can suggest a different ontological theory, since everything in digital photography is built out of digital bytes. Yet, digital photographs are translated into an analogical form of mimesis. The visual realism of many if not most digital photographs belongs to the same logic of 'analogy' between the image and it referent. In these cases, the difference between picture and referent in a digital photograph is virtually the same as those in analogue–produced photography.

These continuities between digital and analogue processes might be more succinctly united in the famous phrase by Roland Barthes that the (analogue) photograph is a paradox: 'a message without a code' (Barthes, 1977: 19). The photograph, Barthes argued, gives the impression of there being no cultural intervention in the making of the image. The paradox of this (denotation of) 'naturalness' is that while a camera shows what it sees, *how* it sees what it sees and *why* it shows this or that referent are all *culturally* determined (connoted) factors, ideologically present yet inscrutably absent in the visual impression of reality. Digital photographs inherit this same problematic, that the code of a digital photograph also 'offers' a type of ideology as a natural knowledge. Even where pixels are visible and intervene, they often seem to lend the image a greater sense of authenticity (as in old digital snapshots). Thus even if the ontological base of analogue and digital forms are different, their epistemological problems are the same: they seem to show something that is incontrovertibly 'there' and thus give a strong continuity in the ideological function of digital photographic pictures inherited from analogue photography. A raw computer data code is formulated or 'configured' through a software process to replicate analogue photographs, which are not at all innocent or neutral. We cannot even see this image as a picture until the data in it is processed. In a way,

even this digital processing is mimicked from the model of film photography, itself the product of a long development in the twentieth century and the earlier struggles – experiments with glass and other base materials – in the nineteenth century at the inception of the medium. (We might recall here that 35mm film, the most popular form of photography in the twentieth century, was originally developed for use in the cinema.) In these very general terms the digital photographic image is nothing but a simulation of the analogue photograph that used film, albeit extending its capability, able to operate with much lower levels of light and optical adjustments, which anyway were aspirations for photographers using film technology. From a purely functional viewpoint, there is no problem with using a different technological means to achieve an intended aim or end.

Indeed, in everyday use the digital simulation of photographic codes may seem to be of little importance or significance in itself for many people in their everyday life. The logic of digital simulation seems to cause no issue at all for other media forms in the social sphere. No one, for example, usually complains about the digital process of modern telephone calls, where the voice at the end of the line is the electronic simulation of that person's voice. It is only when the immediacy of the sound wave pattern breaks down or a 'digital delay' disrupts the reception that people are even remotely disturbed or consciously aware of its fabrication. My own moment of visual recognition of this digital simulation was in a London cinema where a digital *glitch* appeared on the screen of the 'film' I was watching. The split-second interruption in the projection was enough to realize that what I had thought was a celluloid film projection had already been replaced by that cinema with a High Definition digital projector. As this digital 'shock' dwindled, I scrutinized the projection and screen for further evidence of digitalization, but could not in honesty see any. Eventually the narrative pulled me back into the diegesis of the movie. An odd data glitch eventually becomes normal, 'accepted', as part of the system, just as those dust specks and blots that once occasionally appeared on film were accepted, so long as they did not interfere with the viewing experience too much. Such experiences are, I suspect, common to all new media; as the shock of the new wanes they becomes habitual. We may easily translate this into the general condition of computer devices and their electronic data screens. The digital replacement of the old cultural values from the inside out, despite the differences between them, tend to end up looking virtually the same. This is the process of simulacra or simulation.

Jean Baudrillard argues that a simulation obscures the distinction between truth and falsity and aims 'to rejuvenate ... the fiction of the real' (Baudrillard, 1988: 172). His argument is illuminating: 'It is no longer a question of a false representation of reality (ideology), but of concealing the fact that the real is no longer real, thus of saving the reality principle' (1988: 172). So much for the ontological grounding of photography situated as a reflection of reality. Baudrillard's theory of simulation has a popular parallel in science fiction alien 'replicant' stories, where unbeknownst to the rest of the community, human beings are gradually inhabited by aliens who replace them 'identically'. The aliens continue to act in every way like their

original human hosts, except for one or two minor flaws and until these glitches eventually reveal the real 'difference' over time. Unlike those stories though, there is no moment of reckoning for the digital replacement of analogue photography, no old status quo to return to. This digital condition is something we are stuck with. Signs are no longer (if they even were) a guarantee of what they say. In simulation, the suspicion that there is only the illusion of a reality principle is surely a good thing; it means there is a question to be asked of any image. Indeed, the emergence of the digital screen seems to be precisely the tool ready-made to interrogate the image, and makes the questioning of image-value potentially a far more widespread norm.

The immediate phenomenological difference of digital photographs to their analogue counterparts must surely be that the image is now most commonly seen and disseminated via digital screens. We should not overlook this fact. The illuminated digital display screen is perhaps already the dominant format for spectatorship of any kind of digital material, whether images, texts, sounds or their combination. There are several important factors to remember here. First, the screen images continue to pursue the same goals of resemblance and visual realism already established in photography; the pictures look to all intents and purposes (in the usual conditions of fleeting perception) 'the same'. Second, the digital image, lit as an illuminated electronic screen, is an active computational process (the print is a passive form), so the screen is an (active) interface between a computer code and the visual simulation of the photographic image. These two points combine to implicitly underpin the third one, which is that because the digital screen 'photograph' is fully electronic and active, it can be mobilized, moved around and enlarged, thus interrogated and, depending on the computer connected to the screen (e.g. on a camera, laptop, mobile phone), it can also be edited, adjusted, cropped, the perspective changed, the contrast, density, brightness, focus and colour can all be modified, and of course it can be deleted, thrown away. The consequence of the screen image being modified on the spot (even with many automated cameras) is a reconfiguration of the work of image processing, and the actual place that work occurs. The camera-computer is a darkroom – anywhere.

The software available to the viewer via a digital display screen, even at a basic level of moving the picture around with your digits, or magnifying a section of it, affects the viewer's relationship to the picture. The opportunity to enlarge or adjust the digital picture enables anyone to explore a picture in much the same way that film theorists have already argued digital technologies inform a new and different type of spectatorship of cinema. Laura Mulvey, for example, argues that 'new technologies' enable viewers to see a film *differently* than in the cinema, where a film was always in constant movement. Now it can be 'halted or slowed or fragmented' (Mulvey, 2006: 181). DVD or digital hard drives enable the experience of film as a flow or movement to be disrupted with the ability to stop, freeze or rewind sequences, which creates a different perceptual or even critical relation to the idea of cinema as a narrative form. In Mulvey's argument, the slowing of film opens cinema to a 'pensive spectator', one who thinks about

the image. Conversely, a more 'possessive', fetishistic and fragmented view of the narrative film can emerge, one fixated on particular stilled scenes. These phenomenological differences are significant for Mulvey as they indicate that changes offer not merely a technological possibility of a different consciousness of cinema, polarized as a curiosity or possessive attitude towards moving images, but also show the mechanisms of desire (often unconscious) involved in looking at pictures at their intersection with technological form (Mulvey, 2006: 161). Photographs have a quite different spectator relation to the cinema image in terms of temporality and space. The characteristic 'stillness' of still photography is disrupted by the opportunities to explore a still photograph 'digitally' on the electronic viewing screen. The screen opens up a digital malleability to the picture, where critical thought, curiosity, reverie or, more pessimistically, 'possessive' spectatorship are all possibilities.

Whatever the photographer and viewer's attitude towards a still photograph, moving the image around on a screen offers a different spatial relation; in enlarging it to see the pixels, fringing or 'zooming' in to examine the details of a background element of the picture, the spectator can become a semiotician or photo-detective, analyzing the detailed construction of the picture without any formal training. From the clumsy analogue darkroom process of image 'enlargement' in Antonioni's 1966 film *Blow Up* to the instant computer 'enhancement' of Ridley Scott's 1982 film *Bladerunner*, the difference is in the electronic automation and the placelessness of the process. The spatial movement of the digital photograph around an electronic screen enables the viewer to consider the question: what actually *is* a photograph and where is it? The fact that this same picture can be shrunk and sent as an electronic message or automatically re-sized and uploaded to a website (such as Facebook or Flickr pages, etc.) changes the relation of a photographer-spectator to the location of pictures. This new 'familiarity' with the visible photographic image as an electronic substance that is both material and immaterial (it disappears when the screen is switched off) turns the static image into a process, forging restlessness that only comes to rest in the material print. In this modified sense of the electronic place of photography, its topographic belongingness is scattered even more than before into the ether of the environment. It is perhaps no coincidence then that 'feeling scattered' with respect to the substance of digital images is something we are in the process of adjusting to.

It should be noted that the electronic screen also allows a reversal to occur in the process Mulvey sees within the cinema. Whereas a moving image is more easily 'stilled', the fast data capture ('frame rate') of a digital stills camera can create the illusion of movement in a sequence of frames. To slide images across the screen or click through them can form a kind of 'primitive cinema', a simple animating affect of still pictures into a basic version of cinema. The digital screen makes no visible distinction between displaying a still or moving digital picture (even if the buffer rate is variant). The data screen is equally at home with still or moving images, text, sound or any mixture of them. In this way the device has a hybridizing effect on the still and moving images. Indeed, the high definition 'movie' mode on stills cameras

has already proven this, with DSLR (Digital Single Lens Reflex) stills cameras used to make HD (High Definition) digital 'films', documentaries, fiction movies, etc. Nevertheless, the distinction between still and moving images as binary opposites remains, even if these *seem* to have merged or 'converged' in some cases. Even Hollywood cinema, a form that is restless in its editing of movement, combines moments of stillness alongside images of movement. Digital photographic imaging has merely moved them closer together, as 'stills that can be animated' or 'animated stills'. Cinema is still dominated by its capacity for narrative and storytelling, while still photographs are dominated by ideas of description, 'information', captivation or reverie.

We also need to consider the way digital photographs can interact on display screens with sound and text, which also involves the way conventions of magazine and newspaper design layouts can be integrated or mutated to include cinematic conventions and photographic layouts. The potential 'mash-up' (montage or collage) of different analogue cultural conventions on one screen shows, again, the tension between a potential for mutative forms and the continuity of institutional goals. Practices developed for specific purposes in simulated forms remain alongside one another so long as they remain driven by the very social institutions that developed them in the first place, e.g. news journalism, advertising, television, cinema, art, etc. Yet the various aims and ambitions inherent to those institutions work towards a discontinuity of conventions wherever it means a continuity of purpose. Advertising, for example, usually seeks out the cultural spaces inhabited by its target audiences, advertising online, even if this means a mutation of its usual billboard or magazine form. Indeed, mutation is often the watchword of modern media. The electronic gaming industries mutate the forms of cinema, graphic novels and conventional board games into singular 'interactive games'. Here it is most clear that the forms of old media are reconfigured, absorbed as the content of new media.

It should be clear from the foregoing argument that, even though digital photographic processes mark a strong continuity with analogue photography, in subtle and less-subtle ways their digital condition has begun to change what we understood as 'photography'. This process can be recognized as occurring across other digitized cultural forms too: music, cinema, television, geography and mapping, and so on. The very simulation of analogue photography that digital processes were developed to continue also contaminates those older signification processes, and eventually our own subjectivity in relation to them too. What does this mean in practice and what is its significance?

III

In a wider sense the processes of visual digitization affect the relation of knowledge to visual forms. The digital photograph is one part of this wider shift of societies to computerized systems in the production, distribution and consumption of all knowledge, not just of pictures. The French social theorist Jean-François Lyotard

already anticipated some of the general issues and questions that arise from this computerization of societies in his famous book *The Postmodern Condition*. Already then, in 1979, Lyotard was thinking about the effects of computerization not only on societies in general, but on languages, communication and media, linguistics and translation in relation to the new information storage, data banks, telematics and intelligent terminals, to name but a few items (Lyotard, 3–4). Lyotard speculates on the impact of these on teaching and learning:

> To the extent that learning is translatable into computer language and the traditional teacher is replaceable by memory banks, didactics can be entrusted to machines linking traditional memory banks (libraries, etc.) and computer data banks to intelligent terminals placed at the students' disposal.
>
> *(Lyotard, 50)*

We can observe that much of this has already taken place in universities, museums, image libraries and other archives, mostly easily accessed via mobile computers. The modern student has become a 'global' viewer in a world where the university is also decentred, now located 'nowhere' on mobile device screens. Lyotard continues:

> Pedagogy would not necessarily suffer. The students would still have to be taught something: not contents, but how to use the terminals. On the one hand, that means teaching new languages and on the other a more refined ability to handle the language game of interrogation – where should the question be addressed, in other words, what is the relevant memory bank for what needs to be known? How should the question be formulated to avoid misunderstandings?
>
> *(Lyotard, 50)*

Lyotard is sensitive to the fact that, as extensive information becomes available via memory banks, the 'operators' need to know how to negotiate the information gained access to, to use it intelligently as knowledge. He remarks: 'Data banks are the Encyclopedia of tomorrow. They transcend the capacity of each of their users. They are "nature" for postmodern man.' (Lyotard, 50) Any computer with information storage is now also a data bank of memory. If 'nature' is a communications network of data, then its cultural forms are still the means and methods of its process into social knowledge. Now it is not information that is necessarily difficult to obtain with a computer, but the issue of how to 'actualize' it as knowledge, even before the question of its transmission. The condition of digital photography belongs to this new 'postmodern' nature.

What was perhaps not anticipated is the way digital photographs have permeated these systems as knowledge. The simplicity of picture-making and their dissemination, especially through automation and as indicated in the three key factors outlined

previously, means that digital photographs have pervaded far more systems of discourse than before. Photographic images are systematically embedded in many more social procedures as a form of knowledge, from parking meter attendants to information websites, the photographic image is a condition of knowledge. The old relations between images and language are modified; the use of 'caption' texts are no longer secondary, but a primary search tool in data tagged images. Even or especially with automated search engines, a researcher (e.g. a student) has to anticipate the linguistic and data logic of museum websites, archive libraries and the like. This is not so much a new 'democracy' of the image as the integration of digital photography further into institutional language games. These visual modes of signification are still enmeshed in textual systems and linguistic forms of knowledge, yet who can deny that the spread of so many visual websites does not bring the logic of pictures into the foreground of cultural space. Streams of photographs appear like streams of consciousness, not necessarily linked in an explicit fashion, but drifting in a type of 'visual consciousness' that is entirely 'photographic'. Through these non-verbal strings of messages the image is renewed but also scattered, bringing different conceptions of the world, shockingly sometimes, as the self is constantly subject to pictures. We are subjected to pictures but these pictures also subject us to a new form of experience, where the photographic is merged with sensory experience. The many streams of 'online' photographs suggest a loosening of the tongue, 'chatter' in a visual sense. The 'language' of these new arrangements of pictures demands renewed semiotics, taking these images as an object beyond the single picture: visual narratives, sequences, dream-work drifts and dream-like reveries abound. Like the invention of the silent movie, these strings of images with the claim of a 'universal language' still demand the uses of text and linguistics even if in a subdued form. We may yet have to return to those forms for inspiration of understanding: the structure of silent movies, the sequencing in picture magazines, the logic of dreams and the associative 'consciousness' of the essay film form.

What of the lot of the 'photographer', the person who makes pictures? Are they still a configuration of motivations, conscious and unconscious, desire, different aims, skills and knowledge, institutional values that drive their engagement with the 'camera'? Surely yes, but it is just that now, the act may not be so special; it can be just like writing a little note, or a series of notes. If digital media practices have also begun to empty out the connections between old symbolic forms and image contents, the question is not how to re-join those symbolic forms (e.g. photographic images) to contemporary culture, but how to comprehend a contemporary space where culture itself appears as visibly dispersed, detached from the institutional rules and economic conditions that support them. The temptation to homogenize the consequences of these different digital issues must be resisted. Just as the internet is decentred and plural, so are its consequences. It is not, in calling this situation a 'digital condition', that they can all be gathered up as one thing, but rather to begin to identify the conditions in which their differences emerge.

Note

1 Even the return of 3D photography offers nothing substantially new except a better technical resolution of the quality of three-dimensionality, a democratic version of the nineteenth-century middle-class interests in greater technical 'realism'.

Bibliography

Roland Barthes, *Image-Music-Text*, London: Fontana, 1977.
Jean Baudrillard, *Jean Baudrillard: Selected Writings*, ed. Mark Poster, Cambridge: Polity, 1988.
Jean-François Lyotard, *The Postmodern Condition*, Manchester: Manchester University Press, [originally published in French, 1979] 1986.
Diego Mormorio, *Tazio Secchiaroli*, New York: Harry Abrahams, 1999.
Laura Mulvey, *Death 24x a Second: Stillness and the Moving Image*, London: Reaktion, 2006.

6

CURATING THE PHOTOGRAPHIC IMAGE IN NETWORKED CULTURE

Andrew Dewdney

Part 1

Introduction

The place of photography within the general system of representation[1] and its technical organization in digital transmission and reception continues to present a problem for media theory, since photography is both distinct in fixing the automatic light reflecting latent image, as well as being entailed in the relay of photo-mechanical and photo-electronic processes of reproduction. For this reason photography in culture has historically been analyzed in two distinct registers, first as an adjunct to anthropology and literature in producing 'texts' and 'signs', capable of being read semiologically and psycho-analytically; and second as an adjunct to sociology, as a technology producing a medium of popular ritual and record. While this is somewhat of a reduction, since photography also crosses the interests of science, art history, cultural studies and philosophy, the problem of the photograph as a sign/text and as medium/technology and how to grasp these objects and relations and assess their significance within human communication remains. The recent technological entailment of the automatic latent image[2] in computing and the proliferation of the digital image once more brings photography to attention as a contrary object of both singular distinction and general diffusion. With computing the digital image makes photography ubiquitous and more clearly automated and it is this that presents new questions of photography's authorship and cultural authority for those to whom its singularity remains a central principle.

The tension between the dispersal of the practices of photography into general computing and the increasing aggregation of analogue photography in archives, collections, exhibitions and their organizational systems represents a new moment of an older problem of the identity of photography. The advent of large and small scale high-definition flat screens in fixed and mobile combinations, together with

increased digital file sizes, greater storage capacity, transmission speeds and net-worked databases, now brings the screen and image in what have been their dominant forms – television and photography – into a new embrace. Such developments have stirred strong interests in academia and are currently leading to a reframing of photography within fields of interest and research.[3] Taken together the proliferation of images, screens and the network represents a new moment of accelerated convergence,[4] which is not only evident in commercial products and new forms of media distribution, but is becoming visible in the educational and public arts sector, through independent digital media organizations and projects exploring the curation of images in the network. In Britain projects such as Furtherfield[5] have been involved in the curation of online new media projects since 1997 and Mute[6] was established as a new media publishing project as early as 1994. However, more recent examples reflect the rising currency of screens, such as the Ryerson Image Centre in Toronto, which includes the 'Salah Bachir New Media Wall', five metres long and visible from the street; the 'Urban Screens' project of the Institute of Networked Cultures; the European Union funded urban facades project 'Connecting Cities 2012–16', initiated by the Public Art Lab; and 'The Wall' project of The Photographers' Gallery, London, which reopened in May 2012.[7] Such projects are indicative of emergent cultural forms of new media, crossing the interests of photography, television, film and video, which seek to define the screen and network's relationship to the public realm.

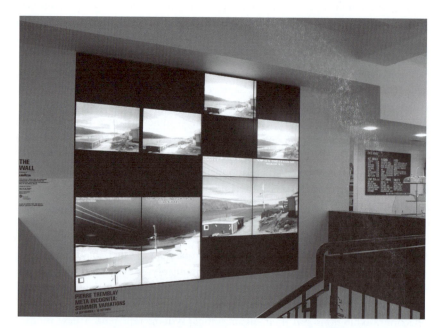

FIGURE 6.1 The Photographers' Gallery video wall, Pierre Tremblay. *Meta-Incognita: Summer Variations*. Screened at The Photographers' Gallery, 15 September – 10 October 2012.

The accelerated convergence of screen and networked computing along with interest in the creative possibilities of its uses by new media organizations runs in parallel to a related moment of contemporary interest in media by mainstream museums and particularly contemporary art museums. The opening of Tate Modern's Tanks in July 2012 and its inaugural 18-week programme is one such example of a cultural turn to media within nationally-established institutions. The argument developed in what follows seeks to differentiate the cultural politics of, on the one hand, independent new media organizations responding to the challenge of what the public face of networked culture might look like, and, on the other hand, the incorporation and rising status of art, which uses media within mainstream contemporary art museums. The distinction between what the historic idea of the public realm looks like in 'networked culture' and the network's entailment within the established forms of the public realm, of which the museum is an exemplar, becomes crucial in understanding the limits and possibilities of photography as a singular medium within museum culture and as the distributed image in networked culture.

The chapter examines a set of practical and theoretical reasons for what is clearly a powerful interest in, but also an anxiety about how public museums and galleries relate to networked culture. In general the World Wide Web, by its networked and distributed nature, has challenged the analogue socio-technical systems of representation that developed over the twentieth century. Public museums, public service television, photojournalism and archival record continue to perform representational roles in selecting and framing those aspects of the natural world and human affairs considered worthy of record and expression. The light-formed image remains centrally entailed in representational performances; hence, what is happening to the photographic image in network culture serves as a prime example of accelerated technological convergence and its reconfiguring relationships of cultural knowledge and authority. Networked behaviours, of both data and human users, circumvent and challenge representational hierarchies established by analogue media and this is as much the case for museum collection and display as it is for journalism, record or entertainment. The problem this chapter grapples with is that two discourses, that of the art museum and digital technology and that of media and digital technology have, by and large, remained separate. This separation reinforces the continued fetishization of the object over the subject in the art museum as much as it does the fetishization of the user over the materiality of the network. In the case of the photographic image in network culture the argument over the materiality/de-materiality of the image contains both forms of fetishism in what is ultimately a reification of social practices, because the image and the network are products of organized labour. The rejection of subject/object relations in favour of performativity and the agency of humans and objects (Latour 2007: 52) allows for a new framing of subjectivities, which in turn demands a new view of the object of human attention and with it a revised cultural politics. If museums, galleries and, more generally, public cultural institutions wish to maintain their claim to be representational, through collection, exhibition, education and curation,

then, as the argument goes, they will have find ways of engaging with network culture because as a remediation of analogue cultural forms it prefigures who the new public are, what they are doing and how they are behaving. What is coming into view, and promises to shed light upon the photographic image in this accelerated moment of convergence, is that the cultural form and responses to television can no longer be separated from viewing the screen image.

Television studies of the early twenty-first century now survey a mediascape in which television is radically reconfigured. Television has migrated out of the domestic living room; it is experienced on multiple platforms and this has changed viewing experiences. Television production has been deregulated and now takes place in multiple, just-in-time facilities rather than in the vertical organized industrial studios, which has in turn changed the form and formats of television to meet specialized audiences. More importantly, computing has broadened the basis of production such that in principle everyone with access to a computer can make TV and concomitantly television has changed spatially, now based upon personalized and social networks, which can be local or global. In this new configuration television studies recognizes that audiences are segmented in consumer markets in more personalized ways, no longer passive, if indeed they ever were, and for whom television operates in highly differentiated and transcultural modes.

Television is the default of the digital screen

The replacement of the cathode-ray tube by the high-definition flat screen radically changed the resolution and aesthetic of the television image and quickened the convergence of television and computing, in which computing is now remediating television, parallel to the remediation of photography. This is what gives ground for positing the technical convergence of the photographic and television image as electrical transmissions made manifest on light emitting diode displays (LED screens), since they now share the same technology of digital capture and screen transmission. Early digital camera technology of the mid 1970s developed from the same video-tape technology that recorded television images, both deploying a CCD (Charged Coupled Device) to register and convert light, colour and intensity as electrical signals that could be retained as code. Subsequent technical developments in photography and digital television remain focused upon higher image resolution through greater pixel capture, larger screen sizes, as well as new forms of interactive control. Electronic image capture and display now forms a central nexus of digital reproduction and is thus entailed in all major commercial, industrial, scientific and cultural practices, which involve the production, transmission and storage of visual information.

In a remarkably short period of time public and private life in advanced industrial societies has come to involve screen interactions as unremarkable acts in everyday life and it is this proliferation of screens together with advances in the resolution of the image and network connectivity that gives ground for considering the cultural remediation of the photographic image by the cultural form of television. Such

countless encounters with screens are part of an endless flow and succession of images, as Williams noted about 'watching television' (1974: 78). While screens using motion graphic and animation software are at their simplest media platforms for the display of discrete media packages, the screen itself is not a neutral carrier, and as McLuhan reminds us is itself a message that directs and frames attention; as Williams would have it, the screen is also a social response within a historical and cultural context. In this sense, while the screen has been predominantly understood so far as a workstation, an interface with computer databases and operations, the screen of the ubiquitous image includes the screen of the cultural form of television. That is to say that while computing is technically remediating television along with everything else, it is not only the screen of labour upon which life is played out in the network, but the screen of recuperated leisure time, which historically is associated with the social conditions of 'watching' television. Of course in practice the flat screen is a hybrid that combines viewing strategies and subject positions from both computing and television; however, the cultural form of television is an important inclusion when considering the question of the shaping of the cultural value of the networked image through its screen presence.

How does viewing digital images on screens change ideas about and relationships to the photograph? Here there is abundant evidence that in everyday life, rapidly advancing screen technologies have already altered the ways in which the visual image is made present and how new forms of interaction are entailed.[8] Less obviously, how does the presence of screens in museums and galleries change or challenge the collection and exhibition of images? The very ubiquity and hybridity of the digital screen image would seem to present obstacles to established forms of cultural authority based upon collection and the discourse of aesthetic modernism. These two lines of enquiry, the presence of more screens in everyday life upon which more images circulate and the presence of screens in spaces of the public realm, previously reserved for viewing highly selective analogue images, are inescapably connected through the network to previous modes and behaviours of viewing photographs and watching television. One way to understand this connection is to say that the particular historical forms of authority and knowledge embedded in cultural institutions, which have previously selected, curated, collected, conserved and interpreted objects of visual culture under the system of aesthetic modernism,[9] is now overwhelmed by what has been termed 'image capitalism', in which, 'Images have become a constitutive dimension of the capitalist forces reshaping our affective world. They are, therefore, no longer merely an automatic, replicative reflection of the real world' (Mbembe 2011). While image capitalism remains to be fully theorized it resonates with Derrida's argument that in the society of the spectacle the image is capital (Barker 2002: 109) and with what Castells (2010: 69) has called the 'informational economy' and, more recently, with Terranova's exploration of the idea of 'free labour' in producing the culture of the digital economy.

Something more dramatic and less easily identifiable than technical remediation is therefore happening in the ways in which cultural authority on the one hand, and social utility and ritual on the other, is circulating in what is still taken to be

the photographic and televisual image. That previously registered as private life in the photograph has dissolved into the temporal flow of images that 'act' in the giant spaces of network circulation, and what was previously made public in broadcast television has merged with what was private space but is now the spaces of personalized consumption (Baudrillard 1985: 127). Up until this moment the ontology of photography, largely taken to be discrete and technical, has been a guarantor of the coherence of the individual subject, whilst the ontology of television has been a guarantor of the existence of public space. It is the distinction between public and private, interior and exterior, held in place by the general representational system, which is now in a crisis produced by networked behaviours, globalized modes of production and transcultural subjects. What Williams (1974: 26) defined as the new subject position of 'mobile privatization', which corresponded to the needs of post-war industrial capitalism and was expressed through domestic television, might now also be considered to be reforming. While the social location of the reception of media remains for the large part the domestic home, private space has itself been mobilized metaphorically and materially by the 'spaceless' and 'timeless' exchanges of the internet (Castells 2010: 430).

If such a proposition were to be granted then it brings about the need to reconsider the already uncertain place of 'the photographic image in digital culture', or, within the narrower confines of intellectual interest here, to appraise what the digital image is doing to certain kinds of consecrated photographic cultures. The passage of time along which the more singular idea of digital culture has travelled has itself been overwhelmed by the very practices it originally called forth, such that now there is a multiplicity and reduplication of image-knowledge hybrids,[10] which confound attempts to maintain linear historical accounts and singular objects. The technological apparatuses that now encode, store and circulate images have made the historically received notion of the photograph all but redundant, and yet it appears that no matter how many technical 'deaths' the photograph suffers, the visual conventions and cultural institutions of representation that support it persist. The puzzle remains of a situation in which the photograph is now apparently produced without photography, which has been theorized as photography's anterior state in Laruelle's concept of 'non-photography' (2011). Laruelle does not argue the position of non-photography on the basis of technological change, but on the philosophic basis that the photographic apparatus produces something 'fictive' and separate from reality and hence parallel to the world. In this way Laruelle can argue that a photograph is 'wholly real but in its own mode'; for him it is an essence unto itself. What is interesting about the theoretical position of non-photography is that it has a correspondence with attempts to understand what the algorithms, which code the light capturing sensors and produce images and their movement, are doing outside of or in parallel with the reading of the digital image within representational codes. What problems does such an intellectual puzzle present to the very idea and possibility of curating the digital image in the network of screens whose default is the screen of television?

Part 2

The location of the screened image in the public realm: the case of The Photographers' Gallery

How, in network culture, in the emerging economy of the image, in the new spaces of image circulation, is the historically defined idea of the photograph to be regarded? The visual images and animated graphics encountered on screens are no longer met in isolation, in print, books frames and albums. Indeed the torrent of digital images produced by computers will only exist as files, retrieved on screen through the intermediary of software. The screen image that appears on palmtop, laptop and desktop computers comes through a graphic interface as an embedded file; the image will typically be surrounded by text and graphics, which set out the procedures by which the file can be manipulated, filed, tagged and transferred. Images can be viewed, resized, edited and deleted instantly at any stage in their screen life. The swipe, tap and pinch of mobile and tablet touch screens allow images to be scrolled, enlarged and reduced. They can be arranged in countless albums, become searchable through the addition of tags, copied, displayed and published. In short, images are accessed, viewed, shared, altered and stored online within a seamless and interactive flow. Hand (2012: 1) usefully points out that digital imaging has shifted from a professional or specialized process to a routine and unavoidable aspect of everyday life. At the same time, he points out that what was once amateur or snapshot photography has become potentially global in scope. 'Where many once imagined a future of digital simulation and virtual reality we now, arguably have the opposite: the visual publicization of ordinary life in a ubiquitous photoscape'.

The photograph in computing has become mutable, fugitive, fleeting and restless. In its boundless quantities it is repetitive and replaceable. But what is still taken to be the photographic image on the computer screen has also become an emanation of light, an intensity. It is more of an 'image-potential' than a fixed image through variable scalability of all its visual parameters. The photographic images on high-resolution LED screens are filled with brilliance and brimming with detail. They are, as has been noted more abstractly elsewhere, more real than real; they approach the hyper-real (Baudrillard 2002: 177). It is the 'synthetic' quality of the hyper-real, which is the technical product of non-photography.

One attempt to grapple with the new conditions of the mutable image can be found in the media wall project of the newly refurbished Photographers' Gallery in London. The building is situated in Ramillies Street, accessed from Oxford Street, with its dense ranks of shops, down a narrow alley, in the heart of the West End, on the edge of Soho. The building refurbishment arranged over six floors is itself somewhat like a department store, with glass frontage on the ground floor, which contains a café, a flight of stairs to a bookshop in the basement and a lift directly opposite the entrance. Between the lift and the café, framed above the stairs to the basement, is an eight-panel video wall measuring 3 x 2.8 metres. The streetscape of

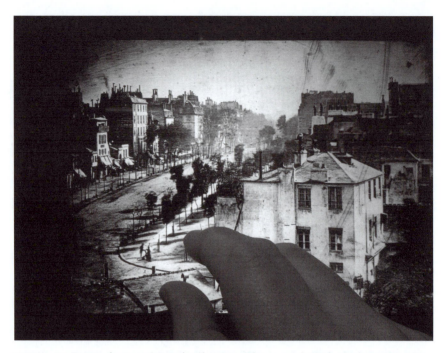

FIGURE 6.2 Frame from animated gif using iPhone and iPad, Andrew Dewdney. Screened at The Photographers' Gallery as part of *Born In 1987: The Animated Gif*, 19 May – 10 July 2012.

the gallery blends well with the commercial environment full of flagship stores, which also deploy digital screens in their windows advertising their brands and products. Niketown on the north-east corner of Oxford Circus is a prominent example, but there are many more along the length of the street, as there will be in other cities around the world and in other shopping centres around the country. These advertising screens use video formats, which combine graphics with moving image sequences as media assets bundled and assembled by a software application, which orders and distributes graphic files in what is an obvious remediation of hubristic fashion posters and music videos. The Photographers' Gallery media wall courts the appeal of the popular and ephemeral in photography, and by virtue of its screen presence is linked to photography's place in reproduction, rather than to the curation of the singular analogue photographic print.

The Photographers' Gallery media wall project has been established as a discrete curatorial project[11] complementing their main exhibition programme and its educational/public engagement projects. In the context of a gallery-based programme the accommodation of a digital strand of programming has willy-nilly imbued the digital curator with traditional specialist cultural authority, in this case that of digital and networked photographic practices. What current strategies for curating the non-photography of the network are available to the curator?

The discrete digital strand of curation within the gallery has an organizational parallel with the Intermedia Art programme at the Tate (2008–10), which focused on art that engaged the use of new media, sound and performance. Over the period of the programme Intermedia presented a selection of artist commissions, events and broadcasts, supported by artist interviews, written articles and discussions. The Intermedia online art archive on the Tate website also contains the archive of the Tate's Netart projects from 2000 onwards. The Tate's curatorial approach can be understood as a legitimation project to establish a new category/genre of art practice based upon artists using technology, and accommodated within an established art canon supported by the work of academic art historians. At The Photographers' Gallery, the parallel to the art museum's conventional approach would be to limit interest in network photography to the project of a selective canon in which an historical lineage is validated in order to continue the tradition of selecting only what is considered high quality artist/photographer's work. This established curatorial approach was also evident in the project of Christiane Paul, the first adjunct curator of new media at the Whitney Art Museum, which had links with the Tate's Intermedia project.

The evidence of the digital programme at The Photographers' Gallery to date suggests that the limits of this established approach are more than recognized, even though it is evident that even when it comes to new media, the dominant curatorial system of representation holds sway by virtue of the institutional location of the project. What other curatorial strategies might be available in these circum-stances, which also recognize the hybridity and distributed nature of non-photography? The problems associated with a traditional curatorial model applied to digital photography arise immediately from the fact that photography is imbricated within general reproduction, which produces the hybrid and converged networked image, which is sutured into the fabric of code and its database. The screen of the video wall's television default has no singular mode of attention, no fixed position of the subject, but instead positions the spectator by a continuous flow, whatever the duration of the discrete loop. Such recognitions were firmly in evidence in the opening show of 'The Wall', entitled *Born in 1987: The Animated Gif* (19 May 2012–10 July 2017). As Sluis has noted, 'the gif image works on a different economy in which its value is based not on its uniqueness and scarcity (as in certain forms of art) but its circulation and proliferation'[12.] While this opening gambit avoided the obvious pitfalls of regarding the screen as an electronic photo-frame, the subject of the animated gif unavoidably announced a cultural agenda, which resonated with a constituency of new media practitioners already present on the web. The opening show brought 'The Wall' project into a temporary alignment with those whose practices are based upon a critique of established cultural authority and who see the web as offering a reformation of the terms and engagement of art. Sluis has acknowledged that 'The Wall' project shares the concerns of Netart, by 'raising questions concerning authenticity, authorship and "the social"', but she also noted the project's motivation, 'in the need to rethink familiar notions of photography and temporality, indexicality and the

economy of the image', concerns which, she said, 'presently haunt the field of photography theory'.

The Photographers' Gallery's 'The Wall' project has mounted three subsequent exhibitions: Susan Sloan's *Studies in Stillness: Motion Capture Portraits* (11 July–14 August 2012), Pierre Tremblay's *Meta Incognita: Summer Variations* (15 Sept–10 October 2012) and *For the Lol of Cats: Felines, Photography and the Web* (12 October–6 January 2013). Each of these screen displays has sought to exemplify the possibilities for considering image capture and circulation in the network. Thus, for example, Susan Sloan's 'portraits' of her mother were produced using motion capture data and screened as video, which while bearing a striking resemblance to photographic and video portraiture were in fact neither. The computer-rendered animations using motion capture data had produced Sloan's mother as human but not human, a subject unable to enter into the representational relation of photographer and sitter, and hence had become a species of computing, characteristic of a character in a videogame.

Pierre Tremblay's *Meta Incognita* is a time-lapsed video of over 500 still images captured by a public weather webcam in Kimmirut on Baffin Island, Canada. Tremblay 'plays' with the automated capture of information from a remote location and renders his selection and composition within the concerns of landscape photography and the analogue aesthetic of the sublime. Unlike the single image distilled for scrutiny, Tremblay's video cycles through what might otherwise be an indeterminate and endless selection. The resulting video is not of a representational landscape, although clearly figural, but a cycling of remote data, reminiscent of

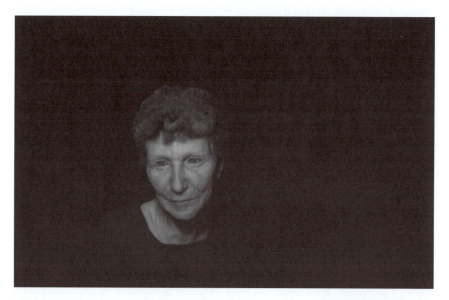

FIGURE 6.3 Video frame grab, Susan Sloan. *Studies in Stillness: Motion Capture Portraits.* Screened at The Photographers' Gallery, 11 July – 14 August 2012.

McLuhan's recognition of telepresence in what is a work of formal and technical abstraction (1994: 60).

The most recent exhibition, curated by Sluis, is based upon images of cats circulating on the internet, including internet 'cat memes'. By choosing a popular subject category of image, Sluis is able to trawl the ephemeral sub-cultures of the internet as well as look at internet behaviours.

The topicality of the image of cats works between the history of photography and the networked image and, as Rubinstein noted about *Born in 1987: The Animated Gif*, the apparent subject operates to reveal 'a moment when the history of the network becomes the material from which the digital image draws its living energy'.[13] In other words, the object of 'The Wall' project is not what the network produces, but the operations of the network. This is a significant and ambitious project by any standards, which raises serious methodological problems, not least with the form of exhibition and its material context. Sluis has said elsewhere that she sees 'The Wall' project developing from open democratic research methods, which seek collaborative approaches,[14] a strategy that has already opened

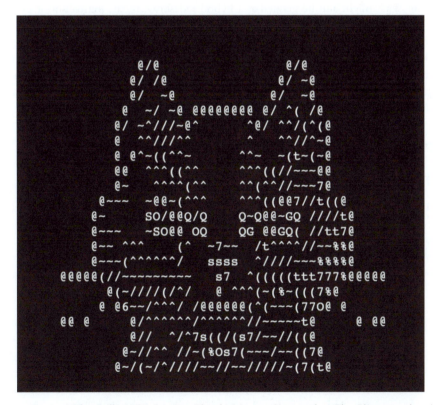

FIGURE 6.4 Video still, *ASCII Cat Art*, Glenda Moore. Screened at The Photographers' Gallery as part of *For The Lol Of Cats: Felines, Photography and the Web*, 12 October 2012 – 6 January 2013.

up a collaborative and research-led approach in order to avoid the representational bind of both singular photography and aesthetic modernism. While the displays mounted on 'The Wall' are condensed as exhibition, it is more the case that the form of gallery exhibition constrains what a programmable online and offline screen wall is capable of doing. However, this very constraint brings the question of how the values of the operations of the network are to be culturally registered and established. Who, after all, is 'The Wall' for; who sees it and how is the value of its transmissions registered? More abstractly, such questions lead to the larger framing of how network operations become visible in and constitutive of the public realm, precisely because exchange and use values entailed in networked practices are transacted in the network image economy. However, it is one thing to consider the question of value as the exchanges of millions of users at globally dispersed terminals in the network and another to consider the value processes of one screen transmitting to an institutional audience in central London as exhibition. So far the 'The Wall' has been used to screen edited offline material, which 'samples' web practices and operations in something like case studies or reviews organized by an established editorial process. In the remediated sense the initial exhibitions of 'The Wall' might also be grasped as a hybrid slideshow, media journalism or even v-jaying. When the screen is used as an online portal, the question of editorial and moderating processes will change, as will the audience, and it is in this challenge that the question of value and cultural authority in the image economy will come to the fore. It is also in the precise relationship of the screen to the screen's image that the place of the photography in networked culture, both as reproduction and as a singular image, can be discovered.

Part 3

The digital network at the door of the analogue museum

This should be an exciting period for the art museum to engage with network culture, in which the historical logic of collection, acquisition and exhibition could be opened-up for scrutiny, re-examined and reconfigured through a distributed means in and by network participation; why then is there such a marked reluctance to engage with the digital? Bishop writing in *Artforum* (2012: 2) hazards the view that

> mainstream contemporary art simultaneously disavows and depends on the digital revolution, even – especially – when this art declines to speak overtly about the conditions of living in and through new media. But why is contemporary art so reluctant to describe our experience of digitized life? After all, photography and film were embraced rapidly and wholeheartedly in the 1920s, as was video in the late 1960s and 1970s. These formats, however, were image-based, and their relevance and challenge to visual art were self-evident. The digital, by contrast, is code, inherently alien to human perception.

The screened image in the art museum constituted as the work of art derives from the work of artists and curators who, since the 1960s, have worked with video and to a lesser extent film as mediums of conceptual and affective expression. Photography, film and video have all been used by artists, within the discourse of art, to produce screen-based works of art destined for installation in museums and galleries. This has led art historical and curatorial interest in classifying such work in genres, schools or movements, such as video art and more recently digital art. The attempt to include media-based fine art within the canon of twentieth-century aesthetic modernism has taken a number of routes. In Britain an early manifestation of interest in computing and art was the exhibition *Cybernetic Serendipity*, curated by Jasia Reichardt at the ICA in London in 1968, which has subsequently been framed as a meeting of art, science and technology (Gere 2008: 1). More conventionally, the use of media or more broadly technological machines by artists has been understood as a new set of tools of the twentieth-century avant-garde, such that contemporary digital art can be traced back to early adopters such as the Dadaists or conceptual art (Paul 2003: 11). Much the same can be said of the approach of Rush (1999: 21), who traces the use of digital imagery in contemporary art back to a long-standing artistic fascination with film and photography.

The problem with attempting this seamless insertion of new media or the digital aesthetic into art practice and its historical canon, under whatever title, and 'screen media' seems to be the most recent contender (Reiser 2002), is that while it recognizes technological change, it confines the reproductive function to that of a medium-specific tool within the existing practices and arrangements under which art is produced. Such art historical or curatorial endeavours neither pay attention to, nor see any need to relate the larger transformation taking place in the general system of representation and communication to, the disciplines and knowledge practices of art schools and museums. The cultural paradigm of art institutional practice still follows the logic of aesthetic modernism and its privileging of the autonomy of art and the singular role of the artist even in the midst of a veritable maelstrom of paradigmatic change in knowledge production and subject identity (Dewdney *et al.* 2013: 217).

In the programme notes that accompanied the opening of the Tate Modern Tanks, Chris Dercon, Director of Tate Modern, wrote an introductory 'open manifesto' in which he discusses the changing role of audiences dominated by social media and new modes of broadcast, and argues that 'We can think of the museum in the twenty first century as a new kind of mass medium.'[15] This is a bold and optimistic statement about the function of the art museum, and a curious reversal of the position when television was a mass medium of centralized control and museums were places of distinction for an educated minority. The claim strikes an initial cord in the recognized commodification of art as part of mass tourism and reflects the spectacular success of the Tate Modern in attracting visitors since its opening in 2000. But what kind of new mass medium could the art museums be? It could be, as Castells (2010: 433) claims, a universal 'cultural connector of time and space' as a counter to the fracturing of social space in network atemporality. However, the embrace of 'media art' in contemporary exhibition, including a selective tradition

of photography, as part of the international art market and of national heritage, could be seen as a further symptom of the crisis of representation provoked by technology and global change, rather than a moment of its revelation. The inclusion of photography and other media practices within the canon of modernist art practices has, by its own logic, to exclude photography as reproduction.

With the project of the digitization of analogue photographic archives, photography as organized reproduction is once more made invisible, while digitization is made transparent as a select group of artists/photographers, agencies, historians and curators admit photography to the museum. The digital image circulating as information in networked databases and present in screen transmission is now the central default of reproduction and it is this function that guarantees the exclusion of the networked image from the art museum. Reproduction cannot be embraced by art because that is precisely what undoes the prevailing logic of art and museums, which are in large part committed to the preservation of art and their collections, both public and private. To admit the network would entail the high risk of setting in play not simply a reversal of the polarities of the knowledge production of and about art, which would be risk enough, but the obliteration of the paradigm itself and a tearing up of the rule book. The network challenges the notion that the creation of art is carried out necessarily by a singular vision intended for a singular viewer who is the sole locus of intended meaning (Woods 1998).

Writing on the socio-technical organization of photography from the 1870s, Tagg saw the contradictory division of photography into a domain of artistic property and that of the scientific and technical, where 'what we begin to see is the emergence of a modern photographic economy in which the so-called medium of photography has no meaning outside its historical specifications' (1993: 246). Such contradictory divisions within the 'medium' of photography are the source of the anxieties around the dispersal of historical practices into general computing, which is played out within a number of institutional communities of interest. Museums, contemporary art galleries, academia and public funding for the arts in Europe, North America and Australia are in the process of acknowledging the cultural significance of media to a greater extent. But there are questions to be asked about this contradictory moment in which a selective canon of photography and its historical archives are fully and finally included in the artistic legacy of twentieth-century aesthetic modernism and acknowledged as a medium of contemporary art, while photography as analogue media's mode of reproduction is finally dissolved into computing. At the risk of oversimplification the situation appears to follow Benjamin's insight that the change in the technical mode of reproduction changes the function of art, and it can now be added that the objects of the mechanical mode of reproduction are being repurposed in the mode of acceptance of the aesthetics of photography. If something like this is taking place then it presents the existing organization of the production of art, centred on its exhibition and exchange value, with a major challenge. One of the most pronounced signs of confusion and resistance to these changes in major cultural organizations has been

their reluctance to practically conceptualize the aesthetic of the internet, based upon digital code and its visual manifestation on screens.

The established and normative notion of spectatorship entailed in aesthetic modernism, based upon the idea of a singular and exceptional transaction between two foundational subjects in the encounter with the work of art, is unsustainable in the face of new subjectivities engendered by the screen interface. While the relationship between a media object and a viewing subject has been previously understood to be constructed on both sides with the possibilities for counter readings of object and subject, as in feminist and queer cinema theory, or postcolonial critiques of spectatorship (Rogoff 2000: 10), such analysis always returned to the question of meaning in the object or the identity of the subject.

What has been called here the embrace of photography and television is based in a nexus of socio-technical developments of the screen, mobile communication and network behaviours, which has created an image economy and a screen-based culture. That economy involves conditions of production and modes of consumption in which the uploading and circulation of countless billions of images derived from multiple sources of differing orders and provenance have currency. Broadcast television has been, up until now, the centralized form of public transmission organized along national lines with private and domestic forms of reception, while photography has historically had both public and private forms of circulation and reception. The remediation of both television and photography in computing and their convergence in the networked screen image calls forth new conditions of reception, new subject positions, which need to be understood. The transaction between viewer (user) and image (computing) is continuous with older representational codes, which the new conditions of production and circulation challenge, while the new transactions remain to be understood. The foundational subject and her/his gaze is at the heart of what the screen and network is busily undoing, creating a highly populated, yet unnamed space of viewing and being viewed. This situation can be identified as a cultural form of subjectification, in which subjectivity now appears as 'transconnective' and as an 'encounter' (Ettinger 2006: 41). Such subjectivity is characteristically 'liquid' in the sense that Bauman (2000: 7) has explored as a fluid condition of human existence in a period of rapid change.

The paradox produced by the circulation of what stubbornly refuses to be anything other than the photographic image in digital culture is that while the screen transmission produces something other than a photograph, its precise effect in everyday life is to make the photographic image more present and saturating. The history and contemporary practices of photography currently being elevated by and admitted to national and international museums and galleries is not photography as reproduction, nor the networked image, but an abstraction of the analogue and its historical archive.

What needs understanding in this curious state of affairs is that not only has the old order of analogue technologies been radically replaced but that those who cleave to its image can only do so as heritage because the paradigm of representation, which sustained the analogue photograph's embodiment of the real, has been

made redundant. What is now at stake is the struggle for a new paradigm, a new epistemology that would account for the strange new world of computer systems in terms that are meaningful to the world of social relations, enmeshed with and admitting the computational means of reproduction. In this endeavour those attempting to 'curate the networked image' are leading the way, while those admitting the analogue media archive to the canon of modernist art are engaged in nostalgia.

Notes

1 The term 'general systems of representation' is used throughout to denote historically specific, differential aggregations of social, political, technical and sensory systems, which cohere as organizational and responsive modes. In visual representation it encompasses what Berger (1972) called 'ways of seeing'. It also resonates with Williams' (1977) idea of culture as a 'structure of feeling'. The stress on a general system is also parallel to Agamben's development of Foucault's term *dispositif* as apparatus to account for a complex formation of what is both said and not said. It is also expressed in a more phenomenological way in *Thrift*, when he talks of 'the geography of what happens'. The paradigm of visual representation developed from the European Renaissance can also be considered in material cultural terms to be an expression and constituent part of a persistent and general system of representation.

2 The latent image refers to the historical discovery that reflected light passing through a small aperture will form an automatic image on a surface, most obviously present in the camera obscura. With the development of analogue photography, the latent image was considered to be the registration of the pattern of reflected light exposed onto the surface of film/paper prior to being made visible by the chemical development. In digital photography the latent image is present in the organized pattern of reflected light produced by an integrated circuit called a charged coupling device (CCD), which converts variable reflected light signals into measurable electrical signals.

3 See for example the Arts and Humanities Research Council's highlighted research call under the title 'Digital Transformations'.

4 The notion of acceleration is usefully articulated in Lipovetsky's notion of *Hypermodern Times* (2005).

5 Furtherfield is a London-based, independent new media organization, co-founded in 1997 by Ruth Catlow and Marc Garrett (www.furtherfield.org).

6 Mute is a London-based new media publishing project, started in 1994, but received revenue funding from the Arts Council of England in 1999, which ended on 31 March 2012. Mute also contains the Post-Media Lab – a project within the Digital Media Center (EU Innovation Incubator, Leuphana University Lüneburg, Germany), organizing residencies, publishing projects and public events in collaboration with *Mute* magazine. See www.postmedialab.org.

7 The specific example used here, around which this tension is explored, is the installation of eight 60" LCD panels arranged to create a 3 x 2.8m screen, at The Photographer's Gallery, London, for a project entitled 'The Wall'. The screens are manufactured by the Japanese company Sharp and possess a 'local dimming' feature, which ensures that any pixels not used will switch off, producing a deep matte black, to increase the contrast and luminosity of the active screen area. This has a particularly strong effect on the presence of still photographic images on screen. The installation of the digital wall during the gallery's recent refurbishment is accompanied by a two-year curatorial programme, which was inaugurated in May 2012 with the exhibition *Born in 1987: The Animated GIF*.

8 Examples are copiously given in Hand's book *Ubiquitous Photography*.

9 Aesthetic Modernism is used throughout as a shorthand for the system of thought generated from the Enlightenment, which placed the human at the centre of all meaning, created the distinction between rational science and nature and led to the foundational subject of the modern artist. The implied critique of aesthetic modernism stems from Latour's account in *We Were Never Modern*.

10 Hybridity is derived from Latour's account of Actor Network Theory and intended to indicate objects that cross the previously separated realms of humans and objects, in which ideas and concepts as well an non-humans can have agency within a network.

11 The appointment of a curator was funded by the Esmee Fairbane Foundation with corporate support for 'The Wall's' technology. The first curator of the digital programme is Katrina Sluis.

12 www.furtherfield.org/features/interviews/interview-katrina-sluis-digital-curator-photo-graphers-gallery

13 http://joyofgif.tumblr.com/post/23221545148/daniel-rubinstein

14 www.furtherfield.org/features/interviews/interview-katrina-sluis-digital-curator-photo-graphers-gallery

15 Taken from 'An Open Manifesto: 15 Weeks of Art In Action'. Dearcon. C. The Tanks Programme Notes. Tate Modern. 18 July – 28 October 2012.

Bibliography

Agamben, G. (2009) *What is an Apparatus*. Stamford. Stamford University Press.

Barker. R. (2002) 'Woburn in My Mind and in My (Mind's) Eye: Beckett's Poiesis'. In M. Verdicchio and R. Burch (eds) *Between Philosophy and Poetry: Writing, Rhythm, History*. London. Athlone Press.

Baudrillard, J. (1985) 'The Ecstasy of Communication', in H. Foster (ed.) *Postmodern Culture*. London. Pluto.

——(2002) *Screened Out*. London. Verso.

Bauman, Z. (2000) *Liquid Modernity*. London. Polity.

Bishop, C. (2012) 'Digital Divide'. New York. *Artforum*. September 2012.

Blackman, L. (1998) 'Culture, Technology and Subjectivity', in J. Wood (ed.) *The Virtual Embodied*. London. Routledge.

Bourdieu, P. (1993) *The Field of Cultural Production*. London. Polity.

——(2007) *Distinction: A Social Critique of the Judgement of Taste*. London. Routledge.

Castells, M. (2010) 'Museums in the Information Era: Cultural Connectors of Time and Space', in R. Parry (ed.) *Museums in a Digital Age*. London. Routledge.

Dewdney, A. and Ride, P. (2006) *The New Media Handbook*. London. Routledge.

Dewdney, A., Dibosa, D. and Walsh, V. (2013) *Past Critical Museology: Theory and Practice in the Art Museum*. London. Routledge.

Ettinger, B. (2006) *The Matrixial Borderspace*. Minnesota. Minnesota University Press.

Gere, C. (2008) *Digital Culture*. London. Reaktion.

Hand, M. (2012) *Ubiquitous Photography*. London. Polity.

Heidegger, M. (1977) *The Question Concerning Technology and Other Essays*. New York. Harper & Row.

Latour, B. (2007) *Reassembling the Social*. Oxford. Oxford University Press.

Laruelle, F. (2011) *The Concept of Non-Photography*, trans. Robin MacKay. Falmouth and New York. Urbanomic Press.

Levinson, P. (2001) *Digital McLuhan*. London. Routledge.

Lister, M., Dovey, J., Giddings, S., Grant, I. and Kelly, K. (2009) *New Media: A Critical Introduction*. Second Edition. London. Routledge.

Mbembe, A. (2011). 'The Dream of Safety'. *Figures and Fictions Conference*. Victoria and Albert Museum lecture. Available: *http://dreamofsafety.blogspot.co.uk/2011/07/achille-mbembes-lecture-at-victoria-and.html* (accessed 23 December 2012).

McLuhan, M. (1994) *Understanding Media: The Extensions of Man*. Massachusetts. MIT Press.

Paul, C. (2003) *Digital Art*. London. Thames and Hudson.

Reiser, M. (2002) *New Screen Media: Cinema / Art / Narrative*. London. BFI.

Rush, M. (1999) *New Media in Late Twentieth Century Art*. London. Thames and Hudson.

Rubinstein, D. and Sluis, K. (2008) 'A Life More Photographic'. *Photographies*, 1 (1), 9–28.

Rogoff, I. (2000) *Terra Infirma: Geography's Visual Culture*. London. Routledge.

Tagg, J. (1993) *The Burden of Representation*. Minnesota. University of Minnesota Press.

Thrift, N. (2008) *Non-Representational Theory: Space, Politics, Affect*. London. Routledge.

Williams, R. (1971) *The Long Revolution*. London. Pelican.

——(1974) *TV, Technology and Cultural Form*. London. Fontana.

7

THE PHOTOGRAPHIC IMAGE IN DIGITAL ARCHIVES

Nina Lager Vestberg

Photography is dead and it is going to die, as Roland Barthes might have said if he were alive today.[1] Or, rather, photography has died several deaths since its demise was first announced in the early 1990s, and yet it is somehow still refusing to lie down. Used to represent the revenge of the dead on the living ever since Hippolyte Bayard staged his own self-portrait as a suicide in the 1840s, photography is the zombie medium (Hertz and Parikka 2012) *par excellence*; the defunct technology that keeps coming back, feeding on and infecting the variants of digital media that have apparently replaced it. The technical signs of photography are everywhere programmed into the algorithmic infrastructure that supports our current digital visual culture. Lev Manovich has described it as the 'paradoxical logic' of digital imaging, that it 'annihilates photography while solidifying, glorifying and immortalising the photographic' (2003 [1995]: 241). From the audiovisual simulation of a shutter clicking and closing, as you take a picture with your smartphone, to the web-based Hockneyizer tool, which turns any digital image file into a Polaroid collage in the style of the artist David Hockney, analogue photography maintains a haunting presence as digital image.

This chapter will concentrate on one aspect of the rich afterlife of photography, specifically the figure of the photographic archive. Building on a growing body of research mapping the complex relationships between digital, visual and archival technologies, it will consider both how digital technology has transformed the production and distribution of archival photographic material, and how the digitisation of photographic (re)production has changed the cultural status of photographic objects from the pre-digital era.

A little history of archives and photography

The relationship between photography and the archive has been a recurrent theme in critical studies of the medium. The 1980s in particular saw the publication of a

number of influential works, which shared an emphasis on photography's instrumental function as it was put to archival uses in the mid- to late-nineteenth century.[2] Writers such as Georges Didi-Huberman (1982), Allan Sekula (1986) and John Tagg (1988) investigated the uses and abuses of photographic archives in the service of institutional surveillance, control and punishment. These critical accounts were vital in developing scholarly awareness and debate of photography as a tool of oppression and objectification. They tended to approach photographic archives from a materialist perspective, in the sense that they posited ownership and/or control over the means of photographic production as the key factor in the photographic production of meaning. As exemplified in Tagg's *The Burden of Representation* (1988) and Didi-Huberman's *The Invention of Hysteria* (1982), not to mention Sekula's output (1986 and 2003[1986]) in this period, the materialist approach meant attending to the historical, material practices and institutions by and through which photographic archives came into being. It also meant attempting to recover the perspective of those who were subjected to or contained by the archive, whether these be the poor, the criminal, the ill, the sexually deviant or the ethnic 'other'. A crucial point made by critics such as Sekula was that the people whose faces, bodies and practices were inventoried by the photographic archive were excluded from the process of assembling or interpreting it. In fact, as he noted, 'at any stage of photographic production the apparatus of selection and interpretation is liable to render itself invisible' (Sekula 2003 [1986]: 446). Yet in identifying the existence of this apparatus, Sekula overlooked the subjectivities of the people by whom it was made to function. Presumably this was because, in performing the work of selecting and interpreting, the 'photographer, archivist, editor and curator' remained, for him, proponents of 'the dominant culture of photography' (Sekula 2003 [1986]: 446) and thus part of the problem he sought to address.

The commercial end of the photoarchival spectrum did not receive much attention from scholars until the late 1990s. Since then, however, a growing number of researchers have taken an explicit interest in the seemingly invisible apparatus of dominant photogaphic culture, in the form of what has variously been called the picture industry, the stock business and now, increasingly, 'the visual content industry' (Frosh 2003). Two early contributions to the field were UK design historian Helen Wilkinson's 1997 study of an advertising agency's archive from the 1930s, and US designer J. Abbott Miller's chapter on the development of stock photography in the book *Design Writing Research* (1999), co-written with Ellen Lupton. In 2003, two important monographs were published in English and German, respectively, by Paul Frosh (*The Image Factory: Consumer Culture, Photography and the Visual Content Industry*) and Matthias Bruhn (2003a, *Bildwirtschaft – Verwaltung und Verwertung der Sichtbarkeit*).[3] The studies by Wilkinson and Miller are first and foremost historiographical in that they seek to account for the emergence of a certain phenomenon within a specific historical context. The books by Frosh and Bruhn, meanwhile, have been more concerned with mapping the cultural impact and significance of an industry that provides 'the wallpaper of consumer culture' (Frosh 2003: 1). Perched somewhere in the middle of these two approaches, Estelle

Blaschke (2009 and 2011) has examined the commercialisation of imagery in an historical perspective as a conceptual development from 'picture archive' to 'image bank'. The impact of digital distribution technology on the visual content industry has been further analysed by Doireann Wallace (2010), while Cheryce Kramer (2005) has investigated the system of production that enables a visual content provider such as Getty Images to construct what is effectively a 'visual esperanto' from the alphabet of photography.[4]

The historical-materialist critiques of the 1980s were particularly attentive to nineteenth-century technologies, such as filing cabinets and index cards, which enabled the archives of hospitals, police departments and mining companies to fulfil their taxonomic and disciplinary functions. In a similar way, writers investigating the current-day visual content industry have highlighted the various contemporary technologies – ranging from printed catalogues to direct-download websites – through which industrial volumes of 'visual wallpaper' is continually rolled out (see for instance Frosh elsewhere in this volume). Unlike the stable analogue apparatus of the 1880s and 1890s, however, contemporary digital technology is a fast-moving target, constantly threatening to outrun researchers attempting to enclose it in hard analysis. Descriptions and predictions that appeared highly plausible just ten years ago have turned out to be astonishingly wide of the mark. Some of the more descriptive studies, which were produced just as digital working practices were being adopted on a wide scale, are nevertheless helpful in order to establish how the transition from analogue to digital as the default archival mode was realised in quite different ways.

At this point it might be appropriate to declare an interest. For ten years between 1997 and 2007 I worked on and off as a picture researcher, first in a picture library and then on newspaper picture desks. In the course of those years I experienced at first hand a dramatic change in working practices due to the comprehensive implementation of digital technologies for storing, sending, searching and selecting images for publication. My own motivation for investigating the relationship between photographic and archival technologies is therefore prompted by the personal experience of working through the digitisation process, and as a consequence my approach to the subject is informed by the insider's viewpoint, although it is by no means limited to it.

Digitisation increasingly arose on the agenda of all kinds of image collections as the 1990s progressed. This was as true of public research collections as of private, commercial ones. For the sake of clarity, it might be worth disambiguating (as Wikipedia would call it) the term digitisation from the outset. Its usage could be said to cover two distinct but related processes, namely, the rendering of existing analogue content into digital formats, on the one hand, and the computerisation of working practices, on the other. It might be more appropriate, in other words, to reserve the term 'digitisation' for the technological changes that have affected images, and use 'computerisation' to denote those that have affected people. In fact, computerisation preceded digitisation by some considerable degree in most photographic archives. As in other workplaces, computers gradually assumed

functions that had previously been performed using a variety of tools, from the typewriter and the card index to the contacts book and the fax machine.[5] This first of all meant that tasks carried out using different tools in different parts of the library became concentrated around the desktop computer, with its monitor and keyboard. In picture libraries, as in book libraries, the first stage of digitisation tended to be the creation of a computer catalogue of holdings to replace the card catalogue or printed cross reference index. This would usually amount to a textual record, modelled on the index card, with fields for recording author name, subject and production date, as well as descriptive keywords, location, publication details if applicable, and so on. Even while the pictures themselves remained stored as slides or prints in filing cabinets, their metadata – which in many libraries had previously only been recorded on the backs of prints or the mounts of slides – became more easily retrievable, and also more easily combined with other kinds of information, through the shared interface of the computer screen. As computer processing capacities improved, many software packages would allow for the record to include a low-resolution scan of the relevant image for reference purposes, and eventually – following implementation of the digitisation process proper – links to the high-resolution reproduction file. At this point, the manual file search, which had been the most important and also most effort-intensive way of locating photographic images in archives, was rendered practically superfluous by the adoption of electronic retrieval systems.

According to a study carried out by information scientists Stephen Tope and Peter Enser in the late 1990s, there was a great deal of variation in the ways digital technology was adopted and adapted from institution to institution (Tope and Enser 2000: 94–95). From commercial stock agencies via newspaper picture libraries to museum archives, strategies varied according to factors such as users' needs, size and format of analogue holdings, access to technical expertise and, not least, budgets (Tope and Enser 2000: 101–4). In their study of how electronic retrieval systems had been implemented, Tope and Enser found that once users had direct access to holdings via the search engine operated from their own desktop, picture librarians and archivists 'no longer needed to carry out searches on the user's behalf' (Tope and Enser 2000: 64). At the same time, the researchers discovered that because the metadata upon which the retrieval system depended was often unreliable or insufficient, a different kind of expertise was increasingly needed in order to improve the user's experience of the online database. In the analogue archive, the function of picture librarians had been to mediate 'between the image and the user', whereas the digital archive to a much greater extent required mediation 'between the image and the system' (Tope and Enser 2000: 64).

The photographic archive used to be an invisible apparatus, as we recall Sekula arguing in the 1980s. That is not to say its prints, folders and shelves were invisible to researchers and archivists, rather that such archival furniture went unnoticed as anything other than an efficient means for storing and retrieving documents. Just as the wood can be impossible to spot for all the trees, the archival apparatus is easily obscured by its constituting objects and only comes into view from an

appropriate distance. Tangible archival instruments such as folders and filing cabinets have now been replaced by unseen servers and seemingly transparent screens as the primary tools of storage and access. The mediating function of the picture librarian, meanwhile, is being performed by hidden algorithms churning away behind the perceptible interface of the image database. Yet, as I will go on to show, the analogue infrastructure of picture libraries has not entirely disappeared. The old and outdated forms of working *in* the archive have in fact obtained a new visibility as one of those historical material practices recorded and preserved *by* the archive itself.

Photographs in the analogue archive

In February 2012 a headline in the British newspaper the *Guardian* reported that the photographic archive of the Tate had been 'rescued from a skip' (Alberge 2012). Its rescuer was the Paul Mellon Centre for Studies in British Art, whose director had apparently been tipped off at the last minute that the archive was considered surplus to requirements and was about to be scrapped. The article compared how the Tate photographs had been saved to the manner in which a comparable curatorial archive at the V&A Museum had been destroyed, a year earlier, when an employee in charge of the archive had allegedly 'skipped the lot' without informing or consulting with curators beforehand. The archives in question consisted largely of photographic reproductions of artworks both within and without each museum's collection, and they were consulted by curators, conservators and other researchers in connection with exhibition-planning, restoration work, questions of attribution and so on. The *Guardian* quoted a Tate spokesperson denying that it had intended to discard its photo archive, claiming instead that it had been 'decided [that] it would be more useful for scholars if this photographic research material … were to be located with equivalent material at Paul Mellon Centre' (Alberge 2012). For its part, the V&A admitted to 'dumping archival material using "a secure data disposal service"', yet rejected the notion that this had been a rogue decision by an individual employee. Rather, the move was in accordance with museum policy, based on the belief 'that a thematic archive "wasn't a method of classification that was really necessary any longer", as it had duplicates of photographs and digital files' (Alberge 2012). In addition to confronting the two institutions about the handling of their respective archives, the *Guardian* had sought opinions from an art historian and the director of a charity promoting the conservation of artworks, both of whom used the term 'scandal' to describe the disposals. One of them added, '[f]or historians to destroy archives, it should be inconceivable' (Alberge 2012).

The threat of 'the skip' looms large here. If the museums had simply decided to mothball their photo archives, or store them less accessibly off site, there would not be a news story: for there to be a scandal there has to be the threat or fact of destruction. The skip, or scrapheap, in this respect poses as the antithesis of the archive. An archive is, among other things, a repository of things that a culture

deems valuable, whereas a scrapheap is an indiscriminate pile of matter that it judges to be valueless. The work of distinguishing between the two, and of deciding what will be deposited where, is a less straightforward task than one might suppose, as the case of these two archives indicates. The fact that both collections of photographs were discarded by their originating institutions is interesting because it appears counterintuitive: old and outdated stuff should go *into* museums, not get chucked out of them. The paper's decision to report this story is equally interesting because it reveals a surprising concern for a class of cultural objects that must safely be assumed to remain for the most part under the radar of the average newspaper reader – even the stereotypically cultured and highly-educated *Guardian* reader.

A clue to the *Guardian*'s concern for the fate of photographic archives might be had from an exhibition organised by the newspaper on the occasion of its moving headquarters in 2008. The new space was heralded by the paper's editor as specifically adapted to 'a digital age', in contrast to its old 'frankly, analogue' premises, with paper and website production to be 'largely integrated', and what used to be 'newsroom' operations 'to a large extent devolved into specialist "pods" across both newspapers and web' (Rusbridger 2008). Somewhat unexpectedly, in a building designed for 'a 24/7 digital future' (Rusbridger 2008), the chosen theme for the inaugural show in its exhibition space was *The Lost Art of the Picture Library*. The show featured 70 photographic prints selected from the collection of around 100,000 items, which by the early 2000s constituted the joint picture library of the *Guardian* and *Observer* newspapers. In the words of the exhibition's curator, Luke Dodd, it represented 'an idiosyncratic sample of a wildly idiosyncratic collection', with motifs ranging from dictators and criminals to sports, celebrities and stock shots of milk bottles (Dodd 2008). The content of the chosen pictures was only half the story, however, as amply demonstrated in the printed catalogue published to accompany the exhibition, where the *recto* (front) and *verso* (back) of each print were reproduced in equal scale and detail, on opposite pages of each other. As in most analogue picture libraries, the available metadata for each image had usually been recorded by picture editors on the back of the print – often according to varying and entirely arbitrary standards. In the course of time, the reverse side of certain prints had become not only more informative than the image featured on the front, but even more visually arresting. For instance, a standard black-and-white head-shot dated 1967 of the racing driver Jackie Stewart sitting in his car (no. 50 in the catalogue) is completely upstaged by the accompanying colour reproduction of its verso. The original caption, typed in blue ink on a green paper label, has here been supplemented by red and black pencil scribbles; various date stamps in red ink; the newspaper's proprietary stamp in green ink; a copyright stamp in fading black, and a number of additional captions in yellowing newsprint, cut out from published copies of the paper where the image has been reprinted over the years. The evident fascination with the signs and inscriptions recorded on the reverse sides of photographic prints exemplified by *The Lost Art of the Picture Library*, and more particularly the catalogue that accompanied it, is symptomatic of an increased

preoccupation with the (analogue) photographic object, which seems to have developed in parallel with the apparent (digital) dematerialisation of the photographic image.[6] It is significant in this respect that the exhibition itself was produced as a wholly 'analogue' event: it first went up on the *Guardian* premises in winter 2008 and then toured to Northumbria University Gallery in summer 2009. Surprisingly, for a show that inaugurated the newspaper group's new 'digital hub', it was only supplemented by an old-fashioned printed catalogue and had no digital avatar in the shape of an online slideshow or similar. This could be explained by issues of reproduction rights: although all the photographic prints shown in the exhibition belong physically to the *Guardian* picture library, the newspaper is unlikely to hold the copyright to more than a handful of the images instantiated in those prints. As the fee for reproducing an image in a limited one-off print run tends to be considerably lower than for unlimited online usage, it may very well be that the print format was chosen primarily for economic reasons.[7] Regardless of the pragmatic concerns that may or may not have motivated the format in which they were produced, both the ephemeral event of the show itself and its more permanent record in the shape of the catalogue can be seen as monuments to an archival past, manifested in appropriately analogue media. As Dodd explained in his introduction to the catalogue, the remaining hard-copy picture files have been rehoused in the new building, in 'bespoke archival vaults with state-of-the-art environmental control … where the collections will be cared for, studied and loved' (Dodd 2008: n.p.). Entombing it in a vault is no doubt the logical way of looking after a library, the contents of which these days appear 'largely on the obituary pages', as Dodd noted (2008: n.p.). By guarding these relics of the printed past within the very building that is supposed to represent the digital future, the *Guardian* also ensures that, unlike the destroyed archives of the V&A Museum, the art of its picture library is not quite lost after all, but remains to be sought and found again.

Photographs in the digital archive

The *Guardian* has not been alone, however, in preserving both the art and the image of the analogue picture library. These days, if you enter the search term 'picture library' into the online image bank of a major visual content provider such as Getty Images there will appear on your screen a selection of both historical and contemporary scenes set among the filing cabinets and shelves of photographic archives. Approaching two such images as archival documents in their own right can produce important insights into the fate of photographic images in digital archives, the function of photographic archives in digital photography and the economic apparatus that currently makes them available for consultation, purchase and publication.

The photographs reproduced here as Figure 7.1 and Figure 7.2 both show a young woman handling photographic prints in the context of a photographic archive or library. From this purely denotative description, the two pictures would appear very similar. Yet when viewed and analysed for their connotative form and

content, these images illustrate – one might even say embody – the profound changes that the visual content industry has undergone over the past decades. Figure 7.1 is a black and white image, which carries the title *Pile of Pictures* and is captioned, 'A woman working at the Keystone Press Agency picture library with two piles of photographs'. Figure 7.2 is a colour photograph entitled *Vintage Photo Album* and captioned 'A woman handling pictures from the Hulton Archives'. The first photograph is dated 1951 and the collection from which it is taken is given as 'Hulton Archive'. The second image belongs to a collection called 'Vetta', and is undated. Even such a small sample from the much larger amount of metadata provided for each image tells us a good deal about the status of the photographic pictures depicted in them. Just the fact that Figure 7.1 carries a specific date, while Figure 7.2 does not, is significant. It suggests a wish to locate the former in some sort of historical context, and a corresponding reluctance to do the same with the latter photograph. This image nevertheless carries a number of visual signs to indicate that it was produced quite recently, as we shall see.

In the caption provided for the first image, the activity going on is clearly identified as work, and the photographs are evidently the material with which the woman is working. The textual information is reinforced visually by the clerical

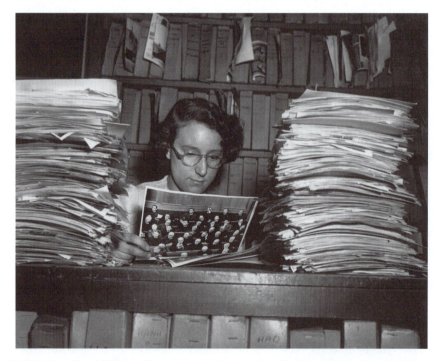

FIGURE 7.1 *Pile of Pictures:* 'A woman working at the Keystone Press Agency picture library with two piles of photographs' (1951). © Fred Ramage/Hulton Archive/Getty Images.

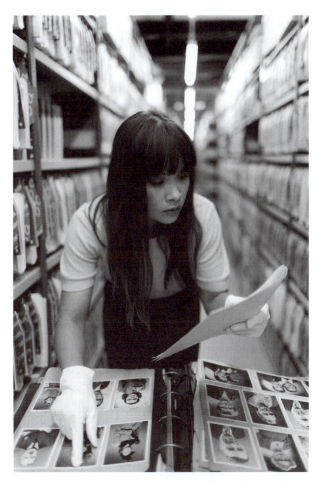

FIGURE 7.2 *Vintage Photo Album:* 'A woman handling pictures from the Hulton Archives' (undated). © René Mansi/Vetta/Getty Images.

impression created by the spectacles and tight, 1950s-style perm worn by the woman as she sits leafing through a sheaf of photographic prints while framed on either side by two large piles of more prints. One print is held up with its picture face facing out towards the viewer, presumably because she is reading the caption information contained on the back. It further looks like the worktop is some sort of shelf, as the foreground reveals the tops of filing boxes, which look more or less exactly like the boxes stacked on the much higher shelves in the background. Prints are piling in everywhere in the frame, with the woman's face hovering almost disembodied among them. The second photograph, by contrast, shows a young woman wearing neutral colours and a 'timeless' hairstyle, who is leaning over a photographic album that lies open in the picture foreground. Wearing white protective gloves, she is holding a few sheets of paper in her left hand, possibly

containing a list of some sort. Meanwhile the index finger of her right hand is either touching or pointing towards one of the portraits contained on a page of the open album, identified as 'vintage' by the picture title. This choice of descriptive term is one strong indication that the photograph is of recent date, another is that it refers to the presence of black-and-white photographs within a colour photograph. The flat light and almost extreme neutrality of colours further supports a dating in the 2000s–2010s, when the trend in stock photography moved away from the bold colours and high contrasts that dominated high-end visual content in, say, the 1990s.[8] Above all, however, what serves to anchor this image in a digital age is the way it represents the photo archival space as such. For one, the caption makes clear that this is not a depiction of work in a picture library, but rather a scene of 'handling' precious items in an archive. The background, while heavily out of focus, sketches in an orderly and brightly-lit archival space where neat rows of suspension files recede into the distance. The shallow depth of field further establishes the woman as, literally, the focus point of the picture. This is in marked contrast to the cramped, messy and dingy work space of the 1950s picture, where the horizontal lines of the shelves both in front and behind the woman produce a static impression of the human figure practically integrated into the archival apparatus.

Constant physical proximity to '*the actual files*' was essential for picture library staff, according to Charles H. Gibbs-Smith (1950: 14, original emphasis), who in 1947 devised the classification system for the Hulton Picture Post Library. A number of incarnations later, this library still forms the core of what is currently known as the Hulton Archive, where the photograph in Figure 7.1 is now preserved. In Gibbs-Smith's view, the only way to develop 'the immense visual experience necessary in a picture librarian' was to keep library staff 'constantly soaked in their material' (Gibbs-Smith 1950: 14). The photograph must be said to provide an almost direct visualisation of this principle, even if we cannot be sure that it is an accurate record of exact work methods. Yet if the picture librarian of the 1950s appears to sit permanently ensconced in the very material she is searching through, the woman handling a vintage photo album in the contemporary image looks like she has come in from somewhere else in order to retrieve a singular item. Rather than rifling through a stack of photographs, turning them back and forth to see both what is depicted on the front and what is written on the back, she looks to be working from a list of some sort, checking the visual contents of the album against the (presumably) textual information on her piece of paper. Just as the 1950s photograph documents the visually-led working practices of its own day, the more recent image illustrates how picture research in the digital age has become word-bound – even if, or perhaps especially when, the picture that is sought still resides in a physical archive – because the digitised catalogue and the keyword-based search engine have all but replaced the visual memory and expertise previously held by picture librarians and archivists. This is not to deny or ignore the existence and increasing prevalence of so-called image recognition software, which carries out searches on the basis of an uploaded image rather than an entered keyword. In the most advanced versions of such software the search algorithms are able to locate

images that are for example similar in form or colour. It is nevertheless the case that the most widely-used type of image search facility, the Google Search by Image feature, still relies on keywords or 'tags' in order to find similar images. It is, in Google's own terms, 'optimised to work well for content that is reasonably well *described* on the web' (Google 2012, my emphasis).[9] While it may appear as if the software can 'see', in other words, in fact it is still only reading and computing alphanumerical code.

Reading these two images as visual documents will, however, only get us so far in identifying their distinguishing traits as different kinds of archival photographs. In a particularly perspicacious discussion of how digital image archives are structured by the classificatory technology of keywording, Doireann Wallace has argued that the keywords assigned to digital image files are not so much intended to '*indicate* the location of the hidden image, but need to *stand in* for it' (2010: 88, original emphasis). As a totality, she suggests, 'the keyword cluster aspires to be *synonymous* with the image' (Wallace 2010: 88, original emphasis). Put another way, we could say that the keywords try to create a textual image, which corresponds as closely as possible to the visual one. Let us then consider the textual synonyms of the two photographs we are examining here, in the form of the keyword clusters that accompany them when the image files are called up via the Getty Images website. Figure 7.1 is furnished with the following set:

Scrutiny, Horizontal, Indoors, Europe, Black And White, Occupation, Examining, Holding, UK, England, Working, One Person, Photograph, 1951, Mid Adult, Librarian, Group Of Objects, Large Group of Objects, Mid Adult Women, Only Mid Adult Women, One Mid Adult Woman Only, One Woman Only, Picture Library, Photography, Filing Documents, Adults Only.

Figure 7.2, meanwhile, is identifiable with a much longer list of words and concepts:

Cotton, Care, Underground, Inside, Man Made, People, Activity, Image, Concepts & Topics, Description, Household Equipment, Clothing, Care, Equipment, Man Made Object, Built Structure, Furniture, Decor, Container, Casual Clothing, Garment, Information Equipment, Place of Work, Building Feature, Concentration, Box, History, Memories, Protective Workwear, Printed Media, Topics, Art and Craft Product, Research, Composition, Image Technique, Vertical, Waist Up, Indoors, Public Building, Image Type, Architectural Feature, Medium-length Hair, Document, Education Building, Warehouse, Standing, Looking, Touching, Examining, Holding, Library, Colors, White, Condition, Material, Old, Textile, Cotton, Position, Inside Of, Physical Description, Underground, Fragility, Shelf, Cellar, Glove, One Person, Beauty, Photograph, Sensory Perception, Moving Activity, Non-Moving Activity, Adult, Young Adult, Color Image, Bending, File, Photo Album, Nail File, Storage Room, Storage Compartment, Protective Glove, Searching,

Series, All People, Females, Women, One Young Woman Only, Only Women, One Woman Only, Picture Library, Setting, Photography, Physical Position, Photography Themes, Body Care, Focus On Foreground, Adults Only, Archives, Beautiful People, Cargo Hold, Basement, Human Gender, Number of People, Box, Beautiful Woman.

Apart from the considerable discrepancy in size between these two keyword clusters, the first thing that strikes one is how the words attached to the older image are more concrete, or rather, they require less imagination in order to associate with the depicted motif than do a number of the words attached to the more recent photograph. The 1950s photograph appears likely to find use as illustration of concepts and subjects more or less directly relevant to its motif, such as 'scrutiny', 'examining', 'photography', 'picture library' or 'filing documents'. The contemporary picture, meanwhile, is clearly intended for service in an almost endless variety of contexts, ranging from the obvious 'photography' to the nonsensical 'nail file'(!). Only six words are considered descriptive of both these photographs: 'indoors', 'holding', 'one woman only', 'picture library', 'photography' and 'adults only'. This is a surprisingly meagre overlap between the textual images of two photographs, which, to my mind, share so many visual components. Yet it may be explained by the different archival logics at work both at the point of production and at the stage of distribution. *Pile of Pictures* was probably produced to document, and potentially publicise, the working practices of the Keystone Press Agency, while *Vintage Photo Album* was most likely created on the basis of a conceptual brief.[10] This means that, whereas the photograph from 1951 will have been first 'keyworded' when it was selected from the analogue files and digitised, a number of the keywords pertaining to the contemporary image may have preceded the actual production of the photograph itself, as the outline of a textual image seeking visualisation.

It is worth exploring the ramifications of two other pieces of information provided by the metadata for each of these images. One is the 'licence type', and the other is the 'collection' to which each photograph belongs. The licence type indicates what kind of agreement a prospective picture buyer enters into when choosing to reproduce an image from a visual content provider. For Figure 7.1 the licence type is given as 'rights-managed', meaning that each use of the image will have to be individually specified and paid for, with a percentage of the reproduction fee – known as royalties – being paid to the photographer or his rights-holders in each case, for as long as the photograph is in copyright. In order to include the photograph in this volume, for example, the publisher has agreed to use it only once, inside the book and on an appropriate place in any electronic equivalent of it, for a limited period of up to seven years. After this period has expired, if the publishers wish to reprint the book, a new licence must be negotiated. The same applies if, within the period, they decided to include it on the cover of another edition, or in a different publication altogether. Such rights-managed licences are what Miller (1999) refers to with his expression 'pictures for rent', since they are the visual content providers' way of retaining control over the contexts in which an image appears. This in turn

safeguards its re-sale value, since it (at least in theory) stops an image being used for wildly conflicting or competing purposes at one and the same time. Figure 7.2, on the other hand, has what is termed a 'royalty-free' licence, which means that prospective users pay one fee only, and upon downloading the image file are free to use the photograph as many times and in as many contexts as they wish, in perpetuity. In these cases, the size of the fee varies only with the size of the file one wishes to download: small jpegs for online screen use only are cheap, whereas larger tiffs usable for print reproduction are more expensive. For this book, for instance, the fee paid for the royalty-free image was twice as large as that paid for the rights-managed one; however, the main difference is that the publishers are now free to store the image file for future use in any publication they wish. Another significant difference is that the contemporary image is furnished with signed model and property releases, meaning that both the person who posed for the picture and the owners of the place in which it was taken have signed agreements not to expect any (further) financial remuneration for their contribution. Such releases are these days common in both rights-managed and royalty-free collections, and many providers will not accept photographs of people that do not have model releases, for fear of litigation in case the image should be used in a context that disagrees with the person depicted. As model releases are not always readily obtainable from people who agree to be photographed simply in the process of doing their job, a photographer intending to produce a photograph for royalty-free usage is likely to engage a model to pose as the professional – which in this case may explain both the contrivance of the photo album scene and the inclusion of the tag 'beautiful woman' among the keywords.

The licence type is frequently tied to the kind of 'collection' to which an image is assigned by the visual content provider. Large commercial actors such as Getty Images use collections as ways of branding their stock, as it were, according to aesthetic, conceptual as well as economic criteria. The Vetta Collection, for instance, to which the 'Vintage Photo Album' image belongs, is described on the Getty website as 'hand-picked by a team of editors for accomplished art direction and intelligently executed concepts' (Getty Images 2012a), whereas the Hulton Archive collection, from which the *Pile of Pictures* photograph is taken, 'offers a wealth of socially significant, historical stock photos, editorial shots and more' (Getty Images 2012b).[11] In both these descriptions, the term collection is implicitly understood as an abstract entity; it designates a label attached to a certain number of images, which is intended to communicate something about their character, provenance or usability. Indeed, it is possible to browse the entirety of each collection by clicking on the hyperlinked title, just like ticking the box next to a keyword will take you to all the images in the database that have that word attached. Nevertheless, there is an important difference between the Vetta and Hulton Archive collections that is especially pertinent to the present discussion. This is the fact that while the Vetta Collection only exists in virtuality – as a trade name or brand for a certain number of digital image files that at any one time fulfil a specific set of aesthetic, conceptual and legal requirements – the Hulton Archive exists both in

virtuality and in actuality. That is to say, in addition to being a classificatory function on a website, the Hulton Archive is also a large, hangar-like space in West London, containing rows upon rows of shelves and filing cabinets, which in turn accommodate an estimated 60 million items, including the entire archive of the London branch of the Keystone Press Agency, from which the image in Figure 7.1 originates. When *Pile of Pictures* is identified as belonging to the Hulton Archive, then, this is true both of the analogue paper print, which is filed in a box somewhere in Woodfield Road, London W9, and of its digital incarnation as a piece of code, which may be rendered via software and screen into a visual as well as a textual image, accessible from anywhere in the world. What is more, it is precisely the Hulton Archive premises that provide the setting for the scene in Figure 7.2, which as we recall is captioned 'A woman handling pictures from the Hulton Archives'. Funnily enough, then, the older photograph may be one of the prints contained within those pristinely-ordered files filling the background of the newer image. In this way, the posed scene of the woman handling an album among the shelves can be read as a visual representation of how the digital archive turns its analogue predecessor into an object which is itself worth archiving.

Residual archives

Over the past years, as so-called 'new media' studies have proliferated, a good deal of research has also been produced on the subject of media technologies that have been made obsolete or outdated by the triumph of digitality. A variety of labels have been applied to these technologies, including 'dead' (Sterling n.d.) or 'zombie' media (Hertz and Parikka 2012). Over these slightly melodramatic alternatives we may instead choose the term 'residual media', which perhaps better conveys the complex relationship between old and new materials and practices. Coined by Charles R. Acland, the concept of residual media is directly inspired by the cultural theorist Raymond Williams, who argued for a dynamic division of cultural forms into the 'emergent', the 'dominant' and the 'residual' (Williams 1973, cited in Acland 2007: xx). Williams defined 'the residual' as that which 'has been effectively formed in the past, but is still active in the cultural process' (Williams 1982, cited in Acland 2007: xx). The residual, in other words, occupies a flexible territory where the past overlaps with the present, and where 'the formerly state of the art' (Acland 2007: xx) interfaces with the current cutting edge. Acland further explains that, '[t]he residual can be artifacts that occupy space in storage houses, are shipped to other parts of the world, are converted for other uses, accumulate in landfills, and relate to increasingly arcane skills' (Acland 2007: xx). The very same words might be used to describe the variety of ways in which analogue photographic archives persist into the digital age, whether as physical holdings taking up storage space, waste deposited in skips, or embodiments of a fast disappearing know-how. Collections such as those deaccessioned from the Tate and the V&A, or preserved by the *Guardian* and Getty Images, are, in short, residual archives shaped in and by the past, which nevertheless still exert agency in contemporary culture.

The analogue era produced materialist critiques of the ways photography supported and reinforced existing power structures through the institutional apparatus of the archive. This apparatus consisted of both technical installations such as filing cabinets and working practices such as classificatory editing; however, its workings were for the most part hidden in plain sight, that is to say, obscured by the visual impact of its contents. Today, the digital machinery that enables browsing and searching through online picture archives has become imperceptible to its users in much the same way. Yet as computers have assumed the position of default archival hardware older instruments of storage and retrieval have acquired a new visibility as both metaphor and referent. Thus the use of terms such as 'lightbox' and 'contact sheet' to denote interface features that allow researchers to assemble and print out search results from online image banks links directly to the analogue apparatus that has been replaced by software, in the same way that the fundamental digital concept of the 'file' reveals the archival origins of all computer technology.[12] In his much-cited book *Archive Fever*, Jacques Derrida noted that, 'the technical structure of the *archiving* archive also determines the structure of the *archivable* content' (1995: 17, original emphasis). Through the transfer of images from actual to virtual archives, the technical structure of analogue filing systems has itself become a form of archivable content worthy of preservation. In the case of a collection such as the curatorial archive of the V&A museum, it was precisely the destruction of its thematic classification system – in other words, its specific technical structure – which was decried as a scandal, regardless of the fact that its contents had been recorded and preserved in other systems. *The Lost Art of the Picture Library*, meanwhile, thematised this overlap between content and structure in its very title. The notion of a 'lost art' could refer with equal relevance to the photographers' images as unknown or unrecognised artworks, and to the 'art' of picture librarianship as a disappeared cultural practice. The marks and scribbles on the back of the photographic prints reproduced in the exhibition catalogue served in this context as the technical signs of an obsolete structure. Signifying the tactile materiality of analogue archival objects, they pointed to more than one kind of loss experienced in the migration of photographic images from analogue to digital archives. Most obviously, the prints embodied the era of paper and ink, which the *Guardian* newspaper was explicitly said to be leaving behind as it moved into its new, digitally-adapted premises. Less conspicuously, they were also the material traces of a lost profession, the practitioners of which had by the time of the exhibition become residual, if not altogether redundant. The two photographs from Getty Images illustrate how the digital archive is able to absorb even this aspect of the analogue archive as a visual residue of its technical structure. The figure of the working professional in the Hulton Archive photograph has in the Vetta Collection image been 'upgraded' to that of a posing model performing a simulation of the picture librarian's art. In this sense, the latter photograph produces what Michelle Henning (2007: 62) would call a 're-enchantment' of work in the analogue photographic archive, in much the same way that an Instagram picture presents a re-enchanted vision of analogue photographic imagery. Viewed together the two images provide an analogy of the very process

of digitisation, where the analogue referent is not just preserved but enhanced by its digital record. We are back at the 'paradoxical logic' identified by Manovich (2003 [1995]: 241), whereby digital technology effectively supplants the physical archive, yet in the process contrives to solidify, glorify and immortalise the archival.

Notes

1 This is a riff on Barthes (2000 [1980]: 95–96).
2 Questions of photography's archival logic have furthermore been prominent in debates on the posthumous reception of work by particular photographers, most notably that of Eugène Atget (see Krauss [1982] 1985 and Solomon-Godeau 1986). For a more recent approach to the nineteenth-century photographic archive, see Kelsey (2007).
3 A short article on the same subject was also published in English translation that year, see Bruhn (2003b).
4 In addition to these works, which have all been conducted broadly from within the field of visual culture studies, information scientists have produced a great deal of research into the more technical aspects of image archives, such as the design of search engines and metadata. This type of research investigates some of the same questions as those addressed in the present study, and at times it produces results that may productively inform the argument developed here. It is not, however, the task of this chapter either to survey or discuss the information-scientific take on visual archiving in detail, beyond the occasions where there is an immediately obvious and productive overlap of concern.
5 Computers of course also replaced a good number of people whose jobs it had been to operate these now-defunct tools – not least the original computers, who, as N. Katherine Hayles (2005: 1) reminds us, were for the most part women who spent their working days doing sums on analogue calculators.
6 This phenomenon was discussed in greater detail in Vestberg (2008).
7 It is significant that the two images used in the online promotion of the exhibition are credited to Robert Smithies, who was a staff photographer on the *Guardian* in the 1950s and 1960s (see Wainwright and Stephenson 2006).
8 The easiest way to establish a likely date for this photograph is nevertheless to Google the name of its photographer, René Mansi, and thereby locate his online portfolio, hosted by royalty-free stock provider iStockphoto. Here another photograph from this series appears, showing the same model in a different part of the archives, in the context of a blog post dated 16 August 2011 with the title 'IOTW' (most likely an acronym for 'Image Of The Week'), suggesting that the pictures had been recently submitted for promotion by the visual content provider at this time. The blog can be found at: www.istockphoto.com/urbancow [last accessed 10 October 2012].
9 The process is described by Google (2012) under the heading 'How It Works', in the following terms: 'Google uses computer vision techniques to match your image to other images in the Google Images index and additional image collections. From those matches, we try to generate an accurate "best guess" text description of your image, as well as find other images that have the same content as your search image. Your search results page can show results for that text description as well as related images.'
10 On Getty Images' pioneering use of briefs 'enjoining photographers to produce visuals that conjure up specific moods, feelings, and aspirations', see Kramer (2005: 144).
11 At the time of writing (September 2012) the number of 'intelligently executed concepts' available on a royalty-free licence from Vetta via the Getty website was in the region of 68,000, compared to approximately 42,000 'socially significant' historical and editorial images from the Hulton Archive. This in itself may give some indication of where the money is to be made on the photographic stock market.

12 On the often problematic use of metaphors in interface design, see Fuller (2003: 100–102).

Bibliography

Acland, C. R. (2007) 'Introduction', in *Residual Media*, Minneapolis, MN: University of Minnesota Press.

Alberge, D. (2012) 'Tate's national photographic archive "rescued from skip" after internal tip-off', *Guardian*, 23 February. Online. Available: www.guardian.co.uk/artanddesign/2012/feb/23/tate-national-photographic-archive-rescued (accessed 21 March 2013).

Barthes, R. (2000 [1994]) *Camera Lucida: Reflections on Photography*, trans. R. Howard, London: Vintage.

Blaschke, E. (2009) 'Du fonds photographique à la banque d'images. L'exploitation commerciale du visuel via la photographie – Le Fonds Bettmann et Corbis', *Études photographiques*, 24: 150–81.

——(2011) 'Photography and the Commodification of Images: From the Bettmann Archive to Corbis (ca. 1924–2010)', doctoral thesis, Paris: École des Hautes Études en Sciences Sociales.

Bruhn, M. (2003a) *Bildwirtschaft. Verwaltung und Verwertung der Sichtbarkeit*, Weimar: VDG.

——(2003b) 'Visualizing Services: Stock photography and the picture industry', *Genre*, 36: 365–82.

Derrida, J. (1995) *Archive Fever: A Freudian Impression*, trans. E. Prenowitz, Chicago: University of Chicago Press.

Didi-Huberman, G. (2003 [1982]) *The Invention of Hysteria: Charcot and the Photographic Iconography of the Salpêtrière*, Cambridge, MA: The MIT Press.

Dodd, L. (2008) *The Lost Art of the Picture Library*, London: the *Guardian* and the *Observer*.

Frosh, P. (2003) *The Image Factory: Consumer Culture, Photography and the Visual Content Industry*, Oxford: Berg.

Fuller, M. (2003) *Behind the Blip: Essays on the Culture of Software*, Williamsburg, VA: Autonomedia.

Getty Images (2012a) 'Vetta Collection – Premium Royalty Free Imagery', *Getty Images*. Online. Available: www.gettyimages.co.uk/Creative/Frontdoor/Vetta?Language=en-GB (accessed 21 March 2013).

——(2012b) 'Hulton Archive – Historical stock images and editorial shots', *Getty Images*. Online. Available: www.gettyimages.co.uk/creative/frontdoor/hultonarchive?isource=gbr_ImageCollections_RMCollections (accessed 21 March 2013).

Gibbs-Smith, C.H. (1950) 'The Hulton Picture Post Library', *Journal of Documentation*, 6(1): 12–24.

Google (2012) 'Search by Image – Google Images Help'. *Google*. Online. Available: http://support.google.com/images/bin/answer.py?hl=en&answer=1325808 (accessed 20 March 2013).

Hayles, N.K. (2005) *My Mother Was a Computer: Digital Subjects and Literary Texts*, Chicago: University of Chicago Press.

Henning, M. (2007) 'New Lamps for Old: Photography, Obsolescence, and Social Change', in C. R. Acland (ed.) *Residual Media*, Minneapolis, MN: University of Minnesota Press.

Hertz, G. and Parikka, J. (2012) 'Zombie Media: Circuit Bending Media Archaeology into an Art Method', *Leonardo*, 45(5): 424–30.

Kelsey, R. (2007) *Archive Style: Photographs and Illustrations for US Surveys, 1850–1890*, Berkeley, CA: University of California Press.

Kramer, C. (2005) 'Digital Beasts as Visual Esperanto: Getty Images and the Colonization of Sight', in L. Daston and G. Mitman (eds) *Thinking with Animals: New Perspectives on Anthropomorphism*, New York: Columbia University Press.

Krauss, R. (1985) 'Photography's Discursive Spaces (1982)', in *The Originality of the Avant-Garde and Other Modernist Myths*, Cambridge, MA: The MIT Press.

Manovich, L. (2003 [1995]) 'The Paradoxes of Digital Photography', in H.V. Amelunxen, S. Iglhaut and F. Rotzer (eds) *Photography after Photography*, Munich: Verlag der Kunst. Reprinted in L. Wells (ed.) *The Photography Reader*, London: Routledge.

Miller, J.A. (1999 [1996]) 'Pictures for Rent: From Stereoscope to Stereotype', in E. Lupton and J.A. Miller (eds) *Design Writing Research: Writing on Graphic Design,* London: Phaidon.

Rusbridger, A. (2008) 'Kings Place, the Guardian's new home', *Guardian*, 15 December. Online. Available: www.guardian.co.uk/media/2008/dec/15/theguardian (accessed 1 September 2012).

Sekula, A. (1986) 'The Body and the Archive', *October*, 39: 3–64.

——(2003 [1986]) 'Reading an Archive: Photography between Labour and Capital', in L. Wells (ed.) *The Photography Reader,* London: Routledge.

Solomon-Godeau, A. (1986) 'Canon Fodder: Authoring Eugène Atget', *The Print Collector's Newsletter,* 16(6): 221–27.

Sterling, B. (n.d.) 'The Dead Media Manifesto', Alamut. Online. Available: www.alamut. com/subj/artiface/deadMedia/dM_Manifesto.html (accessed 3 April 2013).

Tagg, J. (1988) *The Burden of Representation: Essays on Photographies and Histories* London: Macmillan.

Tope, A.S. and Enser, P.G.B (2000) 'Design and Implementation Factors in Electronic Image Retrieval Systems', *Library and Information Commission Research Report*, 105, London: Resource: The Council for Museums, Archives and Libraries.

Vestberg, N.L. (2008) 'Archival Value: On Photography, Materiality and Indexicality', *Photographies*, 1(1): 49-65.

Wainwright, M. and Stephenson, H. (2006) 'Obituary: Bob Smithies', *Guardian*, 3 August. Online. Available: www.guardian.co.uk/news/2006/aug/03/guardianobituaries.pressand publishing (accessed 21 March 2013).

Wallace, D. (2010) 'Words as Keys to the Image Bank', in C. Bailey and H. Gardiner (eds) *Revisualizing Visual Culture,* Farnham: Ashgate.

Wilkinson, H. (1997) '"The New Heraldry": Stock Photography, Visual Literacy, and Advertising in 1930s Britain' *Journal of Design History,* 10(1): 23–38.

8

BEYOND THE IMAGE BANK

Digital commercial photography

Paul Frosh

Is there a Leviathan of the image? Can we speak of a single, gigantic creature that encompasses and contains individual photographs, contractually appropriating their rights, purposes and capacities in a manner similar to the relationship proposed by Hobbes between human individuals and the state? An odd thought-experiment perhaps, given the ever-increasing diversity of images available for viewing since the invention of photography; an even stranger analogy given the almost profligate abundance of image sources, styles, content and uses that has accompanied the emergence of digital technologies, not to mention the challenge these technologies pose to the material stability of the photograph. In such conditions, how could something as mythically gargantuan as 'the Leviathan', or the reflections of a mid-seventeenth-century treatise on the contractual foundations of the absolute sovereign, have anything enlightening to impart about the state of the digital image?

A 2012 promotional video made by advertising agency AlmapBBDO might give some pause to our skepticism. The video was made for Getty Images, the largest corporation in the cultural industry known as 'stock photography', which to this day manufactures the overwhelming majority of images used in commercial contexts. The film is called *From Love to Bingo in 873 Images*,[1] and it shows 873 images selected from Getty Images' vast archive at a frame rate of 15 images per second. The carefully crafted result is a narrative montage that opens with a young man and woman kissing. It then shows various images of romance, moving through physical intimacy and partial nudity, intimations of sex and orgasm (pictures of fireworks), conception, birth, childhood, parenthood, extended family, community, aging, death (dark clouds, lightning), mourning and depression. The video draws towards its close with an upbeat visual crescendo of pictures depicting male success, riches and adventure (immense yachts, open seas), and ends with the planet Earth viewed from space accompanied by the title of the film and the final words 'Getty

38,297,841 Images' (with the 1 changing to a 2 and then a 3 in the closing seconds).[2] Throughout, the frame-rate ensures that the disparate images are incorporated into a moving storyline without being entirely subsumed, conserving their formal identities as individual pictures. The message is playful, clever and abundantly clear: all human life (if not all life on Earth) is gathered here, all stories, scenes and subjects preserved and contained within, ready for display (just as the numerical tally of images is 'contained' between the words 'Getty' and 'Images'). The film does not show life; it shows Getty Images showing life. The corporation, like the film that promotes it, is depicted as a replete microcosm of the world (or more properly, of the world-picture), and at the same time as the legitimate human ordering of the images that constitute it: a total archive that is also an ideal existence.[3]

There are several reasons why this video seems to support the weight of the Leviathan analogy. The most banal is that a corporation like Getty Images aspires to be state-like in its power, dominating the digital scene of commercial images as the absolute sovereign dominates the body-politic. This substantive analogy is given formal reinforcement when one recalls that the famous 1651 frontispiece to the first edition of Leviathan shows a giant monarch, bearing scepter and crosier, whose torso and arms are comprised of over 300 individual figures. The monarch is an indexical icon of totality, governed by relations of resemblance and composition with its subjects. Similarly, Getty incorporates individual images as the state does singular persons, simultaneously reproducing its own hierarchy and promoting its own legitimacy as a total archive: each photograph, in both its generality and its susceptibility to reconfiguration, acting as a kind of homunculus of the larger body to which it belongs.

The Getty video offers a fair introduction to the image-repertoire of stock photography. It is a world most of us find familiar – slim young executives gathered rapturously around the screen of a laptop computer; smiling parents and children frolicking in the surf on a sandy beach; an elderly couple walking serenely through an autumnal park – since the stock photography industry manufactures, promotes and distributes the bulk of photographic images used for marketing, advertising, editorial purposes, multimedia products, websites and other digital platforms; and, as I have noted elsewhere (Frosh 2003), its leading corporations also own some of the most important historical photographic archives and the digital reproduction rights to much of the world's fine art. Commercial stock photographs are by and large the kind of images we notice only peripherally as we flick through magazines, scan adverts in newspapers, pass by billboards, glance at publicity brochures and traverse windows, websites and screens on our mobile devices. Forming an overlooked but enveloping visual environment, stock photographs are the wallpaper of consumer culture.

Despite their familiarity, the ordinariness of these images is neither naturally given nor easily achieved. It is the result of an elaborate system of manufacture, distribution and consumption that is itself largely concealed from view: a system that for most of its history was known only to a relatively small coterie of cultural intermediaries working in photography, advertising, marketing, design, publishing and

a number of other media professions. Even today, despite its increased conspicuousness on the web in recent years, many if not most viewers have not heard of stock photography, and are unaware of the provenance of the pictures that surround them (surprisingly enough, most scholars of contemporary photography, visual culture, advertising and consumer culture have also ignored the stock business: rare exceptions include Miller 1999 and Machin 2004). Stock photography therefore seems to enjoy a powerful ideological advantage over other sectors producing contemporary visual culture: invisibility.

A common habit of thought among critical analysts of visual culture would have us conclude from this that we are the victims of some horrific plot: obscure powers systematically producing the visual background to our lives, and the 'monopoly of appearance' (Debord 1970: 12) of our societies, while escaping our conscious attention; Leviathan indeed, but hidden. Yet the general analogy to the state, and the hermeneutics of suspicion that instinctively informs much critical work on consumer and commercial culture (and the gesture of unveiling which is its common antidote), break down into more subtle and slippery components when the 'system' of commercial photography comes into closer view. These include what we might call – following Martin Jay (1988) – 'moments of unease' in the dominant scopic regime. Hence, in this chapter I will attempt to examine stock photography dialectically, as a set of discourses and cultural practices that can tell us not only about the systemic organization and efficient functioning of digitized commercial visual culture, but about its crises and fault-lines, paying particular attention to developments that have occurred since the 2003 publication of my book *The Image Factory: Consumer Culture, Photography and the Visual Content Industry*. In particular, this chapter will explore how digital technologies have helped to destabilize – though not necessarily transform – commercial visual culture in a number of overlapping domains: the rise and tribulations of global stock photography corporations dominating commercial image-production; the expansion of an informational understanding of photographs as 'visual content' that blurs traditional distinctions between editorial, art and advertising images; and the advent of 'microstock' and photo-sharing sites that have ostensibly broken down barriers between amateur and professional photographers through forms of 'crowd-sourcing'. Before I turn to these topics, however, a little background is in order.

Taking stock of stock

The stock photography business emerged as a fully-fledged, self-conscious industry in the 1970s.[4] Following a period of radical reorganization and aggressive consolidation in the early 1990s, in which large stock agencies were acquired by yet larger competitors and integrated into global conglomerates in a burgeoning 'visual content' industry (Frosh 2003, Chapter 8), stock photography is today dominated by two multinational 'super-agencies' headquartered in the US but global in their reach and aspirations. The largest (in terms of revenues and profits) is Getty Images PLC, which owns such brand names (and image libraries) as The Image Bank,

Tony Stone (renamed Stone) and historical collections such as the Hulton-Deutsch archive (renamed the Hulton Archive); its principal competitor is Corbis, privately financed by Microsoft President Bill Gates and sometimes considered the image-acquisition arm of Microsoft (and still, according to most industry observers, of uncertain profitability: Lang 2006c; Weiss, December 9, 2010). These global conglomerates compete alongside a much larger number of smaller and medium-sized agencies in a range of specialist fields: 'creative' lifestyle and marketing imagery, contemporary editorial photography, historical images, sport, celebrities, illustrations and fine art prints, and stock film footage.[5]

How are photographs produced within the stock business? It is worth distinguishing between two principal production models. In the traditional model, known generally as 'rights controlled', 'managed rights' or 'rights protected' stock photography, agencies 'rent out' images: they sell clients in advertising, marketing and related sectors the right to reproduce images that they themselves have acquired from freelance photographers. In return the photographers get a share of the revenue (usually well below 50 per cent) generated from these sales. These images are kept in 'stock' by the agency, duplicated, filed, categorized and cross-referenced according to general classifications of content, style, provenance and potential meanings, before being marketed – formerly through printed catalogues and CDs, today almost exclusively through agency websites. Prices are subject to negotiation with clients but are primarily determined by usage, and they can range from several hundred US dollars for use in a small brochure to many thousands for national advertising campaigns.

In the 1990s, digital technologies enabled the relatively inexpensive storage, duplication and distribution of images, giving rise to an entirely new sector of 'royalty free' (RF) photographs. Royalty-free photographs are sold on a single-fee, multiple-use, mass-distribution principle, which means that, in contrast to rights-protected stock photography, purchase of the image includes purchase of a very broad, non-exclusive license to use the image as the purchaser sees fit. In other words, royalty-free embodies a pay-per-image principle, in contrast to rights-controlled stock that embodies a pay-per-use principle. This difference reflects the way photographers are paid: in the rights-controlled system photographers receive a percentage every time a license to use their image is sold; with royalty-free they are paid for the initial reproduction rights but not subsequently. Available individually or through virtual collections online at around $500 for anything between 50 and several hundred photographs, royalty-free images are priced beyond the mass consumer market they were originally targeted at in the late 1990s, and now mainly appeal to professional cultural intermediaries looking for 'low-end', lower cost and instantly available images without the need for exclusivity. Despite early concerns that royalty-free 'hack work' would take business away from rights-controlled stock photography, all of the large super-agencies, and many of the smaller ones, operate both systems side-by-side, seeking competitive advantage in an increasingly crowded and image-saturated field by increasing rather than limiting the options available to their clients.

Indeed, one of the most conspicuous characteristics of the stock industry over the last decade or so has been the proliferation of a number of new business and production systems. Some of these are 'hybrid' forms combining the exclusivity and purported image quality of rights-protected stock with the online ease of access and standardized contracts and pricing associated with royalty-free (Stafford 2005). Some of the systems are borrowed from neighboring industries (for instance, traditional news wire services), such as monthly and yearly subscription plans, and some of them are initiatives originating with photographers themselves (more about which later in this chapter). What are the implications of these fluctuations in organizational and image-production systems for broader trends in visual and consumer culture? The clearest way of answering this question is by looking in turn at three interlinked questions: 1) how is representational power (the power to define and construct images of the world) currently organized; 2) what is the *reach* of the industry in terms of its control over archives and in terms of its relation to other, related sectors of photographic production; 3) what does 'the spectacle' look like – what visual regime characterizes the stock industry and the domains it supplies?

Representational power and cultural authority

The informational ontology of the stock image

Stock photographs are information. More to the point, they were always information, even before the advent of digital technologies. Their informational structure is manifested in their alienability from a particular referential source, their autonomy from a specific intentionality of use and reception, their material malleability (the fact that they are amenable to replication, alteration and fragmentation) and their archival origination – all features of the contemporary conceptualization of information as a particular kind of 'stuff' in the world (Nunberg 1996).

Central to this informational character is the 'generic' nature of the stock photograph. This refers to two key forms of delimited ambivalence: referential and interpretive. The generic image is *referentially ambivalent* because even though it is putatively anchored in the space-time of its referent by photographic indexicality, it uses paid models and is almost always staged: i.e. the reference world depicted by the image has been pre-constituted in order to be photographed; it is a performance shaped to resemble the prevalent image-genres already recognizable to stock agencies, advertisers and consumers (this is one reason why stock photography is archival in Foucault's (1972) sense: it is a generative system that governs the production of statements). The generic stock image is *interpretively ambivalent* because it is polysemic and formally malleable by design. It is 'promiscuous' (McQuire 1998), intended to be resold time and again for a range of diverse uses and products, media platforms and contexts of reception, many of which are unanticipated by either the photographer or stock agency. Nevertheless, while the specificity of actual future uses and meanings is impossible to predict, the semiotic possibilities of the image are *not* infinite: again, this is because the image is 'generic', governed by

categorical conventions of resemblance and affiliation to image-types and the marketing sectors they are associated with (an image of a young couple walking along a beach at sunset may be used to promote vacation packages, life insurance or a dating agency: it is unlikely to be used to sell computer screens). Hence the stock image is designed to offer a *parsimonious plurality* of possible interpretations: genre acts as the framework within which potential meanings can be actualized. That is why the stock photograph is, to invert Barthes, 'a code without a message' (Frosh 2003).

Why, then, is this 'generic' condition informational? The generic image's parsimonious plurality of meanings is in effect an anticipated range of message outcomes. These outcomes are dictated by the overall mode of commercial photographic production, where photographers utilize the success of other images and image categories to gauge the possible interpretations of cultural intermediaries (stock photography agencies), who in turn estimate the possible interpretations of *other* cultural intermediaries (their clients: advertisers, marketers, etc.), who in turn anticipate the possible interpretations of consumers. The stock photograph is thus a deliberately *probabilistic* entity within an overall system of multiple calculation and anticipation. This echoes the definition of information in Warren Weaver's influential extension of Claude Shannon's signal transmission theory:

> The word information relates not so much to what you *do* say, as to what you *could* say. That is, information is a measure of your freedom of choice when you select a message. The concept of information applies not to the individual messages, as the concept of meaning would, but rather to the situation as a whole
>
> *(Weaver, 1966: 17–18)*[6]

Within the stock system the meaning of a given image is held in abeyance, made *overtly* dependent upon the probabilistic calculation of future decodings. Crucially, it is as a probabilistic entity rather than as a particular semantic message that the stock image's monetary value is realized: the higher an image's range of informational 'freedom' (in Weaver's definition), the larger the variety of likely interpretations and uses, the greater the number of repeat sales it will enjoy, and the more income it will accrue for its photographer and stock agency.

The informational nature of stock photography thus has far more to do with its commercial and organizational structure than with whether analog or digital technologies are being employed. This does not mean that digital technologies have not impacted the production and distribution of commercial photographic images, or – as we shall see below – that the proliferation of platforms and devices has not destabilized notions of photographic expertise, as well as industrial price mechanisms. It does suggest, however, that the informational logic of digital systems not only preceded those systems historically (as many others have claimed (Robins and Webster 1999)), but also that if we wish to trace the transformations wrought by digital media we would do well to shift our gaze away from the ontology of the image.

The disappearing middle and the proliferation of expertise

Resonating with claims that the current era is characterized by the 'excluded middle' (Silverstone 1999: 26), medium-sized stock agencies have found it increasingly hard to compete with the delivery systems, costs and marketing power of the super-agencies on the one hand, and the specialist capacities of small niche agencies on the other. In fact, a symbiotic relationship has emerged between specialist niche agencies (which focus on subjects as diverse as medical imagery, golf, lesbian and gay images, ethnic minorities, aerial photography, etc.) and the super-agencies, which is somewhat akin to the way that giant media conglomerates relate to high technology start-ups looking to develop 'killer applications': the small agency develops the market along with its own brand and clientele and then enters into an exclusive distribution partnership with a super-agency. Occasionally the super-agency buys out the niche agency entirely, especially if the latter has achieved brand recognition across the board: one of Getty's key acquisitions in the mid-2000s was Photonica, a highly-regarded Japanese agency specializing in 'avant-garde', 'signature style' (Miller 1999: 129) and unconventional stock photography (i.e. stock photography that doesn't look like stock photography).[7]

The implications of this kind of structure are revealed in the words of the Getty Images Press Release (May 13, 2005) announcing the deal: Photonica (and its sister collection, Iconica),

> are considered the 'hidden gems' of the imagery business – highly respected by creative professionals but with limited global sales, marketing and distribution. As a result of this acquisition, both Photonica and Iconica will be distributed via gettyimages.com, the de-facto homepage of visual communicators.

This quote reveals the structure of brand values, which discursively underpins the stock industry's institutional division into an upper tier of oligopolistic super-agencies and a lower tier of intensely competitive niche agencies. The upper tier is based upon the super-agencies' status as aggregators and their unprecedented ingathering of vast numbers of images (Getty is the 'de facto homepage'; 'Getty is the obvious one-stop shop': Anderson 2005); their expensively developed, fast and reliable delivery technologies; their omnipresent marketing and their grandness of scale in general: these, at least, are the reasons art buyers in large US advertising firms seem to give for mainly using Getty and Corbis (see Anderson 2005; Gordon 2012). In response, the lower tier of small agencies is impelled towards a continual proliferation of market niches (genres, styles and subject-matter), and the concomitant multiplication of apparently singular forms of aesthetic, technical and substantive proficiency. Photographic practices and the photographable world are differentiated into a profusion of ever-narrower areas of specialization, which can be harnessed to rhetorics of expertise and to the promotion of each agency's brand distinctiveness. Finally, these niche specializations are integrated via the super-agencies

into a new alignment that attempts to resolve some age-old tensions at the heart of industrial cultural production in general: between formula and originality, familiarity and novelty, quantity and singularity (Adorno and Horkheimer 1979; Gendron 1986; Ryan 1992). In terms of content and style the super-agencies are voracious generalists for whom each photograph, illustration or film clip is yet another standardized unit of pixels, costs and revenues (Frosh 2003); but then they have all these minutely calibrated brands (Photonica, Stone, The Image Bank, Photodisc, Hulton), each a distinctive expert in its particular field, each reliably and quickly delivering to your computer the very specific image you so badly need.

Crowd-sourcing stock?

Notwithstanding this symbiosis of super-agencies and niche expertise, new forms of organization are developing that potentially undermine conventional certainties about photography as a commercial profession. The most significant are 'microstock' websites, or as they were once known 'community-based' or 'micropayment' sites. Primarily aimed at individual consumers and small businesses (though IBM were found to have bought an image from a microstock site: Lang 2006a), microstock services directly exploit the uploading, archiving and distribution potential of digital photography and the internet, selling stock photographs for as little as one dollar (or ten for a higher resolution image), with photographers earning approximately 20 per cent every time an image is sold. They also offer virtually anyone with a reasonably good digital SLR camera and basic technical ability the chance to post and market their images.[8] Microstock sites therefore seem to promise a radical democratization of technical and aesthetic expertise or, looked at from the point of view of many 'high end' stock photographers and executives, threaten to devalue the professional status of the stock industry altogether. This is not merely because of their low rates, fast turnover and simple methods of contributing images; it is also because many of the microstock sites position themselves as self-organizing *communities* of people interested in creating images and designs, and in helping others do so (hence the 'community-based' moniker). Istockphoto, one of the first and along with Shutterstock among the most successful microstock services, began in 2000 as a site for designers and photographers to exchange images. Members not only had access to a vast selection of photographs, illustrations and design projects, which were available for download for anything from between a few dollars to several hundred (depending upon resolution, topic, source provenance), they could also read articles giving practical advice on all manner of technical issues (how to shoot in twilight, how to work with models etc.), participate in forum discussions on related questions and receive constructive critiques of their images by other members. The site used interactive technologies, the data structures and rhetoric associated with virtual communities (forums, membership) and the web's version of a gift economy to promote itself as simultaneously a space of commercial exchange and of altruistically nurtured creativity and learning. It is tempting to see such altruism as a ruse, especially since the acquisition of Istockphoto by Getty Images in 2006. Yet it also

reveals the radical definitional fluidity of the 'field' of commercial photography; even of a burgeoning classification struggle (Bourdieu 1993) over previously unquestioned distinctions and assumptions: who can be a stock photographer (and who decides)? Why is stock photography a profession? And perhaps most significantly, what is the difference between an exclusive, expensive, rights-controlled image made by a veteran Getty Images photographer, and a $1 image made by a talented amateur or semi-professional? Especially if the latter is good enough for IBM?

Such challenges – and their potential resolution in terms favourable to the 'Leviathan' of commercial imagery – are evident in two other examples: the rise of Alamy, and the relationship between Getty and Flickr. Alamy was established in 1999 as a completely open site, accessible to professionals and non-professionals alike, without distinction. The company's website boasts that 15,000 new images are added every day, with '450,000 new images every month from world leading image libraries, award winning professional photographers and talented amateurs.' (www.alamy.com – 12 September 2012). Its individual contributors – '[with] over 27,000 photographers, from top notch professionals to accomplished enthusiasts, Alamy is home to the world's most diverse group of image creators' – are promised maximum flexibility, non-exclusive contracts and fees of 60 per cent of each sale (according to Alamy, the highest in the industry). In a sense, Alamy represents one apparently logical outcome of the rise of Web 2.0 initiatives, and the collapse of discernible aesthetic differences – in most contexts and on most platforms – between professionally produced images and photographs created by skilled amateurs: given this collapse it would seem nonsensical to maintain the distinctions between them through separate websites, terminology (stock versus microstock) or corporate entities (the marketing fiction of Istockphoto's autonomy from Getty). '

Yet Getty's relationship with photo-hosting and sharing site Flickr reveals that these distinctions can nevertheless prove useful. A 2008 agreement allowed Getty Images to approach Flickr contributors whose images it liked with an offer to license their pictures for sale through a special 'Flickr' branded section on Getty's own website (Lowensohn 2008).[9] According to its current (2012) website Getty now promotes 120,000 Flickr images. This is how the 'collection' is described:

> Flickr. Life as it happens.
> Welcome to the collection that points a lens at real life. With shots that look and feel authentic – because they are. Rather than commissioned shoots, Flickr photographers capture what they love – real people, real settings, real events as they unfold. ... Our Flickr collection reflects the passion of a community of photographers worldwide, featuring uniquely personal images with an authenticity rare in stock photography.
>
> *(www.gettyimages.com/creative/frontdoor/flickrphotos)*

Alamy collapses the distinction between professional and non-professional images by 'monetizing' the latter as though they were the former. Getty is more subtle: it turns Flickr's amateur images and community ethos into saleable commodities while

utilizing their non-commercial status as brand values ('real' people, 'community', 'passion' and above all 'authenticity') that set it apart from mere 'stock photography' cliché. As a result of this discursive manoeuvre Getty itself becomes the agent of aesthetic renewal and populist realism in an industry whose very name – 'stock' – conveys the dominance of the formula and the commodity. Getty, the largest stock photography company in the world, becomes both thesis and antithesis, incorporating its own opposition. In simpler words: it can have its cake and eat it.

These examples and issues are of course connected more broadly to the development of Web 2.0 platforms, as well as to concepts associated with digital culture more generally, especially notions of cultural convergence (Jenkins 2006) and prosumption (Ritzer and Jurgenson, 2010): indeed, the very term 'crowdsourcing' was coined in a 2006 article in *Wired* magazine whose primary example of the phenomenon was Istockphoto (Howe 2006). While classification struggles for cultural authority principally engage the attention of those within the traditional stock photography industry, the destabilizing consequences of technological change are broadly consonant with similar trends in a range of cultural industries. Yet, as with Getty's exploitation of Flickr, this consonance should not disguise the fact that the industry has always been based on the systemic reconciliation (through marketing and price differentiation) of apparently insuperable distinctions in the expertise of practitioners or in the status of images (Frosh 2003). Although the rise of digital networks has greatly broadened the fronts on which these reconciliations are challenged and performed, they have not necessarily changed the logics through which they operate.

The reach of the stock industry

In the late 1990s and early 2000s a new term, the 'visual content industry' (introduced and largely employed by Getty Images), seemed to be emerging to describe the expansion of the stock industry's super-agencies into new areas: sport photography, celebrity photography, fine art reproductions, illustration, stock film footage, historical archives and photojournalism.[10] While the use of this term has not caught on ('stock photography' has shown a great deal of resilience) the expansion has become increasingly institutionalized, as has the apparent blurring of discursive and organizational boundaries between the three great photographic fields of art photography, advertising photography and documentary photojournalism (known in the trade as 'editorial photography').

It is in the latter case that this realignment of fields has become most conspicuous. Here Getty is pitted not just against Corbis but also against the three main global wire services: Reuters, Associated Press (AP) and Agence France-Presse (AFP). Getty's move into editorial work gathered pace in the mid-2000s:

> In the last two years, Getty has steadily encroached onto the newspaper market long dominated by AP and Reuters. Though editorial sales account

for only 12 percent of Getty's overall revenue, the company sees its bylines in the major newspapers as invaluable advertising for its commercial licensing business.

(Defoore 2005)

Getty's forward advance into the wire services' territory was accompanied by the hiring of veteran wire service photographers and editors in the US as well as in growing new markets such as China. Reuters and AP reorganized their photography divisions in response: AP currently has a global distribution agreement with Corbis, while AFP entered into a global content sharing and distribution partnership with Getty in 2003. In what was possibly the opening salvo in a counter-offensive against Getty's core business, AP announced in 2006 that it would allow its employees to use company equipment to shoot commercial stock images in their spare time (Lang 2006b). Currently AP is behind a new separate photography agency (Invision) designed to counter Getty's venture into entertainment news images.

It is tempting to conclude from these developments that the distinctions between documentary photography and advertising imagery are collapsing entirely, notwithstanding the crucial differences in their modes of signification. Such a conclusion could be supported by the packaging of Getty's photojournalistic content both as 'advertising' for its commercial imagery (as Defoore puts it), and as merely one among many diverse services Getty now offers to newspapers:

> The newspaper world is one of the most diverse and those people have very different picture needs ... We can supply travel pictures, lifestyle pictures, celebrity, sports and news pictures. I don't think the traditional wires offer anything close to that.
>
> *(Richard Ellis, Getty Images Senior VP Business Development, quoted in Defoore 2005)*

However, Getty is at pains to distinguish itself from the traditional 'generalist' approach of the wire services by emphasizing the role of specialization: its photographers remain in their areas of expertise (stock, entertainment, celebrity, sports, news) and one is unlikely to find the kind of transitions where editorial staff photographers are encouraged to shoot stock in their spare time (AP, in contrast, emphasizes the 'universality' of photography and overall standards of quality in all fields). Hence as part of the rhetoric used to position itself as the ultimate 'one-stop-shop' for newspapers as well as for advertisers and marketers, Getty has shifted away from its former promotion of 'content' as an abstract universal and is reinstating discourses of field-specific expertise and cultural authority as a way of expanding into new markets (this echoes the strategy of simultaneous incorporation and differentiation employed with Flickr). This gives it a persuasive answer to the most obvious question a prospective client would ask: why would a commercial photography corporation like Getty be any good at photojournalism? Rather than

saying 'because shooting editorial is like shooting stock, and a good photographer can do both', Getty says 'because we recognize that photojournalism is *not* like stock, so we've hired the best photojournalists'. Of course, a key upshot of Getty (and Corbis') expansion into photojournalism is that documentary photographs do therefore become more like stock: they become increasingly subject to an informational logic, abstracted from immediate contexts of use and open for multiple forms of resale and recycling in a plethora of contexts, both journalistic and non-journalistic (such as publishing and advertising). The paradox is that in order to integrate traditionally separate cultural fields in pursuit of such forms of content mobility and synergy, an organization like Getty needs to re-emphasize their distinctive practices, values, forms of expert knowledge and signifying modes.[11]

What does the spectacle look like?

Variety and hegemony

Perhaps the key question to be asked after the foregoing political-economic account of the stock industry is: yes, but what do stock images look like? Do they promote a particular, unified view of the world, as the analogy of the Leviathan suggests? And do they privilege certain visual practices and forms of looking?

Traditionally the stock system is often accused – by clients and industry insiders as well as critics – of encouraging conservatism and the constant reproduction of formulaic images, which reflect, construct and reinforce cultural stereotypes. Although some commentators, looking at microstock sites in particular, claim that the sheer range of customer needs and new image providers (photographers) has led to an expansion in the variety of images – for example, Shutterstock's 'contributors have covered almost every-thing, topic-wise – to the extent that, even with my occasionally zany image searches, it's extremely rare to have a query come up blank' (Garber 2012) – this does not seem to characterize the industry as a whole. Recent surveys and interviews with stock photography clients repeatedly emphasize the predominance of clichéd and stereotypical images (Photoshelter 2011; Gordon 2012;), just as they did more than ten years ago. Such images are primarily geared towards consumer advertising's traditional promotion of products through the promulgation of well-being (Leiss, Kline and Jhally 1997), and they therefore almost always focus on middle-class American and European leisure activities (for instance, beach vacations), demographic categories (especially age, gender and ethnicity), as well as seemingly universal depictions of 'relationships' – kinship, friendship and romance.

Nevertheless, shifts in advertising and marketing practices since at least the mid-90s have led to the appearance of less obviously stereotyped and more diverse image styles and content, including 'artistic' or 'edgy' images, more 'realistic' images (i.e. images with a domestic or amateur aesthetic) and images of 'ordinary' (that is, not conventionally good looking), 'ethnic' and minority subjects. A recent

foray into the perpetual search for 'ordinary' or 'real' people – individuals whose appearance could work well in adverts because they don't look like the kind of people who would appear in adverts – is the advent of an agency like 'Citizen Stock', whose 'models aren't models at all, but children, moms, dads, grandparents, skateboarders, lawyers, teachers, musicians, chefs, artists, office workers, clothing designers, shop clerks and small business owners, to name a few' (www.citizen-stock.com, September 10 2012). What unites all of these disparate identities and trades is their 'non-model' status, as though – notwithstanding the ubiquity of cameras in our everyday lives – the performativity of photographic staging could be contained to a handful of 'unreal' professional models: somehow, it is assumed, none of the rest of us 'act' when a camera is present. More particularly, these non-models are all photographed against a standard white background, thereby easing their decontextualization and reconfiguration with other image elements in the production of further image-composites. In other words, the continual search for 'non-stock' stock images, characterized by 'real' people, is nevertheless designed to facilitate the extreme generalization of individuals and the radical decontextualization of referents that together constitute stock photography's chief contribution to the visual logic of consumer culture.

Thumbnail visibility

Can we discern a dominant mode of viewing that is promulgated by stock photography? One largely neglected factor affecting the style of stock images – in fact, of potentially all images displayed as part of an archive or database on a computer screen – is described as follows:

> The primary thing right now in the world of online is visibility. It really comes down to simplicity. This cannot be overstated. If a photographer incorporates that into how they shoot images, it will be greatly to their benefit. ... [They] have to assume that it will not be seen at larger than thumbnail size on the first-go round. So when constructing an image, it means that you're going to come in tighter, or you'll put less subtlety in an image, which is a shame because some of the best pictures in the world are extremely subtle.
>
> (Patrick Donehue of Corbis, quoted in Stafford 2005)

This is an acute observation. It means that for all the stock industry's rhetoric about visionary photographers, avant-garde and edgy styles, the pioneering use of new techniques and digital technologies, one of the most profound aesthetic developments in commercial photography is linked to that largely overlooked (in both the literal and metaphorical sense) contemporary form, the *thumbnail image*. The thumbnail appears as the formal and technical embodiment of a number of intertwined, paradoxical and self-perpetuating dynamics at work more broadly in contemporary media-saturated societies: a) the increasing colonization of material and virtual spaces by an ever growing quantity of images, leading to b) the

burgeoning of media 'clutter' and 'noise', which are perceived to interfere with the ideal of attentive communication between viewers and images, not least because they result in c) a viewing culture that privileges visual distraction and the inattentive glance in order to accommodate the increasing demands of so many images upon one's attention.[12]

In terms of the stock industry the conundrum works as follows: the challenge for photographers and stock agencies is to make every image an 'arresting' image, seizing hold of the viewer's mobile gaze amid the 'clutter' generated by all other images. Every image therefore cries out for attention, and yet in so doing every image also threatens to become 'noise', distracting the viewer from neighbouring images. The thumbnail physically reduces this narcissistic cacophony of images to an instrumental grid on a screen, and its smallness of scale demands of photographers an increasing simplicity of style, content and form, since subtlety cannot be swiftly scanned in such minutiae.

Is this the promised future of commercial and even editorial photography? More intensively researched, expertly crafted, niche-marketed images that turn out to be at least as starkly stereotypical as those that preceded them, since no one has enough time to pay attention to subtlety and complexity? There is no easy answer to this question. One observation is certainly apt: the thumbnail image represents the *relocation* of the pre-digital printed catalogue onto the computer screen, rather than a repudiation or alteration of previous modes of image display. The graphic grid of the pre-digital catalogue page was itself informational and archival in ways that have been replicated and extended by new media, and these logics persist in their 'remediated' digital form (Bolter and Grusin 1999), augmented rather than transformed by the search capabilities that can 'refresh' the grid of images from an underlying database. Yet as a result of this extension it may be that in 'thumbnail visibility' the stock industry has found a representational figure for a total visual archive that also turns out to be retrospectively perspicuous: a template of simplified images that invites the superficially scanning eye, and is designed to do nothing less than populate the overlooked visual environment that forms the background to our lives. Stock photography's thumbnail galleries may constitute the ultimate sample cases of the contemporary consumer spectacle.

Conclusion: Leviathan laughing alone with salad

In the introduction to this chapter I referred to the potential 'fault-lines' and 'moments of unease' in the scopic regime of contemporary consumer culture that may be glimpsed as a result of the digitization of commercial stock photography. 'Woman Laughing Alone with Salad' is one such fault-line: vast numbers of generic stock images of conventionally attractive young women eating salads alone, while laughing. Encountered individually – in, for instance, promotional material for diets or health food – such images rarely invite comment. Yet when assembled in their tens at websites such as The Hairpin (http://thehairpin.com/2011/01/women-laughing-alone-with-salad), or aggregated by the search algorithms of

Google or the participatory 'sharing' conventions of social media such as Tumblr, these images' asinine nature becomes obvious: one woman laughing while eating a salad alone might be explicable, but all of these women doing it, as though it was somehow routine behavior, is not. The images become surreal, ridiculous, and – in their presentation of women as facile – offensive (the same applies, it should be added, to 'Women Struggling to Drink Water': http://thehairpin.com/2011/11/women-struggling-to-drink-water/). Indeed, it is less the images themselves that are opened to ridicule and critique, than the drive to repeat them, the trope itself, and the whole mechanism whereby apparent realities are constructed through the proliferation of pseudo-variations of a (patriarchal) template.

Two elements of digital technologies have conspired to enable this fissure in the system. The first is the aggregating capacities of the web: before the web images of women eating salad or struggling to drink water would only have been encountered singly, and anyone seeking to assemble and display them publicly as a category would have had to engage in a Warburgian trawl through catalogues and archives (to which they would have needed access) and publish them in print. Few outside of the stock industry would have had the ability to do this, and few within it the motivation. The fact that the web is effectively a vast, interlinked database, that stock photography has moved most of its (contemporary) archives online, and that much of the work of locating and aggregating content has been automated through software and amplified by social media, means that the core image categories of everyday consumer culture can now be made visible in concentrated form.

The second element of digital technologies is their current propensity to foreground the 'memetic' nature of much cultural production. 'Memes' – units of cultural content and form characterized by replication and mutation – are not new, neither in conceptualization nor in practice, but the web and social media have enabled their multiplication as preferred modes of web-based popular expression, while at the same time making visible memetic procedures of replication, mutation and dissemination (Shifman forthcoming). The exposure and aggregation in concentrated spaces of so many similar stock images shows them not only to be variants of the same format, but poses the question of who, precisely, in an era of popular internet memes produced through 'participatory culture' (Jenkins 2006), would dream up this particular memetic content, and what mechanisms would facilitate the extensive replication of such repressive inanity. The memetic dynamics of web-based popular cultural production have not only potentially increased awareness of the procedures and techniques for replicating and mutating texts; they have created a reflexive space, a fault-line, for the critique of those procedures as they are practiced behind previously opaque walls of institutional and ideological invisibility.

We have become used to speaking of digital technologies in terms of 'transformation', focusing on whether or not they have changed the very shape and fabric of our world. This is to speak the language of alchemy, of magical alteration, of the substitution of forms and the reconstitution of matter. It would be prudent to adopt – at least in this instance – a different metaphor: 'distress'. For as I have argued,

digital media have not altered the core logics of commercial stock photography, since those logics were already informational. What they have done is to extend them beyond previous institutional, generic and technical boundaries. It is therefore more fitting to say that digital media have *distressed* rather than transformed the domain of commercial photography: they have distressed it in the way that a storm can distress the material and structure of a building, stretching and straining its original form and putting it under new degrees of pressure without reconstituting its entire being. Of course, distress can lead to structural and material damage: fault-lines and cracks that require repair, maintenance and occasional adaptation. And it is frequently through the sudden presence of these cracks that bypassers can catch a glimpse of the infrastructure, of how the whole edifice operates and is held together still. Digital distress has helped to fissure the system, making Leviathan observable beneath the routine banality of its millions upon millions of images.

Notes

1 The video can be seen on YouTube at: http://youtu.be/E7xc7J8bdsU.
2 This estimate of close to 40 million images for the Getty Archive seems very conservative. Reports at the time of Getty's $3.3 billion sale to private equity company The Carlyle Group in 2012 put the number closer to 80 million.
3 Interestingly, the film is stylistically and thematically similar to others either made by or in homage to media corporations: for instance, Google's NFL Superbowl commercial 'Parisian Love' (http://youtu.be/nnsSUqgkDwU) and 'A Life on Facebook' (http://youtu.be/mCUCZCBso_w), both of which share the Getty film's 'lifecourse' narrative arc and its theme of informational totality.
4 For analyses of stock agencies in earlier periods see Miller (1999), Wilkinson (1997) and Hiley (1983). For a fuller consideration of its historical emergence and its principal characteristics see Frosh (2003), especially Chapters 2 and 3.
5 Getty, for instance, as well as selling clips from its own wholly-owned film archives, also distributes footage from Universal Studios films, just in case you want a few frames from *Apollo 13* in your next advert, corporate video or multimedia product.
6 Weaver's extension of Shannon was influential but also controversial: see Ritchie (1986).
7 Photonica was bought by Getty along with Iconica, a slightly more conventional rights-controlled brand, from the Tokyo-based Amana Group in 2005 (for $51 million). See 'Getty Images to Acquire Photonica and Iconica' (Getty Images Press Release, May 13 2005).
8 Microstock sites usually require photographers to be approved as contributors by submitting images for inspection: the standards vary from site to site, but while many are amenable to technically proficient amateurs, only 20 per cent of applicants to Shutterstock in 2011 were approved (Garber 2012).
9 Since 2009, Flickr contributors have been able to submit a portfolio to Getty on their own initiative (Shankland 2009).
10 More recently Getty has further expanded its archive to include stock music.
11 However, see Soar (2003) for a discussion of the historical and contemporary recruitment of famous documentary photographers for advertising campaigns.
12 On the dialectic of attention and distraction in Western modernity, see Crary (2001). On the glance as antithesis to the attentive gaze see Bryson (1983). Conceiving stock photography in relation to the 'attention economy' (Lanham 2006; Crogan and Kinsley 2012) – both the monetization of attentive energy by corporations and the circulation of attention across media and social groups – offers a rich seam for future research, and is beyond the scope of this essay. Nevertheless, I would argue that stock photography

challenges us to think more about the production of *in*attention and the imaginary constitution of the 'overlooked' phenomenal ground to everyday social consciousness, topics largely ignored by most work on the attention economy.

Bibliography

Adorno, T. and M. Horkheimer (1979) *Dialectic of Enlightenment*. London: Verso.

Anderson, M. (2005) 'Art Buyers Talk Stock'. *Photo District News*, April, p. S12(3).

Bolter, J. D. and Grusin, R. (1999) *Remediation: Understanding New Media*. Cambridge, MA: MIT Press.

Bourdieu, P. (1993) *The Field of Cultural Production*, trans. Randal Johnson. Cambridge: Polity Press.

Bryson, N. (1983) *Vision and Painting: The Logic of the Gaze*. New Haven, CT: Yale University Press.

Crogan, P. and Kinsley, S. (2012) 'Paying Attention: Towards a Critique of the Attention Economy'. *Culture Machine* 13. Available at www.culturemachine.net/index.php/cm/article/view/463/500 (accessed 21 July 2012).

Crary, J. (2001) *Suspensions of Perception: Attention, Spectacle, and Modern Culture*. Cambridge, MA: MIT Press.

Debord, G. (1970) *Society of the Spectacle*. Detroit, MI: Black & Red.

Defoore, J. (January 25 2005) 'Reinventing the Wires: How Getty is Shaking Up the Wire Service Business, and what AP and Reuters are Doing in Response', *Photo District News*, p. 24(2).

Garber, M. (2012) 'The Tao of Shutterstock: What Makes a Stock Photo a Stock Photo'. *The Atlantic Online*. Available at www.theatlantic.com/technology/archive/2012/05/the-tao-of-shutterstock-what-makes-a-stock-photo-a-stock-photo/257280 (accessed 18 May 2012).

Foucault, M. (1972) *The Archaeology of Knowledge*. New York: Pantheon.

Frosh, P. (2003) *The Image Factory: Consumer Culture, Photography and the Visual Content Industry*. Oxford: Berg.

Gendron, B. (1986) 'Theodor Adorno Meets the Cadillacs', in T. Modelski (ed.) *Studies in Entertainment* (pp. 18–36). Bloomington, IN: Indiana University Press.

Getty Images (2005) 'Getty Images to Acquire Photonica and Iconica'. Getty Images Press Release. Available at http://company.gettyimages.com/article_display.cfm?article_id=104&isource=corporate_website_ind_press_release (accessed 13 May 2005).

Gordon, J. (2012) 'AfterCapture Stock Report'. *Rangefinder*. Available at www.rangefinder-online.com/aftercapture/commercial/AfterCapture-Stock-R-6302.shtml (accessed 20 March 2013).

Hiley, M. (1983) *Seeing Through Photographs*. London: Gordon Fraser.

Howe, J. (2006) 'The Rise of Crowdsourcing'. *Wired*. Available atwww.wired.com/wired/archive/14.06/crowds.html (accessed 14 June 2012).

Jay, M. (1988) 'Scopic Regimes of Modernity', in H. Foster (ed.) *Vision and Visuality* (pp. 3–27). Seattle, WA: Bay Press.

Jenkins, H. (2006) *Convergence Culture*. New York: New York University Press.

Lang, D. (2006a) 'What a Dollar Can Buy in Stock Photography'. *PDN Online (Photo District News)*. Available at http://talkmicro.com/forum/viewtopic.php?f=7&t=36 (accessed 14 April 2013).

Lang, D. (2006b) 'New AP Contract Lets Photogs Shoot Stock'. *PDN Online (Photo District News)*. Available at www.stockphototalk.com/phototalk/2006/02/with_high_hopes.html. (accessed 14 April 2013).

Lang, D. (2006c) 'Corbis Revenues Up, Still Not Profitable'. *PDN Online (Photo District News)*. Available at www.filmjournal.com/pdn/esearch/article_display.jsp?vnu_-content_id=1002117588. (accessed 14 April 2013).

Lanham, R. A. (2006) *The Economics of Attention: Style and Substance in the Age of Information*. Chicago: University of Chicago Press.

Leiss, W., Kline, S. and Jhally, S. (1997) *Social Communication in Advertising: Persons, Products and Images of Well-Being*. London: Routledge.

Lowensohn, J. (2008) 'Select Flickr Photos to Sell Via Getty License'. CNET News/ Webware. Available at http://news.cnet.com/8301-17939_109-9985516-2.html (accessed 8 July 2008).

Machin, D. (2004) 'Building the World's Visual Language: The Increasing Global Importance of Image Banks in Corporate Media', *Visual Communication*, 3(3): 316–36.

McQuire, S. (1998) *Visions of Modernity*. London: Sage.

Miller, J. A. (1999) 'Pictures for Rent', in E. Lupton and J. Miller *Design Writing Research: Writing on Graphic Design* (pp. 121–32). London: Phaidon.

Nunberg, G. (1996) 'Farewell to the Information Age', in G. Nunberg (ed.) *The Future of the Book* (pp. 103–36). Berkeley: University of California Press.

Photoshelter (2011) *Selling Stock Photography*, Winter 2011.

Ritchie, D. (1986) 'Shannon and Weaver: Unraveling the Paradox of Information', *Communication Research*, 13(2): 278–98.

Ritzer, G. and Jurgenson, N. (2010) 'Production, Consumption, Prosumption: The Nature of Capitalism in the Age of the Digital "Prosumer"', *Journal of Consumer Culture*, 10(1): 13–36.

Robins, K. and Webster, F. (1999) *Times of the Technoculture: From the Information Society to the Virtual Life*. London: Routledge.

Ryan, B. (1992) *Making Capital from Culture: The Corporate Form of Capitalist Cultural Production*. New York: Walter de Gruyter.

Shankland, S. (2009) 'Getty and Flickr Deepen Photo-Licensing Ties'. CNET News/Deep Tech. Available at http://news.cnet.com/8301-30685_3-10391406-264.html (accessed 5 November 2009).

Silverstone, R. (1999) *Why Study the Media?* London: Sage.

Shifman, L. (forthcoming) 'Memes in a Digital World: Reconciling with a Conceptual Troublemaker'. *Journal of Computer Mediated Communication*.

Soar, M. (2003) 'Image Ethics and the Advertising Photography of Richard Avedon and Sebastião Salgado', in L. Gross, J. Katz and J. Ruby (eds) *Image Ethics in the Digital Age* (pp. 269–93). Minneapolis, MN: University of Minnesota Press.

Stafford, S. (2005) 'Taking Stock: Three Agency Players Weigh in on the State of the Industry', *Photo District News*, 25 April, p. S6(3).

Weaver, W. (1949/1966) 'The Mathematics of Communication', in A. G. Smith (ed.) *Communication and Culture* (pp. 15–24). New York: Holt, Rinehart and Winston.

Weiss, D. (2010) 'Corbis and Cosco'. Debra Weiss Creative Consultant (Notes). Available at www.facebook.com/notes/debra-weiss-creative-consultant/corbis-and-costco/498124 218906 (accessed 9 December 2010).

Wilkinson, H. (1997) '"The New Heraldry": Stock Photography, Visual Literacy, and Advertising in 1930s Britain', *Journal of Design History*, 10(1): 23–38.

9

THE RHETORIC OF THE JPEG

Daniel Palmer

> The story of photography will be, in no small part, that of its file formats, the kinds of compression and storage it undergoes, as they in turn produce what is conjurable as an image.
>
> *(Matthew Fuller 2012)*

The first edition of this book was published in the very early years of the World Wide Web. A single reference to the internet in the index points to a definitional note in one of the essays, where it is described in terms of 'so much information that it is often difficult to find what you want, and the interface is very "user-unfriendly" with not-very-descriptive filenames, etc.' The author adds that 'Images can be downloaded, but this takes a long time, and the images tend to be b/w and very low resolution' (Graham 1995: 92). Needless to say, things have changed. Today, high-quality colour photographs circulate on the internet in overwhelming abundance, and since 2001 publicly available images have been searchable via Google's dedicated image search function. In 2011, Google even made it possible to search for an image using another image. That we tend to take all of this entirely for granted can be read as a measure of the success of the various technical standards that have enabled it to happen. Technical issues were judiciously downplayed in the 1995 edition of this book, in an effort 'to think about photography as a set of practices with different purposes' (Lister 1995: 14) and to complicate the myth of a 'clean break' between analogue and digital photography (Lister 1995: 20). Most writers on digital photography had, until that point, been overly preoccupied with the transformation from chemical photography as a physical object to a generic 'digital image' of zeros and ones. However, technology cannot be easily separated from cultural practice, and just as 'analogue photography' was always more than one technology, 'digital photography' is born of a series of technological innovations and conventions. In this chapter I focus on one such innovation, the ubiquitous JPEG file

format, which I understand as a materially significant dimension of digital photographic practices. Although it might seem an unpromising topic, I seek to unpack its ubiquity as the default mode by which we currently experience photographs on-screen, and argue that the JPEG is rhetorically linked to the idea of visual democracy in an age of networked photography.

More than 50 years ago, Roland Barthes famously called the photographic image 'a message without a code' (Barthes 1977a: 17). Barthes was concerned with the photograph's illusionary transparency, its apparent naturalness that concealed what he identified as the 'denoted' and 'connoted' meanings at work in its interpretation. Three years later in 'The Rhetoric of the Image' (1964), Barthes suggested that the photograph 'corresponds to a decisive mutation of informational economies' (Barthes 1977b: 45). Hinting at the medium's indexical nature that later preoccupied him in *Camera Lucida*, Barthes explained that 'the relationship of signifieds [what is represented] to signifiers [the forms of the image] is not one of "transformation" but of "recording", and the absence of a code clearly reinforces the myth of photographic "naturalness"' (Barthes 1977b: 44). Barthes argued that since all images are polysemous (having more than one potential meaning), *reading* a photograph therefore involves a rhetorical analysis of the cultural codes within which it make sense to readers. Yet the photographic image itself remains, paradoxically, 'a message without a code,' since it is grounded in analogical representation and captured mechanically (Barthes 1977b: 36). This claim was always debatable, but it is literally untrue in the case of digital photographs that are comprised of nothing but code. Barthes was referring to cultural codes that conditioned representation, but there is equally nothing natural or neutral about the digital code that lies behind the images we now see. Just as the myth of photography as a universal language has been destroyed, digital images are not universally intelligible or, as it were, equally capable. Unlike the character in the film *The Matrix* (1999) who can seamlessly translate streams of green data into images, digital code operates by being largely invisible to human viewers and readable only by machines. As one observer put it recently, digital code is 'inherently alien to human perception … Convert any .jpg file to .txt and you will find its ingredients: a garbled recipe of numbers and letters, meaningless to the average viewer' (Bishop 2012: 441).

Charge-coupled devices (CCD) were already under development when Barthes published those influential essays. By the late 1960s, CCD sensors could convert photons to electrons, collecting light and converting it to a voltage charge and a numerical code. By the mid-1970s, computer programmers were at work developing compression techniques that would eventually lead to standards such as the JPEG and TIFF. Digital photography is encoded all the way through, in elaborate algorithms built of zeros and ones, yet this code remains as invisible as the cultural codes that govern the reading of images. Indeed, under ordinary circumstances, when we see a digital image on-screen, or printed on paper, its numerical basis is actively repressed. The makeup of the image only becomes visible when the algorithms are pushed to their outer limits, typically in the form of cosmetic disturbances such as jagged edges. As I will explain in detail below, these noticeable distortions – which can similarly

affect audio and video media – are known as 'compression artifacts' because they are caused by the application of 'lossy data compression'. Typically an undesired outcome of an editing or distribution procedure, unforeseeable but substantive, they are an 'accident' built into the program itself. A product of the desire for immediacy, they can be read as part of Paul Virilio's political economy of speed, in which technology and the accident are caught in a dynamic and fatal relationship (Virilio 2007).

Compression artifacts have themselves become objects of exploration by artists and photographers, most famously by Thomas Ruff in his *jpeg* series (2004–07). In these large-scale photographic works, the German artist not only reveals the pixel grid through the enlargement of digital images, but purposely degrades the images to produce a kind of impressionistic abstraction when viewed up close. Ruff became interested in the effects of JPEG compression after looking for images of 9/11 online, and one of the most famous images in the series depicts the Twin Towers of the World Trade Center in clouds of smoke. Ironically, given the images are largely sampled from the internet (combined with private holiday snapshots) – re-scaled and then recompressed in his words 'as the worst possible quality JPEGS' (Lane 2009: 138) – Ruff's images demand to be seen in the flesh as gigantic prints. But the very fact that his images are named after a compression format for digital files means, as Bennett Simpson argues, that it is 'impossible to view Ruff's photographs as pictures without simultaneously viewing them as processes. Their content stands for their condition' (Simpson 2009: np). That condition, of course, is the proliferation of

FIGURE 9.1 Thomas Ruff, *jpeg ny02,* 2004. Courtesy David Zwirner, New York/London.

digital images online, and the promiscuous mingling of press and personal images. By producing museum-scale physical versions of low-quality popular imagery, Ruff seems to make an analogy to the fragile state of mediated human memory in an age of image overload. In this sense, the image of the Twin Towers is something of an update of Andy Warhol's *Death and Disaster* series of silkscreens (1962–63). More unusual is the reference to JPEGs in the art gallery in the first place. Digital photography has largely entered the gallery as a simulation of the fine print photography that preceded it – smooth and unpixellated, completely removed from photography's more popular contexts of reception. Ruff's *jpeg* series – inviting us to contemplate the structure of an image form that we normally only scan the surface of – reminds us that the unwanted artifact is in fact an authentic part of digital photographic culture.

The evolution of a file format

The JPEG is worth paying attention to, if only because it is the default mode by which we currently experience photographic images on-screen, from computer monitors to mobile devices. In other words, JPEGS make up almost all of what has been called 'transient photography': 'the kind of photography that most people now make, use and view most of the time ... digital files that are produced, reproduced, transmitted digitally and not printed, but viewed on screens' (Bull 2010: 28). According to a 2011 press release from the official site of the Joint Photographic Experts Group that gave their name to the format, over a trillion JPEG images have been created (see www.JPEG.org). The same press release reminds us that the format has 'contributed to the progress of e-commerce, where digital images offer new opportunities in the form of products and services' and that 'the existence of standard image coding formats' has been an 'enabler' of our 'digital imaging ecosystem'. Facebook and Flickr are proudly cited as examples of this ecosystem, and indeed JPEGs make up the overwhelming majority of the 100 million photographs reportedly uploaded and shared every day by Facebook's 750 million users (2011 figures). The expressions 'upload' or 'email a JPEG' have become part of the cultural vernacular.

It is surprising, then, that so little writing on digital photography has explicitly focused attention on the meaning and significance of the JPEG. Most people probably understand that the name stands for a digital file format associated with the distribution of images via the internet, and photographers and media theorists would appreciate that the JPEG is a technical standard that specifies how continuous-tone image data is compressed into a stream of bytes and decompressed back into an image. But the JPEG – and other compression/decompression protocols ('codecs') – is almost entirely neglected in the critical literature around digital photography. On the one hand this is unsurprising, since this writing has been dominated either by art historians, for whom the final image is privileged as an expression of a singular vision, or by social theorists, for whom photography is a cultural practice. For both groups, discussion of the technical means of its production is largely considered irrelevant. It

could be argued that few people in the analogue period appreciated the significance of Kodak, Agfa or Fuji film stock either (despite Kodak's attachment to Caucasian skin tones as the normative standard). A photographer's choice to use one or the other was based on habit and aesthetic preference rather than a technical knowledge of the materials. However, file formats are more consequential than film, not least because they are not something we necessarily choose to use. Instead, they are usually built into cameras and software as the default. Their aesthetic and cultural implications should matter to both art historians and social theorists.

Perhaps the real reason why so little is known about the JPEG is that it appears so 'natural', and so concurrent with the digital era. Paul Caplan, one of the few writers to pay attention to this point, notes that the JPEG has become so familiar that it has 'become transparent and taken for granted' (Caplan 2010: 1). And indeed, the history of the JPEG – buried in obscure reports and technical releases – is largely unremarkable and controversy free. It started with early research in the 1970s around the 'discrete cosine transform,' a complex trigonometric formula for 'decorrelating' image data, to enable the prediction of pixel values based on neighbouring pixels – thereby reducing (and in some cases eliminating) interpixel redundancy. International standards bodies began the push for a generic image compression standard in 1982, responding to a need to foster the implementation of new digital image coding equipment. This resulted in the formation of the aforementioned Joint Photographic Experts Group in 1986, a joint committee between the International Organization for Standardization (ISO) and the International Telecommunication Union (ITU). Founded in 1947, the ISO promulgates worldwide proprietary, industrial and commercial standards – and was also responsible for the measure of photographic film's sensitivity to light ('film speeds' such as ISO100, ISO400, and so on). The official JPEG standard dates to 1992 in Geneva, although it was already in use a few years prior.

German media philosopher Friedrich Kittler has described computing as a 'general interface between systems of equations and sensory perception' (Kittler 2010: 228). Indeed, the JPEG format was designed to exploit the human eye's differing sensitivity to chrominance and luminance, and specifically to discard information that the eye cannot easily see. Essentially this means the so-called 'redundant data' of subtle colour distinctions and high frequency brightness variations imperceptible to the human eye (Murray and Van Ryper 1996). However, since the quality of an image declines as data is removed, JPEG compression is also considered 'lossy'. The original format offers only 8 bits of data per colour, providing a relatively coarse 256 levels between complete darkness and complete brightness (newer versions of the standard, such as JPEG2000, remain marginal). As a consequence, images containing large areas of a single colour, such as blue skies, are prone to a form of compression artifact known as 'posterization' or 'banding', where a continuous gradient appears as a series of discrete steps or bands of colour (the human eye perceives a blue sky as millions of gradations of colour). Nevertheless, a 20:1 compression ratio can be achieved without noticeable loss of quality: thus a one megabyte TIFF (Tagged Image File Format) – Adobe's popular format for high

colour-depth images – can be converted into a snappy 50 kilobyte JPEG, and so on. If rhetoric is classically defined as 'the art of adapting discourse, in harmony with its subject and occasion, to the requirements of a reader or hearer' (Genung 1900: 1), the rhetoric of the JPEG is that of reducing an image's file size to the minimum while magically suppressing attention to that loss.

Smaller file sizes are valuable for two important reasons: to save storage space (memory or disk), and for faster transmission across networks (to enable faster downloads and copying). Since JPEG compression was developed at a time when computer memory was expensive, camera makers welcomed more images fitting on a memory card. Moreover, the official release of the JPEG format effectively coincided with the first popular graphical web browser, NCSA Mosaic, in 1993, quickly followed by Netscape, Internet Explorer and others. It could be argued that having evolved out of existing phone networks as a text-based medium, the popular explosion of the World Wide Web in the mid-1990s occurred only when browsers could display pictures in addition to text. In those early years of slow dial-up modem connections, so-called 'progressive JPEGs' were commonly used to divide image files into a series of scans for progressive rendering as they gradually loaded. The first scan, which arrived quickly on screen, showed the image at the equivalent of a very low-quality setting. Each successive scan gradually improved the quality, with the image slowly losing its blurriness and becoming clearer. At the time, when the World Wide Web was far more textual than the audio-visual experience it is today, the option to 'disable images' in the browser preferences was a very practical one for many users.

Lev Manovich has suggested that rather than 'an aberration, a flaw in the otherwise pure and perfect world of the digital … lossy compression is the very foundation of computer culture' (Manovich 2001: 55). Put another way, it is built into its very economy. Indeed, in tandem with the rising popularity of the internet in the 1990s, amateur photographers proved unexpectedly content to accept a lower-quality image for the convenience of digital photography. Even Kodak eventually admitted their early miscalculations on this front. Although a pioneer in the field of research into digital photography in the 1970s, Kodak came belatedly to promoting and manufacturing digital cameras for obvious reasons – since the bulk of their profits were generated from manufacturing and selling film – and mistakenly believed that film sales would continue to flourish simply because celluloid produced a superior image. They also believed that sales would grow in developing markets, where computers were less common. Kodak, perhaps more than any other company – given their success had always related to mass market value and ease of use – should have understood that economics and efficiency would eventually win out over conventional measures of image quality.

From image quality to image currency: the role of software

Image quality remains the dominant discourse within which JPEGs are understood. Thus, a typical consumer photo-lab will proffer advice regarding the level of JPEG

compression that 'will not lead to visible loss in quality or detail' in the print. More dramatically, a best-selling guide to Adobe Photoshop proposes that 'shooting in JPEG mode is like taking your film to a high street photo lab, throwing away the negatives and then making scans from the prints' (Evening 2008: 120). For 'serious' amateurs and professional photographers, JPEGs have come to be considered as degraded, even inauthentic, copies of a camera's sensor data. These photographers prefer so-called RAW and DNG files, which are akin to 'digital originals', wherein the image is uncompressed and camera settings are saved separately from the image data (ironically, RAW files are proprietary formats specific to different camera manufactures, which led Adobe to develop the open standard DNG, short for 'digital negative'). The JPEG algorithm not only disposes of potentially valuable sensor data, but is also associated with irreversible changes to the pixel arrangement (known as 'destructive editing'). The growing awareness that to post-process JPEGs is to risk an avalanche of unwanted artifacts has also focused attention on file formats, at least among more committed photographers. Others are concerned with the issue of format obsolescence that has long plagued professional image archivists (will a JPEG file be readable in 50 years?).

But image quality and permanence are not the whole story. Much more is at stake, since the JPEG format is part of the new computational logic of photography that gives the image an entirely new currency. Indeed, the production of 'in-camera' JPEGs is compromised for the previously-mentioned serious photographers by 'in-camera' processing, in which variables such as colour balance and sharpness are set automatically at the moment of capture, as opposed to the flexibility of choosing such settings afterwards in professional software such as Photoshop, Lightroom or Aperture. In certain respects, the increasingly blurry distinction between 'in-camera' or 'on computer' processing updates a familiar craft-versus-automation tension. Don Slater has shown that the history of popular photography elicits a conventionalization of *how* things can be photographed, in which, after Kodak, '*Taking* photographs is itself structured … as the paradigm of structuring a complex skill into a few simple actions' (1996: 134, 141). Julian Stallabrass has similarly argued in relation to electronic SLR cameras that relieving the camera user of manual control has the paradoxical effect of *mystifying* the camera's processes (Stallabrass 1996). In practice, today, varying levels of automation are available depending on the cost of the camera equipment and the desired outcomes. A wedding photographer, for instance, may opt to shoot in JPEG mode to speed up their 'workflow'. On the other hand, an art or fashion photographer requiring maximum control might never use JPEGs at all in their working life (except for Polaroid-like instant feedback on a camera screen or laptop, or to promote their work via the internet); indeed, many professionals still use medium or large-format film and scan the negatives.

Image software occupies an increasingly important place in the photographic process, and access to and skills related to this software produces new distinctions among photographers. The software also maps on to 'a deep techno-fetishism' among hobbyist photographers (Slater 1995: 142). Although the economics of film-less photography encourage photographers to 'over-sample' their subjects, and

defer their imaginative conception of the image to its post-processing, not everyone has the ability, desire, or time to spend hours using professional image editing software. This is where popular software such as smart phone apps (more on these below) and Apple's iPhoto excel. Designed for simplicity rather than expert level control, iPhoto's ability to manage, organize and edit people's growing archive of photographs has proved enormously successful since its release in 2002. Such software does not rely on the JPEG protocol, but 'it is designed to work best with JPEG files', which remain the default format (Apple 2012a). RAW files are now supported by iPhoto, but a JPEG copy is made at the time of import, 'which allows other parts of Mac OS X, which don't understand the RAW format, to use your images even before you edit them' (Apple 2012b). Likewise, a key driver behind JPEG-producing point-and-shoot camera design is to automate what photographers such as Ansel Adams used to call 'previsualisation' (Rubinstein and Sluis 2008: 12–13). Such automation now extends beyond exposure simulation and familiar genre–modes (portrait, landscapes, and so on) to include smile–activated shutters and basic forms of face recognition that prioritize focus and exposure when a familiar face appears in the frame. Once again, these features are not exclusively reliant on the JPEG protocol but are a function of the transformation of the image into digital data. Increasingly, digital photography must be understood in conjunction with software developments (in cameras, on computers and online).

Thus, more importantly than image quality, the JPEG stands for the broader transformation of cameras into sensors and of images into actionable data. Crucially, all digital cameras save JPEG files with EXIF data (an acronym for Exchangeable Image File). The camera model and settings such as shutter, aperture and ISO speed, capture date and time, focal length, metering, flash mode and geolocation are all stored as metadata – helping to enable images to be catalogued, searched, shared and used. In short, digital cameras supplement the recording of image content with the recording of an image's production context. Likewise, descriptive tags – often semi–automated via software – are built into the JPEG format. This metadata is fundamental to the workings of photo–sharing and social networking sites (Rubinstein and Sluis 2008), and is part of the way the JPEG protocol enables interoperability between databases (Caplan 2010). In the 1930s, Walter Benjamin asked whether captions will 'become the essential component of pictures' (Benjamin 1980: 215). Today, metadata – and the practice of tagging in particular – enables photographs to be searchable in databases and has become essential to their circulation within online photo–sharing platforms.

As Daniel Rubinstein argues, 'An untagged image is worthless, as it is invisible to search engines and so cannot enter the economy of the search industry' (Rubinstein 2010: 198). The tag, moreover, is premised on a fantasy of 'identicality between an image and a descriptor while concealing the inherent ambiguity of a photograph' (Rubinstein 2010: 199). The latter point could also be said of captions more generally, which function to 'anchor' an image's possible meanings (Barthes 1977b: 39). However, unlike captions, metadata is also largely invisible to human users (although highly readable by computer software). This has already resulted in

some unexpected outcomes, such as the attempt by online photo-sharing site Flickr to patent the algorithm for their 'interestingness' ranking. Flickr seeks to capitalize on the commercial value of this new class of metrics, based in part on the quantity of metadata attached to the relevant image. Facebook, meanwhile, as part of their effort to 'monetize' their 'Like' feature, introduced a new search command in 2013 called Graph Search, whereby photographs are displayed in the order in which Facebook thinks they would be most important to you, determined by the number of likes and comments an image has.

The rhetoric of apps

The currency of the JPEG has been further enhanced by the development of smart phones, the Apple iPhone most notably, which since its release in 2007 has combined the taking, processing and distribution of images in one device (Gómez Cruz and Meyer 2012). Almost all of the visual chatter enabled by smart phones is JPEG-based, since – like most point-and-shoot cameras – this is the only format they are currently capable of capturing. Despite the initial low quality of the camera, iPhone photography in particular has become a phenomenon – in part due to the proliferation of photo 'apps' available for download through the Apple iTunes 'App Store' (Palmer 2012). Apps have been described as 'bundles of meaning and functionality each marked by its own distinctive name and icon' (Chesher 2012: 99). Part of the appeal of the iPhone is that it is a device with seemingly endless potential, since each new app adds more functionality. As Chris Chesher puts it, 'Any app that uses the iPhone's camera becomes an interface between user events of photography and a particular set of possible visual and informational processes' (Chesher 2012: 99).

Most photo apps introduce a range of filters and tools to modify the pictures of the camera phone, including colour and panorama effects. In certain instances, multiple versions of an image are generated, while others elicit the novelty of random effects. Apps thus take advantage of the digital image's well-known capacity for multiple variations, whereby the event of capture is supplemented by the 'event of visualization' (Osborne 2010: 66). There is a performative quality to this visualization, as if to compensate for the banal familiarity of most of the scenes depicted. Indeed, the relatively poor focal quality of the early iPhones was a creative incentive for popular apps such as Hipstamatic, which makes a virtue of the poor quality by nostalgically mimicking the lo-fi look of inexpensive film cameras (Palmer 2012: 88). The app produces square format images with faded tones, vignetting and chromatic aberration effects. Although seemingly semi-random, Hipstamatic produces highly conventionalized images through a programmed structure of image manipulation. Such apps quickly give character and mood to mobile phone photographs, and could be said to embody a particular relationship to self-presentation. All such photo apps are synchronized to dominant photo-sharing websites such as Twitter, Tumblr and Flickr (where the iPhone has become the most used image-creation device).

In enabling real-time transformations of the photographic image, and facilitating their immediate circulation online, the smart phone extends a long history of amateur photography being transformed by technological developments. Arguably, apps are now central to amateur photography, and their success has become big business. Many are free, and most make very little money – with Apple simultaneously benefitting from the DIY energies of aspirational software developers and the marketing activities of companies keen to trade on their 'hip' appeal. However, some apps succeed spectacularly. Instagram, an app specializing in nostalgic photographic effects on a social media platform, was purchased by Facebook for a whopping $1 billion in 2012. It had only launched in 2010, but attracted more than 30 million users in less than 18 months, sharing more than five million new pictures per day (Rushe 2012). The free app allows users to apply various filters – with names like Lo-fi, Earlybird and Walden – to images taken on their smart phones. As Chesher notes, 'Instagram positions itself as a hybrid of the Polaroid and the telegram: a neo-retro device that makes instant images transmissible anywhere' (Chesher 2012: 108). Instagram is fundamentally a distribution platform, merging characteristics of Twitter (such as followers) with a photo app. As with many other photo sharing *services*, users can vote on pictures and add comments. Co-founder Kevin Systrom presents Instagram in terms of the dynamics of user-generated content:

> We tried to lower the bar for producing awesome stuff, so people can walk around with their iPhones and produce amazing pictures. The network really democratises attention: everyone from celebrities to a random guy in Japan taking pictures of his dog every day can get many thousands of followers. Taking images is the great equaliser.
>
> *(Rushe 2012)*

Indeed, Instagram enables users to connect directly and personally with an audience – which is precisely why the service is used by countless public figures including presidents and celebrities, as well as brands such as McDonalds and Nike. Moreover, the use of Instagram is not confined to amateurs. Photojournalists, for instance, struggling to maintain a revenue base, can also use it to develop audiences. Thus photojournalist Matt Eich speaks of 'mobile dispatches' and describes it as 'a fluid form of visual note-taking [that] allows a seamless interaction with an ever-expanding mobile community' (Laurent 2012).

Facebook's purchase of Instagram is especially revealing, because the powerful social media company's stated aim to provide 'the best photo sharing experience' (Rushe 2012) – that is, to consolidate their share of the 'photo upload market' – underlines a strong desire to monetize the popular transaction of images. Photo apps are thus an exemplary commodity of digital capitalism, an 'immaterial' consumer product that enlists the energies of amateur production and then commodifies those energies via online services. Despite the rhetoric of democracy and participation that accompanies the camera phone – notably through associations with citizen journalism – as David Levi Strauss warns, 'the overwhelming trend is toward managed "social"

networks, ideological isolation, and mandatory advertising' (Levi Strauss 2007). For Levi Strauss:

> the desire for public, democratic participation has been displaced onto consumer goods and services and dispersed into isolated individual speech.
>
> *(Levi Strauss 2007)*

This negative assessment, whereby images are 'deprived of any meaning beyond the personal', could be countered with examples such as the use of camera phones by ordinary people during the Arab Spring in 2011. For Nicolas Mirzoeff, photography here goes beyond the democratization of the means of reproduction to a 'democracy of the self', within which images become a 'claim to personhood' and collectively 'the demand of a people to be recognized as "the people" with attendant sovereignty' (Mirzoeff 2011: 44–46). Clearly, the circulation of JPEGs is ambiguous in its political effects. As Hito Steyerl has suggested of the 'poor image' more generally, it is 'perfectly integrated into an information capitalism thriving on compressed attention spans', while simultaneously feeding into alternative visual economies (Steyerl 2009). Nevertheless, in each case, as the unit of circulation, the JPEG has become a valuable currency.

The ideology of the JPEG

In what sense is the JPEG file format determining of photographic practices? That is, what are the unexpected consequences of a file format that has become a universal standard for sharing photographs? Lev Manovich, pioneering the field of study known as 'software studies', has argued that there is no such thing as digital media in general, no essential 'properties' of the digital medium, only operations and affordances defined by software (Manovich 2001: 48). More recently Manovich has argued that software studies aims 'to investigate both the role of software in forming contemporary culture, and cultural, social, and economic forces that are shaping development of software itself' (Manovich 2008: 6). In considering the JPEG as a software 'object', Jonathan Sterne's work on the mp3 music file format offers an instructive model (Sterne 2006). As Sterne notes, the mp3 is an historical, cultural and political phenomenon – a form designed for massive exchange, casual listening and massive accumulation. As he argues: 'The possibility for quick and easy transfers, anonymous relations between provider and receiver, cross-platform compatibility, stockpiling and easy storage and access' were all 'built into the [file] form itself' (Sterne 2006: 829). Precisely the same can be said of JPEG; as we have seen, it is a format whose ubiquity across devices has facilitated cultural practices such as online photosharing.

Alex Galloway has argued that 'protocols' such as a HTML (HyperText Markup Language) are the governing feature of the internet, and constrain us to act to the rule-sets that underpin them (Galloway 2004). More specifically, Caplan has added that protocols such as JPEG 'determine' 'a new scopic regime characterised by

network relations ... built around a discourse of "the archive" and an ideology of visual democracy' (Caplan 2010: 5). This point is crucial to my argument, even if the precise shape and implications of this 'new scopic regime' are open to debate, as we have seen. Caplan notes that the JPEG extends the discourse and sales pitch of photography as 'a nominally democratic medium', based on ease of use, accessibility and openness (Caplan 2010: 2). But, as Caplan also observes, this discourse of participation is an ideological one, since 'imaging practices are located within ... complex relations of ownership, control and power' (Caplan 2010: 2). As we have already seen, everyday photographic practices are articulated within and around networks and images spaces that are closed and proprietary, 'existing as part of new media giants' such as Yahoo and Google's portfolios of dataspaces primed for mining and advertising' (Caplan 2010: 5).[1] Caplan borrows from Bruno Latour's 'actor–network theory' and Graham Harman's 'object-oriented philosophy' in order to understand the JPEG compression protocol:

> as an "actant" doing things in the world: making images findable and viewable in browsers; making them small enough to be distributed and exchanged in mobile spaces; playing a part in Facebook's face recognition business plans and Apple's App store domination.
>
> *(Caplan 2011a)*

Because the JPEG is a royalty-free, open-source codec established by a non-profit UN-style organisation, we might assume that it stands above narrow commercial interests. However, circulating within private commodity spaces, the JPEG is 'enfolded' in the imaging practices and industries that make up the economic-political relations of Web 2.0.

A primary motivation of the JPEG committee is to accelerate the adoption of new imaging products and services by the market. They often invite industry experts to their regular meetings to report trends in their products and applications and to identify needs for new digital imaging standards. By making the JPEG standard freely available, hardware manufacturers and software publishers can confidently integrate support for the file format into their products. The outputs created on an iPhone, for instance, must be able to interface with the Apple media universe of iPads, AppleTV, the image cloud, HDTVs and so on. As a result, one could say that the JPEG has a certain hegemonic power. Today, as Caplan puts it, images *must* become JPEGs, either captured or converted as such, if they are to find a place within social media (Caplan 2011b). Furthermore, the openness of the format is far from guaranteed. For instance, the JPEG committee recently adopted JPEG XR – extended range – as part of the continual evolution of the file format. What was eventually ratified is an open format, however Microsoft had initially sought to retain some proprietary control.[2]

Google – as part of its 'make the Web faster' effort – announced a new graphics format called WebP in 2010, amid claims that its use could cut image file sizes by 40 per cent. In a move that again underlines the socio-technical basis of digital

photography, WebP has a tendency to blur images rather than create a JPEG-like blocking – and is therefore considered preferable for facial skin tones in particular. Earlier this year, Google quietly slipped this potential 'JPEG killer' into Gmail, Picasa and its Chrome browser, which automatically and invisibly convert JPEG images to the WebP format. Google's move is directly related to its effort to push their new web video format, WebM. As Google's developer site explains, in language quite foreign to traditional photography scholarship:

> Predictive coding uses the values in neighboring blocks of pixels to predict the values in a block, and then encodes only the difference (residual) between the actual values and the prediction. … The residuals are then transformed, quantized and entropy-coded as usual.
>
> *(developers.google.com/speed/webp)*

Such is the language of codecs, guided by the imperative to 'calculate the inefficiencies of the human eye and run as little data as necessary to fool it into perceiving a clear, clean picture' (Cubitt 2011: 10). Sean Cubitt laments that predictive coding represses an image's inherent temporality and instability under the dominant reign of spatialising and mapping. This is particularly the case in video imagery, where codecs like the MPEG work by giving detail to busy areas of the image. Adrian Mackenzie observes the precise 'psycho-perceptual parameters' within which this calibration occurs (Mackenzie 2008: 54), while for Cubitt this 'automation of expectation' comes at the cost of 'diminishing the freedom of the viewer's gaze' (Cubitt 2011: 10). What is abundantly clear is that faster file transfers and lower network burdens are financially attractive for Google, who point out that images make up around 65 per cent of the typical data of a web page. But there are other penalties to this new compression regime: for instance, encoding and decoding WebP images takes significantly more distributed computing power. And while WebP is an open format, its metadata is potentially extremely valuable to Google. We must never forget that all the data around and embedded in online images is constantly mined and aggregated. The results can become part of valuable algorithms to be patented and used to direct the unpaid labour of online attention through which audiences provide the basis for the advertising economy.

Conclusions

In a widely cited essay from the original edition of this book, Kevin Robins wrote that 'images are significant in terms of what we can do with them and how they carry meaning for us' (Robins 1995: 48). However, one now needs to update this statement to add that digital images are also significant in terms of *what they can do* as part of the computational logic of photography. In effect, an image's *potential* – its visibility and dissemination – is increasingly determined by its ability to be actionable by networked computers (see also Rubinstein and Sluis' contribution to this volume). We tend to forget that the World Wide Web, aside from anything

else, is a giant copying machine; when an image is viewed, it is copied from one database to the user's local hard drive (within devices such as their laptop or smart phone). As we have seen, this copying is made efficient by reduced file sizes, and searching is enabled through the use of metadata. Hence we can conclude that the JPEG has helped to enable fundamental developments in photographic culture (while undoubtedly closing down other options).[3]

Although the JPEG does not have a natural monopoly, after more than 20 years the format is a powerful incumbent – built into every camera, mainstream operating system, web browser, image-editing program, pharmacy photo-printing kiosk and digital picture frame in existence. These material environments, as well as technical standards, screen dimensions and network infrastructures, illustrate the complex forces and relationships within which practices of digital photography operate. Just as we once needed to move beyond the search for the essential characteristics of photography towards an understanding of it as a historical concept and a succession of conventions, these material environments invite us to move away from critical perspectives that seek the essential characteristics of the 'digital image'. Recent scholarship derived from Science and Technology Studies, which recognizes photography as a 'socio-technical network' and seeks to 'understand photography not as representation, technology, or object, but as the agency that takes place when a set of technologies, meanings, uses, and practices align', offers a possible way forward (Gómez Cruz and Meyer 2012: 2). At the same time, we must never lose sight both of the diversity of uses of photography and specific forms and locations of the photographic image.

In the popular imagination, the JPEG stands for everything that digital photography itself seems to symbolize: an enhanced democratization of image making and the free-flowing global circulation of photographs via the internet. Thus, when citizen journalists captured the protests following the 2009 Iranian presidential election against the disputed victory of President Mahmoud Ahmadinejad, it was dubbed 'The JPEG Revolution' on the front page of the *International Herald Tribune* newspaper. The JPEG is indeed rhetorically tied to the idea of democracy in an age of distributed imaging. Yet, as I have attempted to show, there is an uneasy tension between the potential for democratized image making – based on a near universal private image-making capability – and the resulting culture of public images, the workings of which remain highly opaque. The rhetoric of the JPEG, its persuasive power, lies in precisely this kind of invisibility. Indeed, such invisibility is very much part of digital culture, aligned to the abstractions of social relations under the reign of global finance capital. Here, we have arrived at Peter Osborne's argument about the 'social ontology' of the digital image: that it offers an equivalent visual form for the abstraction of value from use characteristic of societies based on relations of exchange (Osborne 2010: 64). We are literally unable to see the underlying social relations just as we cannot see the data behind a digital image. More generally, as Wendy Chun has argued, the very manner in which computer software in general necessarily separates an (image) interface from the algorithms that underpin it 'makes it a powerful metaphor for everything invisible that generates visible effects, from

genetics to the "invisible hand" of the market' (Chun 2011: 2). In all of these ways, the JPEG is a both an active participant and a potent metaphor for visual democracy within digital capitalism, along with the blind spots in any act of seeing.

Notes

1 As a visual artist, Caplan has, among other things, rewritten the EXIF metadata of images, relocating the geolocation of images of sportswear sweatshops in the middle of the Olympic park in London. As he notes: 'These experiments were not about creating images but about using the practice of image-hacking to explore the operation of protocol that made them (both the images and the practices) possible.' He concludes: 'What my experiments showed was that the JPEG protocol, powerful though it was, was unreachable, unrepresentable' (Caplan 2011b).
2 Microsoft submitted its 'HD Photo' format to the ISO in 2007 (hailing greater dynamic range, a wider range of colors and more efficient compression). It can take years before graphics software and web browsers are able to support a new format; JPEG2000 was initially proposed in 1996, but is still not a fully published standard.
3 For example, Lytro's Light Field camera (launched in 2011) allows variable focus after the moment of capture – thus collapsing the distinction between camera hardware and software – and uses a proprietary image format. Once the image files are saved as JPEGs, they lose their interactive focus capability.

Bibliography

Apple (2012a) 'iPhoto "11: Image File Formats"', http://support.apple.com/kb/PH2524? viewlocale=en_US (accessed 24 August 2012).

——(2012b) 'Archived – iPhoto 5 Frequently Asked Questions (FAQ): Working with RAW images', support.apple.com/kb/HT2297 (accessed 24 August 2012).

Barthes, R. (1977a) 'The Photographic Message', *Image Music Text*, London: Fontana, pp. 15–31.

——(1977b) 'Rhetoric of the Image', *Image Music Text*, London: Fontana, pp. 32–51.

Benjamin, W. (1980) 'A Short History of Photography' in A. Trachtenberg (ed.), *Classic Essays on Photography*, New Haven, CT: Leete's Island Books, pp. 199–216.

Bishop, C. (2012) 'Digital Divide: On Contemporary Art and New Media', *Artforum* 51(1) (September): 434–41.

Bull, S. (2010) *Photography*, Oxon: Routledge.

Caplan, P. (2010) 'London 2021: Distributed Imag(in)ings and Exploiting Protocol', *PLATFORM: Journal of Media and Communication* 2(2) (September): 6–21

——(2011a) 'Imag(in)ing theory – A Draft Presentation', *The Internationale*, http://theinter-nationale.com/blog/2011/02/imagining-theory-a-draft-presentation (accessed 7 June 2011).

Caplan, P. (2011b) 'Methodology: Beyond Protocol', *The Internationale*, http://theinternatio-nale.com/blog/2011/03/methodology-beyond-protocol (accessed 7 June 2011).

Chesher, C. (2012) 'Between Image and Information' in L. Hjorth, J. Burgess and I. Richardson (eds), *Studying Mobile Media: Cultural Technologies, Mobile Communication, and the iPhone*, New York: Routledge, pp. 85–97.

Chun, W.H.K. (2011) *Programmed Visions: Software and Memory*, Cambridge MA: MIT Press.

Cubitt, S. (2011) 'The Latent Image', *The International Journal of the Image* 1.2: 27–38.

Evening, M. (2008) *Adobe Photoshop CS4 for Photographers*, Waltham, MA: Focal Press.

Fuller, M. (2012) 'Gifted Economy', *Born in 1987: The Animated GIF*, http://joyofgif. tumblr.com/tagged/text#!/post/23221575402/matthew-fuller (accessed 20 March 2013).

Galloway, A.G. (2004) *Protocol?: How Control Exists after Decentralization?*, Cambridge, MA: MIT Press.

Genung, J.F. (1900) *The Working Principles of Rhetoric*, Boston, MA: Ginn & Company.

Gómez Cruz, E. and Meyer, E.T. (2012) 'Creation and Control in the Photographic Process: iPhones and the Emerging Fifth Moment Of Photography", *Photographies* 5(2): 203–21.

Graham, B. (1995) 'The Panic Button (In Which our Heroine Goes Back to the Future of Pornography)', in M. Lister (ed.) *The Photographic Image in Digital Culture*, London: Routledge, pp. 77–94.

Kittler, F. (2010) *Optical Media: Berlin Lectures 1999*, trans. Anthony Enns, Cambridge MA: Polity Press.

Lane, G. (2009) 'Thomas Ruff: Space Explorer' *Art World*, No, 12 (August-September): 136–43.

Laurent, O. (2012) 'The New Economics of Photojournalism: The rise of Instagram', *British Journal of Photography*, 3 September, www.bjp-online.com/british-journal-of-photography/report/2202300/the-new-economics-of-photojournalism-the-rise-of-instagram (accessed 10 September 2012).

Levi Strauss, D. (2007) 'Click Here to Disappear: Thoughts on Images and Democracy', *openDemocracy*, 13 April 2007, www.opendemocracy.net/arts-photography/click_disappear_4524.jsp (accessed 10 September 2012).

Lister, M. (ed.) (1995) *The Photographic Image in Digital Culture*, London: Routledge.

Mackenzie, A. (2008) 'Codecs' in M. Fuller (ed.), *Software Studies: A Lexicon,* Cambridge, MA, MIT Press, pp. 48–54.

Manovich, L. (2001) *The Language of New Media*, Cambridge, MA: MIT Press.

——(2008) *Software Takes Command* (book draft) http://lab.softwarestudies.com/2008/11/softbook.html (accessed 20 November 2008).

Mirzoeff, N. (2011) 'Inside Out: Photography 2.0', *Foam Magazine*, 29: 43–46.

Murray, J.D. and Van Ryper, W. (1996) *Encyclopedia of Graphics File Formats*, Second Edition, Cambridge, MA: O'Reilly Media.

Osborne, P. (2010) 'Infinite Exchange: The Social Ontology of the Photographic Image', *Philosophy of Photography*, 1.1: 59–68.

Palmer, D. (2012) 'iPhone Photography: Mediating Visions of Social Space', in L. Hjorth, J. Burgess and I. Richardson (eds) *Studying Mobile Media: Cultural Technologies, Mobile Communication, and the iPhone*, New York: Routledge, pp. 85–97.

Robins, K. (1995) 'Will Image Move Us Still?', in M. Lister (ed.) *The Photographic Image in Digital Culture*, London: Routledge, pp. 29–50.

Rubinstein, D. (2010) 'Tag, Tagging', *Philosophy of Photography* 1.2: 197–200.

Rubinstein, D. and Sluis, K. (2008) 'A Life More Photographic: Mapping the Networked Image', *Photographies* 1.1: 9–28.

Rushe, D. (2012) 'Facebook Announces $1bn Purchase of Mobile Photo Network Instagram', *Guardian*, 9 April, www.guardian.co.uk/technology/2012/apr/09/facebook-buys-instagram-mobile-photo (accessed 10 September 2012).

Simpson, B. (2009) 'Untitled Text', in *Thomas Ruff: Jpegs*, New York: Aperture, n.p.

Slater, D. (1995) 'Domestic Photography and Digital Culture', in M. Lister (ed.) *The Photographic Image in Digital Culture*, London: Routledge, pp. 129–46.

Stallabrass, J. (1996) 'Sixty Billion Sunsets', in *Gargantua: Manufactured Mass Culture*, London: Verso, pp. 13–39.

Sterne, J. (2006) 'The MP3 as Cultural Artifact', *New Media and Society* 8:5 (November): 825–42.

Steyerl, H. (2009) 'In Defense of the Poor Image', *e-Flux Journal*, 10, www.e-flux.com/journal/in-defense-of-the-poor-image (accessed 3 November 2010).

Virilio, P. (2007), *Art as Far as the Eye Can See*, trans. Julie Rose, Oxford: Berg.

10

NEW MEDIA AND VERNACULAR PHOTOGRAPHY

Revisiting Flickr

Susan Murray

Graffitied interior walls, a decaying room in a long-abandoned house, dirty toys on moldy carpeting, derelict farmhouses, an empty tunnel, a collapsing roof, stacks of rusted outboard motors against a wire fence, and a dismantled electrical box are just some of the moments captured in photos included in the Flickr group photo pool, "Abandoned Minnesota," which is made up of over 3,000 photos taken by more than 200 members.[1] There are also other smaller groups made up of strikingly similar photos, called "Abandoned Dark and Creepy," "Abandoned City," Abandoned New Mexico," "Abandoned Railroads of the Midwest," and "Abandoned Leather Sofas." In fact, there are almost 19,000 groups that contain the word "abandoned" in their titles, which speaks not only to the amazing breadth of Flickr's collections, but also to its members' interest in the geography and minutiae of the everyday. One of my personal favorites is a group called "Aesthetics of Failure," which is broadly interpreted to include the failures of technology (light leaks, overexposed film, digital glitches, broken shutters) and the failures of photographers (thumbs covering lenses and awkward compositions), as well as much larger and weightier societal failures such as poverty.

In browsing through Flickr, one is invited to explore thousands of such images organized not only through technological features, such as groups and batches, but also through the less concrete processes and functions of fetishization, classification, collection, memory, flow, taste, signification, and identification. On Flickr, each member's page is part of a decentralized network of similar pages, and contributes to the construction of a community and larger collection of photographs. For example, Flickr creates community through the use of categories or keyword tags, notes (which are used to write comments on photos), contact lists (people who subscribe to a member's page), and groups. With the help of these functions, Flickr has become a collaborative experience: a shared display of memory, taste, history, daily life, and judgment through which amateur and professional photographers

FIGURE 10.1 *Untitled* from the 'Aesthetics of Failure' group. Credit: Curt Pulleyblank, 2010.

collectively articulate a novel, digitized (and decentralized) aesthetic of the everyday. Here photography has become less about the special or celebratory moments of domestic life (for such things as holidays, gatherings, baby photos) and more about an immediate, rather fleeting display and collection of one's discovery and framing of the small and mundane (such as bottles, cupcakes, trees, debris, and architectural elements). In this way, photography becomes a more alive, immediate, and often transitory practice/form, as the digital camera has become an essential tool in the navigation and documentation of daily life. This is a definitive *shift* in our temporal relationship with the everyday image and has altered the way that we construct narratives about ourselves and the world around us.

When I first began researching the ways that the photo-sharing site Flickr might be altering our relationship to the practice of photography in 2005, what stood out to me the most was the site's engagement with the mundane and yet often fanciful imagery resulting from the careful attention and framing of daily moments in a

person's life. I also noted how the amateur and professional divide was becoming less meaningful in the context of the Flickr community. These elements are still two of the site's most salient characteristics and are also the ones that have impacted a broader array of digital photography sites and practices over the past few years. However, there have also been considerable changes recently in the online environment for digital photography that have both altered Flickr's standing and expanded the use and habits of photographers in their engagement with social media. Of course, the most notable difference is that Facebook has taken over the position as the number one social networking site on which people share their photos. As of July 2012, 300 million photos were being uploaded to Facebook every day[2] while Flickr had 560 million uploaded photos in all of 2011.[3] In the spring of 2012, Instagram, a free photo-sharing program recently purchased by Facebook, reported that it had reached an average of over five million uploads a day and a total of over one billion photos uploaded since its launch in 2010.[4] As Facebook has become the primary location for photo-sharing on the internet, some sites such as Kodak/Ofoto have completely shut down while others, such as Shutterfly, have begun to focus mostly on storage and the production of photo-related memorabilia (albums, mugs, cards, and stationary, for example). Facebook has centralized and streamlined the practice of disseminating photos to a community of friends and family for many people. Instead of having to upload photos to storage sites and then send out links to the sites to smaller groups of individuals, Facebook enables users to easily and quickly post individual photos or whole albums from their phone or computer. Although Flickr does not offer the larger access to community and engagement with the broader exchange of materials and communication that are made available on Facebook, it has remained popular with and significant to a particular type of user/photographer. This is likely to be because it offers a variety of communal and aesthetic functions that Facebook does not. In this chapter, I will discuss how this new landscape for social media and digital photography has helped solidify specific features and functions of Flickr and its relationship to aesthetic practice in recent years, while also revealing community anxieties about the proliferation of digital images across social media formats. I will also argue that Flickr represents an alteration in our engagement with the everyday image that has to do with a move towards transience and the development of a communal aesthetic that does not respect traditional amateur/professional hierarchies.

Flickr continues to influence the development of photographic techniques, the choice of objects/subjects photographed and fads in the way that a photo is altered, framed, or presented. (For instance, I think one could argue that the current fad of using digital filters to acquire a "vintage film" look can be directly traced back to the adoption and fetishization of that aesthetic by the Flickr community years before the appearance of Instagram and Hipstamatic.) However, Flickr also provides an interface that, more than in any other social media platform, emphasizes the *practice* of photography and overtly addresses its members as practitioners, artists, and/or image-makers. Flickr is unique precisely because, more than anything, it centers on the practice of photography and therefore appeals most to users who see

their photos as products of aesthetic practice more than extensions or evidence of their online social identities and off-line lives. As *The New York Times* noted in a 2011 article on Flickr's standing in relation to Facebook,

> No one questions Flickr's appeal to photographers who post, admire and comment on a wealth of artistic images, many of which are magazine quality. Where Flickr is faltering is with people who want to store and share more mundane snapshots.[5]

In response to the proliferation of online photo-sharing since Facebook's takeover of all things social media, a "slow-photography" movement has developed that likens itself to the "slow food" movement. Although apparently small in number, members of the slow photography movement argue that digital photography, in the manner it is most often practiced, has become too focused on the accumulation of massive amounts of photos and lacks the deliberative and careful focus that, they believe, was at the heart of much film photography of the past. In an article *Slate* in 2011, author and amateur photographer Tim Wu articulated a definition of the movement:

> the real victim of fast photography is not the quality of the photos themselves. The victim is us. We lose something else: the experiential side, the joy of photography as an activity. And trying to fight this loss, to treat photography as an experience, not a means to an end, is the very definition of slow photography. Defined more carefully, slow photography is the effort to flip the usual relationship between process and results. Usually, you use a camera because you want the results (the photos). In slow photography, the basic idea is that photos themselves – the results – are secondary. The goal is the experience of studying some object carefully and exercising creative choice. That's it.[6]

Whether or not the slow photography movement has any real legs or is even a valid critique of the current state of digital image making, it is still an interesting (and some might say fairly predictable) development at a time in which the practice of photography has become so very altered by digital platforms and social networking software. It reveals an anxiety about the proliferation and use of photographic images in the era of the digital that has less to do with content or privacy issues and more to do with the desire to return to an idealized, engaged, and attentive visual process. This attentiveness or slowness has surely existed in the history of photography, but the photo produced has also been the goal. Slow photography therefore is not so much about a return as yet another redefinition within digital practice. In comparison to other social media sites and platforms, we might find Flickr – with its emphasis on the aesthetic practice and the cultivation of a community of practitioners – more closely aligned with the aims and products of the slow photography movement than say Facebook or Instagram. Both employees

and members of Flickr work to cultivate it as a community center for photographers through things such as the central Flickr blog that highlights specific techniques, approaches or types of subjects, and the groups that form around the sharing and teaching of specific lighting and photographic practices, which certainly distinguishes it from other photo-sharing and social networking sites.[7] Flickr is a social tool for those who want to share their photos with others, but it is also a tool for those who want to connect around (and perhaps reconnect with) the act of photography.

When thinking through the changes in the practices and forms of digital photography and image-based social media that have occurred over the last decade or so, we must recognize that how we understand such changes is informed by a long and complex history of amateur photography and its relationship to domesticity, leisure, consumerism, and artistic production. In the next section, I will detail some of that history in order to provide a context for what exactly is at work in photo-sharing sites in general and Flickr specifically.

Brief history of amateur and domestic photography

In order to better understand the shift in production, representation, and sociality that Flickr represents, it would be helpful to consider a brief social history of the more transformative moments of amateur photography over the last 130 years. This history reveals the manner in which both the form and practice of photography is informed by historically specific discourses stemming from the consumer camera industry as well as the culture around artistic practice and leisure. In tracing this history we will see how the categories of amateur and professional are not demarcated simply by who gets paid for their work and who doesn't, but more by what kind of camera is used and what it requires of its user, what objects are photographed and how they are presented, and how the act of photography relates to the demarcation between public and private life.

According to Patricia Zimmerman, with the advent of Kodak's easy-to-use roll-film cameras in the late 1880s, amateur photography became not simply just an immensely popular leisure/consumer activity, but also an organized social and artistic practice that was valued for its spontaneity, authenticity, naturalness, and emotionalism (particularly in the widespread use and reference to pictorialism).[8] In other words, there were two types of amateurs: those who took photos for fun or to record special events and the like and those "serious amateurs" who considered themselves engaged in the making of art and yet were also enmeshed in middle- to upper-class leisure. (Professionals were largely understood to be those who worked almost exclusively in studios.) Yet the influence of pictorialism and the call to imitate or reference painting was so pervasive that it pushed other approaches and content other than nature into the realm of the unacceptable. This was especially true for images of modern urban life (which now populate photo-sharing and social networking sites) and other everyday images. Zimmerman makes the argument that this "deflected cameras, at least on the discursive level, from insertion into the day-to-day world of industrial capitalism."[9]

By the turn of the century, Kodak was actively creating a market for its $1 Brownie camera and consequently re-defining what amateur photography was supposed to look like and mean. Through its advertising, manuals, promotional literature, and trade journals (*Kodakery, Kodak Magazine, Kodak News*) the company defined amateur photography as a practice that could easily be integrated into everyday leisure activities and could be used to express artistic impulses, yet more than anything else was centered on capturing those special moments of domestic life. Indeed, along with the mass dissemination of cameras came the rise of snapshot photography and perhaps stronger divisions between those who took themselves seriously as artists and those who viewed photography more functionally. Dee Dee Halleck has argued that "Kodak and other photo giants never suggested that camera owners take pictures of their work places, or that they record such significant events as community life, industrial pollution or rank-and-file strikes."[10] Certainly it is true that marketing discourses pushed by companies such as Kodak had a limiting effect on the potential uses of photography, however even those who were deeply invested in encouraging creativity and artistic process in photography (such as the pictorialists) initially stayed away from the harsher realities of modernity and instead focused on the pleasing and pretty ways of nature and the body. As Zimmerman points out, amateurism during this period "became the social and cultural site where one could revive one's true self, which was invariably vivacious, ambitious, and imaginative."[11]

Amateur or snapshot photography experienced another surge in popularity during the 1950s, this time accompanied by commercialization. Not only was the camera to be used to document the good life in postwar America, it could also be used as a means to that end. Popular photography magazines suggested to amateurs that they could make money out of their hobby by selling them to advertisers looking to cash in on images of domestic happiness. Yet, in the 1960s and 1970s, these images came to have more than just a commercial or familial function as the snapshot aesthetic entered the world of art photography as a way to point out the medium's complicated relationship with reality as well as with the construction of family and private life. Like snapshot photography, home movies gained purchase in the 1950s as amateur film was promoted more intensely as a hobby and a commodity.[12] The appearance of the Super-8 on the market in 1965 made amateur and home movie-making even more affordable and accessible (and continues to be used by amateur and professional filmmakers alike as an alternative to video).

Laurie Ouellette has shown that the discourses that shaped and contained vernacular photography were also present in the construction of another amateur media form – the camcorder.[13] Just as Kodak emphasized the domestic uses of photography in order to sell its cameras on a mass scale, Sony, RCA, and other manufacturers sold the camcorder to consumers in the 1980s as an updated, easier to use, extension of the home movie camera – a technology that was itself sold as an extension of the easy to shoot still camera. Of course, other discursive formations accompanied the rise of the camcorder, in particular the anxieties

around vigilante video and, relatedly, the power of amateur videomakers to not only disrupt the traditional institutional practices of newsgathering, but to also offer a home-grown aesthetic that carried with it implicit cultural connections to realism and authenticity.

Consumer digital cameras represent the next major shift – in terms of technology and practice – in popular photography. In limited use during the 1990s, the market began to take off in 2000 as prices of digital cameras began to decline and, according to the market research firm InfoTrends, by 2004, 28 billion digital photos were produced. That number represents six billion more photos than were shot on film even though twice as many people owned film cameras than digital.[14] (By 2011 it was estimated that 80 billion digital photos were taken by Americans alone.[15]) As Martin Hand reveals in his history of the consumer digital camera, while similar in many aspects to film consumer cameras, these new digital devices offered "post production skills of the professional photographer" (such as various enhancements and modifications both on the device and through accompanying software) as well as the immediacy that comes with being able to see your photos in the viewfinder, and the camera's ability to store hundreds of photos.[16] Hand notes that *Popular Photography* initially (in the early 1990s) framed digital photography as a vexed and threatening technology that would likely lead to "decision free" photography, thereby taking away knowledge of and control over how the camera works, but by the early 2000s it began to report on digital in a way that emphasized the manner in which it would offer more control over the photographic process.[17]

In the late 1990s and early 2000s, digital media theorists and researchers did not have that much to say about the social practices and aesthetics of amateur/ consumer digital photography specifically. Instead, the focus tended to be on the question of indexicality and the impact the digital has had on the moving image. As Kris Cohen remarked in a 2005 essay, "With new digital processes, it seems, we return to old theoretical haunts, and so we again find ourselves asking, 'What has become of the Real?'"[18] In his book *The Reconfigured Eye: Visual Truth in the Post-Photographic Era*, William J. Mitchell identified the early 1990s as the start of the "post-photographic" era, since it was at this point that digital imaging became more prevalent than traditional emulsion-based photography.[19] Noting the manner in which digital imaging technologies were in the process of restructuring institutions, memory, meaning, and social practices at that point, Mitchell concludes that "a worldwide network of digital imaging systems is swiftly, silently constituting itself as the decentered subject's reconfigured eye."[20] The dissemination of these technologies has obviously caused some to valorize film photography and others to participate in the construction of what Phillip Rosen has deemed the "digital utopia."[21]

In 1995, Don Slater wrote an article on domestic photography and digital culture that discussed the potentialities of the consumer digital camera, particularly in relation to self-representation.[22] Slater had a difficult time discussing the practices already in use since as he said:

it is the very early days yet for the digital domestic snapshot. ... Private images have not yet entered the datastream of either telecommunications or digital convergence (for example computer-based multimedia which would integrate the photograph within a flow of manipulable public and private images, still and moving, with sound, text and other forms and organizations of information).[23]

The very same year that Slater published his article, Lev Manovich wrote about what he considered to be the paradoxes of digital photography and managed to be quite prescient about the way that it would be used and received over a decade later.[24] He refused to confirm or deny the common belief that the digital would revolutionize photography, but instead argued that

The logic of the digital photograph is one of historical continuity and discontinuity. The digital image tears apart the net of semiotic codes, modes of display, and patterns of spectatorship in modern visual culture – and, at the same time, weaves this net even stronger. The digital image annihilates photography while solidifying, glorifying and immortalizing the photographic. In short, this logic is that of photography after photography.[25]

In the past several years, more media theorists and scholars of photography have studied digital images in the context of social media and have moved beyond questions of representation/indexicality.[26] Hand argues, in contrast to claims made earlier in the twentieth century, that the digital image is or can be made material and that claims made in relation to the ubiquity and assumed ephemerality of digital photography run the risk of underselling the value and meaning of these images to the individual photographers as well as to the broader culture.[27] Kris Cohen studied a group of photobloggers to better understand how they understand the practice of blogging in relation to photography and found that disentangling the two proved impossible. According to Cohen, "Photography and blogging become interarticulated. They become mutually motivating. Motivation derives from the way the photoblog bifurcates one's sense of time."[28] He also found that photobloggers mostly produce "photographs of what they call 'the everyday', the 'banal' or the 'mundane'" and that they do so in order to underscore what their images are not about – traditional domestic and special event snapshot photography. Instead, they want "pictures of life as it happens, as they experience it."[29]

The move to the digital alters many of the basics of photographic practice – whether practical or theoretical – for users and scholars alike. While theorists grapple with the meaning of photography without film, consumers have had to learn new practices and protocols and many have found new ways to incorporate their camera into their daily lives. The relationship between photographer, camera, spectator, and the image changes in some fairly significant ways and yet, as Manovich, Hand, and others have pointed out, there is also much continuity between the practice of digital photography and what came before.

Transience, collection and the everyday image

Whether professional or amateur, photography has traditionally been discussed in relation to history, memory, absence and loss. Fredrich A. Kittler, Andre Bazin, Walter Benjamin, and Roland Barthes have all made arguments that have consigned the meaning and practice of photography largely to its ability to preserve moments in time. As Barthes has stated,

> If photography is to be discussed on a serious level, it must be described in relation to death. It's true that a photograph is a witness, but a witness of something that is no more. Even if the person in the picture is still in love, it's a moment of this subject's existence that was photographed, and this moment is gone. This is an enormous trauma for humanity, a trauma endlessly renewed. Each reading of a photo and there are billions worldwide in a day, each perception and reading of a photo is implicitly, in a repressed manner, a contract with what has ceased to exist, a contract with death.[30]

Bazin has made similar claims, arguing, for example, that in family albums,

> the gray or sepia shadows, phantomlike and almost undecipherable, are no longer traditional family portraits but rather the presence of lives halted at a set moment in their duration for photography does not create eternity, as art does, it embalms time, rescuing it simply from its proper corruption.[31]

Indeed, its connection to memory and history is an essential aspect of photography's social use and meaning. Nevertheless, I would argue that the introduction of digital photography and accompanying websites such as Flickr have created an additional function for photography that has much more to do with transience than with loss. As Nancy Martha West has pointed out in her work on postmortem photography of the Victorian era, the depth of photography's connection to death or loss has a different meaning or weight at different historical moments. In terms of the early to mid-nineteenth century, the period at which West is looking, photography was overtly and regularly linked discursively to mortality, while in a more contemporary moment of snapshot photography, this concept might seem quite foreign and abstract.[32]

Those who use sites such as Flickr use their photography as a daily diary of impressions that teeters somewhere between a collection and a blog promising frequent updates. Flickr is set up in such a way that a user's "photostream," which is located on the left hand side of the page, contains the most recent uploaded photograph at the top of a vertical string of all photographs ever posted by a user. Depending on the layout a user selects (Flickr offers six options), five to 18 photos appear on the first page, along with possibly a group of thumbnails that exist on the right side of the page and that stand as links to "collections" and/or "sets" usually on certain themes, topics, time frames, or events. Since Flickr allows you to

subscribe to another person's page through its "contacts" function, you are notified when new photos are posted. What results is that a typical user (as constructed in relation to the Flickr platform) will return to their contacts page in the same way they might relate to a blog – revisit and refresh in order to get the most recent information/feedback/images/stories. The regular use of Flickr means that while the creator of a page might use their albums as a place for storage and collection (and might provide new visitors with backstory), their photostream is the active, narrative center of their presentation of work and self to the rest of the community. The photostream moves old pictures out of the way to make room for the new, which creates a sense of temporariness for the photos – as if each one had limited time in the spotlight before it would be replaced by something newer. In her work on mobile imaging (primarily cellphones), Heidi Rae Cooley theorizes that the use of these images in moblogs (that are streamed somewhat similarly to Flickr pages) is non-narrative in nature yet still autobiographical. She maintains that "mobile imagining as autobiographical practice proceeds according to a logic of catalog or database ... Such a logic privileges techniques of selection and (re)combination, which do not operate according to cause-effect relations."[33] Caterina Fake, the co-founder of Flickr, describes this aspect of the site as moving the focus away from the single image and says, "The nature of photography now is it's in motion. It doesn't stop time anymore, and maybe that's a loss. But there's a kind of beauty to it."[34] A user's Flickr page works as autobiography or diary by layering an ever-changing or growing stream of photos on the page.

Some groups and pools function as more of a collection than a story and often have rules that require that all photos posted to the group clearly share highly specific features. For instance, "Doors and Windows in Decay," which is described as a "strict" group, has many rules and requirements for any photo contributed to it, including rules that there can be no gates, fences, or people in the shots; photos cannot be taken through a window or a door; and photos "could be new or old, urban or rural, but must be clearly decaying and not stuff that could be resolved with a wet cloth and some detergent."[35] The result is over 14,000 photos that share a number of specific characteristics but are also unique. The intention here is to have photos of decaying doors and windows that both highlight the structural elements of the objects and emphasize the varied effects "authentic" wear and tear have on them. There is less narrative coherence in the practice of "strict groups" and much more of a fascination with the process of compilation and comparison.

The most popular Flickr pages tend to contain images of the mundane along with biographical references that either hint at or blatantly refer to their creator's work/home life (including photos of desks, co-workers, pets, laundry, etc.). They are also likely to have some sort of artistic aspirations or pretensions in their composition, use of lighting, or overall references and display. Snapshot hobbyists, serious amateurs, and professionals all post photos on Flickr and it can often be difficult to tell the difference between the latter two groups as most people don't self-identify either way. However, the pages that are most subscribed to are often those at the center of a community of photographers (such as Heather Powazek

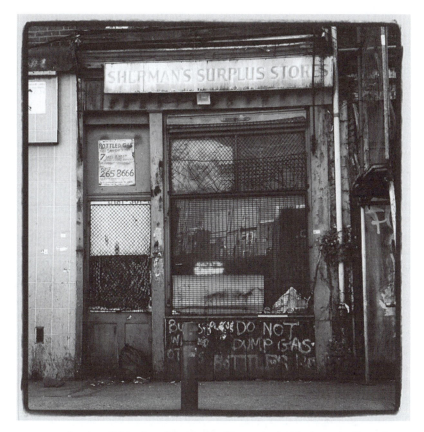

FIGURE 10.2 *Surplus, Whitechapel* from the 'Doors and Windows in Decay' group. Credit: Tim Rich and Lesley Caton, 2012.

Champ, a popular photoblogger who was eventually hired by Flickr in 2005). The content has little relation to traditional snapshot photography, is in many ways the opposite of pictorialist amateur photography (with its focus on realism, urbanization, and the small objects in life that often go unnoticed), and has little to do with studio photography. It seems to speak to a new aesthetic and function – one dedicated to the exploration of the urban eye its relation to decay, alienation, kitsch, and its ability to locate beauty in the mundane. Some have claimed that it is indeed a new category of photography, called "ephemera."

It is, perhaps, the confluence of digital image technology along with social network software that has brought about this new aesthetic. Digital photography has provided the sense that photographs are no longer as precious (and expensive) as they were with traditional roll film photography. The ability to store on and erase memory cards as well as to see the images immediately after taking them provides a sense of disposability and immediacy to the photographic image that was never there before. Images therefore do not have to be so precious as it is possible

to affordably and reasonably incorporate the taking of photos into your everyday life rather than saving film for "special" moments. The mass of images that can be collected on one's hard drive and/or Flickr page contributes to altered notions of permanency and the collection as loss and absence are also redefined. Online photo albums may consist of wedding photos or holidays, but they are just as likely to be organized around ephemeral themes and collections. Group photo pools act as larger albums that highlight not only shared interests between community members but shared fetishes for certain objects, colors, styles, and themes.

When everyday digital photography meets social media, as it does in Flickr, there is an implicit acknowledgement of the inability of photos to hold on to certain moments. Rather than interpreting this as a type of death in the display of digital photography in social network (and photo-blogging) sites, there is an accepted temporariness to the sense of a publicly-presented self. There seems to be an acknowledgement that while you are building a biographical narrative of sorts, it rests upon older versions of yourself and the things that you encounter in your everyday life; that subjectivity shifts and that our relationship to the temporal can never be fixed. There is sadness and a longing in the relationship to memory and history that theorists such as Barthes ascribe to traditional photography, which may not be altogether present in the social construction of vernacular digital photography and its communities. Instead it is understood that an everyday aesthetic – whether present in digital photography, the internet, television, or in the life of the city streets – is fleeting, malleable, immediate, and contains a type of liveness in its initial appearance that is lost once it is placed under glass or *re*placed by an even more recent image. This sense of immediacy and disposability, however, does not mean that digital photography in general, or Flickr in particular, disposes with its relationship to memory and permanence. While there is often a focus on immediacy and disposability in relation to the ubiquity of digital imagery in social media, there is also a valuing of specific images as belonging to a person or cultural archive. As Hand states, "digitization allows for a reinvigoration or remediation of what is essentially a form of album-making, which can co-exist with other forms of memory-making."[36] Jose van Dijck argues that while digital photography has become a social tool for "identity formation, communication, and experience" it also remains – like the forms of photography before it – a tool of memory. Van Dijck writes,

> Digital personal photography gives rise to new social practices in which pictures are considered visual resources in the microcultures of everyday life. In these microcultures, memory does not so much disappear from the spectrum of social use as it takes on a different meaning.[37]

Photo-sharing and communal aesthetics

I would briefly like to consider one of the social features related to representation found in Flickr. The comment function, which enables any number of members to

comment on a photo (as long as it is marked "public"), is an important aspect of developing community bonds to be sure, but, more importantly perhaps, of building a shared aesthetic and negotiating the limits of judgment. Obviously, Flickr was not the first to allow for such group comments on a singular piece of photography. In his 1965 book *Photography: A Middle-Brow Art*, Pierre Bourdieu uses his now-familiar concepts of habitus and ethos to understand the social workings of amateur camera clubs.[38] Finding that most members of such clubs have considerable disdain for domestic or snapshot photography, Bourdieu finds that they have established their own norms, values, and systems of aesthetic judgment that serve to legitimate practices, styles, and subjects that are relatively unique to their community (but that also had artistic and social-class bound aspirations). In this way, there are some similarities between the camera clubs of the 1960s that Bourdieu is looking at and the current Flickr community. Yet the size of the online photo community along with its decentraliziation results in the development of sub-communities of users that may contain variations and alterations of a larger Flickr aesthetic. One could also argue that the exclusion or marginalization of certain types of photos or photographers may happen at the level of self-selection for membership on these sites; the amateur and professional become virtually indistinguishable in their interaction in the comments section and comments move back and forth between the aesthetic, the personal, and the whimsical. Moreover, snapshot/domestic photography is placed alongside amateur and professional, often on the same page, creating less distinction between the two forms. While there is preference for a certain type of everyday aesthetic, the hierarchal relationship between hobbyist, serious amateur, and professional does not really exist on these sites. Heidi Rae Cooley makes the argument that those who moblog with MSDs (mobile screenic devices) are "amateur professionals and professional amateurs" who use the technology in both work and leisure.[39] She also argues that many of the professional's claims to expertise (such as access to distribution) have been undermined by the new technologies the amateur can now use with ease.

While the boundaries between amateur and professional are becoming difficult to discern on these sites, there are still norms and values to follow and judgments to be made regarding items such as choice of subject, lighting, color, and framing. Through their comments, members reward one another for "good" (which could mean beautiful, funny, quirky, unique, etc.) images and reveal the specific features they privilege in certain types of photographs. These preferences or judgments can also be influenced by the almost daily photos posted on Flickrblog (http://blog.flickr.net), discussions on Flickrcentral (a group for all members), and interactions that occur at local (in-person) member meet-ups organized by members and advertised on the site. Flickerblog, a companion Wordpress blog managed and edited by Flickr employees, showcases photos or groups of photos taken by members that are considered to be the "best of" on a certain theme or topic.[40] Visiting the blog provides members with a sense of what those who work at Flickr consider to be the ideal look of a Flickr photo. This is further reinforced when members share tips or favorites in the discussion groups on Flickrcentral and through the in-person

interactions that occur at meet-ups. Moreover, the partnership that Flickr entered into with Getty Images in 2008 (See Frosh, in this volume), which enabled Getty to use the site as a large and always growing archive of stock photos, also highlights the assumed potential for visibility – and payment – for any Flickr member.

Most of these sites of interactions (comments, discussion groups, Flickrblogs, and meet-ups) do not involve distinctions between amateur and professional, and the overall focus on the everyday brings both snapshot and professional photos closer together in terms of their value to the community. For example, depending on the context, a photo taken of an object with a low-resolution cell phone can be just as valued – or sometimes even more so – than one taken with a professional quality camera if it is creative in its subject or framing or overall look. The subject can be mundane or typically domestic in some way and still be valued by the community for some other reason, perhaps its ironic stance to the subject or its mimicking of traditional style, or even just its simplicity. The tagging system employed by Flickr is a bottom-up classification system that not only decentralizes control over many collections and pools, but also contributes to the development of a non-heirarchical community aesthetic. As an example of folksonomy, Flickr's tags help connect people with similar interests, and as Gene Smith explains:

> Folksonomies can work well for certain kinds of information because they offer a small reward for using one of the popular categories (such as your photo appearing on a popular page). People who enjoy the social aspects of the system will gravitate to popular categories while still having the freedom to keep their own lists of tags.[41]

While it has been said that digital photography has in many ways raised our standards for the quality of the image, even in snapshots, as we erase our mistakes and work to find the perfect shot before saving it (temporarily) in our camera's memory, there is also an accompanying acceptance of what might be considered the "imperfect image." For example, images such as those resulting from low resolution cell phones (which often lack the pixels needed for a sharp image), digital cameras set at the "wrong" aperture or shutter speed, and Polaroids, which are commonly scanned and then posted on Flickr, are not only popular forms on these sites but are often fetishized for their low-end look. In the last few years, the phone camera applications Hipstamatic and Instagram have both fostered the proliferation of photos that have a vintage film look to them – similar to what would have been produced on Kodak's Instamatic model of the 1960s. As one of Hipstamatic's creators Lucas Buick put it in a press conference in 2012, "Someone said that Hipstamatic took a shitty photo and made it shittier. That was my favorite review."[42] Both Hipstamatic and Instagram turn the low res features of camera phones into a highly recognizable and widely coveted distinctive aesthetic that can be found all over Flickr and Facebook.

It is as if our move towards clarity is accompanied by nostalgia for the blurry or grainy, which is interesting given all the early hand-wringing by critics and scholars

over the predicted loss of difference, mistakes, and "realness" in the photographic and filmic image that would come with the widespread use of digital image technologies.[43] These early critics feared a loss of texture and authenticity, features they believed were inherent in old image technologies and missing in the cold inhuman perfection of the digital. This idea was perhaps best encapsulated in Bill Nichols statement that "the chip is pure surface, pure simulation of thought. Its material surface is its meaning, without history, without depth, without aura, affect, or feeling."[44] What Nichols claimed and others feared is not turning out to be the case. It would seem that in the ever-shifting temporal mode of this new image environment, there is a place for both the sharp and the grainy; for the perfect and the imperfect. Moreover, it is important to note that there is always a certain amount of degradation in digital photos. As Lev Manovich explains, the process of storing and transmitting photographs at a size that is reasonable involves "lossy compression," a process that involves the deletion of information to create smaller image files. Therefore Manovich argues:

> [T]here is actually much more degradation and loss of information between copies of digital images than between copies of traditional photographs ... So rather than being an aberration, a flaw in the otherwise pure and perfect world of the digital, where not even a single bit of information is ever lost, lossy compression is the very foundation of computer culture, at least for now. Therefore, while in theory, computer technology entails the flawless replication of data, its actual use in contemporary society is characterized by loss of data, degradation, and noise.[45]

So, in fact, the notion of the pure, depthless, ahistorical digital image is a false one and has served to both elevate and denigrate the digital image when compared to film. However, as this quote from Manovich reveals, the digital image bears remnants of its own history, which may not be exactly the same as, say, scratches on a film negative, yet nonetheless shows traces of its own use and manipulation. (These scratches, glitches, and errors are of course transformed by Hipstamatic and Instagram into something that mimics the scratchy graininess and overexposures of older consumer film technology.)

In Flickr, we find an altered temporal relationship to the everyday image, a leveling of the hierarchy between professional and amateur, a unique sense of a community of viewers/producers, as well as a differing relationship to the collection, display, categorization, and distribution of the digital image. Instead of purely evoking loss, preservation, and death, users and viewers are encouraged to establish a connection with the image that is simultaneously fleeting and a building block of a biographical or social narrative. While these sites build a collection, they also privilege the immediacy of the image and acknowledge the inability of photography to hold onto time even as it provides avenues for nostalgia and memory. In addition, on the photo sites at least, the everyday communal aesthetic that has been constructed is one that privileges the small, the mundane, the urban, and/or the

industrial. While digital photography has not revolutionized photography or led to a loss of the authenticity of an image as predicted early on, it has significantly altered our relationship to the practice of photography (when coupled with social networking software), as well as to our expectations for and interactions with the image and an everyday aesthetic.

Acknowledgements

Portions of this chapter originally appeared as "Digital Images, Photo-sharing, and Our Shifting Notions of Everyday Aesthetics," *Journal of Visual Culture*, 7 (2), 2008: 147–63.

Notes

1 www.flickr.com/groups/abandoned_minnesota/pool/with/7622198414/#photo_76221
98414
2 Katrina Trinko, "Awash in Kodak Memories," *USA Today*, July 10, 2012. www.usato-
day.com/news/opinion/forum/story/2012-07-10/online-photos-facebook-sharing/56135
292/1. Last accessed August 1, 2012.
3 www.flickr.com/photos/franckmichel/6855169886/
4 Liz Gannes, "Instagram by the Numbers," *All Things D.* http://allthingsd.com/
20120403/instagram-by-the-numbers-1-billion-photos-uploaded/. Last accessed August
1, 2012.
5 Verne Kopytoff, "At Flickr, Fending Off Rumors and Facebook," *New York Times*,
January 31, 2011, B, p. 3.
6 Tim Wu, "The Slow-Photography Movement: What's the Point of Taking Pictures,"
Slate, January 18, 2011. www.slate.com/articles/life/obsessions/2011/01/the_slowpho-
tography_movement.html. Last accessed July 31, 2012.
7 See the Flick blog at: http://blog.flickr.net/en. See examples of technique based Flickr
groups at www.flickr.com/groups/whenlightleaksin/ and www.makeuseof.com/tag/10-
flickr-groups-for-serious-shutterbugs/
8 See Zimmerman, op. cit.
9 Zimmerman, op cit., p. 39
10 Laurie Ouellette, "Will the Revolution be Televised? Camcorders, Activism, and Alter-
native Television in the 1990s," *Transmission 2*, Peter d'Agostino and David Tafler (eds),
Thousand Oaks, CA: Sage, 1999, pp. 165–87.
11 Zimmerman, p. 10.
12 Zimmerman, p. 113.
13 Ouellette, op cit.
14 Amy Harmon, "Stop them Before they Shoot Again," *New York Times*, May 5, 2005,
Section G, Column 4, p. 1.
15 Figure from *National Geographic* Infographic from the April 2012 issue reproduced
on http://hyperallergic.com/48765/how-many-photos-do-americans-take-a-year/. Last
accessed August 5, 2012.
16 Martin Hand, *Ubiquitous Photography*, Cambridge: Polity Press, 2012, p. 115–17.
17 Ibid.
18 Kris R. Cohen, "What Does the Photoblog Want?" *Media Culture & Society*, 27 (6): 883–901.
19 Mitchell, op cit., p. 85.
20 Mitchell, op cit., p. 85
21 Rosen 2001, op cit., p. 318
22 Don Slater, "Domestic Photography and Digital Culture," in *The Photographic Image in
Digital Culture*, Martin Lister (ed.), New York: Routledge, 1995, p. 145.
23 Ibid, 131.

24 Lev Manovich, "The Paradoxes of Digital Photography," *Photography After Photography* Exhibition catalog, Germany 1995. www.manovich.net/TEXT/digital_photo.html. Last accessed March 21, 2013.

25 Ibid.

26 For example, see: Hand, 2012; Jose van Dijck, *Mediated Memories in the Digital Age*, Stanford, CA: Stanford University Press, 2007; Helen Jackson, "Knowing Photographs Now: The Knowledge Economy of Photography in the Twenty-first Century," *Photographies*, 2(2), September 2009: 169–83; Martin Lister, "A Sack in the Sand: Photography in the Age of Information," *Convergence*, 13(3), 2007: 251–72; Sarah Pink, "Amateur Photographic Practice, Collective Representation and the Constitution of Place," *Visual Studies*, 26(2), 2011: 92–101; Melissa Terras, "The Digital Wunderkammer: Flickr as Platform for Amateur Cultural and Heritage Content," *Library Trends*, 59(4), 2011: 686–706.

27 Hand, op cit., p. 95.

28 Cohen, op cit., p. 895.

29 Cohen, op cit., p. 887.

30 Roland Barthes, "The Grain of the Voice," in *Image Music Text*, New York: Hill and Wang, 1978, p. 356.

31 Bazin, op cit., 14.

32 Nancy Martha West, *Kodak and the Lens of Nostalgia*, Charlottesville, VA: University of Virginia Press, 2000, p.142–43.

33 Heidi Rae Cooley, "The Autobiographical Impulse and Mobile Imagining: Toward a Theory of Autobimetry." Presentation at the Thinking Through New Media Graduate Conference, Duke University, June 7–8, 2006.

34 Harmon, op cit., p. 1.

35 Doors and Windows' Flickr group: http://www.flickr.com/dwd/. Last accessed August 5, 2012.

36 Hand, op cit., p. 164.

37 Van Dijck, op cit., p. 116.

38 Pierre Bourdieu, *Photography: A Middle-brow Art*. Trans. Shaun Whiteside. Stanford, CA: Stanford University Press, 1990.

39 Heidi Rae Cooley, " 'Identify'-ing a New Way of Seeing: Amateurs, Moblogs and Practices in Mobile Imaging," *Spectator*, 21(1), Spring 2004: 68.

40 http://blog.flickr.net.

41 Gene Smith, "Folksonomy: Social Classification," Atomiq.org, August 3, 2004. www.flickr.com/groups/dwd/. Last accessed April 14, 2013.

42 A. G Beato, "Disposable Hip," *The Baffler*, Mar 2012(19): 107–11.

43 See the *Wide Angle* issue on "Digitality and the Memory of Cinema", 21(1), January 1999.

44 Bill Nichols, "The Work of Culture in the Age of Cybernetic Systems," in John Thorton Caldwell (ed.), *Electronic Media and Technoculture*. New Brunswick, NJ: Rutgers University Press, 2000, p. 101.

45 Lev Manovich, *The Language of New Media*. Cambridge, MA: MIT Press, 2001, pp. 54–55.

Bibliography

Barthes, Roland (1978)."The Grain of the Voice" in *Image Music Text*. New York: Hill and Wang.

Bazin, Andre (1967). *What Is Cinema?* Trans. Hugh Gray. Berkeley, CA: University of California Press.

Beato, A. G. (2012). "Disposable Hip," *The Baffler*, March, 19: 107–11.

Bourdieu, Pierre (1990). *Photography: A Middle-brow Art*. Trans. Shaun Whiteside. Stanford, CA: Stanford University Press.

Cohen, Kris R. (2005). "What Does the Photoblog Want?" *Media Culture & Society*, 27 (6): 883–901.

Cooley, Heidi Rae (2004). "'Identify'-ing a New Way of Seeing: Amateurs, Moblogs and Practices in Mobile Imaging," *Spectator* 21(1), Spring: 65–79.

Cooley, Heidi Rae (2006). "The Autobiographical Impulse and Mobile Imagining: Toward a Theory of Autobimetry." Presentation at the Thinking Through New Media Graduate Conference, Duke University, June 7–8, 2006.

Gannes, Liz (2012)."Instagram by the Numbers." *All Things D*. http://allthingsd.com/20120403/instagram-by-the-numbers-1-billion-photos-uploaded/. Last accessed August 1, 2012.

Hand, Martin (2012). *Ubiquitous Photography*. Cambridge: Polity Press.

Harmon, Amy (2005). "Stop Them Before They Shoot Again," *The New York Times*, May 5 Section G, Column 4, p. 1.

Jackson, Helen (2009). "Knowing Photographs Now: The Knowledge Economy of Photography in the Twenty-first Century," *Photographies*, 2 (2), September: 169–83.

Kopytoff, Verne (2011)."At Flickr, Fending Off Rumors and Facebook," *New York Times*, January 31, 2011, B3.

Lister, Martin (2007). "A Sack in the Sand: Photography in the Age of Information," *Convergence*, 13 (3): 251–72.

Manovich, Lev (1995). "The Paradoxes of Digital Photography." *Photography After Photography* exhibition catalog. www.manovich.net/TEXT/digital_photo.html. Last accessed April 14, 2013.

Manovich, Lev (2001). *The Language of New Media*. Cambridge, MA: MIT Press.

Mitchell, William J. (1992). *The Reconfigured Eye: Visual Truth in the Post-Photographic Era*. Cambridge, MA: MIT Press.

Nichols, Bill (2000). "The Work of Culture in the Age of Cybernetic Systems," in John Thornton Caldwell (ed.), *Electronic Media and Technoculture*. New Brunswick, NJ: Rutgers University Press, pp. 90–114.

Ouellette, Laurie (1995). "Will the Revolution be Televised? Camcorders, Activism, and Alternative Television in the 1990s," *Transmission 2*, Peter d'Agostino and David Tafler (eds). Thousand Oaks, CA: Sage, pp. 165–87.

Pink, Sarah (2011). "Amateur Photographic Practice, Collective Representation and the Constitution of Place," *Visual Studies*, 26 (2), 92–101.

Rosen, Phillip (2001). *Change Mummified: Cinema Historicity, Theory*. Minneapolis, MN: University of Minnesota Press.

Slater, Don (1995). "Domestic Photography and Digital Culture," in Martin Lister (ed.), *The Photographic Image in Digital Culture*. New York: Routledge, pp. 129–46.

Smith, Gene (2004). "Folksonomy: Social Classification," Atomiq.org, August 3rd. www.flickr.com/groups/dwd/. Last accessed April 14, 2013.

Terras, Melissa (2011). "The Digital Wunderkammer: Flickr as Platform for Amateur Cultural and Heritage Content," *Library Trends*, 59 (4): 686–706.

Trinko, Katrina (2012). "Awash in Kodak Memories," *USA Today*, July 10.

Van Dijck, Jose (2007). *Mediated Memories in the Digital Age*. Stanford, CA: Stanford University Press.

West, Nancy Martha (2000). *Kodak and the Lens of Nostalgia*. Charlottesville, VA: University of Virginia Press.

Wu, Tim (2011). "The Slow-Photography Movement: What's the Point of Taking Pictures," *Slate*, January 18. www.slate.com/articles/life/obsessions/2011/01/the_slow photography_movement.html. Last accessed July 31, 2012.

Zimmerman, Patricia (1995). *Reel Families: A Social History of Amateur Film*. Bloomington, IN: Indiana University Press.

11

BLURRING BOUNDARIES

Professional and citizen photojournalism in a digital age

Stuart Allan

Evaluated from the vantage point of today, early prognoses regarding photojournalism's likely reconfiguration in digital terms remain intriguing. Tempting as it may be to tick boxes on an imaginary scorecard, awarding praise for those correctly foreseeing how developments would duly unfold, it quickly proves more productive to consider emergent, inchoate points of convergence and divergence of continuing relevance.

With this in mind, this chapter endeavours to contribute to a critical historiography of the digital ecology of photojournalism by elucidating discursive tensions in varied, evolving inflections of journalism, technology and innovation from the 1990s onwards. In attending to differing perceptions of these tensions – via a close reading of mainstream news coverage, as well as on the basis of the recollections of practitioners themselves – particular attention is devoted to examining the blurring of traditional definitional boundaries demarcating the amateur from the professional news photographer.[1] Several instances of what I term 'citizen witnessing' (Allan 2013) will be assessed in order to better discern these boundaries, ranging from imagery of the September 11, 2001 attacks to cameraphone documentation of the London riots a decade later. It will be argued that in striving to bear witness with personal recording technologies, citizens are generating first-hand, embodied forms of visual reportage – via digital photographs, camcorder video, cell or mobile telephone imagery and the like, shared across social networks – with important consequences for revisioning the proclaimed epistemic certainties of photojournalism's norms, values and protocols.

Cracks in the mirror

While the photography world was busy congratulating itself last year on the 150th anniversary of the medium, and while photojournalism was being recognized as an art in several touring museum exhibitions, the public territory of still photography was quietly eroding.

This is what critic Andy Grundberg (1990) of the *New York Times* observed in January, 1990. 'World events, which still photography has long memorialized, rushed by so rapidly at decade's end that cameras seemed for once unable to keep up', he continued. 'At least this was true of cameras that use film, the traditional bearer of the news images that become etched in the public mind.' In marked contrast was television, which deserved credit in his view for capturing truly memorable, 'real time' images of political upheaval in 1989. Television's 'new-found mobility' considerably enhanced its 'power to capture our attention', especially live video images – frequently blurred, shaky and feverish – surveying the scope and magnitude of breaking news events. The reason why 'photojournalists today feel like an embattled breed' was understandable when photography 'keeps slipping further from its erstwhile role of giving events their primary emotional contours'. Exceptions were evident, of course, but the extent to which television news was usurping photojournalism's role seemed increasingly apparent. The emotional immediacy of television news, like its 'unceasing presence', resonated with viewers, Grundberg suggested, because it offered a view of events ostensibly less-edited or premeditated than that associated with the news photograph, albeit one less organised or coherent in visual terms. At the same time, however, 'television also tends to lower the threshold that distinguishes real events from entertainment', he added, because its intrinsic commercialism 'ultimately diminishes all hierarchies of visual experience'.

Grundberg was one of a growing chorus of critics at the time raising the spectre that photojournalism was increasingly at risk of conceding its reportorial authority as an impartial recorder of reality in light of the impending shift toward 'electronic' or 'digital' image-making (see also Norville 1990; Reaves 1987; Ritchen 1984; Power 1987). To the extent attendant frictions were considered newsworthy, however, mainstream press coverage in the US and Britain tended to be relatively sanguine, typically revolving around the benefits to be afforded by novel technical innovations. 'I think the 1990s will be a decade of frustration and experimentation for the picture world', journalist Tony Spina (1990) opined. 'There will be cameras for amateurs and professionals that will record pictures on tiny disks, viewed instantly on a TV monitor, stored in computers, and sent to other computers anywhere.' The relative advantages of 'still video' cameras – in effect, a refashioned video camera capable of taking single images, which could then be relayed over a modem – were attracting positive comment. CNN's use of the technology to document student-led pro-democracy protests in Beijing's Tiananmen Square the year before had demonstrated its potential, enabling the network to broadcast images hours ahead of its rivals. Newspapers, in particular, were enthusiastic about the prospect of still-video being a 'timesaving tool' when shooting news stories under pressure, while also alert to possible cost savings with the new format, given that the chemical processing of film would be replaced by erasable disks. 'Not all photojournalists will want to carry the somewhat heavier and bulkier still video units', Paul Saffo (1990) noted, 'but they are likely to become common in areas such as sports photography, where deadlines are tight and photographers need to plan ahead'.

The efficiency gains achieved under such circumstances – much being made of the electronic camera's consignment of the darkroom to the dustbin of history – were sufficient in the eyes of some to offset lingering qualms about the disappearance of the film negative as a trustworthy record of the original shot.

Fully-fledged 'filmless' cameras would not become available for several years, but 1990 had seen excitement growing in the press about advances in wire service technology enabling ever-faster distribution of images (each still-video photograph from Tiananmen having required three or four minutes to relay back to CNN's newsroom in the US). Greater confidence in handling 'electronic' images led some news organisations to experiment with digital colour separations during the printing process, though not always successfully. 'The *San Francisco Examiner* is learning about integrating digital color photography into its pages the hard way – by trial and glaring error', Pamela Pfiffner (1990) remarked; 'Perhaps the most valuable lesson the daily newspaper has learned is that you can't shoehorn whiz-bang new technology into time-honored practices and expect a perfect fit'. Evidently readers were all too aware the *Examiner* was 'practicing in public with color', as the photographs 'often registered incorrectly, with visible color casts, moires and little shadow detail'. Meanwhile, other newspapers were testing new methods of image capture and manipulation, striving to perform 'traditional darkroom techniques' using scanners and bespoke processing software. Insights drawn from industry served to inform readers that digital imagery could be subjected to alteration by anyone with the requisite computer skills. Still, press coverage regarding the ethical implications of 'electronic photo manipulation' for photojournalism was sparse (Photoshop 1.0, formally released in February of 1990, was overlooked), with little indication that concerns about 'retouching' would cross the professional threshold into the realm of wider public debate.

In retrospect, it is curious that these early signs that photojournalism's privileged claim to provide a transparent 'window on reality' was being recast in the digital realm were not deemed to warrant greater attention. If they seldom featured in the press at the time, however, within newsrooms they chimed with simmering debates regarding photojournalism's wider social responsibilities (see also Becker 1991). The professional's claim to be the people's witness, the dispassionate relayer of factual truths for the benefit of distant viewers, was proving increasingly open to contestation. Press photographers, William J. Mitchell (1992: 16) pointed out, 'scented a cybernetic dystopia in the making – a world infested with subversive, uncontrollable image hackers who would appropriate photographic fragments at will and recombine them into fictions'. Few disputed that ethical dilemmas posed by image manipulation were longstanding, but some nonetheless expressed grave misgivings that the adoption of digital imaging technology in 'electronic darkrooms' (where 'images are stored as electrical impulses that can be enlarged or shrunk, cropped, lightened or darkened on a terminal') would 'spell the end of what's left of the composing room' (AP 1989). Still, while some professional forums gave voice to ethical quandaries – 'Journalism's latest ethical nightmare: photographs that lie', in the case of *The Washington Journalism Review* – not everyone was overawed by the prospect of 'digitalized darkroom

razzle-dazzle', journalist Don Kowet (1989) contended. He cited AP President Louis Baccardi's counter argument: 'You can do it with an air-brush as well as electronics, except that it just takes longer.' Baccardi then continued: 'I don't think editorial policies will change one iota. It's either an honest picture or it's not.'

Converging realities

By the mid-1990s, the idealised tenets underpinning news photography's proclaimed alignment with objectivity – 'the absence of an invested point of view', to borrow Martha Rosler's (1989) phrase – were beginning to buckle under mounting pressure (see also Lister 2007). Issues raised from within photojournalism's inner circles about safeguarding the visual integrity of the still photograph were proving to be evermore newsworthy, not least because the computer hardware and software necessary for image manipulation was becoming increasingly affordable, and thereby widely available to professionals and amateurs alike.

'With taps on a keyboard, or the sweep of a mouse, the new breed of image-maker can take an object in a real photograph and clone it, move it, paint it a different color, rotate it, flip it, or switch it to another photo scene entirely', the *Washington Post*'s Kathy Sawyer (1994) reported. While 'phonied photographs' were not new, 'the latest technology makes deceptions much easier and faster to accomplish and much harder – if not impossible – to detect'. For Pat Kane (1994) writing in London's *Sunday Times*, the consequences seemed clear: 'the claim of the photographic to bear true witness is currently collapsing, from inside and outside.' It was all too apparent that the 'advent of digital imaging threatens to subvert photographic realism once and for all', effectively inviting 'a digitally aware audience' to question whether a given image was reflecting reality or simulating it. 'Digitality brings us to a point where we either trust news professionals to act in an ethical manner about the realism of photo-images, or we do not', Kane surmised; 'More likely, our growing knowledge of post-photographic techniques will encourage us to suspect hidden persuaders at work on every level of visual culture'. Further expressions of disquiet that the 'camera's grip on reality' was slipping revolved around perceived changes – 'corruption', in the eyes of some – in the values driving what was characterised as a growing tabloidisation of news, where hard, factual reporting gives way to light 'human interest' stories. 'To say photojournalism is dying' misses a vital dimension, Jean-Francois Leroy argued. 'The right question to ask is: Is the press dying? The press is dying because it is more and more interested in frivolity' (cited in Riding 1996). As a result, he concluded, photojournalism was at a crossroads, its future far from certain.

Sceptics required further convincing that a language of crisis was merited, of course. 'I worked for *Life* magazine when it was a weekly', photojournalist David Burnett recalled in 1997. 'And when *Life* folded in 1972, everyone said, well, that's the death of photojournalism. And about every three or four years, we've gone through a new death of photojournalism.' Confidently predicting that the web would provide new outlets for growing numbers of photojournalists, he added: 'I think

it's a little early to cry the death knell one more time. But we do have to keep on our toes in trying to figure out new ways and new avenues to present our work' (cited in NPR 1997). This tempered enthusiasm was being similarly expressed in the newsrooms of several major newspapers and magazines at the time, where the potential benefits promised by digital cameras were gaining attention – particularly with respect to factors such as speed (transmitting digital images in minutes) and finance (the prohibitive cost of initial outlay soon recovered by savings in film and processing). Describing the growing use of digital cameras in the field, Geof Wheelwright (1994) noted 'photojournalists are able to join print scribes in sending their work as computer files via "modem" over telephone lines'. This meant there 'is no waiting for the lab to develop film, no dashing to get the processed film to a courier and no nail-biting wait at the picture desk'.

This capacity to handle deadline-driven priorities was recurrently underscored as a key factor by photographers cited in press reports describing the arrival of the first digital news camera – the NC2000 produced as a joint-venture between Kodak and the Associated Press – in 1994. For seasoned photographer John James of the *Birmingham Post and Mail*, who managed to borrow the new camera from AP to test, its near-instant results made it a serious rival for television. 'As soon as I got my hands on the new equipment I knew there was no going back', he later recalled. 'It's potential was absolutely phenomenal. Finally we could print pictures nobody else could get. To me that's what photojournalism was all about' (cited in Summers 1999). Similarly extolling its virtues was Nick Didlick of *The Vancouver Sun*, who highlighted how gains in 'speed and immediacy put the news back into news photography' (cited in *The Straits Times* 1995; Rodgers 1995). Further considerations coming to light included improvements in the portability of equipment. David Holmstrom (1995) maintained that 'if digital imagery becomes commonplace, photojournalists will applaud the resulting lightness of their camera bags'. As he pointed out, on some assignments, '40 to 60 pounds of equipment are not unusual – even before adding the dozens of rolls of film'. Those criticising digital images for lacking sufficient image quality to rival film were countered by those suggesting this limitation seldom mattered on the web, where the lower resolution was serviceable for small images on computer screens. 'The future model of photojournalism is no longer unidimensional. It is dynamic', *Time* photojournalist Dirck Halstead insisted. 'The potentials of the new technologies have only just begun to be explored' (cited in Anstead 1997).

Hope was flickering that photojournalism would be soon poised to compete with the immediacy of television news, but much depended upon securing a firmer institutional purchase in online contexts. Success in this regard would necessarily entail resolving – in the words of Alan Riding (1996) in the *New York Times* – 'the profession's deep identity crisis at a time of shrinking outlets for photojournalism with strong political and social content, of growing numbers of young photographers entering the market and of uncertainty over the impact of new forms of digital storage'. Decreasing at an alarming rate, he observed, was the space available to the self-employed freelance photojournalist coping with 'the sidewalk snapshots

supplied by paparazzi', on the one hand, and competition over breaking news from the news agencies (e.g. AP, Reuters, Agence France-Presse, UPI), on the other. The market for 'serious' photojournalism, it seemed to many commentators, was being decisively undercut by television infotainment across a plethora of new cable and satellite channels, widely perceived to be responsible for creating a public obsession with trivial matters of celebrity tittle-tattle. 'Photojournalism had become a different profession. The sums of money have increased with the dumbing down of journalism where entertainment is cash', James Adams of UPI argued. 'The money is not in reporting on wars or famine, but in getting a picture of a celebrity topless. Today's market is Dodi kissing Diana on a boat in the Mediterranean. That sells' (cited in Sonenshine 1997).

In the UK at this time, it is worth noting how frequently the professional status of the photojournalist was defined in stark opposition to the 'amateur paparazzo' prior to the death of Princess Diana, her companion Dodi Al Fayad and their chauffer in a car crash following a high-speed chase by photographers on motorbikes. Mike Maloney, chief photographer of Mirror Group Newspapers, had told the *Guardian* a year before the August 1997 accident that any 'fly-by-night Johnnie-come-lately' could establish themselves as a rival. 'They might be welders or bricklayers. They buy a state of the art camera and suddenly they are photographers. They cause problems. We are all tarred with the same brush' (cited in Boseley 1996). The conduct of news photographers of all descriptions was subjected to close scrutiny in the aftermath of the crash, with the paparazzi singled out for fierce public derision. 'The paparazzi consider themselves foot soldiers in a new and growing army of information-gatherers in a media age in which information-gathering has somehow gotten confused with newsgathering', former *Newsweek* contributing editor Tara Sonenshine (1997) remarked. New, 'high-tech tools' indicative of a wider 'communications revolution' were inviting 'the public to play reporter', even though 'merely toting the tools of the trade does not make any individual with a camera or a computer a member of the profession', she reasoned. Before, that is, she reversed tack and asked: 'Or does it?'

As one century gave way to the next, answers to this question were proving elusive. 'It is only when you hear photo-journalists reminisce about the superb pictures they used to bring back from every corner of the world in the '80s that you understand how bitter they feel today', Michel Guerrin (2000) of *Le Monde* commented in 2000. 'Self-confident, individualistic, indomitable and highly respected, they used to be the kings and queens of photography.' Precisely what counted as photojournalism – and who was justified in self-describing themself as a photojournalist – defied straightforward definition, particularly when set against a backdrop of dramatic transitions underway in the brave new world of digital media. Journalism *on* the internet appeared to be gradually transfiguring into journalism *of* the internet, and in so doing rewriting protocols of news reporting in ways proving disruptive to familiar assumptions about amateur–professional boundaries. Several events were suggestive of the implications at stake, but none so profoundly as those occurring on a fateful day in September, 2001.

'Inviting the public into our world'

The New York-based International Center of Photography estimated between 150 and 200 print photographers were on the scene in Lower Manhattan, one of whom – Bill Biggart, a freelancer – was killed when the second tower of the World Trade Center collapsed. Several others were injured, including New York *Daily News* photographer David Handschuh who sustained a broken leg, while others would suffer lingering health (respiratory, but also psychological in some cases) complications (Fischer 2002; Trost 2002). Supplementing their efforts in ways regarded as unprecedented at the time – due to the emotive immediacy, scope and sheer volume of the ensuing imagery – were ordinary citizens engaged in spontaneous, spur-of-the moment forms of camera witnessing.

Less than ten minutes after the first passenger jet struck, eyewitness accounts began to appear on the web, followed shortly thereafter by an astonishing array of images and video footage documenting the unfolding crisis. 'The eyes were everywhere', visual editor David Friend (2007) later recalled. 'Witnesses were observing, and photographing, the deadliest terrorist strike in American history even before they realized it […] As the moments elapsed, and people took to the streets, Manhattan seemed alive with cameras' (2007: xiii; see also Zelizer 2011). The contributions of 'amateur newsies' or 'personal journalists' engaged in 'DIY [Do-It-Yourself] reporting' or 'citizen-produced coverage', to use the terms appearing in the press, 'deluged' the web from diverse locations, so diverse as to make judgments about their relative veracity difficult, if not impossible. Some claimed to be survivors of the havoc, but more typical were shots offered by onlookers or bystanders, as well as relief and rescue workers arriving on the scene. 'Anyone who had access to a digital camera and a Web site suddenly was a guerrilla journalist posting these things', said one graphic-designer-turned-photojournalist at the time. 'When you're viewing an experience through a viewfinder, you become bolder' (cited in Hu 2001). Gayle MacDonald (2001) of Canada's *Globe and Mail* was one of many journalists to maintain that the 'most vivid images were captured by the pedestrians with hand-held cameras who found themselves playing bit parts in this unfathomable tragedy'. This judgement led her to contend, in turn, 'the preponderance of this pocket-sized technology is radically changing the way the world views things'.

In the years to follow, the active participation of amateur photographers in the news-gathering process corresponded to the growing ubiquity of cheaper, easier to handle digital cameras. Where in the past it was typically the case that a photo-journalist would be dispatched to the field following a tip called into the newsroom by a member of the public, now it seemed ordinary citizens were often prepared, camera in hand, to bear witness themselves. Increasingly likely to be first on the scene, so-called 'amateur snapshooters' or 'citizen shutterbugs' were making the most of opportunities to document breaking news. Arguably the most iconic of the images capturing the *Columbia* space shuttle explosion in 2003, for example, was revealed to have been shot by a cardiologist, Scott Lieberman, with his digital SLR. 'Within hours, [the *Columbia* images were] out there on the wire around

the world', newspaper editor David V. Berry recalled, due to Lieberman's Canon EOS-D60. 'There was no "I've got film in my camera, where do I get it processed?"' delay engendered. 'We've realized that digital cameras have made it easier to say "We can't get a photographer there – can you take a picture and e-mail it to us?"' Berry added (Berman 2004). If images of usable quality tended to be the exception rather than the rule, it was patently clear that citizen contributions were well-worth considering, particularly when payment usually consisted of a simple credit upon publication. In the case of a hotel fire in Brisbane, Australia, in May 2004, 'customers and passers-by began snapping away with digital cameras and picture-taking mobile phones', a local newspaper reported. 'Where once there would have been plenty of witnesses but not much in the way of a permanent record, much of yesterday's fire is stored away in camera memory cards' (Thompson 2004; see also Berman 2004; Glaser 2001).

This type of alternative, citizen-centred photojournalism gained wider recognition as a vital strand of what was being called 'citizen journalism' in the immediate aftermath of the South Asian tsunami of December 2004. 'Digital cameras blew the lid off Iraq's Abu Ghraib prison and exposed a major scandal', journalist Mike Barton (2005) observed, 'and now with the Asian tsunami disaster people with digital cameras and video recorders have delivered the first and most vivid accounts from the scene'. News organisations found themselves in the awkward position of being largely dependent on amateur reportage to tell the story of what was tran-spiring on the ground. 'Never before has there been a major international story where television news crews have been so emphatically trounced in their coverage by amateurs wielding their own cameras', one British newspaper declared; 'Producers and professional news cameramen often found themselves being sent not to the scenes of disaster to capture footage of its aftermath, but to the airports where holiday-makers were returning home with footage of the catastrophe as it hap-pened' (*The Independent* 2005). Despite its ambiguities, the term 'citizen journalism' was perceived to capture something of the countervailing ethos of the ordinary person's capacity to bear witness, thereby providing commentators with a useful label to characterise an ostensibly new, vernacular genre of reporting. The striking range of eyewitness imagery – much of it posted online through blogs and personal webpages – being generated by individuals on the scene won accolades for making a unique contribution to mainstream journalism's coverage. One newspaper headline after the next declared citizen journalism to be yet another startling upheaval, if not an outright revolution, being ushered in by digital technologies.

The significance of bottom-up, inside-out contributions from increasingly image-savvy publics – in contrast with the top-down, outside-in imperatives of professional news reporting – was being regarded as indicative of a broader 'citizen journalism movement' throughout 2005 (Schechter 2005). The summer of that year saw a crisis unfold that appeared to consolidate its imperatives, effectively dispensing with claims that it was a passing 'fad' or 'gimmick' for all but its fiercest critics. The immediate aftermath of the bombs that exploded in London on 7 July, destroying three underground trains and a bus, leaving 56 people dead and over 700 injured,

was precipitously recorded by citizens making use of digital cameras. In the face of official denials that anything was amiss, news organisations seized upon diverse forms of citizen witnessing to piece together the story. 'What you're doing is gathering material you never could have possibly got unless your reporter happened by chance to be caught up in this', BBC News' Vicky Taylor maintained on the day (cited in Jesdanun 2005). Mobile telephones had captured the scene of fellow commuters trapped underground, with many of the resultant images resonating with what some aptly described as an eerie, even claustrophobic, quality. Video clips were judged to be all the more compelling because they were dim, grainy and shaky, and – even more important – because they were documenting an angle on an event as it was unfolding. The citizens in question were proffering a firsthand, personal vantage point, rather than the ostensibly impersonal perspective of the dispassionate observer. 'The value of this is you'll know more about what's actually happening, why you should care, what it means', online editor Will Tacy said at the time. 'You know about what's happening to individuals. That's always been the best of journalism' (cited in Parry 2005; Weiner 2005). Remarking on this transition of news source to news gatherer, he added: 'We aren't even close to where this is going to end up in inviting the public into our world'.

In the days to follow, appraisals of the changing nature of the dynamics between professional journalism and its amateur, citizen-led alternatives sparked robust opinions. 'With the camera phone and digital wizardry any idiot can snap a great news photo. Or can they?' photojournalist Nick Danziger (2005) asked in *The Times*. 'Recording the extremes of human existence is not a job for amateurs', he argued, namely because it is 'not enough for a photographer to be in the right place at the right time'. It is the professional prepared to go to extraordinary lengths, often at great personal cost, 'to bring you, the viewer, the truth', who makes the decisive contribution. 'All good reportage photographers go beyond being an eyewitness', Danziger insisted. 'They establish evidence through a spirit of inquiry, compassion and communion.' Elsewhere in the press, more accommodating views were rehearsed, some employing a discourse of partnership, albeit cautiously so. 'We are in the earliest stages of a revolutionary relationship, and its current urgency is bound to be tempered by setbacks', Emily Bell (2005) of the *Guardian* surmised. The rewards to be gained by 'opening doors and distribution platforms to everybody' were substantial, she believed, but not without risk: 'It might take only one faked film, one bogus report to weaken the bond of trust, and, conversely, one misedited report or misused image to make individuals wary once again of trusting their material to television or newspapers'.

Shifting paradigms

News organisations wasted little time fashioning new strategies to verify the authenticity of submitted imagery or 'user-generated content', even when aware that checking veracity offered no absolute guarantees where safeguarding against duplicity, let alone hoaxes, was concerned. Still, over a range of crisis events to

follow in subsequent months, assessments of how the news-gathering process was being effectively democratised by 'digital snappers' tended to be upbeat. 'Have Camera Phone? Yahoo and Reuters want you to work for their news service', announced a *New York Times* headline (Hansell 2006). Commentators pointed to 'milestones' indicative of how such imagery surpassed – or 'scooped' in journalistic parlance – alternatives offered by professionals, such as during the French riots in the autumn of 2005, the Buncefield oil terminal explosions or the execution of Saddam Hussein (a security guard's mobile footage, distributed anonymously over the web, proffering chilling detail) a year later. 'It very much shows that citizen journalism's time is now', Feargall Kenny of Citizen Image asserted with regard to the revelatory significance of the Hussein imagery; 'You're going to see this more and more, especially as the phones get better' (cited in Lang 2007a).

'These are giddy times for citizen journalism', Daryl Lang (2007b) mused wryly in *Photo District News*; 'Venture capital is flowing, blogs are atwitter, and it's hard to resist the storyline of do-it-yourself amateur photographers and reporters trouncing the hapless mainstream media'. For those welcoming this 'new army of citizen reporters', to use the *Independent*'s Guy Clapperton's (2006) phrase, a paradigm shift appeared to be underway. Traditional photo-reportage, with its adherence to common principles of dispassionate relay, seemed increasingly open to the charge of being formulaic in its appeal to the codified strictures of objectivity (Allan 2006). Moreover, its polished aesthetic qualities risked being perceived as bland, even contrived, particularly among those disinclined to reaffirm official source-led news as relevant to their personal concerns or circumstances.

Citizen photojournalism, in marked contrast, inspired a celebratory language of revolution in the view of advocates. Journalism by the people for the people was heralded for its alternative framings, values and priorities; it was immediate, independent and unapologetically subjective. 'You can never know exactly where or when something compelling or newsworthy will happen', Dave Boyle, photo editor at the *New York Post* argued in 2007; 'It's important to be open to receiving images from new, non-traditional sources' (cited in Business Wire 2007). Camera-equipped bystanders had long provided news organisations with this type of imagery (Abraham Zapruder's home-movie of the Kennedy assassination in 1963 and George Holliday's videotaping of the LAPD beating of Rodney King in 1991 being two of the more noteworthy historical precedents), simply not at this volume nor with such speed. 'New technology has made it easier to capture and distribute imagery, leading to citizen photojournalism that is increasingly relevant to the news cycle', Jonathan Klein of Getty Images similarly maintained at this time; 'While this genre will never replace the award-winning photojournalism for which we're known, it's a highly complementary offering that enables us to meet the evolving imagery needs of a broad customer base' (cited in PR Newswire 2007).

Most agreed that citizen photojournalism was proving cheap and popular, hence its not inconsiderable appeal for cash-strapped newsrooms, despite certain misgivings about its impact. For some critics, its dangers outweighed whatever merits might temporarily catch the public's wandering eye. News organisations, they warned,

were at serious risk of losing credibility in their rush to embrace seemingly newsworthy material they could not always independently confirm or verify as accurate. 'Editorially they don't want it to happen but financially they want to let it happen because it increases page views', Marketwatch.com editor Bambi Francisco remarked in March, 2007. 'Content provided by users is generating revenue' (cited in Chapman 2007). For Thomas Sutcliffe (2007), writing in *The Independent*, further concerns revolved around the way such imagery 'necessarily skews the definition of news towards the contingent and the unexpected – the spectacular event that no news diary can schedule ahead of time'. Moreover, he added,

> since photographs and footage of such catastrophes are so compelling to most of us, the increased supply of them is likely to distort news bulletins and coverage towards the visually dramatic and away from the unphotogenic cogs and levers which actually move the world.

Still, even in a world where everyone is an 'incorrigible sensationalist' – to use Sutcliffe's phrase – most news organisations were well aware that facts continued to matter, ethical codes warranted respect and audience trust was paramount. Debates over how best to refashion their provision to be more accessible, responsive and interactive in rapidly converging digital environments recognised a hard truth, namely that citizens were intent on storming the ramparts of what was once regarded as the exclusive domain of the professional in ever greater numbers. Moreover, some 'crowd-sourcing amateurs' were exhibiting a sharply competitive edge, most notably via online sites such as Flickr, Citizen Image, Scoopt, iStockPhoto and the like. 'There are tens of millions of amateur paparazzi out there with camera phones', Kyle MacRae of Scoopt pointed out. 'If you can only find a way for them to sell their stuff, you have the potential to create something very big' (cited in Turpin 2006).

Those seeking financial recompense were a minority (most being satisfied to receive due credit for their contribution), yet sufficient in number to provoke disquiet among wary professionals expressing anxieties that their livelihood was being put at risk. 'What if everybody in the world were my stringers?' Chris Ahearn, President of Reuters media group, had asked in December 2006. One answer – photojournalism would cease to exist as a paid profession – was worrying, to say the least. Compounding matters for what might otherwise have seemed a welcome democratisation of the medium was the apparent indifference to evaluative judgements of quality among audiences. 'People don't say, "I want to see user-generated content"', Lloyd Braun of Yahoo News observed; they want to see interesting, preferably sensational imagery. 'If that happens to be from a cellphone, they are happy with a cellphone. If it's from a professional photographer, they are happy for that, too' (cited in Hansell 2006; Walker 2006). To the extent wider participation in image-making encouraged a recasting of the normative criteria informing visual news values, professional practices and protocols were subject to reconsideration. 'Traditional' standards were shifting under pressure, the implications

coming to the fore in the autumn of 2008 as speculation grew that social networking – most notably via Flickr and Twitter where breaking news was concerned – would be the next foreboding challenge to photojournalism's discursive authority.

'Sorry for blurry images'

Vinukumar Ranganathan's first thought was to grab his digital camera when he heard the explosions outside his home in Mumbai's Colaba district on the evening of 26 November, 2008. 'When I heard two loud reverberating [noises] in the night around 10:45pm, I picked up my camera bag and headed out' (cited in Stirland 2008). An amateur photographer in his spare time, he moved quickly to gather and then share some 112 images via the photo-sharing site Flickr – 'a chilling slideshow,' in the words of an Australian news site (Moses 2008) – documenting the destruction left in the wake of the attacks. London's *Daily Telegraph* credited him with providing 'perhaps the most amazing and harrowing first-hand account of the Mumbai attacks' in a report praising his 'series of photos showing mangled cars, bloodstained roads and fleeing crowds' (Beaumont 2008). Arun Shanbhag, visiting from the US, similarly felt obliged to contribute as he watched fires raging from a nearby terrace. He turned to Twitter to describe the 'thud, thud, thud' of gunfire, and to his personal blog and Flickr to upload photographs. Evidently unaware of the term 'citizen journalism' at the time, Shanbhag later told the *New York Times* that it aptly characterised the reportorial role he was performing. 'I felt I had a responsibility to share my view with the outside world', he explained (cited in Stelter and Cohen 2008).

Social networking seemed to be casting nascent transitional features into ever sharper relief. The imperative to be the first to bear witness, a defining lynchpin of professionalism, was being ceded to ordinary citizens engaged in 'accidental photojournalism' by circulating cameraphone reportage in real-time. More often than not the raw, blurry imagery being generated was prized because it offered a compelling eyewitness perspective, in effect making a virtue of technical deficiencies as a matter of pragmatic necessity. In the weeks following the Mumbai attacks, further examples focused press attention. A dramatic image of a US Airways passenger jet following its emergency landing in the Hudson River in January 2009 was shot by Janis Krums – using his iPhone to upload it to TwitPic – onboard a diverted commuter ferryboat coming to its rescue. The image, showing passengers standing on one of the wings and on the inflatable chute, was forwarded with such intensity it caused the service to crash. TwitPic and related micro-blogging strategies proved similarly indispensable during the G20 summit in London three months later. Among the estimated 35,000 people demonstrating peacefully were a small number of protestors, some involved with anarchist groups, intent on violent confrontations with the police. Citizen-shot still and video imagery recorded several clashes in shocking detail. One incident, in particular, ignited a major controversy – namely, the actions of a police officer knocking passer-by Ian Tomlinson to the ground. Tomlinson, a newspaper seller, collapsed and died after being hit by a

baton (see Greer and McLaughlin 2011). The Metropolitan Police's initial denial that an officer had been involved was flatly contradicted by evidence revealed by the *Guardian* six days later, namely a video clip documenting the assault, handed over to it by an American visitor to the city. For journalist Nik Gowing (2009), the citizen bystander who 'happened to bear witness electronically' represented a telling example of how non-professional 'information doers' were 'driving a wave of demo-cratisation and accountability' redefining the nature of power. 'The new ubiquitous transparency they create', he contended, 'sheds light where it is often assumed officially there will be darkness'.

In seeking to investigate the reasons ordinary people find themselves compelled to engage in first-person reportage, these and related examples usefully illuminated further issues warranting elucidation. To describe those involved as 'citizen photo-journalists' may be advantageous at times, in part by acknowledging that their actions are recognisable as journalistic activity, but such a label brought with it certain heuristic difficulties too. More than a question of semantics, the person inclined to self-identify as someone engaging in a journalistic role – perhaps an independent blogger, photographer or videographer – is likely to differentiate themselves from those who just happen to be nearby when a potentially newsworthy incident happens. Having the presence of mind to engage in citizen witnessing may well be a laudable achievement under trying constraints, but this represents a different level of engagement. 'Let's face it, most of the people who capture this imagery have jobs to work, errands to run, houses to maintain and families to take care of', crowdsourcing analyst Eric Taubert (2012) has observed. 'If asked, they don't consider themselves citizen journalists', he adds, although they will often welcome the opportunity to have their imagery shared with a wider audience. 'Great content captured by smartphone-wielding citizens can die on the vine without ever being seen', unless it 'finds its way into the hands of journalists who know how to wrap a story around it, fact-check it and place it into the distribution chain'. In other words, unless the citizen in question is prepared to assume this responsibility for themselves – which, admittedly, is getting easier to do by the day via digital media – they will likely turn to a news organisation to perform it on their behalf.

Further instances of an emergent, albeit uneven collaborative ethos between professional and citizen photojournalists were apparent during the 'London Riots' of summer 2011. News coverage of a city 'under siege', where certain neighbourhoods were described as 'battle zones' with protestors 'in control of the streets', revolved around alarming imagery. Several journalists recounted violent skirmishes 'from the front lines', cognisant of the risks to their personal safety. Efforts to broadcast live were frequently curtailed, with crews in satellite vans belonging to networks such as the BBC, ITN, Sky News and CNN forced to retreat. 'CNN reporter Dan Rivers, kitted out in a helmet and what looked like body armour under his jumper, and his cameraman were caught between rioters and a police line in Peckham', one reporter stated; 'They beat a hasty retreat as bottles and other missiles began to rain down' (Halliday 2011). Photojournalists were similarly concerned for their safety, their digital-SLR cameras making them all too conspicuous in the eyes of those

alert to the risk of being identified in photographs made public (or secured by the police). The Press Association's Lewis Whyld, fearful of being singled out, watched in dismay as another photographer was targeted by an angry group. 'I put my bag on the ground and got my camera out, but as I did so the other photographer was grabbed by a mob of maybe ten or more men who immediately smashed his cameras and hit him to the ground', he later recalled; 'I quickly moved away into a crowd with them after me, feeling massively guilty about leaving the other photographer but knowing I had to leave immediately if I wanted any chance of keeping my cameras and not being beaten up' (cited in Hope 2012). His professional equipment safely stowed in his car, he continued documenting the carnage around him using his Blackberry smartphone, which also enabled him to relay the images to the newsroom without having to use his laptop. Several of them would duly appear in newspapers around the world.

Mindful of the need to blend into the crowd, photojournalists recognised that opting to use their mobile telephones helped considerably, but still raised suspicions. Everyone taking pictures, it seemed, was being confronted by those anxious to determine whether or not they were 'Feds'. Photojournalist Fil Kaler left the protection of the police line in Brixton to enter a crowd outside an electronics store. 'Once I got in, I knew it didn't feel safe to film', he stated; 'I had my camera down by my side and took some shots on my phone and sent a few tweets and then out of nowhere I got punched in my face, my glasses were knocked off and my camera was nicked' (cited in O'Carroll 2011). The *New York Times'* London reporter Ravi Somaiya said in an interview that the 'rioters didn't like being photographed for obvious reasons, so I had to be subtle about the way I went about it'. The situation was too dangerous for broadcast media to cover the unfolding story, in his view, primarily due to the lack of an adequate police presence: 'In those circumstances – where there were no police to be seen – it wouldn't be possible for [a television crew] to be protected. It was difficult enough for me to send Tweets and discreetly take photographs on my phone'. In many ways, he added, 'it was a story made for Twitter' (cited in Kemp and Turner 2011). Paul Lewis (2011) of the *Guardian* later described how his and film-maker colleague Mustafa Khalili's efforts to document 'what felt like a country at war with itself' had been facilitated by social networking. 'The first portal for communicating what we saw was Twitter', he wrote; 'It enabled us to deliver real-time reports from the scene, but more importantly enabled other users of Twitter to provide constant feedback and directions to trouble spots'.

This rapid forging of impromptu points of connectivity between journalists and citizens enhanced the quality of newsgathering to a remarkable extent. Many residents had taken to the streets to bear witness themselves, capturing still photographs and video footage of significant value to news organisations. An array of 'haunting images' chronicling the violence 'flooded the Internet over the past 24 hours', Lindsay Kalter (2011) of IJNet.com pointed out, with sites such as Flickr, Blottr, Instagram, Citizenside and The-Latest, among many others, offering particularly 'captivating images of the breaking story'. A relatively small portion of the imagery was shot by

the participants themselves, including incriminating 'trophy' snapshots of one another standing in front of ransacked shops (Holehouse and Millward 2011). News editors adopted a curatorial role, moving swiftly to repurpose diverse types of contributions from members of afflicted communities, many of them evidently intent on doing their part to extend the scope of mainstream coverage. Videos on YouTube posted by eyewitnesses were valued for providing raw, frequently poignant, visual testimonies of loss but also personal hardship. 'While the television broadcast images of burned buildings and cars, Tottenham's new citizen journalists captured the full extent of the damage, reaching the corners that the press couldn't', blogger Reni Eddo-Lodge (2011) maintained. Writing as someone who had grown up there, however, she expressed her sadness that it had taken a riot to highlight the complex problems blighting one of the most deprived areas in London.

Renegotiating terms

To close, it is apparent that pronouncements about the impending 'death of photojournalism' – just like the counter-assertion that 'everyone becomes a photojournalist' with a cameraphone – make for lively debate. In resisting the pull of sharply cast binaries, this chapter's discussion has aimed to tease out differing, inchoate perspectives on the visual ecology of digital photojournalism, revealing it to be in a state of flux, open to a myriad of competing definitions. Likely to be shared among its professional practitioners, however, is the recognition that citizen witnessing is rewriting the unspoken rules of the craft, forcing them to adapt to changes while coping with considerable uncertainty simply to protect their livelihoods.

'It's fair game – you can't stop people taking pictures with mobile phones', *Guardian* photographer David Levene admitted, before adding that what is gained in immediacy may be lost with respect to skill. So-called 'citizen snappers' may be lucky enough now and then, but 'I just have to trust that my paper will show a certain amount of loyalty to me' (cited in *Design Week* 2011). When set in relation to the larger political-economy of the crises confronting news organisations struggling to re-profile their news provision in order to survive, let alone prosper in a digital era, the pressures on this type of loyalty become all the more acute. Many newsrooms, facing strict financial demands to trim expenditure wherever possible, deem the resources vital for photojournalism to be a luxury difficult to sustain when confronted with seemingly inexorable market forces. Prescribed standards are at risk of being compromised, many fear, when guiding principles threaten to unravel in a climate of managerial indifference, if not outright neglect. Even those striking a more optimistic chord concede that necessity is dictating a rethinking of roles, which for some photojournalists has led to a decentring of 'hard' or 'spot' news reportage in favour of interpretive modes consistent with long-form photo essays, self-published books, gallery exhibitions or multimedia websites to tell their stories.

Citizen photojournalism's alternative ethos poses challenges while holding out the prospect of solutions forged on the basis of collaborative relationships imagined anew. This chapter, in tracing formative aspects of this emergent ecology in digital contexts, has sought to discern for analysis and critique the ways in which the ordinary person's investment in upholding reportorial commitments – recurrently overlooked in disputes over what counts as legitimate photojournalism – complicates tacit professional imperatives, yet may also occasionally enhance, even reinforce them in certain circumstances. Looking ahead, this dialogic process of mediation invites a renegotiation of terms beyond rigid 'us' and 'them' binaries to help deepen and enrich photojournalism's social contract to document conflicting truths. Still, this is not to deny that the blurring of conventional boundaries will prompt awkward questions regarding the integrity of evolving norms, values and protocols. The search for answers, however, promises to reinvigorate photojournalism's time-honoured responsibilities for tomorrow's participatory news cultures.

Note

1 This chapter's mode of enquiry is underpinned by two methodological commitments. First, in identifying and critiquing mainstream news reporting of what I term the emergent ecology of digital photojournalism, extensive searches have been made of international news organisation archives using electronic databases, as well as drawing upon my personal catalogue of clippings compiled over the years. Second, it is informed by semi-structured interviews with journalists, editors and photojournalists, several of which were conducted for a related project funded by the Swedish Research Council. I am pleased to acknowledge my research assistant, Caitlin Patrick, for her key role with over 20 interviews at various London-based news organisations. And last, my sincere gratitude to Martin Lister for astute editorial advice.

Bibliography

Allan, S. (2006) *Online News: Journalism and the Internet.* Maidenhead and New York: Open University Press.

——(2013) *Citizen Witnessing: Revisioning Journalism in Times of Crisis.* Cambridge: Polity.

Anstead, E. (1997) 'Clear picture of war in the photographs', *The Washington Times*, 18 December.

AP (1989) 'Baltimore daily announces electronic integration of production', Associated Press, 25 January.

Barton, M. (2005) 'Blogs' witness accounts offer the world a fresh view', *Sydney Morning Herald*, 8 January.

Beaumont, C. (2008) 'Mumbai attacks: Twitter and Flickr used to break news', *The Telegraph*, 27 November.

Becker, K.E. (1991) 'To control our image: photojournalists and new technology', *Media, Culture & Society*, 13: 381–97.

Bell, E. (2005) 'Media: opinion', *Guardian*, 11 July.

Berman, A.S. (2004) 'Real pictures in real time', *PressTime*, May.

Boseley, S. (1996) 'Royal pack snaps at "amateur" paparazzo', *Guardian*, 17 August.

Business Wire (2007) 'Citizen image turns photo sharing social networks users into global corps of photojournalists', *Business Wire*, 12 March.

Chapman, G. (2007) 'Internet age lets anyone play news reporter', *Agence France Presse*, 28 March.

Clapperton, G. (2006) 'Anytime, any place, anywhere', *The Independent*, 16 January.

Danziger, N. (2005) 'History in the raw', *The Times*, 3 September.

Design Week (2011) 'Citizen snappers', *Design Week*, 3 February.

Eddo-Lodge, R. (2011) 'Twitter didn't fuel the Tottenham riot', *Guardian Unlimited*, 8 August.

Fischer, D. (2002) 'Through a lens darkly', *The Calgary Herald*, 11 September.

Friend, D. (2007) *Watching the World Change: The Stories Behind the Images of 9/11*. London: I.B. Tauris.

Glaser, M. (2001) 'A new image: why pros go digital', *The New York Times*, 18 October.

Gowing, N. (2009) 'Real-time media is changing our world', *Guardian*, 11 May.

Greer, C. and McLaughlin, E. (2011) '"This is not justice": Ian Tomlinson, institutional failure and the press politics of outrage', *British Journal of Criminology*, 52(2), 274–93.

Grundberg, A. (1990) 'Blurred and shaky images that burn in the mind', *The New York Times*, 14 January.

Guerrin, M. (2000) 'Shooting stars bitter as they fall to earth', *Le Monde*, reprinted in the *Guardian*, 27 September.

Halliday, J. (2011) 'London riots: Sky, ITN and CNN reporters attacked', *Guardian*, 9 August.

Hansell, S. (2006) 'Have camera phone? Yahoo and Reuters want you to work for their news service', *The New York Times*, 4 December.

Holehouse, M. and Millward, D. (2011) 'How technology fuelled Britain's first 21st century riot', *The Telegraph*, 8 August.

Holmstrom, D. (1995) 'Our best shots', *Christian Science Monitor*, 28 December.

Hope, T. (2012) 'War on the streets', *Photo Professional*, 64 (February), 24–28.

Hu, J. (2001) 'Home videos star in online attack coverage', CNET News, 12 October.

Independent, The (2005) 'Immediacy of amateur coverage comes into its own', *The Independent*, 3 January.

Jesdanun, A. (2005) 'Proliferation of digital imaging tech broadens newsgathering', *Associated Press*, 7 July.

Kalter, L. (2011) 'Five websites where citizen journalists are documenting riots in London', International Journalists' *Network, IJNet.org*, 8 August. Available at http://ijnet.org/blog/how-london-citizen-journalists-are-using-smart-phones-capture-riots

Kane, P. (1994) 'Putting us all in the picture', *The Sunday Times*, 28 August.

Kemp, S. and Turner, M. (2011) 'London riots: Journalists under attack share stories from the front lines', *Hollywood Reporter*, 10 August.

Kowet, D. (1989) '"Uplink" to speed sending of AP photos', *Washington Times*, 21 September.

Lang, D. (2007a) 'Citizen journalism: part disaster photos, part UFOs', *Photo District News*, 3 September.

——(2007b) 'Hussein execution is another milestone for cell phone cameras', *Photo District News*, 3 January.

Lister, M. (2007) 'A sack in the sand: photography in the age of information', *Convergence*, 13(3): 251–74.

MacDonald, G. (2001) 'The Handicam world', *The Globe and Mail*, 13 September.

Mitchell, W.J. (1992) *The Reconfigured Eye: Visual Truth in a Post-photographic Era*. Cambridge: MIT Press.

Moses, A. (2008) 'Mumbai attacks reported live on Twitter, Flickr', *The Sydney Morning Herald*, 27 November.

Norville, D. (1990) 'Interview: Brown, Ritchin, Smolan on computer manipulation of photographs', NBC News: Today, 3 August.

NPR (1997) 'Interview with Yunghi Kim and David Burnett', Morning Edition, National Public Radio broadcast, 29 August.

O'Carroll, L. (2011) 'London riots: photographers targeted by looters', *Guardian Unlimited*, 9 August.

Parry, K. (2005) 'When citizens become the journalists', *Star Tribune*, 17 July.

Pfiffner, P. (1990) 'Newspaper seps on "bleeding edge"', *MacWeek*, 31 July.

Power, M. (1987) 'Can you believe your eyes?', *The Washington Post*, 26 April.

PR Newswire (2007) 'Getty images acquires Scoopt with vision of making citizen photojournalism more accessible to the mainstream media', *PR Newswire*, 12 March.

Reaves, S. (1987) 'Digital retouching: is there a place for it in newspaper photography', *Journal of Mass Media Ethics*, 2(2), 40–48.

Riding, A. (1996) 'Photographers look inward, and discover self-doubt', *The New York Times*, 12 September.

Ritchen, F. (1984) 'Photography's new bag of tricks', *The New York Times*, 4 November.

Rodgers, P. (1995) 'A concept that will really click', *The Independent*, 10 April.

Rosler, M. (1989) 'Image simulation, computer manipulations: some considerations', *Afterimage*, 17(4), 7–11.

Saffo, P. (1990) 'The day the image stood still', *Personal Computing*, 1 February.

Sawyer, K. (1994) 'Is it real or is it … ? Digital-imaging fiction leaves no "footprints"', *The Washington Post*, 21 February.

Schechter, D. (2005) 'Helicopter journalism', Mediachannel.org, 5 January. Available at www.asiamedia.ucla.edu/tsunami/1yearlater/article.asp?parentID=19220

Sonenshine, T. (1997) 'Is everyone a journalist?', *American Journalism Review*, October.

Spina, T. (1990) 'Forward to the year 2000', *The Record*, 28 January.

Stelter, B. and Cohen, N. (2008) 'Citizen journalists provided glimpses of Mumbai attacks', *The New York Times*, 29 November.

Stirland, S. L. (2008) 'As TV networks focus on Mumbai landmarks, local captures ground shots on Flickr', Wired.com, 27 November. Available at www.wired.com/threatlevel/2008/11/as-tv-networks/

Straits Times, The (1995) 'Two Canadian newspapers snap up high-tech cameras', *The Straits Times* (Singapore), 6 February.

Summers, D. (1999) 'New technology for new deadlines', *Birmingham Post*, 30 August.

Sutcliffe, T. (2007) 'Ethics aside, citizen reporters get scoops', *The Independent*, 2 January.

Taubert, E. (2012) 'So, you're still using the phrase citizen-journalism', Dailycrowdsource.com, 14 May. Available at http://dailycrowdsource.com/crowdsourcing/articles/opinions-discussion/1092-so-you-re-still-using-the-phrase-citizen-journalism

Thompson, E. (2004) 'Amateurs scorch the pros with hotel fire snapshots', *Courier Mail*, 22 May.

Trost, C. (2002) 'They took the images America can't forget', *USA Today*, 9 September, p. 15A.

Turpin, A. (2006) 'The paparazzi are now everywhere', *The Sunday Times*, 29 January.

Walker, D. (2006) 'Reuters and Yahoo calling all citizen photojournalists', *Photo District News*, 4 December.

Weiner, E. (2005) '"Citizen journalists" at the point of breaking news', National Public Radio, *Day to Day show*, broadcast 12 August.

Wheelwright, G. (1994) 'Journalists among first to be exposed to digital cameras', *The Financial Post*, 15 October.

Zelizer, B. (2011) 'Photography, journalism, trauma', in B. Zelizer and S. Allan (eds), *Journalism after September 11*, 2nd edn. London and New York: Routledge, pp. 55–74.

INDEX

Please note that page numbers relating to Notes will have the letter 'n' following the page number. References to Figures or Tables will be in italics.